Places of Public Memory

Places of Public Memory

The Rhetoric of Museums and Memorials

Edited by Greg Dickinson, Carole Blair, and Brian L. Ott

THE UNIVERSITY OF ALABAMA PRESS
Tuscaloosa

Typeface: Bembo

∞

The paper on which this book is printed meets the minimum requirements of
American National Standard for Information Sciences-Permanence of Paper for
Printed Library Materials, ANSI Z39.48-1984.

Library of Congress Cataloging-in-Publication Data

Places of public memory : the rhetoric of museums and memorials / edited by Greg
Dickinson, Carole Blair, and Brian L. Ott.
 p. cm. — (Rhetoric, culture, and social critique)
 Includes bibliographical references and index.
 ISBN 978-0-8173-1706-5 (cloth : alk. paper) — ISBN 978-0-8173-5613-2
(pbk. : alk. paper) — ISBN 978-0-8173-8360-2 (electronic) 1. Place (Philosophy)
2. Memory. 3. Memorialization. 4. Museums—Social aspects. I. Dickinson, Greg.
II. Blair, Carole. III. Ott, Brian L. IV. Title: Rhetoric of museums and memorials.
 B105.P53P59 2010
 069.01—dc22

 2010000248

Cover: James Casebere, *Samarra*, 2007, digital chromogenic print mounted to Plexiglas
© James Casebere. Courtesy of the artist and Sean Kelly Gallery, New York.

Contents

Illustrations

Acknowledgments

Like many collections, this one found its genesis in a number of conference panels and conversations over glasses of wine inspired by these presentations. This book could not have come together without these initiating discussions. More specifically, the book depends on the care and creativity of its contributors, all of whom demonstrated significant patience with our editorial requests.

We want especially to thank Barbara Biesecker, for her careful reading and many helpful conversations and suggestions; V. William Balthrop, for reading earlier versions of the introduction; and Christian Lundberg for useful advice on issues of rhetoric and memory. We received significant help from the book's anonymous reviewers. All of the editors and staff at The University of Alabama Press have shown unflagging support for this project.

Places of Public Memory

Introduction

Rhetoric/Memory/Place

Carole Blair, Greg Dickinson, and Brian L. Ott

The story is told of the poet Simonides of Ceos who, after chanting a poem in the honor of Scopas, was called from the banquet hall in which he had performed. During his absence the roof of the hall came crashing down, killing all of the guests. The guests' bodies were so maimed that their relatives were unable to identify the remains. Simonides, however, remembered where each guest was sitting just before he left the hall. He was able to identify the victims' remains by their positions in the destroyed hall. This is a founding legend of the rhetorical art of memory. As Cicero tells the story in *De oratore,* Simonides realized that "it is chiefly order that gives distinctiveness to memory; and that by those, therefore, who would improve this part of the understanding, certain places must be fixed upon, and that of the things which they desire to keep in memory, symbols must be conceived in the mind, and ranged, as it were, in those places; thus the order of places would preserve the order of things."[1] The story also appears in Quintilian's *Institutio oratoria* and in the *Rhetorica ad Herennium.* Much later the story would be retold in the first paragraphs of Frances Yates's germinal book *The Art of Memory.*[2]

We remember this story here because it introduces three intersecting concepts that form the *topoi* of this volume: rhetoric, memory, and place. As the retelling of the Simonides story in Quintilian, Cicero, and Yates suggests, our interest in these three *loci* is part of a deep cultural history. As important as memory was in the founding works of the rhetorical tradition—memory was, after all, one of the five ancient canons of rhetoric—rhetorical studies has for years relegated memory to a background issue. Nor has Simonides' realization that place organizes memory been of much contemporary interest to rhetoric. The argument of this collection, however, is that within the contemporary moment rhetoric, memory, and place form complex and important relations.

We began this project with the belief that exploring the relations among rhetoric, memory, and place is of crucial importance to understanding contemporary public culture. Public memory increasingly preoccupies scholars

across the humanities and social sciences. Further, much of their scholarship suggests at least by implication that memory places are rhetorical. The position of this anthology is that strong understandings of public memory and of public memory places can emerge only by comprehending their specifically rhetorical character. The assumptions that motivate this collection are that memory is rhetorical and that memory places are especially powerful rhetorically. The essays in this book, then, explore places of public memory, attending in particular to their rhetorical (both symbolic and material) character and function. The contributing authors, who all work in some way at the nexus of rhetoric, memory, and place, offer a fascinating array of exemplary memory places, material conjunctions of our three entitling ideas.

Our principal task in this introduction is to argue for the value of understanding public memory and public memory places as fundamentally rhetorical. Such a task does not imply a simple or uncomplicated vision of memory or of place. For reasons that we hope will become clear, introducing rhetoric to memory and place studies does not unify these fields of study or even simplify them.[3] If anything, it adds complexity, but a congenial complexity, to the far-ranging, contemporary conversations about both memory and place. We explore the ways in which rhetoric, memory, and place seem to haunt one another in recent scholarship and how that haunting might be materialized in a serious, productive, and animated conversation among these different, highly complex coordinates of public life. We mean to stage this conversation not just as turn taking by three independently interesting participants. We stage it as a conversation of mutual recognition, one in which the participants articulate their own positions, but do so in relation to the other participants. Thus, the conversation narrows in focus as it successively takes up issues of interest to all three coordinates. We begin with a brief introduction about rhetoric, move on to a discussion of public memory in relationship to rhetoric, and finally take up the specific character of public memory places.

Rhetoric

Rhetoric is the study of discourses, events, objects, and practices that attends to their character as meaningful, legible, partisan, and consequential.[4] But what most clearly distinguishes rhetoric from other critical protocols (cultural studies or literary criticism, for example) is that it organizes itself around the relationship of discourses, events, objects, and practices to ideas

about what it means to be "public." We take up both the subject matters and features of rhetorical studies in turn, beginning with the subject matter of rhetorical study.

We do not see rhetoric as a genre of discourse, or even as necessarily discursive at all. Rather, we take rhetoric to be a set of theoretical stances and critical tactics that offer ways of understanding, evaluating, and intervening in a broad range of human activities. There is a rich legacy in modern rhetorical study of engaging with critical targets as diverse as poetry, tourist sites, photography, sculpture, television programming (from news to situation comedies), music, corporate advocacy, performance art, film (from documentary to Hollywood drama), advertising campaigns, and architecture, as well as political speech and persuasive writing. Such arts, cultural apparatuses, and technical practices, like those that ancient thinkers deemed *techné,* have come to be understood as at least rhetorically accented.[5] Certainly rhetoric's oldest western traditions theorized it as a more particularized kind of practice—persuasive speech in the public domains of the agora, courts, and deliberative assemblies.[6] Many of the concepts and concerns of the earliest rhetoricians continue to animate modern rhetorical study, but they have application well beyond speech.

When we use the term "meaningful," we exploit two very different understandings of the word, both of which are taken account of in rhetoric. The first, a common usage, takes discourses, events, objects, or practices to be significant, in an emotionally inflected sense. Meaningful discourses, events, objects, and practices carry evocative, affective weight. They create and/or sustain emotional affiliation. So, in this first sense, meaningful-ness invites us to consider how discourses, events, objects, and practices inflect, deploy, and circulate affective investments. "Meaningful" enables a second set of associations if we understand it as filled with meaning. Thus, discourses, events, objects, and practices are composed of signs that may take on a range of signification. For most rhetoricians, the notion of signification is of serious importance, for it suggests in what ways a discourse, event, object, or practice might come to reference particular meanings.[7] But the materiality of the signifier itself, as a mode of mediation, has taken on increased importance in contemporary times, clear in an intensified focus on material rhetoric. Michael Calvin McGee, for example, suggests that "Discourse, even language itself, will have to be characterized as material rather than merely representational of mental and empirical phenomena." He argues that "It is a medium, a bridge among human beings, the social equivalent of a verb in a sentence."[8] To borrow Ernst Cassirer's pithy phrase, "all

symbolism harbors the curse of mediacy," for it re-presents, or perhaps even creates, the reality it purports to capture or copy.[9] In sum, most rhetoricians consider human activity to be necessarily but differentially mediated.[10]

The notion of legibility operates in rhetoric in a number of different ways. It implies, of course, a sense of readability or understandability of an expression. But what makes a discourse, event, object, or practice legible? The presence of a rhetorician is certainly not required in order to claim that reading or interpretation is never an activity of transparency or innocence. Rhetorical legibility is predicated in publicly recognizable symbolic activity *in context*. That is, rhetoric typically understands discourses, events, objects, and practices as timely, of the moment, specific, and addressed to—or constitutive of—particular audiences in particular circumstances.[11] The contexts within or against which it interprets discourses, events, objects, and practices are multiple, ranging from the historical accretion of various symbols to immediate political interests, to social norms, to available generic prototypes and cultural predispositions toward symbolicity in general.[12]

Rhetoricians also take discourses, events, objects, and practices to be partisan. That is so, in the most basic sense, because these phenomena are symbolic, and hence partial. Rhetoric has understood, in most of its western renditions, that discourses, events, objects, and practices have attitude. They are not "neutral" or "objective," but tendentious. They are understood as deployments of material signs serving as the grounds for various identifications or perceived alignments to take shape.[13] Another way of understanding this characterization is to heed Michel Foucault's caution that "everything is never said."[14] And one might add that everything is not constructed as an event, not all possible objects are actually made, and not all possibilities of practice take place. Hence, those statements that are uttered, those objects that are actually made, those isolated moments that take on the character of an event, and the ways in which people act (as opposed to how they do not) come to be seen as important, correct, normal, and so forth. That renders their far more numerous unmaterialized counterparts as perhaps not so important, correct, or normal. Thus, rhetoric takes discourses, events, objects, and practices to be activities of a partisan character, embracing some notions and despising others, willfully or not.

Discourses, events, objects, and practices are, for rhetoric, consequential, or at least potentially so.[15] One of the formative positions in rhetoric in the twentieth century held that criticism in rhetoric "is not concerned with permanence, nor yet with beauty. It is concerned with effect."[16] Although Herbert Wichelns and many others of his time took rhetoric to be a genre of discourse, specifically oratory, a concern with effect has marked much

of the theorizing and criticism in rhetoric, despite many other changes of assumption. Indeed, Richard A. Cherwitz and John Theobald-Osborne have argued that the potential of rhetoric to exert effect is the foundational assumption of the field.[17] Once conceived as a rather narrow standard of assessment in oratory (Did a speaker achieve his/her ends?), rhetoric has broadened its sense from effect to "consequence" (effects that exceed or run counter to goals), and more recently to "effectivity" (understood as social value or utility, as modes of re-use or circulation).

John Louis Lucaites and Celeste Michelle Condit remind us, finally, that the most ancient traditions claimed by rhetoric in the West emphasized the need to consider rhetoric as fundamentally public activity.[18] Sometimes, rhetoric's situatedness in "public" is described in terms of its mode of addressivity, in which case rhetoric has been understood as distinct from practices with "specialized or elite audiences (e.g., the discourses of astronomy or medicine) and [from] private discourses addressed to more personal audiences that did not directly affect the social and political community at large."[19] More complicated—but perhaps more useful—is the notion of "public" understood to describe a mode of action in the circumstances of collective contingency, that is, as dealing with circumstances that are neither necessary nor impossible.[20] "Public" is not an uncontested concept; it certainly is not considered by rhetoricians as a simple or unproblematic setting for activities of various kinds. Itself a quite elastic concept, a public is often thought of as an ensemble of stranger interactions, predicated upon boundary conditions, normative standards, and/or particular instantiations between the individual and the state.[21] Its various theoretical identities are clear even in the various terminological associations it often entails—"the public," "the public sphere," "subaltern publics," "counterpublics," "public opinion," and so forth.[22] Rhetoric surely is not the only academic discipline to which "the public" is important or within which "publicity" is theorized.[23] Nonetheless, whether one posits "the public sphere" or immanent modes and practices of "publicity," these notions have served consistently as assumptive, normative coordinates—or as problematics—of the rhetorical.

Rhetoric and Public Memory

Predicated in the early twentieth-century writings of Maurice Halbwachs, particularly *Les Cadres Sociaux de la Mémoire,*[24] and given fresh impetus by Michel Foucault,[25] contemporary scholarship has posed memory as an activity of collectivity rather than (or in addition to) individuated, cognitive

work. The assumption of a shared understanding of the past is captured in the multiple modifiers attached to "memory" in recent years; talk of collective memory, social memory, popular memory, cultural memory, and public memory is much in evidence in a multiplicity of academic fields. The particular nuances of the modifiers matter, of course, as is evident in Edward Casey's parsing of different "forms" of memory.[26] Although we are less inclined than Casey to understand the different modifiers as representing different *kinds* of memory in practice, there still is a distinct theoretical connotation brought to bear by researchers in choosing a particular modifier.[27] We have chosen to use the designator "public" memory here, because of rhetoric's emphasis upon concepts of publicity; thus, it seems preferable in elaborating a rhetorical understanding of memory. That is so, we believe, because "public" situates shared memory where it is often the most salient to collectives, in constituted audiences, positioned in some kind of relationship of mutuality that implicates their common interests, investments, or destinies, with profound political implications. Regardless of the particular modifier attached to "memory," the assumptions of contemporary memory studies seem to be widely shared. In referencing this larger domain, then, we acknowledge that the terminological variances make a difference, but we collapse under the sign of "public memory" those studies taking the stance that beliefs about the past are shared among members of a group, whether a local community or the citizens of a nation-state.

In addition to the assumption that remembering takes place in groups, contemporary memory scholars appear to hold to a number of positions, which we will reference as their consensual (or nominally consensual) assumptions. We take them up as follows: (1) memory is activated by present concerns, issues, or anxieties; (2) memory narrates shared identities, constructing senses of communal belonging; (3) memory is animated by affect; (4) memory is partial, partisan, and thus often contested; (5) memory relies on material and/or symbolic supports; (6) memory has a history. Although there may be apparent agreement on other propositions as well, these are thematized frequently and relatively consistently by memory scholars across disciplines, methodologies, and substantive interests. We describe each of these positions briefly and then place them into conversation with rhetoric.

First, public memory is understood by most, if not all, contemporary scholars as activated by concerns, issues, or anxieties of the present. That is, groups tell their pasts to themselves and others as ways of understanding, valorizing, justifying, excusing, or subverting conditions or beliefs of their current moment. That is not to suggest that they concoct their pasts out

of whole cloth, although some scholars have noted cases of memory practices that come close to complete fabrication.[28] Rather it is to suggest that groups talk about some events of their histories more than others, glamorize some individuals more than others, and present some actions but not others as "instructive" for the future. In other words, they make choices. Wittingly or unwittingly, they do so, conclude most memory scholars, on the basis of how they understand or value their present conditions. As David Lowenthal suggests, we "select, distil, distort, and transform the past, accommodating things remembered to the needs of the present." He concludes that "The prime function of memory, then, is not to preserve the past but to adapt it so as to enrich and manipulate the present. . . . Memories are not ready-made reflections of the past, but eclectic, selective reconstructions based on subsequent actions and perceptions and on ever-changing codes by which we delineate, symbolize, and classify the world around us."[29] As Lowenthal suggests and as most memory scholars concur, our understandings of and investments in the past change as our present conditions and needs change.

Second, public memory is theorized in most scholarship as narrating a common identity, a construction that forwards an at least momentarily definitive articulation of the group. It also offers to individuals a symbolic connection with the group and a sense of belonging to it, "anchoring the self," as Iwona Irwin-Zarecka puts it, in the comfort (or sometimes discomfort) of a collective.[30] Jan Assmann summarizes this position elegantly, in his claim that memory "comprises that body of reusable texts, images, and rituals specific to each society in each epoch, whose cultivation serves to stabilize and convey that society's self-image. Upon such collective knowledge, for the most part (but not exclusively) of the past, each group bases its awareness of unity and particularity."[31] So important is public memory to groups' self-definitions and adherents' identity that some scholars, like Michael Kammen and John Bodnar, have articulated it directly with patriotism.[32]

Third, public memory is typically understood as animated by affect. That is, rather than representing a fully developed chronicle of the social group's past, public memory embraces events, people, objects, and places that it deems worthy of preservation, based on some kind of emotional attachment. Perhaps the most underdeveloped of public memory's assumptions, it may also be one of the most central. The significance of affect to public memory is typically articulated in one of two ways: as a simple irreducible, and unexplored, assumption, or as the particularized ground for phenomenological explorations of trauma. Both of these articulations

are important, but both strike us as inadequate. The first, which amounts simply to assertion, invites but does not produce a serious exploration.[33] The second—and, at some level, more satisfying—articulation offers an in-depth examination of very particular kinds of responses to a very particular kind of event, memorable because of its violence and the suffering it proliferates. The "trauma literature" is powerful, large and growing, and useful in helping to sort out the affective dimensions of the relation of affect to memory in response to the extraordinary.[34] Nonetheless, it can hardly be generalized to account for what we might consider more "ordinary" public memory (unless one generalizes modernity as essentially characterized by trauma, which some do).[35] Moreover, as Assmann wisely points out, different traditions of thought link memory to violence differentially and sometimes not at all.[36] His contrast of Nietzsche and Halbwachs is crucial here, and that distinction accounts in part for these two different articulations of the affect assumption.[37]

A frequent corollary to the assumption of memory's animation by affect has been a series of attempts to locate the differences and relationships between history and memory.[38] Indeed, Jay Winter suggests that "Historical remembrance is a field which has helped bring affect back into historical study."[39] It is Pierre Nora's account of this relationship that surely has been the most cited by other scholars, although with varying attitudes of approbation and opprobrium:

> Memory and history, far from being synonymous, are thus in many respects opposed. Memory is life, always embodied in living societies and as such in permanent evolution, subject to the dialectic of remembering and forgetting, unconscious of the distortions to which it is subject, vulnerable in various ways to appropriation and manipulation, and capable of lying dormant for long periods only to be suddenly reawakened. History, on the other hand, is the reconstruction, always problematic and incomplete, of what is no longer. Memory is always a phenomenon of the present, a bond tying us to the eternal present; history is a representation of the past. Memory, being a phenomenon of emotion and magic, accommodates only those facts that suit it. It thrives on vague, telescoping reminiscences, on hazy general impressions or specific symbolic details. . . . History, being an intellectual, non-religious activity, calls for analysis and critical discourse. Memory situates remembrance in a sacred context. History ferrets it out; it turns whatever it touches into prose. . . . At the heart of history is a criticism destructive of spontaneous memory.[40]

Although the distinction, as Nora draws it, certainly is not universally accepted, it does at least serve to mark out different tendencies that are frequently attributed to memory and history. Among those is the animation of memory by affective dimensions, which may serve less well to distinguish it from history than it does to suggest the parameters by which it typically is assessed. If history can be said to be judged by its adherence to protocols of evidence, we might say that public memory is assessed in terms of its effectivity.[41] While some, like Nora, draw a sharp distinction between these two modes of representing the past, even posing them as at odds with one another, it seems fair to say that most public memory scholars probably would embrace Marita Sturken's far less stark delineation; she suggests that history and memory are "entangled," rather than comprising completely distinct activities.[42]

Fourth, memory studies posits public memory as partial, partisan, and thus frequently contested. As Barbie Zelizer has argued, a "basic premise in our understanding of collective memory concerns its partiality. No single memory contains all that we know, or could know, about any given event, personality, or issue."[43] Because a collective's memories are selective, they are seen as also deflecting other memories. Perhaps the most common assertion among public memory scholars is that memory is operationalized by forgetting. This idea is evident above in Nora's identification of remembering and forgetting as a dialectical pair, and the assumption is rearticulated emphatically by Andreas Huyssen: "Freud already taught us that memory and forgetting are indissolubly linked to each other, that memory is another form of forgetting, and forgetting a form of hidden memory. Yet what Freud described universally as the psychic processes of remembering, repression, and forgetting in individuals is writ large in contemporary consumer societies as a public phenomenon of unprecedented proportions."[44] And indeed, Sturken declares memory and forgetting to be "co-constitutive processes," each "essential to the other's existence."[45]

Because public memory is definitively partial, it is subject to challenge on the grounds of its nature as such. That is, public memories may be challenged by different versions of the past, by introduction of different information or valuations. As Michael Schudson has observed, "People are wary of the past, recognizing that it is often used as an ideological weapon and knowing that any account is vulnerable to challenge and revision."[46] Not all memory representations are challenged publicly, but some clearly are. Despite its partiality, memory is, as David W. Blight has remarked, "often treated as a sacred set of potentially absolute meanings and stories, possessed as the heritage or identity of a community."[47] Thus, in the case

of memory conflict, the stakes can be high. Bodnar observes that "Public memory speaks primarily about the structure of power in society because that power is always in question in a world of polarities and contradictions and because cultural understanding is always grounded in the material structure of society itself."[48]

Fifth, public memory is typically understood as relying on material and/or symbolic supports—language, ritual performances, communication technologies, objects, and places—that work in various ways to consummate individuals' attachment to the group. As Irwin-Zarecka argues, "to secure a presence for the past demands work—'memory work'—whether it is writing a book, filming a documentary or erecting a monument. Produced, in effect, is what I call here the 'infrastructure' of collective memory, all the different spaces, objects, 'texts' that make an engagement with the past possible."[49] Barbara A. Misztal concurs, naming as the "conditions and factors that make remembering in common possible" such supports as "language, rituals, commemorative practices and sites of memories."[50] Jay Winter and Emmanuel Sivan add film, memoirs, poetry, art, and architecture to the list, concluding simply that "artefacts matter."[51] Still, the presence and necessity of memory supports—the manifestations of *techné*—are no simple matter. Despite Winter and Sivan's summarizing epithet and Huyssen's synoptic position that the past "must be articulated to become memory,"[52] assumptions about the presence and necessity of material and/or symbolic memory apparatuses have had very different entailments. Since those entailments frequently depend upon how the history of memory is understood and elaborated, we discuss them at more length in relation to the final consensual assumption about memory.

Sixth, public memory has a history. Indeed, however one conceptualizes memory, scholars agree that it is historically situated, that both its cultural practice and intellectual status have changed over time and in different societies. Frances Yates's well-known treatise traces memory's fortunes from its instantiation in ancient mnemonics of Greek and Roman rhetorics through the European Renaissance.[53] Almost regardless of the claims they forward, most public memory theorists refer back to her work.[54] Ultimately, though, her treatise typically represents little more than an aside for most, since memory's many historical discontinuities appear to dislocate its modern manifestations from ancient conceptions. Many theorists follow Le Goff in claiming that public memory's history should be organized around shifts in communication technologies, so that literacy, printing, and electronic means of communicating and storing information about the past have given different shape and texture to memory practices.[55] Alison

Landsberg argues that memory "is not a transhistorical phenomenon, a single definable practice that has remained the same over time. Rather, like all other modalities, memory is historically and culturally specific; it has meant different things to people and cultures at different times and has been instrumentalized in the service of diverse cultural practices. At times, these shifts in the meaning of memory and in the shape of memory practices have been catalyzed by technological innovation." Indeed, she posits the notion of "prosthetic memory," made possible by modernity and mass cultural technologies.[56]

However, not everyone frames the history of public memory the same way or sees it as changed by the same historical forces. Winter, for example, suggests that the two major "memory booms" of the modern period came about as a result of both intellectual labor and world historic events. So, for example, he argues that works by Freud, Bergson, Rivers, Proust, Halbwachs, and others whose writings gained prominence toward the end of the nineteenth century and into the first two decades of the twentieth century were a factor. But he goes on to argue that World War I changed fundamentally how memory would be understood and practiced for the remainder of the twentieth century. Furthermore, claiming that "the Second World War and the Holocaust broke many of the narratives at the heart of the first 'memory boom,'" he concludes that "we are in another world."[57]

Nora offers an additional, arguably even more significant, example. He distinguishes between a tradition-grounded memory situated in *milieux de mémoire*, a sort of natural habitat for establishment of communal beliefs about the past, and memory based on *lieux de mémoire*, artificial memory props that stand in for a national memory.[58] He claims that "Societies based on memory are no more: the institutions that once transmitted values from generation to generation—churches, schools, families, government—have ceased to function as they once did."[59] Peter Carrier suggests that, "In the wake of the social transformations of modernity, broadly characterized by Nora as globalisation, democratisation, massification, and mediatisation, *lieux* function as traces of such 'environments' [*milieux*] in a society cut off from its past; society thus commemorates and monumentalizes these traces as a means to perpetuate its lost tradition and maintain collective identities."[60]

Although Landsberg's purposes are very different, there remains a certain homology between her "prosthetics" and Nora's "*lieux*." She identifies four reasons for her choice to call this "new form of memory" prosthetic,[61] the first two of which bear a noticeable resemblance to Nora's account. Landsberg argues that prosthetic memories "are not natural, not the prod-

uct of lived experience—or 'organic' in the hereditary nineteenth-century sense—but are derived from engagement with a mediated representation (seeing a film, visiting a museum, watching a television miniseries)." Her second reason for naming prosthetic memories as such is that they are analogues to artificial limbs.[62] Like Nora, then, she seems to suggest that there is something like a naturally occurring memory that is quite different from a mediated or "artificial" memory.

These latter disagreements, on memory's particular history and its relation to material/symbolic supports, are symptomatic of the need to approach this and the other "consensual" assumptions with caution. Indeed, we might be wise to think of them as only nominally consensual, given the kinds of issues and conflicts they do or could (and perhaps should, in some cases) inspire. As we move on to an engagement between memory and rhetorical studies, we examine some of these issues and conflicts and reflect on the possibilities of rhetoric to broach them in productive, arguably necessary, ways.

If rhetorical study's work focuses on and troubles meaningfulness, legibility, partisanship, consequentiality, and publicity as they manifest in and among discourses, events, objects, and practices, how does it engage with contemporary memory studies? The easiest answer—and at times a quite accurate one—is that rhetoricians have found what appears to be a natural affinity for the assumptions and work of public memory scholars and have participated in the interdisciplinary enterprise with great ardor.[63] More often than not, rhetoricians have accorded with (or at least rarely questioned) public memory's consensual premises, apparently in the interest of getting on with the business of exploring particular cases of discourses, events, objects, and practices of memory. Such accord, though it has culminated in some undeniably good work, may not have been the most productive route for either memory studies or rhetoric. So, in the remainder of this section, we challenge some of those accords, in the interest of serving both. We return first to memory's relationship to the present.

Public memory has been variously described as responding to needs of the present, serving the interests of the present, animating the present, serving as rhetorical resources of the present, and so forth. How we describe the relationship matters. For example, the position inspired by Hobsbawm and Ranger's "invention of traditions" perspective has come under fire for reducing memory studies to a faux-determinism and for ignoring the material recalcitrance of the past.[64] Schwartz puts the case bluntly, suggesting that scholars have been "seduced into asserting unwittingly, and often despite themselves, that what is not historical must be 'invented'

or 'constructed'—a position transforming the study of collective memory into a kind of cynical muckraking."[65] There almost certainly is no universally accurate designation of the relationships among past and present as articulated in memory. Or such would be the insistence, we believe, of most rhetoricians, if posed with the problem. The situatedness of any discourse, event, object, or practice within a complex context as well as the usually thick sedimentation of symbolism surely would suggest otherwise.

To be sure, most of what passes for public memory bears at least some arguable resemblance to or some trace of a "real" past event.[66] Most public memory is not purely or deliberately fictitious, in other words. But we must acknowledge public memory to be "invented," not in the large sense of a fabrication, but in the more limited sense that public memories are constructed of rhetorical resources. To suggest otherwise is to deny both the material and symbolic dimensions of memory articulations, which underwrite their partiality.[67] Rhetorical invention is about the selectivity and/or creativity implicated in constructing a subject matter in a particular way.[68] It would suggest that there is no "pure" articulation of the past, but that the language, structural elements, arguments, tropes, narratives, justifications, and such in which the event is cast—as well as the availability of knowledge of the event to begin with—are inventional resources available in a culture. To reject "invention" understood in a rhetorical sense is to reduce memory either to a self-identical rehearsal of an event or to assume the transparency of symbolism, neither of which is plausible on its face, much less in light of memory studies' other assumptions. Public memory may be taken to serve interests, needs, and desires of the present; to establish a seemingly unbreakable continuity with the past; to mark off the present as "a different world" from the past; and so forth. It does not do all of those things all of the time. But it does any of them only within the more-or-less-limited confines of a set of available resources for re-presentation and circulation within a specific cultural confluence.

The second and third consensual assumptions—that memory narrates shared identities and that it is animated by affect—require that we move back through a rhetorically inspired meditation on public memory's general character as shared. If the substance of public remembrance is to be truly public (or collective in any sense)—that is, shared *and* embraced as a marker of identity for that group—then two conditions seem to be in play. First, there must be a mode of sharing. It seems uncontroversial that that sharing happens by means of symbolic/material vehicles: language, objects, media products, statuary, and so forth. Second, though, a memory that is shared must somehow attract a certain degree of adherence on the part of mem-

bers of the group. If public memories are taken to be "true" by members of a group, if they are considered worth arguing about, or even in some cases worth dying for, then memory studies requires more than a *general* conception of the symbolic/material vehicles or *techné* that make memory public. And they require a more specific articulation of affects and the "intensities" and investments they furnish to public memory.

It is not enough, for example, to say that those vehicles of memory are narratives or rituals or relics, because some narratives, rituals, and relics secure more collective attachment than others. As Brundage suggests, "for a historical narrative to acquire cultural authority, it must appear believable to its audience."[69] True enough, but believability cannot be the only condition of memory selection, given the kind of devotion that some memories seem to inspire. If it is at all important to memory studies to understand how it is that some memories and not others come to be accepted by groups of people, then a more specific orientation not only to audience but also to the vehicles themselves—one that facilitates an understanding of group adherence or investment in a particular memory—is necessary. It seems quite inadequate to account for the status of memories as simply affect-driven.[70] Such explanations beg the questions: Why is *this memory* so alluring as compared to another? *What affect* is being deployed that helps to secure adherence to this particular memory content and to the group that holds it to be important to its collective identity?

A number of memory scholars have recognized precisely this problem. For example, Irwin-Zarecka suggests that "A 'collective memory'—as a set of ideas, images, feelings about the past—is best located not in the minds of individuals, but in the resources they share." But she cautions, "an abundance of resources does not guarantee that people actually use them, nor is persuasiveness of an account a predetermined constant."[71] Jeffrey K. Olick concurs, observing that, "memory makers don't always succeed in creating the images they want and in having them understood in the ways they intended. Social actors are often caught in webs of meaning they themselves participate in creating though not in ways they necessarily could have predicted."[72] Mizstal too acknowledges the problem, suggesting that various theoretical offerings on public memory fail to account for "why some symbols, events, and heroes, but not others, are incorporated into public memory."[73] But it is Barry Schwartz who has been the most insistent. He argues that "How the past is symbolized and how it functions as a mediator of meaning are questions that go to the heart of collective memory, but they have been skirted." He continues: "Connecting past events to one another and to the events of the present, collective memory is part of cul-

ture's meaning-making apparatus. How this apparatus works is, to say the least, problematic; that we depend on it as part of the nature of things is certain. How collective memory establishes an image of the world so compelling as to render meaningful its deepest perplexities remains to be investigated."[74] Although we generally share Schwartz's assessment, there is a tension lurking between the twinned notions of "meaning" and "meaningful" in his critique. We believe that that tension offers one of the keys to sorting out the question of investment.

What renders messages—memories or other kinds of contents—believable, persuasive, or even compelling to particular audiences at particular times in particular circumstances? Such are the questions that rhetoricians have explored for centuries. Their answers have often been provisional, and they are typically complex. But rhetoric offers a means of probing the activity of public activity, tendering an array of critical concepts and, as Irwin-Zarecka describes them, analytic "tools" for making sense of discourses, events, objects, and practices that seek (and sometimes appear to compel) assent among particular groups in particular circumstances.[75] Among those concepts and analytic tools are reconceptualizations of audiences and publics as well as the forces that constitute them and, in turn, re-mediate them. These works challenge the commonplace understanding of groups as already always positioned as groups, suggesting that a collective is posited immanently, modeled and produced by the discourses, events, objects, and practices that name and animate it.[76] Emergent in a number of fields, including rhetoric—approximately coincident, by the way, with their interest in memory—have been positions that foreground and problematize aesthetics, the archive, and affect. These theoretical positions address centrally the related issues of subjectivity and agency, as well as their relationship(s) to rhetoric. Above all, for our purposes, they provide valuable elaborations of how publics emerge in relationship to discourses, events, objects, and practices, and they offer cues about how it is that affective attachments of various kinds are authorized rhetorically under different circumstances.[77] These are useful provocations, but they do not address affective investment systematically or specifically in relation to public memory, a challenge that we believe is vital to memory studies.

Sara Ahmed's project of mapping a "cultural economy" of emotion offers one way into this crucial issue. The recurring question in her project is: "What sticks?" This seems a particularly apt question as well for any account of public memory. Ahmed's point, of course, is to understand how objects, signs, and bodies "become saturated with affect."[78] Ours is to understand how particular memories capture the imagination and produce

attachments, and how memories achieve durability over time or compelling force in a particular context.[79] In Ahmed's terms, how do memories "stick"? How do they come to matter?

We would suggest that what Aristotle called *philia,* and what we might label affiliation, is, by definition, the principal affective modality of public memory.[80] Surely, affiliation may be produced in multiple ways, but it is definitive because it projects both the collective as well as people's modes of attachment or sense of belonging to it—their particular markers of identity and self-recognition. We are not suggesting that affiliation is simply an ideological effect, but that it produces, mediates, and sustains emotional connection. What "matters," Lawrence Grossberg suggests, is produced by the "articulation of two planes: signification (rather than ideology, since people can be quite emotional about meanings that do not claim to represent reality) and *affect.*"[81] Affective intensities, like pride, contempt, anxiety, anger, horror, shame, guilt, confidence, gratitude, or compassion (as well as other affective states), contribute to the production and maintenance of affiliation in more or less direct ways, in various configurations, and with various investments. Such intensities are difficult to describe and classify, because they are "a-signifying." They do not "inhabit" sign systems but circulate by means of them, and so they cannot be described in the vocabulary of signifieds or "meaning." Affect is "an ability to affect and be affected."[82] Still, as Grossberg points out, "affect can never define, by itself, why things should matter. That is, unlike ideology and pleasure, it can never provide its own justification, however illusory such justifications may in fact be. The result is that affect always demands that ideology legitimate the fact that these differences and not others matter, and that within such differences, a particular term becomes the site of our investment."[83]

Benedict Anderson offers a pertinent illustration in identifying two rhetorical operations that legitimate a "profound love" of the nation (the "imagined community"): the related attributions of naturalness and disinterestedness. He argues that "Something of the nature of this political love can be deciphered from the ways in which languages describe its object: either in the vocabulary of kinship (motherland, *Vaterland, patria*) or that of home (*heimat* or *tanah air* [earth and water, the phrase for the Indonesians' native archipelago]). Both idioms denote something to which one is naturally tied. As we have seen earlier, in everything 'natural' there is always something unchosen. . . . [P]recisely because such ties are not chosen, they have about them a halo of disinterestedness."[84] Anderson describes "purity" in terms of death for one's nation:

Dying for one's country, which usually one does not choose, assumes a moral grandeur which dying for the Labour Party, the American Medical Association, or perhaps even Amnesty International cannot rival, for these are all bodies one can join or leave at easy will. Dying for the revolution also draws its grandeur from the degree to which it is felt to be something fundamentally pure (If people imagined the proletariat merely as a group in hot pursuit of refrigerators, holidays, or power, how far would they, including members of the proletariat, be willing to die for it?). Ironically enough, it may be that to the extent that Marxist interpretations of history are *felt (rather than intellected)* as representations of pure necessity, they also acquire an aura of purity and disinterestedness.[85]

Although speaking of modern nation-states specifically, what Anderson seems to describe here is a naturalized feeling of belongingness that also could, in some cases but not others, characterize nonnational collectives, as he implies in his additional examples. In other words, we are not equating public memory and nationalism, or even affiliation and nationalism, although they certainly are related. The important point here is not the particular organization, raison d'être, or reach of a collective, but that the affiliative mode of public memory is *felt* and *legitimated rhetorically.* Public memories "matter" and are authorized to "speak for" a public that invests in them.[86] Kenneth Burke suggests that the identifications by which people come to be (or feel themselves to be) participants in a collective, render "belonging" a rhetorical configuration.[87]

There are four important implications here for imbricating public memory's rhetorical character with affective investment. The first is that a sense of belonging or affiliation is the condition of possibility for public memory. The second is that the affiliative investment is elementally rhetorical, in the sense that it is produced (and legitimated) by and among discourses, objects, events, and practices and the ways in which these are taken "to matter." Third, we cannot understand the "meaningful" simply by recourse to "meaning"—as the latter is articulated by Schwartz (and that seems to be a fairly typical understanding among memory scholars)—as the product of signification. We must attend to the "asignifying" as well. The fourth is implied by Assmann's reminder that memory—or perhaps, more accurately, memory's modes of production and circulation—can be understood as "violent disciplining" or as "redemptive force,"[88] perhaps both simultaneously. That recognition argues for careful and thoughtful critique.

Ahmed's question "what sticks?" should be supplemented, in a rhetorical key, and in specific configurations of public memory, by the questions "what makes it stick? how? and with what effects?"

The partiality and contestedness of public memory are virtually undeniable. One need look no further than some of the highly visible public contests over standards for secondary school history textbooks; neoconservatives' labeling of the war on terror as "World War IV" (the third world war having been the Cold War, already waged and "won"); the "battles" over the exhibitions on the American West and the *Enola Gay* at the Smithsonian; or the lengthy and emotionally fraught conflicts over the World War II Memorial in Washington, D.C.[89] As any number of memory scholars have demonstrated, such contests and the specific array of arguments they make available tell us much about the past in the present.

The most serious question that arises here, from a rhetorical point of view, is the posited relationship between remembering and forgetting. Nearly an assumptive cliché in public memory studies, its status seems almost beyond question. As elegantly parsimonious as it may seem, it may also suffer from just that quality. We do not question here its potential value in understandings of individuated memory, but as James V. Wertsch cautions, sometimes the metaphoric borrowing between theories of individual memory and public memory (e.g., "collective amnesia") can be problematic.[90]

In particular, we believe that the remembering-forgetting dialectic has been employed as a stand-in or simplistic restatement of the problem of representation in public memory studies. In other words, a failure to represent a particular content publicly is not a necessary, or even provisional, sign of forgetting. To suggest otherwise is to assume that all memory contents are represented publicly and/or that what is articulated publicly is an exhaustive map of memory contents. Either of those assumptions is theoretically indefensible and counterfactual in practice. An excellent exemplar may be found in Olick's useful and nuanced discussion of memory in postwar Germany. It was not, as Olick points out, that Germans didn't know (or remember) particular contents from the Nazi past. It was that there were cultural proscriptions, even amounting in some cases to taboos, about what could and could not be articulated publicly about Nazi policies.[91] Olick's purpose is not to critique the remembering-forgetting dialectic, but his discussion certainly points up what we see as the most fundamental problem of that pairing. As Paul Connerton claims quite correctly, "We cannot . . . infer the fact of forgetting from the fact of silence."[92]

If we are correct, the issues involved are far more complicated than the dialectic renders them. For example, what particular memories or castings

of a particular memory must be forgotten to activate others? If Foucault's principle of discursive rarity, mentioned earlier, is taken seriously, then the domain of the "forgotten" within this so-called dialectical pair is nearly infinite. So, even if the dialectic were somehow "correct," it still would not be terribly helpful in trying to account for the appearance and "robustness" of particular memories by a collective.[93] More importantly, though, it obscures what may be more complicated relationships among various memories and the operations that make possible their relationships. Lowenthal, for example, refers to memory "revision."[94] Schwartz and Irwin-Zarecka both address memories as "superimposed."[95] Schwartz also refers to the coexistence and modification of memories by one another. Still others have discussed the palimpsestic character of memory, suggesting that the traces of past memories are often not obscured in the presence of new ones, but simply written over.[96] Perhaps the wiser approach is to think about the presence and persistence of some contents (as opposed to others) in public memory as modes and conditions of "accumulation" or "additivity."[97] We do not mean to suggest that memories are never suppressed or that every expressed memory content has the same status. But it is more plausible (and ultimately useful) to suggest that even seemingly contradictory contents can be held in public memory simultaneously and that the relationships among memories vary.

This issue is of sufficient importance to take up a lengthy example, namely Schwartz's rejoinder to Peter Karsten on the relative embrace of George Washington and Abraham Lincoln in U.S. public memory during the Progressive Era.[98] Schwartz argues that:

> According to Peter Karsten (1978), America's increasingly centralized and powerful state is the primary reason for the growth of Lincoln's reputation. Arguing on the basis of contrasting political cultures, Karsten regards George Washington as America's paramount "anti statist" symbol; Lincoln, the personification of "statism." That Lincoln's reputation grew so rapidly during the Progressive era, a time of significant expansion of governmental power, makes Karsten's argument plausible; however, two problems detract from it. First, Karsten underestimates Washington's symbolic role, which, in its celebration of liberty—an anti-statist ideal—remained a salient aspect of American political tradition both during and after the Progressive era. Second, Karsten simplifies what Lincoln stood for. Lincoln did represent the power of the twentieth-century state, but he was not commemorated for that reason alone. Embodying the concerns of the common

person—a link that transcends the statist/anti-statist dichotomy—was a necessary element in this twentieth-century reputation.[99]

Neither Karsten nor Schwartz contextualizes his argument explicitly in terms of the remembering-forgetting dialectic. In fact, Karsten's argument predates most of the contemporary work on memory studies that has embraced that dialectical pair. But the thinking is essentially the same: for memory of Lincoln to be in the ascendant, the memory of Washington must be understood to be in decline. Schwartz's carefully detailed analysis casts serious doubt on that way of thinking. Vis-à-vis the remembering-forgetting dialectic, it at least suggests that the conditions for remembering and forgetting vary and that they need to be specified much more carefully. At most, it would suggest that the dialectical assumption offers little interpretive power and probably should be replaced by a more nuanced and evidence-grounded position that takes account of the status of particular memory articulations in relation to others, in particular contexts, with particular attention to the inventional operations that mediate that status.

We turn now to the assumptions regarding memory's history and its relationship to symbolic/material supports. That public memory has its own history and that it relies for its very existence on symbolic/material supports are assumptions that seem unassailable. Indeed, we do not wish to challenge either assumption as such. Instead we wish to question what we see as the problematic entailments of more specific, frequently well-accepted, positions *grounded* in these assumptions, especially having to do with histories of memory predicated in shifts in communication technologies.

As we mentioned earlier, not all public memory scholars embrace the centrality of technologies as the central change agents in memory's history. But it is a popular thesis. It is also extremely difficult to contest. If symbolic/material supports are taken to be the essential material by which memory contents are articulated, surely the character of those media must have some strong impact on the substance of public memory. Still, the challenges even within memory studies should give us pause. If other factors—such as theorizations of memory, large-scale events, and so forth, like those Winter identifies—are also argued forcefully to be at stake in public memory's shifting fortunes, then can memory's history really be said to be a matter primarily of changing media forms? If most public memory scholars were to attend more carefully than they have to Frances Yates's and Patrick Hutton's fascinating histories, the answer might be something akin to a carefully qualified no. Of course, the form in which content is manifested remains important. Indeed, most rhetoricians would insist that form-

content distinctions are highly artificial, and that content is shaped decisively by its formal delivery systems. Nonetheless, there is a rather strange, secondary assumption that seems to be in play in these accounts of memory's history—what Jonathan Sterne has termed the "add technology and stir" position,[100] which harkens back to our discussion earlier about the conditions of meaningfulness.

Sterne argues persuasively that, "Along with this model ["add technology and stir"] comes a series of laments about the alienation of modern life, the loss of community, and the decline of intersubjective recognition as humans use tools more and more to communicate with one another."[101] That may be, at this juncture, a recognizable stance, courtesy of Pierre Nora and others who embrace Nora's general thesis. But as Sterne makes quite clear, the model carries with it both political and descriptive problems. In memory studies, we believe both problems are present. He suggests that "The 'add technology and stir' model is a political problem because it leads communication scholars to invoke a bizarre nostalgia."[102] The descriptive problem may actually be more profound, however. Technologies of communication and preservation do not so much replace each other in most cases as they supplement and reanimate one another.[103] So, for example, it seems impossible to maintain that writing replaced orality or that electronic communication of various kinds has eclipsed literacy. Even if that were the case, to suppose that even primary orality is not itself a *techné* is deeply problematic from a theoretical point of view. However one may wish to resolve this problem of memory's history, one thing seems clear. The historical arguments that foreground communication technologies as the points of discontinuity in memory's history have very little purchase in the specific case studies of public memory, even those that cut across various eras. That seems true not because the historical arguments are wrong, but because they are incomplete. We would suggest that the emphasis on the formal character memories assume must be supplemented by both substantive and additional contextual considerations. The situation is particularly clear perhaps in Landsberg's coinage of "prosthetic" memory. Although a useful metaphor, it seems equally useful to describe the *techné* that shape any public memory, not simply memories reliant upon contemporary technologies.

At the beginning of this introduction, we suggested that rhetoric might add a "congenial complexity" to memory studies' assumptive base. Although we hope that both the congeniality and complexity are already apparent at this stage of the conversation, a summary seems in order. The best approach at this juncture in the conversation seems to be to pose a ques-

tion. What would be the value, and what would be forfeited, if memory studies were to add an additional assumption to its inventory—that public memory is rhetorical—and to rethink its other assumptions accordingly? The easiest part of that question to answer, we believe, is about the forfeit; memory studies surely would sacrifice the simplicity (we mean something like metatheoretical elegance, not simplemindedness here) of its assumptive base. But, in a sense, that is also a legitimate answer to the value portion of the question. Some topics of inquiry simply *are* complex, and memory studies seems clearly to be one of those. That recognition does not entail the loss of general assumptions; it entails the loss of assumptive simplicity.[104]

Yes, public memory bears relationships to the present, but those relationships are highly variable and dependent upon contexts, available rhetorical resources, representational choices, framings by various *techné,* and so forth. Yes, public memory narrates—arguably constructs—shared identities. But it does more even than that. It constructs identities that are embraced, that attract adherents (as well as dissidents). That necessarily presupposes an affective inflection of a memory's contents *for particular audiences in particular situations.* But what affects? How are those affects activated? How do they contribute to public memory's selectiveness and/or to a collective identity? Yes, memory is partial, because of what Irwin–Zarecka labels its symbolic/material "infrastructure," itself a dense set of layered characteristics of discourses, events, objects, and practices. Yes, memory has "a" history; it no doubt has *many* histories, depending upon cultural resources, mnemonic contents, infrastructural capacities, affective deployments, and so forth. The complexities in these revised assumptions are thoroughly rhetorical, having to do with rhetoric's (and memory's) meaningfulness, legibility, partisanship, consequentiality, and publicity as they are manifested in discourses, events, objects, and practices about the past in the present.

Rhetoric, Memory, and Place

If discourses of public memory and rhetoric are diffused and diversified—and thus sometimes fugitive and difficult to fix—the notion of place is even more so. Place and its most frequent companion term, space, seem to be on everyone's lips in recent years, across multiple domains of academic discourse as well as popular culture. One need only reflect on the terminologies of spaces, spatiality, sites, territory and deterritorializing, border cultures, the urban and exurban, social locations, geographies, zones, the ar-

chive, cultural mapping, globalization, communitas, landscapes, the colonial and the postcolonial, to reckon with the complexities of what anyone might mean when s/he deploys one or more of these terms.[105] Some of them reference physical locations; others serve as metaphors for the social imaginary, subjectivities, identities, or epistemologies. Of course, real and imaginary places have long stood metonymically for grand ideas, satirical commentary, geopolitical histories, horrifying or scandalous events, idealized community, maligned political stances, and so forth. We obviously are thinking about more than physical places when we reference Palestine, the Watergate, Columbine, Disney World, the Mexican border, Jellystone Park, the Eiffel Tower, Ground Zero, San Francisco, Verdun, the Great Wall, Pearl Harbor, Yosemite, Hogwarts, the White House, home, or the Hague, but each of these marks a physical locale and/or a widely recognized imaginary one.

These complex significations of space and place offer some starting points, though, for an entry of place into a conversation with memory and rhetoric. Space and place sometimes are used as approximately equivalent terms. However, they are used more often to emphasize a difference in how physical situatedness is experienced. In such usages, a *place* that is bordered, specified, and locatable by being named is seen as different from open, undifferentiated, undesignated *space*.[106] Although this distinction or some variant of it is frequently drawn, many theorists are quick to point out that the relationship between space and place is not necessarily one of opposition. For one thing, place as structured, bordered, or built locale depends in part for its character upon how it deploys space. Architects, for example, "manipulate" space, as Leland Roth observes.[107] Moreover, when differentiated, ideas of space and place inform one another. Tuan suggests that "The ideas 'space' and 'place' require each other for definition. From the security and stability of place we are aware of the openness, freedom and threat of space, and vice versa. Furthermore, if we think of space as that which allows movement, then place is pause; each pause in movement makes it possible for location to be transformed into place."[108] The point, therefore, is not to set space and place off as contraries, but to claim for them a set of mutually constitutive relationships.

At the risk of complicating this discussion just a bit more, space is even more typically differentiated from time, often in a dialectical pairing.[109] That relationship is lurking in Tuan's delineation of space and place above, in his pairing of movement and pause, terms that are situated spatially but that are defined by temporality. Here, perhaps an analogy might help to

establish an initial, if rough, sketch of the relationships of public memory, place, and rhetoric:

place : space :: memory : time

If places are differentiated, named "locales," deployed in and deploying space, we might suggest that memories are differentiated, named "events" marked for recognition from amid an undifferentiated temporal succession of occurrences. Both place and memory, from this point of view, are always already rhetorical. They assume an identity precisely in being recognizable—as named, bordered, and invented in particular ways. They are rendered recognizable by symbolic, and often material, intervention. They become publicly legible *only* by means of such interventions. Their recognizability should not suggest that their identities as named are always uncontested. Just as surely as parties have argued over public memory, they have disputed designations of place. The obvious, if geographically expansive, examples of Northern Ireland and Palestine suggest not only that place is contested, but that the contestations are laced with issues of memory.[110]

Why is place especially important to memory understood rhetorically? There are at least two important answers to this question. In the last section, we suggested that it is not enough to hold a general conception of the symbolic/material vehicles (generated by means of various *techné*) of memory. Place is one such support, with its own particularities and its own kinds of rhetoric. Place is not, for example, a narrative that can be told or read as such.[111] Nor is it at all like a photograph, for places are not merely seen, nor are they transportable. Place effects memory in a variety of very specific ways, but that it does so has been evident for centuries. Ancient rhetoricians invested mnemonics in well-known places, understanding that places could be memory prompts.[112] It is important to our understanding of public memory to address the precise, and often unique, ways in which memory is parsed, represented, shared, and embraced by means of different forms and created by various *techné*. Place has survived as a recognized memory apparatus perhaps longer than any other.

But place is important for a second reason as well. Particular kinds of places are more closely associated with public memory than others, for example, museums, preservation sites, battlefields, memorials, and so forth. These "memory places," as we have chosen to call them in this book, enjoy a significance seemingly unmatched by other material supports of public memory, at least in the United States, as suggested by Roy Rosenzweig and

David Thelen's massive survey and interview study of Americans' uses of the past. Among the most striking results of their research is that "Americans put more trust in history museums and historic sites than in any other sources for exploring the past."[113] Indeed, ranked by respondents on Rosenzweig and Thelen's ten-point scale of trustworthiness, these sites ended with a mean score of 8.4. By contrast, a conversation with someone who was there (a witness) scored 7.8, while college history professors scored a 7.3. Movies and television programs trailed badly with a mean 5.0.[114] Place making, as a *techné* (or, more accurately, a coordination of various *techné*) of public memory, thus becomes vital to any understanding of the means by which that memory is formed and by which it may be embraced. Far from being overshadowed by contemporary media forms, one of the oldest of memory's *techné* seems still to exert a powerful hold.

These memory places, of course, are not all the same; in fact, they differ from one another in significant ways. A battlefield is not very much like a house museum. And a cenotaphic memorial is not very much like a preservation site. Even within the confines of narrower genres, there are major distinctions. The site of Andersonville Prison (Georgia) is not very much like Fort Ross (California), though both are historic preservation sites. Not only are their histories different and their physical spaces quite distinct, but their rhetorics are so dissimilar that one might wonder legitimately how the two can occupy the same paragraph.

Granted the differences, is it possible to draw any generalizations about memory places predicated in their place-ness, their formations of memory, and their rhetoricity, that can set them apart in some way from the products of other memory *techné?* Are there characteristics of these memory places that might begin to account not only for their perceived credibility, but also for their capacity to attract and secure the attention of visitors by the hundreds, thousands, even millions, every year? We offer some provisional answers here that can and should be augmented, supplemented, and perhaps contested by studies "close to the empirical ground," as Irwin-Zarecka puts it, studies like those that compose the remainder of this book.[115]

First, in dealing with memory places, the signifier assumes a special importance. The signifier—the place—is itself an object of attention and desire. It is an object of attention because of its status as a place, recognizable and set apart from undifferentiated space. But it is an object of *special* attention because of its self-nomination as a site of significant memory of and for a collective. This signifier commands attention, because it announces itself as a marker of collective identity. It is an object of desire because of

its claim to represent, inspire, instruct, remind, admonish, exemplify, and/ or offer the opportunity for affiliation and public identification.[116]

The attention to the signifier (as opposed to simply its particular signifieds) has a number of entailments. Because the place, the memory signifier, is an object of attention and desire, and because it is not transportable, it necessitates a particular set of performances on the part of people who would seek to be its audience. Memory places are destinations; they typically require visitors to travel to them. Thus is created a unique context for understanding the past, one that is rooted in touristic practices. To a degree exceeding the products of many other memory *techné,* one's experience of memory places may involve planning (where and when to go, making reservations), financial resources (plane fare, lodging, gas, admission fees), and time to travel (vacation or time off from work).

The touristic context is rooted in a projected or desired departure from the ordinary, in a set of expectations that one will encounter rare or unique relics, learn about highly significant events or people, and/or be moved in particular ways by the experience of the place. Those expectations are formed, in part, because memory places fashion themselves rhetorically to distinguish themselves from the everyday, and in part because of the particularities of secondary representations of the places in other media— advertising, literature, travel writing, photography, film, and so forth. The visit to a memory place is consummatory; it is the action invited by the "mere" existence of the memory place.[117] Of course, visitors may "consummate" their relationship to the place in additional ways, for example, by purchasing a memento in a gift shop, taking photographs, taking a guided tour, and so forth. But the primary action the rhetoric of the memory place invites is the performance of traveling to and traversing it. That effort to participate in a memory place's rhetoric almost certainly predisposes its visitors to respond in certain ways, enthymematically prefiguring the rhetoric of the place—at the very least—as worthy of attention, investment, and effort.

Also related to the centrality of the signifier constituted by the memory place is an expectation of and investment in "authenticity." As Rosenzweig and Thelen note about the "trustworthiness" of historic sites, "Approaching artifacts and sites on their own terms, visitors could . . . feel that they were experiencing a moment from the past almost as it had originally been experienced." They quote one of their respondents as suggesting, for example, that "the museum 'isn't trying to present you with any points of view.'"[118] However we might assess such a position *epistemologically,* memory places are frequently understood as offering a unique access

to the past. But authenticity isn't something that places just have. As Bradford Vivian suggests, "There is a crucial distinction . . . between accepting authenticity on its own terms and regarding it as a feature of the discourse by which memory is enacted."[119] That is, a sense of authenticity is a rhetorical effect, an impression lodged with visitors by the rhetorical work the place does. Different kinds of memory places, of course, authenticate themselves differently. So it is important to understand those differences and how they are enacted at and by different memory places.

Second, memory places construct preferred public identities for visitors by specific rhetorical means. A memory place proposes a specific kind of relationship between past and present that may offer a sense of sustained and sustaining communal identification. By bringing the visitor into contact with a significant past, the visitor may be led to understand the present as part of an enduring, stable tradition. Although any memory *techné* presumably has the capacity to accomplish that rhetorical work, the apparent immutability and permanence of place are important here.[120] Although amusing, the question posed by visitors to Mount Rushmore—"When was this discovered?"—suggests the force of the impression.[121] Granted, at some memory places, the visitor may be invited to grasp a past that seems alien to the present. But the seeming stability of the place may still foster a sense of cross-temporal community.

What is palpably different about the rhetoric of memory places, though, is the recognizability of other visitors at the site. The visitor is not just imagining connections to people of the past, but experiencing connections to people in the present. Memory places cultivate the being and participation together of strangers, but strangers who appear to have enough in common to be co-traversing the place. Memory places are virtually unique among memory apparatuses in offering their symbolic contents to groups of individuals who negotiate not just the place, but stranger relations as well.[122] The presence of others may be experienced by a visitor as belonging to a constituted, if provisional, public sphere.[123] In any case, memory places may function as the secular oracles for the current moment of a civic culture, offering instructions in public identity and purpose not only through proclamation, parable, or proverb, but even more importantly by modes of interaction and contact in the place. As much as they may be read as historical, their rhetoric is principally present, prospective, and imperative. They typically nominate particular acts and agents of history as normative models for present and future modes of "being public."

Third, although all public memory representations are partial, memory places are characterized by an extraordinary partiality. The files of govern-

ment agencies bulge with plans for museums, memorials, and historic preservation programs proposed but never constructed. If utterances are rare, as Foucault suggests, memory places are exceedingly so. Authorization to designate places by partial tales told in architecture, sculpture, diorama, or multimedia presentation is limited, not only because of the symbolic significance of such designations, but also because of their expense. To strain a colloquialism, this kind of "talk" doesn't come cheap. Thus, the establishment of a memory place already marks it for exceptional cultural importance. One does not find major memorials in Washington, D.C., honoring *all* of the U.S. presidents, for example. The monumental core of Washington suggests that we should pay particular attention to only four: George Washington, Thomas Jefferson, Abraham Lincoln, and Franklin Roosevelt.[124] Because of their material form, modes of visibility, rarity, and seeming permanence, places of memory are positioned perpetually as *the* sites of civic importance and their subject matters as *the* stories of the society. The stories they tell are thus favored by being made, quite literally, to matter to the lives of the collective. They are intractably present.

This extraordinary partiality is responsible, in part, for the deeply political character of public memory places. As David Jacobson argues, "Because such symbols and monuments arrange 'place,' locating and orienting peoples spatially and temporally, and are critical in binding and mediating the body politic . . . they determine who 'belongs' to the nation and on what terms."[125] Of course, each memory place proffers a view of who "belongs and on what terms," but the geography of these places also nominates for public audiences very particular views of which people and events of the past are most worthy of memory. Naturally, the extraordinary partiality is also a source of conflicts, over what should be marked in public space, where, by whom, and how. The conflicts are frequently fractious, sometimes even bitter. Occasionally the conflicts are incorporated into the place itself. The two sculptural groups, for example, at the Vietnam Veterans Memorial, were the serial results of two compromises, the first to settle the highly publicized conflict over Maya Lin's original design, and the second to compensate for the partiality of the first compromise. Similarly, the addition of a sculpture of Roosevelt in a wheelchair at the FDR Memorial, in Washington, D.C., was the result of continuing protests by groups concerned with disability rights. The publicly contested character of a memory place sometimes even constitutes a reason to visit it. One thing is certain, though: such conflicts muster the past in ways very much having to do with the present. Thus each conflict, like each place, is different and demands attention to the specificity of its rhetoric.

Fourth, because of their place-ness, memory places mobilize power in ways not always available with other memory *techné*. That is so, first, because memory places are located. They have unique topographies (hills, trees, plains), geographies (cities, towns, capitals, countryside), and contextual structures (other buildings, sidewalks, variable light). As Jacobson suggests, memory sites arrange place, but memory places are also arranged in various spatial orientations that give rise to how they communicate or inculcate memory. Their locations value and legitimate some views and voices, while ignoring or diminishing others. That Mount Rushmore—an ode to white American culture in the United States—is carved out of Native American land materially encodes, enforces, and reinforces the power relations between Native Americans and the U.S. government. That some memory places are located at a city center, while others occupy more peripheral locations, affects how it is that they will be interpreted, or whether they are attended to at all.

Places also mobilize power because they are implacably material.[126] They act directly on the body in ways that may reinforce or subvert their symbolic memory contents. Places of memory are composed of and/or contain objects, such as art installations, memorabilia, and historic artifacts. Their rhetoricity is not limited to the readable or visible; it engages the full sensorium. Such objects produce particular sensations through touch, sound, sight, smell, and taste. Memory places also prescribe particular paths of entry, traversal, and exit. Maps, arrows, walls, boundaries, openings, doors, modes of surveillance all encode power and possibility. The design and building of memorial places often function as "strategy" in Michel de Certeau's sense of that word. At the same time, the uses to which the visitors put memorial sites make, remake, and unmake the imposed structures of power.[127] The important point is that, no matter how overtly a place may exert power through its incorporation, enablement, direction, and constraints on bodies, it has its own power dimension that becomes part of the experience.

Fifth, places of memory almost always incorporate the products of various memory *techné*. The degree to which they do so stipulates but also complicates the ways in which the memory apparatus of place is experienced. A memorial may consist of nothing more than a plain statue or building, although that is relatively rare. Almost all memorials (and other memory places) use words, inscribed and/or spoken, as part of an interpretive program. Some incorporate other symbols, such as flags. A memorial may or may not have a special exhibit with historic photographs or films of its own construction or events that have occurred on its grounds.

Museums are often even more complicated in terms of their mix of multiple mediated forms. The degree to which the memories enacted inside the museum are shaped by its architecture and deployments of space depends very much upon the character of the specific museum. For example, it is not so much the exhibit contents as the interior design that has led commentators to describe the U.S. Holocaust Memorial Museum as "a concentration camp on the Mall."[128] But the contents of a museum—its contained artifacts, films, photographs, audio recordings of oral histories, posted scripts, and so forth—may take center stage, especially in a museum whose architecture or design calls less attention to itself. That does *not* mean that the place ceases to have an influence on the experience, just that it may be less noticeable. All of these differences are important differences; they influence what memory contents are articulated, within what kind of context, with what means of reinforcement, and with what effects.

Finally, memory places themselves have histories. That is, they do not just *represent* the past. They *accrete* their own pasts. Virtually all studies of public memory places take account of the connections memory places draw between past and present. But James Loewen argues that these places actually are marked by three temporal moments, not just two. He suggests that "One is its manifest narrative—the event or person heralded in its text or artwork." The second, he argues, is "the story of its erection or preservation. The images on our monuments and the language on our markers reflect the attitudes and ideas of the time when Americans put them up, often many years after the event." And finally, he identifies a "third age that comes into play whenever one visits a historic site—the visitor's own era."[129]

The second moment identified by Loewen cannot be overlooked nor its importance overstated in rhetorical studies of public memory places. If the third moment represents a current visit to a place, the second accounts for the place's particular modes of existence and invention. Moreover, the relationships between the second and third—the production of the place and current traversals of it—are as significant as the relationships of the first and third—between the "manifest narrative" and current experience. But we might wish to add a fourth "moment" to Loewen's account: that of the interventions and deployments in and of the place between its construction and the visitor's present.[130] Scott Sandage demonstrates convincingly the value of such an augmentation in his attention to events staged at the Lincoln Memorial from 1939 to 1963, and the ways in which the memorial's accreted past prompts current audiences to respond not only

to Lincoln memory but also to civil rights memory.[131] The "production" of memory places is ongoing. Their rhetorical invention is not limited to simply their initial construction. We must attend as well to the intervening uses, deployments, circulations, and rearticulations in the time between the establishment of a place and our current practices in and of the place.

Without doubt, there are many other conclusions one might draw from a serious interaction among rhetoric, memory, and place. We do not mean for this to be the final word, but a provocation for additional claims. What we do hope is clear in our position, however incomplete, is that to take seriously how memory is enacted at public memory places is to take seriously the specificity of the rhetorical workings of those places. Before we move on to introduce the remainder of this collection, an explanation about our chosen terminology is in order, having to do with "memory places."

We have chosen to use the term "memory places," in spite of the possibility that it might be conflated with Nora's *lieux de mémoire,* a possible equation that would seem legitimate, given the very most literal of translations. But a few words of caution are in order here. We believe the French project on *lieux* to be a major contribution to the study of memory and place. But we see our project as staking out a very different position, having to do with its foregrounding of rhetoric. It is worth examining Nora's claims about his project closely, so as to draw the distinctions we see as important. He narrates the origin of his project:

> The point of departure, the original idea . . . was to study national feeling not in the traditional thematic or chronological manner but instead by analyzing the places in which the collective heritage of France was crystallized, the principle *lieux,* in all senses of the word, in which collective memory was rooted, in order to create a vast topology of French symbolism. Though not really a neologism, the term did not exist in French when I first used it. . . . I took it from ancient and medieval rhetoric as described by Frances Yates in her admirable book, *The Art of Memory* (1966), which recounts an important tradition of mnemonic techniques. The classical art of memory was based on a systematic inventory of *loci memoriae,* or "memory places."[132]

Nora describes in an endnote the difficulty of finding an English equivalent for *les lieux,*[133] but finally defines it this way in his preface to *Realms of Memory:* "If the expression *lieux de mémoire* must have an official designation, it should be this: a *lieu de mémoire* is any significant entity, whether

material or non-material in nature, which by dint of human will or the work of time has become a symbolic element of the memorial heritage of any community (in this case, the French community)."[134]

In the first quotation above, Nora acknowledges the source of his terminology, drawn via Yates's rendering from ancient rhetoric, but that seems to be the end of his discussion of rhetoric. Our position is that the linkage between memory places and rhetoric should be more than simply nominal and suggestive, as it seems to be for Nora. The ancient Roman rhetoricians certainly did base their mnemonic order upon *loci* or memorable places. Equally compelling, though, is the observation that Greek rhetoricians before them had named their inventional systems *topoi*. There are any number of cues in ancient rhetorical texts that suggest that the separation among the *officia* (invention, arrangement, style, delivery, and memory) was not much more than an analytic convenience. Thus, it seems at least like a rather hasty dismissal to not take much more seriously the relationships of rhetoric and memory in general, but more specifically also the relationships of invention and memory as they operate in conjunction.

Furthermore, when Nora defines his entitling term, he suggests that a *lieu de mémoire* is rendered as symbolic of a heritage by two different conditions: human will or the work of time. We would maintain that these conditions are so general as to hold almost no value. By contrast, we would argue (and have argued here) that places of memory assume their cultural significance by means of their rhetoric, as marked capacities for meaningfulness, legibility, partisanship, consequentiality, and publicity. Finally, we would suggest that their "material or non-material" forms *matter* in every sense of *that* word. Put simply, places of memory are material locales, and that renders them as quite specific apparatuses of public memory.

Places of Public Memory

While we have engaged in a theoretical discussion of the relations among rhetoric, memory, and place, the crux of our argument has been that the rhetorical consequentiality of memory is best understood through the analysis of particular memory places. To better illustrate the complex relations among memory, rhetoric, and place, this book presents a collection of case studies. What follows are eight critical analyses of memory places. Although each of the case studies attends to the intersecting *topoi* outlined here, we have arranged these essays by the degree to which a particular case emphasizes one of the terms. We have used this emphasis to loosely group the essays.

The book begins with those essays that feature rhetoric as their pivotal term. Bryan Taylor's essay on memory and nuclear culture takes up nearly all the major themes regarding rhetoric discussed above. Part of the rhetorical struggle in designing and building nuclear museums, he argues, surrounds the problem of legibility—how is one to make legible discourses and technologies devoted to mass destruction? His analysis of the efforts to create "meaningful" nuclear museums clearly demonstrates that memory places, along with the efforts to create them, are partisan and consequential. The problem of legibility also animates Victoria Gallagher and Margaret LaWare's reading of The Fist—a monument to Joe Louis in downtown Detroit. Gallagher and LaWare report that Joe Louis's widow remarked on seeing the sculpture, "It could be anybody's arm." While The Fist's openness to multiple readings creates the possibility of counter-hegemonic readings, the sculpture is also nearly meaningless to some audiences, leading to the construction of a more legible counter-memorial. Legibility and thus consequentiality are often assumed to inhere in single or bounded texts. But Gregory Clark's analysis of the National Jazz Museum in Harlem—a museum that does not yet exist in a single building—forcefully demonstrates that dispersed memory places function to evoke what he calls "rhetorical experiences." Using this non-museum, Clark theorizes the ways aesthetic experiences are rhetorical as they can shape citizens and citizenship.

While the first essays accent the rhetoricity of memory places, the second section emphasizes the workings of memory. By contrasting the recently completed World War II memorial on the Mall in Washington, D.C., with local memorials to the National Guard soldiers in Bataan, John Bodnar traces the deeply conflicting memories of the Second World War, thereby complicating the memory/forgetting dialectic often asserted in memory studies. Where Bodnar demonstrates that different memorials to World War II serve to contextualize memories of that war, Cynthia Duquette Smith and Teresa Bergman's engagement with Alcatraz points to the ways a single site can embody and deny conflicted memories and is a case study on what memories are made to "stick" in particular memory places. Alcatraz—the most famous prison site in the United States and the site of one of the most important Native American protests of the twentieth century—privileges the experience of the prison, and, in so doing, diverts attention from remembering and commemorating the protests.

The placeness of memory is the subject of the last section of the book and is evident in Michael Bowman's performative and ethnographic reading of the Mary Queen of Scots House in Scotland. The house, raising the specter of its own inauthenticity and putting history into play, becomes,

in Bowman's analysis, a location or site for visitors to perform an "authenticity of affect." Memory places like the Mary Queen of Scots House not only represent the past; they also have a past. This dual historicity matters, as Bernard Armada argues about the Civil Rights Museum in Memphis, to our understanding of memory places. From its inception as a museum, the site's narrative was complicated by the protests of Jacqueline Smith. But the recent renovation moved this protest to a far less visible site. While the renovation does not entirely forget Smith's protests, her counter-memory is significantly decentralized and diminished. Change over time—the warp and woof of history as it were—is also at the heart of the Draper Museum of Natural History. Eric Aoki, Greg Dickinson, and Brian Ott argue that the Draper is a place that slows time to a near standstill and, in so doing, derails critical engagement with the museum and naturalizes a subject position that sees exchange value in nature.

Having very loosely grouped the eight essays in this anthology into three broad themes, we hope that it is clear that the borders among the themes are porous and fluid. In fact, readers are likely to link the essays in different ways. Some may connect essays about race and ethnicity (Armada, Gallagher and LaWare, Smith and Bergman) or about post-(Cold) war memorialization (Bodnar, Taylor). Others may link those essays about museums built and unbuilt (Aoki, Dickinson, and Ott; Bowman; Clark; Taylor). But regardless of how one might thematize the essays, taking them together suggests that writing about the intersections of rhetoric, memory, and place does not simplify or unify our understanding of places of public memory. Instead, it seems that taking seriously all three of our terms—rhetoric, memory, place—might, in fact, make memory studies more complex. More importantly, we believe that the essays in this volume speak not only to the significance of memory in public culture, but also to the vitality of rhetoric and rhetorical scholarship in coming to terms with our contemporary culture of memory and with the places in which these memories are staged.

Notes

1. Cicero, *De oratore* 2.86, in *Cicero on Oratory and Orators,* trans. J. S. Watson (Carbondale: Southern Illinois University Press, 1970), 186.

2. Frances Yates, *The Art of Memory* (Chicago: University of Chicago Press, 1966): 1–2.

3. We do not mean to imply here that rhetoric, memory studies, and

place studies have never been "introduced" before. Indeed, as Kendall Phillips has pointed out, "The ways memories attain meaning, compel others to accept them, and are themselves contested, subverted, and supplanted by other memories are essentially rhetorical." Introduction to *Framing Public Memory,* ed. Kendall R. Phillips (Tuscaloosa: University of Alabama Press, 2004), 3–4. It will be our position throughout, though, that rhetoric has been an unnecessarily reticent partner in the conversation among these areas, to the disadvantage of all of them.

4. Carole Blair, "Contemporary U.S. Memorial Sites as Exemplars of Rhetoric's Materiality," in *Rhetorical Bodies,* ed. Jack Selzer and Sharon Crowley (Madison: University of Wisconsin Press, 1999), 18.

5. *Techné* has been defined variously as craft, skill, art, or applied science. F. E. Peters, *Greek Philosophical Terms: A Historical Lexicon* (New York: New York University Press, 1967), 190–91. Eric A. Havelock notes that *techné* is "strictly untranslatable, unless in a periphrasis which fuses the modern senses of technology and art into a single notion." *The Literate Revolution in Greece and Its Cultural Consequences* (Princeton, NJ: Princeton University Press, 1982), 269. W. K. C. Guthrie suggests that "those who know no Greek may be helped by the word itself: its incorporation in our 'technical' and 'technology' is not fortuitous." *The Sophists* (Cambridge, UK: Cambridge University Press, 1971), 115n.

6. Even in the case of ancient Greece, however, this limitation is not always so clear. George A. Kennedy notes, for example, that "Aristotle thinks of rhetoric as manifested in the civic context of public address; but he often draws examples of rhetoric from poetry or historical writing, and in the *Poetics* (19.1456a–b) the 'thought' of a speaker in tragedy is said to be a matter of rhetoric." Aristotle, *On Rhetoric: A Theory of Civic Discourse,* trans. George A. Kennedy (New York: Oxford University Press, 1991), 36n.

7. See Kenneth Burke, *A Rhetoric of Motives* (Berkeley: University of California Press, 1969).

8. Michael Calvin McGee, "A Materialist's Conception of Rhetoric," in *Explorations in Rhetoric: Studies in Honor of Douglas Ehninger,* ed. Ray E. McKerrow (Glenview, IL: Scott, Foresman, 1982), 25, 27. Also see Ronald Walter Greene, "Another Materialist Rhetoric," *Critical Studies in Mass Communication* 15 (1998): 21–41; Jack Selzer and Sharon Crowley, eds., *Rhetorical Bodies* (Madison: University of Wisconsin Press, 1999). Although there are at least three or four senses of rhetoric's materiality in circulation, the point is that rhetorical theorists and critics take the idea of it sufficiently seriously to debate about its character.

9. Ernst Cassirer, *Language and Myth,* trans. Susanne K. Langer (New York: Harper, 1946), 7.

10. See Barry Brummett, introduction to *Reading Rhetorical Theory* (Fort Worth: Harcourt, 2000), 8–9. Brummett argues that mediation refers to channels of communication, "what conveys the content or information in a message," as well as to "a technology of communication plus the ways the technology is habitually used." Perhaps the clearest statement on this issue is to be found in Sterne's arguments about the status of a *techné,* as referring "both to action and the conditions of possibility for action." See Jonathan Sterne, "Communication as *Techné,*" in *Communication as . . . : Perspectives on Theory,* ed. Gregory J. Shepherd, Jeffrey St. John, and Ted Striphas (Thousand Oaks, CA: Sage, 2006), 92.

11. See Maurice Charland, "Constitutive Rhetoric: The Case of the *Peuple Québécois,*" *Quarterly Journal of Speech* 73 (1987): 133–50.

12. For the general importance of contextual concern, see Lloyd F. Bitzer, "The Rhetorical Situation," *Philosophy and Rhetoric* 1 (1968): 1–14. For these different kinds of contextual concerns, see, for example: John C. Adams, "Epideictic and Its Cultural Reception: In Memory of the Firefighters," in *Rhetorics of Display,* ed. Lawrence J. Prelli (Columbia: University of South Carolina Press, 2006), 293–310; Michael Calvin McGee, "The Ideograph: A Link between Rhetoric and Ideology," *Quarterly Journal of Speech* 66 (1980): 1–16; Roderick P. Hart, Robert E. Carlson, and William F. Eadie, "Attitudes Toward Communication and the Assessment of Rhetorical Sensitivity," *Communication Monographs* 47 (1980): 1–22; Kathleen M. Jamieson, "Antecedent Genre as Rhetorical Constraint," *Quarterly Journal of Speech* 61 (1975): 406–415; and Christian Spielvogel, "'You Know Where I Stand': Moral Framing of the War on Terrorism and the Iraq War in the 2004 Presidential Campaign," *Rhetoric and Public Affairs* 8 (2005): 549–70.

13. Burke, *Rhetoric,* 19–25.

14. Michel Foucault, *The Archaeology of Knowledge,* trans. A. M. Sheridan Smith (New York: Harper, 1972), 118.

15. See Thomas B. Farrell, "The Tradition of Rhetoric and the Philosophy of Communication," *Communication* 7 (1983): 151–80. Also see James Jasinski, "Answering the Question: What Is Rhetorical Theory and What Does It Do?" *Review of Communication* 3 (2003): 326–29.

16. Herbert A. Wichelns, "The Literary Criticism of Oratory," in *Readings in Rhetorical Criticism,* ed. Carl R. Burgchardt, 2nd ed. (State College, PA: Strata, 2000), 23. Wichelns's essay was published originally in 1925.

17. Richard A. Cherwitz and John Theobald-Osborne, "Contemporary De-

velopments in Rhetorical Criticism: A Consideration of the Effects of Rhetoric," in *Speech Communication: Essays to Commemorate the 75th Anniversary of the Speech Communication Association,* ed. Gerald M. Phillips and Julia T. Wood (Carbondale: Southern Illinois University Press, 1990), 52.

18. John Louis Lucaites and Celeste Michelle Condit, introduction to *Contemporary Rhetorical Theory: A Reader,* ed. John Louis Lucaites, Celeste Michelle Condit, and Sally Caudill (New York: Guilford, 1999), 3.

19. Ibid.

20. See Dilip Gaonkar, "Contingency and Probability," in *Encyclopedia of Rhetoric,* ed. Thomas O. Sloane (New York: Oxford University Press, 2001), 151–65. Contingency and its twinned notion, probability, are complex and made the more so by their interrelationships, the genealogy of which Gaonkar traces. Although contingency is an often mute "background assumption," it has also served, as Gaonkar suggests, as "the conceptual background that underwrites the rhetorical project" (154). Undertheorized, and perhaps even badly understood, rhetoricians have long worked with what Gaonkar labels Aristotle's insistence "emphatically and repeatedly that no one wastes his time deliberating about things that are necessary or impossible." Gaonkar here references Aristotle's *Rhetoric* (1357a.1–8).

21. Craig Calhoun, "Public," in *New Keywords: A Revised Vocabulary of Culture and Society,* ed. Tony Bennett, Lawrence Grossberg, and Meaghan Morris (Malden, MA: Blackwell, 2005), 282–86.

22. See, for example, Jürgen Habermas, *The Structural Transformation of the Public Sphere: An Inquiry into a Category of Bourgeois Society,* trans. Thomas Burger (Cambridge, MA: MIT Press, 1989); Craig Calhoun, ed., *Habermas and the Public Sphere* (Cambridge, MA: MIT Press, 1992); Robert Asen and Daniel C. Brouwer, eds., *Counterpublics and the State* (Albany: State University of New York Press, 2001); Gerard A. Hauser, *Vernacular Voices: The Rhetoric of Publics and Public Spheres* (Columbia: University of South Carolina Press, 2001); and Bruno Latour and Peter Weibel, eds., *Making Things Public: Atmospheres of Democracy* (Cambridge, MA: MIT Press, 2005).

23. See Michael Warner, *Publics and Counterpublics* (New York: Zone Books, 2002).

24. In translation, see Maurice Halbwachs, *On Collective Memory,* ed. and trans. Lewis A. Coser (Chicago: University of Chicago Press, 1992).

25. See especially Foucault, *Archaeology of Knowledge,* and Michel Foucault, *Language, Counter-Memory, Practice: Selected Essays and Interviews,* ed. Donald F. Bouchard, trans. Bouchard and Sherry Simon (Ithaca, NY: Cornell University Press, 1977).

26. He argues that there are fundamental differences among individual, social, collective, and public memory. Edward S. Casey, "Public Memory in Place and Time," in Phillips, ed., *Framing*, 17–44.

27. Sometimes, scholars choose different modifiers altogether, referencing, for example, "historical memory" or "collected memory." Others choose no modifier at all. Some contributors to this large, interdisciplinary literature refer to "traditions," "heritage," "generations," or "reputation." Others discuss "remembrance" or "recollection." Some others choose a specific, substantive modifier, like "Holocaust" or "Watergate." Many related issues are discussed as "commemoration" or as "public history." Still, all these works assume a shared sense of the past. See, for a sampling, the following very diverse works, all of which have been important to our understandings of memory: Jan Assmann, *Religion and Cultural Memory*, trans. Rodney Livingstone (Stanford, CA: Stanford University Press, 2006); John Bodnar, *Remaking America: Public Memory, Commemoration, and Patriotism in the Twentieth Century* (Princeton, NJ: Princeton University Press, 1992); W. Fitzhugh Brundage, ed., *Where These Memories Grow: History, Memory, and Southern Identity* (Chapel Hill: University of North Carolina Press, 2000); M. Lane Bruner, *Strategies of Remembrance: The Rhetorical Dimensions of National Identity Construction* (Columbia: University of South Carolina Press, 2002); Paul Connerton, *How Societies Remember* (Cambridge, UK: Cambridge University Press, 1989); Jenny Edkins, *Trauma and the Memory of Politics* (Cambridge, UK: Cambridge University Press, 2003); Geneviève Fabre and Robert O'Meally, eds., *History and Memory in African-American Culture* (Oxford, UK: Oxford University Press, 1994); Alice Fahs and Joan Waugh, eds., *The Memory of the Civil War in American Culture* (Chapel Hill: University of North Carolina Press, 2004); Gary Alan Fine, *Difficult Reputations: Collective Memories of the Evil, Inept, and Controversial* (Chicago: University of Chicago Press, 2001); John R. Gillis, ed., *Commemorations: The Politics of National Identity* (Princeton, NJ: Princeton University Press, 1994); Peter Gray and Kendrik Oliver, eds., *The Memory of Catastrophe* (Manchester, NY: Manchester University Press, 2004); Eric Hobsbawm and Terence Ranger, eds., *The Invention of Tradition* (Cambridge, UK: Cambridge University Press, 1983); James Oliver Horton and Lois E. Horton, eds., *Slavery and Public History: The Tough Stuff of American Memory* (New York: New Press, 2006); Patrick H. Hutton, *History as an Art of Memory* (Hanover, NH: University Press of New England, 1993); Andreas Huyssen, *Present Pasts: Urban Palimpsests and the Politics of Memory* (Stanford, CA: Stanford University Press, 2003); Iwona Irwin-Zarecka, *Frames of Remembrance: The Dynamics of Collective Memory* (New Brunswick, NJ: Transaction, 1994); Alison Landsberg, *Prosthetic Memory: The Transformation of American Remembrance in the Age of Mass Culture* (New York: Columbia Uni-

versity Press, 2004); Michael Kammen, *The Mystic Chords of Memory: The Transformation of Tradition in American Culture* (New York: Vintage, 1993); George Lipsitz, *Time Passages: Collective Memory and American Popular Culture* (Minneapolis: University of Minnesota Press, 1990); David Lowenthal, *The Heritage Crusade and the Spoils of History* (Cambridge, UK: Cambridge University Press, 1998); David Middleton and Derek Edwards, eds., *Collective Remembering* (London: Sage, 1990); Jeffrey K. Olick, *The Politics of Regret: On Collective Memory and Historical Responsibility* (New York: Routledge, 2007); Jeffrey K. Olick, ed., *States of Memory: Continuities, Conflicts, and Transformations in National Retrospection* (Durham, NC: Duke University Press, 2003); Paul Ricoeur, *Memory, History, Forgetting,* trans. Kathleen Blamey and David Pellauer (Chicago: University of Chicago Press, 2004); Michael Schudson, *Watergate in American Memory: How We Remember, Forget, and Reconstruct the Past* (New York: Basic Books, 1992); Barry Schwartz, *Abraham Lincoln and the Forge of National Memory* (Chicago: University of Chicago Press, 2000); David Simpson, *9/11: The Culture of Commemoration* (Chicago: University of Chicago Press, 2006); Marita Sturken, *Tangled Memories: The Vietnam War, the AIDS Epidemic, and the Politics of Remembering* (Berkeley: University of California Press, 1997); Marita Sturken, *Tourists of History: Memory, Kitsch, and Consumerism from Oklahoma City to Ground Zero* (Durham, NC: Duke University Press, 2007); Jay Winter, *Remembering War: The Great War between Memory and History in the Twentieth Century* (New Haven, CT: Yale University Press, 2006); James E. Young, *At Memory's Edge: After-Images of the Holocaust in Contemporary Art and Architecture* (New Haven, CT: Yale University Press, 2000); and Barbie Zelizer, *Remembering to Forget: Holocaust Memory through the Camera's Eye* (Chicago: University of Chicago Press, 1998).

28. See Hobsbawm, "Introduction: Inventing Traditions," in Hobsbawm and Ranger, eds., *The Invention of Tradition,* 1–14.

29. David Lowenthal, *The Past Is a Foreign Country* (Cambridge, UK: Cambridge University Press, 1985), 184, 210.

30. Irwin-Zarecka, *Frames,* 99.

31. Jan Assmann, "Collective Memory and Cultural Identity," *New German Critique* 65 (Spring–Summer 1995): 132.

32. See Bodnar, *Remaking America.* Kammen suggests that a "history of national memory is hard to separate from the history of patriotism" (*Mystic Chords,* 13).

33. In the relatively rare cases of an elaboration of this articulation, it sometimes is problematically referenced back to the individual and his/her life history. See, for example, Irwin-Zarecka's discussion of "instant memory." She argues that these special memory images require a connection to the "pri-

vate emotional world" of the viewing audience, and she ends the discussion with the suggestive but unprobed claim that collectively constructed "instant memory" is dependent on "the emotional investment in the present" (*Frames,* 171, 174). More typically, the assumption is not elaborated at all, including by some of the memory literature we value most in terms of other kinds of probing. See, for example, Barry Schwartz, *Abraham Lincoln,* and James V. Wertsch, *Voices of Collective Remembering* (Cambridge, UK: Cambridge University Press, 2002).

34. This literature occupies an interesting relationship to contemporary memory literature. Although the presence of trauma presumes a relation of memory, the exploration of trauma is not always thematized explicitly as a memory issue, nor does all memory literature address trauma. One exemplary work to address their relation is Edkins, *Trauma.* Also see Cathy Caruth, ed., *Trauma: Explorations in Memory* (Baltimore: Johns Hopkins University Press, 1995). The relation of memory and trauma has also been taken up by Roland Barthes and Susan Sontag in relation to "shock-photos"—those photographs so traumatizing in their depiction of catastrophic events (war, lynchings, Holocaust atrocities) as to push meaning to the point of illegibility, beyond all signification. Roland Barthes, *Image, Music, Text,* trans. Stephen Heath (New York: Hill and Wang, 1977), 30–31. See also Susan Sontag, *Regarding the Pain of Others* (New York: Picador, 2004). Notably, this work highlights the dynamic ways that affect and memory interanimate one another—affect evoking memory and memory evoking affect. Such a recognition of the interanimation of affect and memory reaffirms the importance of attending to rhetoric's material dimensions, for the rhetorical construction of public memory can invite affective responses in audiences in much the same manner that a song's melody (its nonsymbolic dimension) can elicit sadness or melancholia.

35. See, for example, Patricia Ticineto Clough, introduction to *The Affective Turn: Theorizing the Social,* ed. Patricia Ticineto Clough (Durham, NC: Duke University Press, 2007), 1–33.

36. Assmann, *Religion and Cultural Memory,* 87–100.

37. Also useful here, in spite of major conceptual differences, different theoretical contrasts, and different purposes from Assmann, is the account of an epochal relation of trauma and *ressentiment,* by Olick, *Politics of Regret,* especially 153–73. Also see his discussion of the problems in dealing with trauma as a cultural terminology, 30–33.

38. See, for example, Lowenthal, *Past,* 193–238. Also see Hutton, *History.*

39. Winter, *Remembering War,* 289.

40. Pierre Nora, "General Introduction: Between Memory and History," in *Realms of Memory: Rethinking the French Past,* vol. 1, *Conflicts and Divisions,*

ed. Lawrence D. Kritzman, trans. Arthur Goldhammer (New York: Columbia University Press, 1996). The multivolume *Realms of Memory* is a partial compilation of the massive French project under Nora's direction entitled *Les lieux de mémoire,* published by Editions Gallimard, in 1992.

41. See Carole Blair, "Communication as Collective Memory," in Shepherd, St. John, and Striphas, eds., *Communication as . . .,* 53.

42. Sturken, *Tangled Memories,* 3.

43. Barbie Zelizer, "Reading the Past against the Grain: The Shape of Memory Studies," *Critical Studies in Mass Communication* 12 (1999): 224.

44. Huyssen, *Present Pasts,* 17.

45. Sturken, *Tangled Memories,* 2.

46. Schudson, *Watergate,* 52.

47. David W. Blight, *Beyond the Battlefield: Race, Memory, and the American Civil War* (Amherst: University of Massachusetts Press, 2002), 2.

48. Bodnar, *Remaking America,* 15.

49. Irwin-Zarecka, *Frames,* 13.

50. Barbara A. Misztal, *Theories of Social Remembering* (Berkshire, UK: Open University Press, 2003), 6.

51. "Setting the Framework," in *War and Remembrance in the Twentieth Century,* ed. Jay Winter and Emmanuel Sivan (Cambridge, UK: Cambridge University Press, 1999), 6–39.

52. Andreas Huyssen, *Twilight Memories: Marking Time in a Culture of Amnesia* (New York: Routledge, 1995), 3.

53. Yates, *Art of Memory.*

54. Hutton, *History,* essentially extends Yates's project, elaborating on how memory has been theorized and deployed in modernity.

55. Jacques Le Goff, *History and Memory,* trans. Steven Rendall and Elizabeth Claman (New York: Columbia University Press, 1992). See also Misztal, *Theories,* especially 27–49.

56. Landsberg, *Prosthetic Memory,* 3.

57. Winter, *Remembering War,* 18.

58. Nora, "General Introduction," 1.

59. Ibid., 2.

60. Peter Carrier, "Places, Politics, and the Archiving of Contemporary Memory in Pierre Nora's *Les Lieux de mémoire,*" in *Memory and Methodology,* ed. Susannah Radstone (Oxford, UK: Berg, 2000), 41.

61. Landsberg, *Prosthetic Memory,* 2.

62. Ibid., 20.

63. In offering the following examples, we emphasize that they are simply examples. We do not mean to slight by exclusion, but it is nearly impos-

sible, even within a relatively small disciplinary matrix, to locate *all* of the work within a particular domain or informed by a particular set of assumptions. Moreover, much public memory work has gone on within the related domains of performance studies, cultural studies in communication, organizational communication, and so forth—sometimes, but not always, assuming a rhetorical stance. Even with those works in rhetoric that we see as contributing to memory studies, their authors might not agree. Nonetheless, we offer the following as examples, as an indication of both the degree of interest in public memory among rhetoricians as well as the reach of that work: Bernard J. Armada, "Memorial Agon: An Interpretive Tour of the National Civil Rights Museum," *Southern Communication Journal* 63 (1998): 235–43; Deborah F. Atwater and Sandra L. Herndon, "Cultural Space and Race: The National Civil Rights Museum and MuseumAfrica," *Howard Journal of Communications* 14 (2003): 15–28; V. William Balthrop, "Culture, Myth, and Ideology as Public Argument: An Interpretation of the Ascent and Demise of 'Southern Culture,'" *Communication Monographs* 51 (1984): 339–52; Barbara Biesecker, "Remembering World War II: The Rhetoric and Politics of National Commemoration at the Turn of the Twenty-first Century," *Quarterly Journal of Speech* 88 (2002): 393–409; Carole Blair, Marsha S. Jeppeson, and Enrico Pucci Jr., "Public Memorializing in Postmodernity: The Vietnam Veterans Memorial as Prototype," *Quarterly Journal of Speech* 77 (1991): 263–88; Carole Blair and Neil Michel, "The AIDS Memorial Quilt and the Contemporary Culture of Public Commemoration," *Rhetoric and Public Affairs* 10 (2007): 595–626; Carole Blair and Neil Michel, "Reproducing Civil Rights Tactics: The Rhetorical Performances of the Civil Rights Memorial," *Rhetoric Society Quarterly* 30 (2000): 31–55; Carole Blair and Neil Michel, "The Rushmore Effect: *Ethos* and National Collective Identity," in *The Ethos of Rhetoric,* ed. Michael J. Hyde (Columbia: University of South Carolina Press, 2004), 156–96; Stephen H. Browne, "Reading Public Memory in Daniel Webster's Plymouth Rock Oration," *Western Journal of Communication* 57 (1993): 464–77; Stephen H. Browne, "Remembering Crispus Attucks: Race, Rhetoric, and the Politics of Commemoration," *Quarterly Journal of Speech* 85 (1999): 169–87; Lisa M. Burns, "Collective Memory and the Candidates' Wives in the 2004 Presidential Campaign," *Rhetoric and Public Affairs* 8 (2005): 684–88; J. Robert Cox, *Cultural Memory and Public Moral Argument* (Evanston, IL: Northwestern University School of Speech, 1987); Greg Dickinson, "Memories for Sale: Nostalgia and the Construction of Identity in Old Pasadena," *Quarterly Journal of Speech* 83 (1997): 1–27; Greg Dickinson, Brian L. Ott, and Eric Aoki, "Memory and Myth at the Buffalo Bill Museum," *Western Journal of Communication* 69 (2005): 85–108; Greg Dickinson, Brian L. Ott, and Eric Aoki, "Spaces of Remembering and Forget-

ting: The Reverent Eye/I at the Plains Indian Museum," *Communication and Critical/Cultural Studies* 3 (2006): 27–47; Peter Ehrenhaus, "Silence and Symbolic Expression," *Communication Monographs* 55 (1988): 41–57; Roslyn Collings Eves, "A Recipe for Remembrance: Memory and Identity in African-American Women's Cookbooks," *Rhetoric Review* 24 (2005): 280–97; Victoria J. Gallagher, "Memory and Reconciliation in the Birmingham Civil Rights Institute," *Rhetoric and Public Affairs* 2 (1999): 303–320; Victoria J. Gallagher, "Memory as Social Action: Projection and Generic Form in Civil Rights Memorials," in *New Approaches to Rhetoric,* ed. Patricia A. Sullivan and Steven R. Goldzwig (Thousand Oaks, CA: Sage, 2004), 149–71; Victoria J. Gallagher, "Remembering Together? Rhetorical Integration and the Case of the Martin Luther King, Jr. Memorial," *Southern Communication Journal* 60 (1995): 109–119; G. Thomas Goodnight and Kathryn M. Olson, "Shared Power, Foreign Policy, and Haiti, 1994: Public Memories of War and Race," *Rhetoric and Public Affairs* 9 (2006): 601–634; Stephanie Houston Grey, "Writing Redemption: Trauma and the Authentication of the Moral Order in *Hibakusha* Literature," *Text and Performance Quarterly* 22 (2002): 1–23; Joshua Gunn, "Mourning Speech: Haunting and the Spectral Voices of Nine-Eleven," *Text and Performance Quarterly* 24 (2004): 91–114; Robert Hariman and John Louis Lucaites, "Public Identity and Collective Memory in U.S. Iconic Photography: The Image of 'Accidental Napalm,'" *Critical Studies in Media Communication* 20 (2003): 35–66; Marouf Hasian Jr., "Authenticity, Public Memories, and the Problematics of Post-Holocaust Remembrances: A Rhetorical Analysis of the Wilkomirski Affair," *Quarterly Journal of Speech* 91 (2005): 231–63; Marouf Hasian Jr., "Nostalgic Longings and Imaginary Indias: Postcolonial Analysis, Collective Memories, and the Impeachment Trial of Warren Hastings," *Western Journal of Communication* 66 (2002): 229–55; Marouf Hasian Jr. and A. Cheree Carlson, "Revisionism and Collective Memory: The Struggle for Meaning in the Amistad Affair," *Communication Monographs* 67 (2000): 42–62; Marouf Hasian Jr. and Robert E. Frank, "Rhetoric, History, and Collective Memory: Decoding the Goldhagen Debates," *Western Journal of Communication* 63 (1999): 95–114; Ekaterina V. Haskins, "'Put Your Stamp on History': The USPS Commemorative Program *Celebrate the Century* and Postmodern Collective Memory," *Quarterly Journal of Speech* 89 (2003): 1–18; Cheryl R. Jorgensen-Earp and Lori A. Lanzilotti, "Public Memory and Private Grief: The Construction of Shrines at the Sites of Public Tragedy," *Quarterly Journal of Speech* 84 (1998): 150–70; Richard Marback, "Detroit and the Closed Fist: Toward a Theory of Material Rhetoric," *Rhetoric Review* 17 (1998): 74–91; Shawn J. Parry-Giles and Trevor Parry-Giles, "Collective Memory, Political Nostalgia, and the Rhetorical Presidency: Bill Clinton's Commemoration of the March on Washington, August 28, 1998,"

Quarterly Journal of Speech 86 (2000): 417–37; Phaedra C. Pezzullo, "Touring 'Cancer Alley,' Louisiana: Performances of Community and Memory for Environmental Justice," *Text and Performance Quarterly* 23 (2003): 226–52; Theodore O. Prosise, "The Collective Memory of the Atomic Bombings Misrecognized as Objective History: The Case of the Public Opposition to the National Air and Space Museum's Atom Bomb Exhibit," *Western Journal of Communication* 62 (1998): 316–47; Theodore O. Prosise, "Prejudiced, Historical Witness, and Responsible Collective Memory and Liminality in the Beit Hashoah Museum of Tolerance," *Communication Quarterly* 51 (2003): 351–66; G. Mitchell Reyes, "The Swift Boat Veterans for Truth, the Politics of Realism, and the Manipulation of Vietnam Remembrance in the 2004 Presidential Election," *Rhetoric and Public Affairs* 9 (2006): 571–600; Nathan Stormer, "In Living Memory: Abortion as Cultural Amnesia," *Quarterly Journal of Speech* 88 (2002): 265–83; Nathan Stormer, "To Remember, to Act, to Forget: Tracing Collective Remembrance through 'A Jury of Her Peers,'" *Communication Studies* 54 (2003): 510–29; Bradford Vivian, "Neoliberal Epideictic: Rhetorical Form and Commemorative Politics on September 11, 2002," *Quarterly Journal of Speech* 92 (2006): 1–26; Elizabethada Wright, "Reading the Cemetery, *Lieu de mémoire par excellance*," *Rhetoric Society Quarterly* 33 (2003): 27–44; and Elizabethada Wright, "Rhetorical Spaces in Memorial Places: The Cemetery as a Rhetorical Place/ Space," *Rhetoric Society Quarterly* 35 (2005): 51–81.

64. See, for example, the critique by Misztal, *Theories,* 56–61. By "recalcitrance," we mean something akin to Kenneth Burke's notion in *Permanence and Change: An Anatomy of Purpose* (Indianapolis: Bobbs-Merrill, 1965), 255–61.

65. Schwartz, *Abraham Lincoln,* 11. Although Schwartz levels the charge against followers of Halbwachs and Nora, it is more typically directed against works such as Hobsbawm and Ranger's. Although we agree with Schwartz that there is a risk of "muckraking" in taking a simplistic view of "invention," we believe that Schwartz may be erring in the other direction. His bifurcation of theories of collective memory to include "the politics of memory" and "memory as a cultural system" seems overly reductive. It also seems to caricature the former approach, objecting to its "constructionist" position, and as a result may give too little attention in the end to the political. Although we take most of Schwartz's critiques of memory studies very seriously—indeed agreeing with most of them—they seem to be equally applicable to a variety of approaches.

66. We do not mean to imply that "resemblance" and "trace" are equivalent. Quite the contrary, in fact. What we would suggest instead is that there are rhetorical routines for establishing the supposed authenticity and/or rhetorical

fulsomeness of the trace. See Barbara A. Biesecker, "Of Historicity, Rhetoric: The Archive as Scene of Invention," *Rhetoric and Public Affairs* 9 (2006): 124–31.

67. We might also think of it productively as a denial of the archive. See Biesecker, "Of Historicity, Rhetoric."

68. See Walter Watson, "Invention," in *Encyclopedia of Rhetoric*, 389–404. Also see Karen Burke LeFevre, *Invention as a Social Act* (Carbondale: Southern Illinois University Press, 1987); and J. Robert Cox, "Memory, Critical Theory, and the Argument from History," *Argumentation and Advocacy* 27 (1990): 1–13.

69. Brundage, "No Deed but Memory," in *Where These Memories Grow*, 5.

70. For just a few of the reasons why, see Michael Schudson, "Lives, Laws, and Language: Commemorative versus Non-commemorative Forms of Effective Memory," *Communication Review* 2 (1997): 3–17. We obviously do not agree with Schudson's claims that the "non-commemorative" is always more important than the commemorative, nor that scholars have forsaken the former for the "convenience" of the latter (3). A more temperate and much more defensible view might be that both "types" of public memory are important, complicated, and worthy of investigation.

71. Irwin-Zarecka, *Frames*, 4.

72. Olick, introduction to *States of Memory*, 7.

73. Misztal, *Theories*, 60, 67.

74. Schwartz, *Abraham Lincoln*, 17.

75. Irwin-Zarecka, *Frames*, 41. We do not mean to imply here that "groups" are necessarily already established or stable collectives. Indeed, as contemporary work has suggested, groups are often constituted as such by rhetoric that calls them into existence. See Michael C. McGee, "In Search of 'The People': A Rhetorical Alternative," *Quarterly Journal of Speech* 61 (1975): 235–49. Also see Charland, "Constitutive Rhetoric."

76. In addition to the formative work by McGee and Charland, see, for example: Robert Asen, "Imagining in the Public Sphere," *Philosophy and Rhetoric* 35 (2002): 345–67; and Barbara Biesecker, "No Time for Mourning: The Rhetorical Production of the Melancholic Citizen-Subject in the War on Terror," *Philosophy and Rhetoric* 40 (2007): 147–69.

77. We do not mean to suggest that issues of attachment, affect, emotion, and so forth are somehow "settled" in rhetoric. Indeed, these issues have had a somewhat odd history in rhetoric, in large measure because of antiquity's and modernity's different injunctions against their ethical merit or instrumental value. Some of this new work is written within the contexts of those injunctions. See, for example: Robert Hariman and John Louis Lucaites, "Dissent and Emotional Management in a Liberal Democratic Society: The

Kent State Iconic Photograph," *Rhetoric Society Quarterly* 31 (2001): 4–31; Hariman and Lucaites, "Public Identity and Collective Memory"; Michael William Pfau, "Who's Afraid of Fear Appeals? Contingency, Courage, and Deliberation in Rhetorical Theory and Practice," *Philosophy and Rhetoric* 40 (2007): 216–37; and Kenneth S. Zagacki and Patrick A. Boleyn-Fitzgerald, "Rhetoric and Anger," *Philosophy and Rhetoric* 39 (2006): 290–390. Other work, however, is situated in terms of poststructuralism's challenges to rhetoric. See, for example, Joshua Gunn, "Refitting Fantasy: Psychoanalysis, Subjectivity, and Talking to the Dead," *Quarterly Journal of Speech* 90 (2004): 1–23; John Louis Lucaites and James P. McDaniel, "Telescopic Mourning/Warring in the Global Village: Decomposing (Japanese) Authority Figures," *Communication and Critical/Cultural Studies* 1 (2004): 1–28; Christian Lundberg, "The Royal Road Not Taken: Joshua Gunn's 'Refitting Fantasy: Psychoanalysis, Subjectivity, and Talking to the Dead' and Lacan's Symbolic Order," *Quarterly Journal of Speech* 90 (2004): 495–500; James P. McDaniel, "Fantasm: The Triumph of Form," *Quarterly Journal of Speech* 86 (2000): 48–66; James Patrick McDaniel, "Speaking Like a State: Listening to Benjamin Franklin in Times of Terror," *Communication and Critical/Cultural Studies* 2 (2005): 324–50; Brian L. Ott, "(Re)locating Pleasure in Media Studies: Toward an Erotics of Reading," *Communication and Critical/Cultural Studies* 1 (2004): 194–212; and Bradford Vivian, *Being Made Strange: Rhetoric beyond Representation* (Albany: State University of New York Press, 2004).

78. Sara Ahmed, *The Cultural Politics of Emotion* (New York: Routledge, 2004), 11.

79. We believe that a specifically rhetorical understanding of affect distinguishes it from a felt state on the part of an individual subject. In a sense, affect is a condition of possibility for such feeling states, in its status as a circulating affinity, rather than a space of interior emotional content. We are grateful to Christian O. Lundberg, a colleague in Communication Studies, at the University of North Carolina, for this important insight.

80. Aristotle, *On Rhetoric*, 134.

81. Lawrence Grossberg, *We Gotta Get out of This Place: Popular Conservatism and Postmodern Culture* (New York: Routledge, 1992), 79. Emphasis in original.

82. See Brian Massumi, "Notes on the Translation and Acknowledgments," in Gilles Deleuze and Félix Guattari, *A Thousand Plateaus: Capitalism and Schizophrenia* (Minneapolis: University of Minnesota Press, 1987), xvi.

83. Grossberg, *We Gotta Get Out*, 86.

84. Benedict Anderson, *Imagined Communities: Reflections on the Origin and Spread of Nationalism,* 2nd ed. (London: Verso, 1991), 143.

85. Ibid., 144. Emphasis added.

86. Grossberg, *We Gotta Get Out,* 83.

87. Burke, *Rhetoric,* 28.

88. Assmann, *Religion and Cultural Memory,* 92–93.

89. See, for example, Andrew J. Bacevich, *The New American Militarism: How Americans Are Seduced by War* (New York: Oxford University Press, 2006), especially 175–91; Steven C. Dubin, *Displays of Power: Memory and Amnesia in the American Museum* (New York: New York University Press, 1999), especially 152–245; Edward T. Linenthal and Tom Engelhardt, eds., *History Wars: The Enola Gay and Other Battles for the American Past* (New York: Henry Holt, 1996); Mike Wallace, *Mickey Mouse History and Other Essays on American Memory* (Philadelphia: Temple University Press, 1996), especially 302–318; Nicolaus Mills, *Their Last Battle: The Fight for the National World War II Memorial* (New York: Basic Books, 2004); and Gary B. Nash, Charlotte Crabtree, and Ross E. Dunn, *History on Trial: Culture Wars and the Teaching of the Past* (New York: Alfred A. Knopf, 1999), especially 149–97.

90. Wertsch, *Voices,* 35.

91. Olick, *Politics of Regret,* 40–54.

92. Paul Connerton, "Seven Types of Forgetting," *Memory Studies* 1 (2008): 68. Connerton's purpose importantly is not to dislodge the remembering-forgetting dialectic. Instead, it is to parse out different "types" of forgetting in the interest of demonstrating that not all forgetting is a failing. In fact, his position, except for the one line we have quoted here, seems to accept the dialectic intact, in spite of the problems that entails. Most of his discussion, we think, is about the *desire* to forget or about apparatuses of policing public articulations of memory, not about actually forgetting contents of memory.

93. The notion of "robustness" or memory's lasting character is a matter addressed directly both by Schwartz, *Abraham Lincoln,* and Lyn Spillman, "When Do Collective Memories Last? Founding Moments in the United States and Australia," in Olick, ed., *States of Memory,* 161–92.

94. Lowenthal, *Past,* 206.

95. Schwartz, *Abraham Lincoln,* 301; Irwin-Zarecka, *Frames,* 7.

96. See, for example, David Scofield Wilson, "Old Sacramento: Place as Presence, Palimpsest, and Performance," *Places* 5 (1988): 54–63. Although she doesn't use the term "palimpsest," Karen E. Till's description of Berlin and its relationships and codings of its history and various modernities is a good example. *The New Berlin: Memory, Politics, Place* (Minneapolis: University of Minnesota Press, 2005), 5–6.

97. For a discussion of the many possibilities, see Foucault, *Archaeology of Knowledge,* 118–25. Also see Blair, "Contemporary U.S. Memorial Sites."

98. Peter Karsten, *Patriot-Heroes in England and America: Political Symbolism*

and Changing Values over Three Centuries (Madison: University of Wisconsin Press, 1978).

99. Schwartz, *Abraham Lincoln,* 296.

100. Sterne, "Communication as Techné," 96.

101. Ibid.

102. Ibid.

103. See, for example, Raymond Williams, *Television: Technology and Cultural Form* (London: Fontana, 1974).

104. See Karl E. Weick, *The Social Psychology of Organizing,* 2nd ed. (New York: McGraw Hill, 1979), 35–42. Weick argues that there are "inevitable tradeoffs in inquiry," specifically that inquiry cannot be simultaneously general, accurate, and simple. He suggests that to achieve two of these metatheoretical virtues, one must necessarily sacrifice the third. We are a bit uncomfortable with Weick's term "accuracy" as a criterion for the kinds of research that memory studies and rhetoric typically engage. We might substitute something like "interpretive utility" for the investigation of specific cases. Weick bases his discussion on that of Warren Thorngate, "'In General' vs. 'It Depends': Some Comments on the Gergen-Schlenker Debate," *Personality and Social Psychology Bulletin* 2 (1976): 404–410. See Joshua Gunn and Jenny Edbauer Rice, "About Face/Stuttering Discipline," *Communication and Critical/Cultural Studies* 6 (2009): 215–19. They remind us that speech is both physical and acoustic as well as voiced and symbolic, concluding that it uniquely "harbors an affective and effective ethic" (218).

105. See, for example, the following. As with the memory literature, these are only examples. They contain an almost endless variety of the terminologies of place and space. We take advantage of this opportunity not only to list citations that use such terminology but, more importantly, to acknowledge works that have shaped our thinking profoundly. In many cases, these works are not in accord, nor does (or could) our highly synthetic position reflect all of the specific stances taken up by these authors. But these are works that, together with our years of research on memory places, are formative of the positions that follow. Some are about memory places in particular, others about place and space, still others about tourism. See: Philippe Ariès, *Images of Man and Death,* trans. Janet Lloyd (Cambridge, MA: Harvard University Press, 1985); Gaston Bachelard, *The Poetics of Space,* trans. Maria Jolas (Boston: Beacon Press, 1994); Craig E. Barton, ed., *Sites of Memory: Perspectives on Architecture and Race* (New York: Princeton Architectural Press, 2001); Walter Benjamin, *The Arcades Project,* trans. Howard Eiland and Kevin McLaughlin (Cambridge, MA: Harvard University Press, 1999); Marshall Berman, *All That Is Solid Melts into Air: The Experience of Modernity* (New York: Penguin, 1988); Homi K.

Bhabha, *The Location of Culture* (London: Routledge, 1994); Albert Boime, *The Unveiling of the National Icons: A Plea for Patriotic Iconoclasm in a Nationalist Era* (Cambridge, UK: Cambridge University Press, 1998); Geoffrey Broadbent, Richard Bunt, and Charles Jencks, eds., *Signs, Symbols, and Architecture* (New York: John Wiley & Sons, 1980); Stephen Carr, Mark Francis, Leanne G. Rivlin, and Andrew M. Stone, *Public Space* (Cambridge, UK: Cambridge University Press, 1992); Edward S. Casey, *The Fate of Place: A Philosophical History* (Berkeley: University of California Press, 1997); Michel de Certeau, *The Practice of Everyday Life*, trans. Steven Rendall (Berkeley: University of California Press, 1984); Gregory Clark, *Rhetorical Landscapes in America: Variations on a Theme from Kenneth Burke* (Columbia: University of South Carolina Press, 2004); Simon Coleman and Mike Crang, eds., *Tourism: Between Place and Performance* (New York: Berghahn Books, 2002); Jim Collins, *Architectures of Excess: Cultural Life in the Information Age* (New York: Routledge, 1995); Beatriz Colomina, *Privacy and Publicity: Modern Architecture as Mass Media* (Cambridge, MA: MIT Press, 1994); Steven Conn, *Museums and American Intellectual Life, 1876–1926* (Chicago: University of Chicago Press, 1998); Mike Crang and Nigel Thrift, eds., *Thinking Space* (London: Routledge, 2000); David Crouch and Nina Lübbren, eds., *Visual Culture and Tourism* (Oxford, UK: Berg, 2003); Mike Davis, *Dead Cities, and Other Tales* (New York: New Press, 2002); Kevin Michael DeLuca, *Image Politics: The New Rhetoric of Environmental Activism* (New York: Guilford, 1999); Jane Desmond, *Staging Tourism: Bodies on Display from Waikiki to Sea World* (Chicago: University of Chicago Press, 1999); Greg Dickinson, "Joe's Rhetoric: Finding Authenticity at Starbuck's," *Rhetoric Society Quarterly* 32 (2002): 5–27; Greg Dickinson and Casey M. Maugh, "Placing Visual Rhetoric: Finding Material Comfort in Wild Oats Market," in *Defining Visual Rhetorics*, ed. Charles A. Hill and Marguerite Helmers (Mahwah, NJ: Lawrence Erlbaum, 2004): 259–76; Dubin, *Displays of Power;* James Duncan and David Ley, eds., *Place/Culture/Representation* (London: Routledge, 1993); Kenneth E. Foote, *Shadowed Ground: America's Landscapes of Violence and Tragedy* (Austin: University of Texas Press, 1997); Richard Wightman Fox and T. J. Jackson Lears, eds., *The Power of Culture: Critical Essays in American History* (Chicago: University of Chicago Press, 1993); Vivien Green Fryd, *Art and Empire: The Politics of Ethnicity in the United States Capitol, 1815–1860* (New Haven, CT: Yale University Press, 1992); Paul Fussell, *The Boy Scout Handbook and Other Observations* (New York: Oxford University Press, 1982); Gillis, ed., *Commemorations;* David Glassberg, *Sense of History: The Place of the Past in American Life* (Amherst: University of Massachusetts Press, 2001); Derek Gregory, *Geographical Imaginations* (Cambridge, MA: Blackwell, 1994); Elizabeth Grosz, *Architecture from the Outside: Essays on Virtual and Real Space* (Cambridge, MA:

MIT Press, 2001); Akhil Gupta and James Ferguson, eds., *Culture, Power, Place: Explorations in Critical Anthropology* (Durham, NC: Duke University Press, 1997); Robert Harbison, *The Built, the Unbuilt, and the Unbuildable: In Pursuit of Architectural Meaning* (Cambridge, MA: MIT Press, 1991); David Harvey, *Spaces of Capital: Towards a Critical Geography* (New York: Routledge, 2001); Dolores Hayden, *The Power of Place: Urban Landscapes as Public History* (Cambridge, MA: MIT Press, 1995); Edwin Heathcote, *Monument Builders: Modern Architecture and Death* (West Sussex, UK: John Wiley & Sons, 1999); Amy Henderson and Adrienne L. Kaeppler, eds., *Exhibiting Dilemmas: Issues of Representation at the Smithsonian* (Washington, DC: Smithsonian Institution Press, 1997); Paul Hirst, *Space and Power: Politics, War and Architecture* (Cambridge, UK: Polity, 2005); Jane Jacobs, *The Death and Life of Great American Cities* (New York: Random House, 1961); David Jacobson, *Place and Belonging in America* (Baltimore: Johns Hopkins University Press, 2002); Charles Jencks, *The Language of Post-Modern Architecture,* rev. enlarged ed. (London: Academy Editions, 1981); Ivan Karp, Christine Mullen Kreamer, and Steven D. Lavine, eds., *Museums and Communities: The Politics of Public Culture* (Washington, DC: Smithsonian Institution Press, 1992); Ivan Karp and Steven D. Lavine, eds., *Exhibiting Cultures: The Poetics and Politics of Museum Display* (Washington, DC: Smithsonian Institution Press, 1991); Barbara Kirshenblatt-Gimblett, *Destination Culture: Tourism, Museums, and Heritage* (Berkeley: University of California Press, 1998); Margaret Kohn, *Radical Space: Building the House of the People* (Ithaca, NY: Cornell University Press, 2003); Michel Laguerre, *Minoritized Space: An Inquiry into the Spatial Order of Things* (Berkeley: University of California Press, 1999); Michèle Lamont, *The Cultural Territories of Race: Black and White Boundaries* (Chicago: University of Chicago Press, 1999); D. Medina Lasansky and Brian McLaren, eds., *Architecture and Tourism: Perception, Performance, and Place* (Oxford, UK: Berg, 2004); Brian Lawson, *The Language of Space* (Oxford, UK: Architectural Press, 2001); Henri Lefebvre, *The Production of Space,* trans. Donald Nicholson-Smith (Oxford, UK: Blackwell, 1991); Warren Leon and Roy Rosenzweig, eds., *History Museums in the United States: A Critical Assessment* (Urbana: University of Illinois Press, 1989); Sanford Levinson, *Written in Stone: Public Monuments in Changing Societies* (Durham, NC: Duke University Press, 1998); William J. Lillyman, Marilyn F. Moriarty, and David J. Neuman, eds., *Critical Architecture and Contemporary Culture* (New York: Oxford University Press, 1994); Edward T. Linenthal, *Preserving Memory: The Struggle to Create America's Holocaust Museum* (New York: Viking, 1995); Edward T. Linenthal, *The Unfinished Bombing: Oklahoma City in American Memory* (New York: Oxford University Press, 2001); Edward Tabor Linenthal, *Sacred Ground: Americans and Their Battlefields,* 2nd ed. (Urbana: University of Illinois Press, 1993); Lucy Lippard, *On the Beaten Track: Tourism, Art,*

and Place (New York: New Press, 1999); David W. Lloyd, *Battlefield Tourism: Pilgrimage and the Commemoration of the Great War in Britain, Australia, and Canada, 1919–1939* (Oxford, UK: Berg, 1998); James W. Loewen, *Lies across America: What Our Historic Sites Get Wrong* (New York: New Press, 1999); Setha Low and Neil Smith, eds., *The Politics of Public Space* (New York: Routledge, 2006); Setha M. Low and Denise Lawrence-Zúñiga, eds., *The Anthropology of Space and Place: Locating Culture* (Oxford, UK: Blackwell, 2003); Doreen Massey, *For Space* (London: Sage, 2005); Doreen Massey, *Space, Place, and Gender* (Minneapolis: University of Minnesota Press, 1994); James M. Mayo, *War Memorials as Political Landscape: The American Experience and Beyond* (New York: Praeger, 1988); Malcolm Miles, *Art, Space and the City: Public Art and Urban Futures* (London: Routledge, 1997); Don Mitchell, *The Right to the City: Social Justice and the Fight for Public Space* (New York: Guilford Press, 2003); W. J. T. Mitchell, ed., *Art and the Public Sphere* (Chicago: University of Chicago Press, 1992); Mark Neumann, *On the Rim: Looking for the Grand Canyon* (Minneapolis: University of Minnesota Press, 1999); Nikolaus Pevsner, *A History of Building Types* (Princeton, NJ: Princeton University Press, 1976); G. Kurt Piehler, *Remembering War the American Way* (Washington, DC: Smithsonian Institution Press, 1995); Della Pollock, ed., *Exceptional Spaces: Essays in Performance and History* (Chapel Hill: University of North Carolina Press, 1998); Witold Rybczynski, *City Life* (New York: Simon and Schuster, 1995); Kirk Savage, *Standing Soldiers, Kneeling Slaves: Race, War, and Monument in Nineteenth-Century America* (Princeton, NJ: Princeton University Press, 1997); Paul A. Shackel, ed., *Myth, Memory, and the Making of the American Landscape* (Gainesville: University Press of Florida, 2001); Simon Schama, *Landscape and Memory* (New York: Alfred A. Knopf, 1995); Harriet F. Senie, *Contemporary Public Sculpture: Tradition, Transformation, and Controversy* (New York: Oxford University Press, 1992); Harriet F. Senie and Sally Webster, eds., *Critical Issues in Public Art: Content, Context, and Controversy* (New York: HarperCollins, 1992); Marguerite S. Shaffer, *See America First: Tourism and National Identity, 1880–1940* (Washington, DC: Smithsonian Institution Press, 2001); Daniel J. Sherman and Irit Rogoff, eds., *Museum Culture: Histories, Discourses, Spectacles* (Minneapolis: University of Minnesota Press, 1994); Edward W. Soja, *Postmodern Geographies: The Reassertion of Space in Critical Social Theory* (London: Verso, 1989); Edward W. Soja, *Thirdspace: Journeys to Los Angeles and Other Real-and-Imagined Places* (Malden, MA: Blackwell, 1996); Michael Sorkin, ed., *Variations on a Theme Park: The New American City and the End of Public Space* (New York: Noonday Press, 1992); Lyn Spillman, *Nation and Commemoration: Creating National Identities in the United States and Australia* (Cambridge, UK: Cambridge University Press, 1997); Diana Taylor, *The Archive and the Repertoire: Performing Cultural Memory in the Americas* (Durham, NC: Duke University

Press, 2003); Yi-Fu Tuan, *Space and Place: The Perspective of Experience* (Minneapolis: University of Minnesota Press, 1977); Lawrence J. Vale, *Architecture, Power, and National Identity* (New Haven, CT: Yale University Press, 1992); Alan Wallach, *Exhibiting Contradiction: Essays on the Art Museum in the United States* (Amherst: University of Massachusetts Press, 1998); Jay Winter, *Sites of Memory, Sites of Mourning: The Great War in European Cultural History* (Cambridge, UK: Cambridge University Press, 1995); James E. Young, *The Texture of Memory: Holocaust Memorials and Meaning* (New Haven, CT: Yale University Press, 1993); and Sharon Zukin, *Landscapes of Power: From Detroit to Disney World* (Berkeley: University of California Press, 1991).

106. See, for example, Wayne Franklin and Michael Steiner, "Taking Place: Toward the Regrounding of American Studies," in *Mapping American Culture*, ed. Wayne Franklin and Michael Steiner (Iowa City: University of Iowa Press, 1992), 3–23. Many of the terminological issues and entailments are spelled out by John Agnew, "Representing Space: Space, Scale and Culture in Social Science," in Duncan and Ley, eds., *Place/Culture/Representation*, 251–71. The terminologies, of course, are not stable across fields or works. Place, as drawn in this distinction, for example, seems to be a variant of Lefebvre's "representational space" (*Production of Space*, 42), and it probably would be something like a privileged "space" of intimacy in Bachelard's thinking (*Poetics of Space*).

107. Leland Roth, *Understanding Architecture: Its Elements, History, and Meaning* (New York: HarperCollins, 1993), 45.

108. Tuan, *Space and Place*, 6. This is not to suggest some essentialism of space. As Lefebvre has argued convincingly, space is produced. If we take him seriously, we cannot, for example, think of space as natural and place as artificial.

109. See, for example, Lefebvre, *Production of Space*.

110. The significance of particular places to public memory is illustrated graphically by Bevan's observations about the targeting of architectural icons as a strategy of armed hostilities. He argues that "This is not 'collateral damage'. This is the *active* and often systematic destruction of particular building types or architectural traditions that happens in conflicts where the erasure of the memories, history and identity attached to architecture and place— enforced forgetting—is the goal itself. These buildings are attacked not because they are in the path of a military objective: to their destroyers they *are* the objective." Robert Bevan, *The Destruction of Memory: Architecture at War* (London: Reaktion Books, 2006), 8. Emphasis in original.

111. Gregory's reading of Benjamin is instructive on this point. He argues that "Benjamin effectively 'spatialized' time, supplanting the narrative encoding of history through a textual practice that disrupted the historiographic chain in which moments were clipped together like magnets." Derek Gregory,

"Interventions in the Historical Geography of Modernity: Social Theory, Spatiality, and the Politics of Representation," in Duncan and Ley, eds., *Place/Culture/Representation*, 287.

112. See, for example, Cicero, *[Cicero] Ad C. Herennium de ratione dicendi (Rhetorica ad Herennium)*, trans. Harry Caplan (Cambridge, MA: Harvard University Press, 1954), 205–225. It is widely acknowledged that Cicero was not the author of the *Rhetorica ad Herennium*. For issues of authorship, see the Caplan introduction. Regardless of authorship, it is interesting to note the opening line in the section on memory: "Now let me turn to the treasure-house of the ideas supplied by Invention, to the guardian of all the parts of rhetoric, the Memory" (205).

Also see Quintilian, *The Institutio Oratoria of Quintilian*, vol. 4, trans. H. E. Butler (Cambridge, MA: Harvard University Press, 1922), beginning with book 40.2.1 (pp. 211 ff.).

113. Roy Rosenzweig and David Thelen, *The Presence of the Past: Popular Uses of History in American Life* (New York: Columbia University Press, 1998), 105.

114. Ibid., 91.

115. Irwin-Zarecka, *Frames*, 8.

116. Certainly not all memory sites "command" this attention in the same ways, nor are they equally successful in securing it. A person may be indifferent to the bid for attention. For a fascinating discussion of attention, see Jonathan Crary, *Suspensions of Perception: Attention, Spectacle, and Modern Culture* (Cambridge, MA: MIT Press, 1999).

117. For discussions of "consummatory" rhetoric, see Richard A. Cherwitz and Kenneth S. Zagacki, "Consummatory versus Justificatory Crisis Rhetoric," *Western Journal of Speech Communication* 50 (1986): 307–324; Lin-Lee Lee, "Pure Persuasion: A Case Study of Nühu or 'Women's Script' Discourses," *Quarterly Journal of Speech* 90 (2004): 403–421; and Bruce E. Gronbeck, "The Functions of Presidential Campaigning," *Communication Monographs* 45 (1978): 268–80.

118. Rosenzweig and Thelen, *Presence of the Past*, 106.

119. Bradford Vivian, "Jefferson's Other," *Quarterly Journal of Speech* 88 (2002): 299.

120. As Kohn suggests in *Radical Space*, "The power of place comes from the fact that social relations are directly experienced as inevitable and immutable, an extension of the world we inhabit. A common error reflected in both theory and 'naïve' experience is to mistake the apparent stability of the natural and built environments for immutability" (18–19).

121. Blair and Michel, "Rushmore Effect," 180.

122. Karsten Harries captures the sense of what we mean particularly well: "There is a continuing need for the creation of . . . places where individuals

come together and affirm themselves as members of the community, as they join in public reenactments of the essential: celebrations of those central aspects of our life that maintain and give meaning to its existence." *The Ethical Function of Architecture* (Cambridge, MA: MIT Press, 1998), 365.

123. Here we take quite literally Smith and Low's injunction to "take the geography of the public sphere—public space—seriously." See "Introduction: The Imperative of Public Space," in their edited volume, *Politics of Public Space,* 3.

124. There are several minor memorials that honor U.S. presidents elsewhere in the area. For example, there is a Woodrow Wilson house museum, and there are minor memorials, including ones honoring Theodore Roosevelt and Lyndon Johnson. They are not highly visible, easily accessible, or particularly well publicized. Jacobson suggests that "'A hierarchy of shrines' is evident, beginning in Washington, D.C., and continuing to other cities, but often also within cities themselves. The major monuments are the epicenter of public life, while other monuments—concerning lesser-known figures, for example—are more peripheral" (*Place and Belonging,* 126).

125. Jacobson, *Place and Belonging,* 128.

126. This is not to suggest that other memory *techné* are incorporeal or immaterial. As Blair suggests in "Contemporary U.S. Memorial Sites," modes of materiality differ and should be attended to in any inquiry into the rhetorics of memory.

127. Certeau, *Practice of Everyday Life.*

128. Raul Hilberg, qtd. in Linenthal, *Preserving Memory,* 107–8.

129. Loewen, *Lies across America,* 36, 40.

130. Blair and Michel, "Rushmore Effect," 156. See also Meaghan Morris, *Too Soon Too Late: History in Popular Culture* (Bloomington: University of Indiana Press, 1998), 77–78.

131. Scott A. Sandage, "A Marble House Divided: The Lincoln Memorial, the Civil Rights Movement, and the Politics of Memory, 1939–1963," *Journal of American History* 80 (1993): 135–67.

132. Nora, "Preface to the English-Language Edition: From *Lieux de mémoire* to *Realms of Memory,*" in *Realms,* xv.

133. Ibid., 533n.

134. Ibid., xvii.

I
Rhetoric

I
Radioactive History
Rhetoric, Memory, and Place in the Post–Cold War Nuclear Museum

Bryan C. Taylor

This chapter is concerned with nuclear museums as a rhetorical site of public memory in post–Cold War American culture. Its argument is developed across three sections. I will begin by discussing the unique relationships that exist between nuclear weapons, space, and rhetoric. Next, I will consider museums as reflexive spaces for the "entangled" discourses of nuclear history, memory, and heritage. I then conceptualize and critique the relationship between nuclear museum rhetoric and the evolving context of post–Cold War U.S. culture.

To preview my argument, this relationship may be characterized as follows: In American nuclear museums, currently, we find an ongoing contest between the proponents and opponents of continued nuclear weapons development by the United States and by other nations. That contest is conducted through rhetoric that interprets and evaluates the legacies of Cold War–era nuclear weapons production, and that circulates among audiences girding for the unfolding "Long War" between Western liberal democracies and radical Islamic jihadists.[1] In this process, nuclear museums in the United States continue to serve as sites of struggle for the control of rhetoric that mediates public understanding of nuclear weapons development. At these sites, visitors encounter a throbbing history marked by paradox and risk. These phenomena threaten to breach the narrative "containment" typically sought by nuclear museum officials and their patrons. In this process, the places of nuclear rhetoric and of its apparent referents converge.

How this containment and convergence will evolve is a question that this chapter can raise but not resolve. That resolution requires the development of new nuclear places—of new rhetorical contexts that facilitate the ideal of genuine nuclear-democratic deliberation.[2] To that end, I conclude this chapter with a surrealistic fragment that suggests how museums and rhetorical criticism can facilitate this development.

Nuclear Weapons, Rhetoric, and Place

As a historical and cultural phenomenon, nuclear weapons have created unique and highly charged relationships between space and rhetoric. To unpack this claim, we must consider some of the conditions created by their development.

Most obvious is the threat that nuclear weapons pose to the integrity of space as a potential place of human safety. The principal military innovation created by nuclear weapons arises from their efficiency: a single nuclear weapon instantly yields a scale of destruction that previously required the use of many conventional weapons over time. As a result, the space of a successful nuclear detonation is one of total, mercilessly enunciated force. That force speaks in three hellish registers: heat (producing both immediate incineration and raging firestorms), blast pressure, and ionizing radiation that is pathogenic, invisible, and persistent. The potency of this force was vividly demonstrated in the events of Hiroshima and Nagasaki, which quickly signaled to U.S. military officials that nuclear weapons phenomena could not be easily contained. Once they were coupled with international delivery systems capable of evading detection and defense (officials reluctantly conceded that "the bomber will always get through"), nuclear weapons created a novel existential condition. Under this condition, the human inhabitation of *all* space became precarious and fatalistic, shadowed by fleeting images of devouring flashes and billowing clouds.

The development of nuclear weapons thus destroyed and reconfigured traditional boundaries that had organized the cultural experience of political, military, and social spaces. These boundaries included those between enemy, ally, and Self; between battlefield and home front; and—more abstractly—between the military, industrial, and civilian spheres of society. One example of this process involves the residents of postwar American communities surrounding military bases and defense plants. Reluctantly, those residents realized that proximity ensured that their fates were inextricably tied to the targeting of those facilities by enemy nuclear forces.[3] Another example involves a lesson of the October 1962 Cuban Missile Crisis: As that conflict escalated, the U.S. Strategic Air Command deemed it necessary to deploy its nuclear-capable aircraft at domestic civilian airports. As a result, this crisis undermined the viability of "counterforce" strategy as a tentative agreement between the superpowers that encouraged them to regulate nuclear conflicts by spatially discriminating between "military" and "civilian" targets.[4] In the cultural history of nuclear weapons, then,

American citizens have been required to assimilate the consequences of the military colonization of space for their own mortality.

So far, this account has emphasized a particular scene: a nuclear blast that signals the onset of enemy attack and—perhaps—apocalyptic conflict. While this scene is understandably fetishized, its prominence in the American cultural imaginary is also misleading. There are other modes of nuclear space, and they are—for various reasons—less amenable to representation. These spaces include the domestic and international sites associated with the development, testing, manufacture, and deployment of nuclear weapons. Collectively, these sites constitute a global network of factories, laboratories, waste-storage facilities, military bases, and their surrounding communities. As scenes of industrial, scientific, and military operations, these spaces are alternately valorized, normalized, and obscured in cultural rhetoric. Although their activities occasionally satisfy the requirements of dramatic narrative, these spaces are intensively bureaucratic and mundane. They are characterized by complex and rational articulations of instrumental phenomena such as institutions, technologies, occupations and professions, regulations, policies and procedures, infrastructure, budgets, and oversight.[5]

To understand the rhetorical nature of these spaces, we must remember that nuclear weapons are capable of producing "effects" *whether or not they are actually used as military weapons.* That is, they are technological artifacts whose production requires the reconfiguration of space to serve military, scientific, and industrial goals. This process involves highly consequential—and often irreversible—material practices, including the appropriation, condemnation, and clearing of land; the exposure, displacement, and relocation of indigenous populations; the contamination and devastation of existing ecosystems; and the construction of facilities requiring significant reallocation of water and energy resources. The massive artificiality of this process is neatly captured by environmental historian Hal Rothman in his image of the wartime Los Alamos Laboratory as "cantilevered" and "grafted" onto the existing culture and environment of northern New Mexico.[6]

Mounting—and highly controversial—evidence has established that the nuclear industrialization of these spaces has created destructive and extremely long-lasting consequences for public health, worker safety, and the environment (for example, stemming from the release of radioactive materials into groundwater).[7] This evidence confirms the impossibility of "containing" the effects of nuclear weapons events. Instead, those effects evade control and circulate unpredictably within and across local commu-

nities, regions, and nations. The environmentalist colloquialism "Everything is connected" concisely expresses the sad wisdom arising from this ontological rupture. It suggests how nuclear spaces can be charged with both the ominous aura of illness, war, and death, and also with the material traces of production operations. While both sets of phenomena may create a sense of dread for inhabitants and visitors, the latter also creates unpredictable risk for their bodies.

So far, this account has not said much about rhetoric. Now that we have discussed different types of nuclear spaces, however, we can consider their articulation with discursive systems and practices. Here, two themes are prominent: (1) the role of Cold War rhetoric in containing the imagination and inhabitation of nuclear space, and (2) the dialectic of humane place and instrumental space that animates nuclear rhetoric.

In developing this first theme, we may begin with the work of Paul N. Edwards, whose history of computer technology characterizes Cold War containment as both foreign policy rhetoric and spatial phenomenon. Here, in assessing the United States' nuclear-strategic infrastructure, Edwards argues that "the Cold War can best be understood in terms of *discourses* that connect technology, strategy, and culture." That conflict, he argues, "was quite literally fought inside a quintessentially semiotic space, existing in models, language, iconography, and metaphor, embodied in technologies that lent to these semiotic dimensions their heavy inertial mass. In turn, this technological embodiment allowed closed-world discourse to ramify, proliferate, and entwine new strands, in [a] self-elaborating process."[8]

Here, Edwards echoes Jacques Derrida's argument that, because of their apocalyptic potential for materiality, nuclear weapons exist mostly *in and through rhetoric* (for example, of military war games).[9] As a partly imaginary space, the Cold War shaped, and was shaped by, the rhetoric and technology of nuclear defense. The interaction between these material and symbolic phenomena was shaped by the development of digital computing, whose rigorous, instrumental logics of calculation complemented the official U.S. vision of containment. In that vision, containment involved a dialectic of *protection* and *curtailment* practiced by the U.S. government on its Communist enemies, on its allies, on its domestic citizenry, and ultimately on the utopian global system fantasized as the outcome of U.S. victory. Achieving this victory, however, required the development of new means of integrating human and machine powers to defend national space against nuclear attack.

In this way, Edwards's history echoes an argument made by the cultural critic Paul Virilio: that, by creating a devastating threat that could be reliably

delivered against all defenses, the development of nuclear weapons trau-
matically compressed the phenomena of space and time for U.S. national-
security institutions.[10] Those institutions responded by constructing a mas-
sive apparatus of global surveillance and response. That apparatus would
defend the nation by producing continuous imagery that facilitated the re-
mote and timely sensing, targeting, and destruction of enemy forces. In the
postwar era, the militaristic imperatives of monitoring space, issuing com-
mands, and controlling threats subsequently fused as a context for nuclear
rhetoric.

William J. Kinsella has traced the legacy of the containment trope for
the relationship between the U.S. Department of Energy (DOE) and its
stakeholder audiences such as corporate contractors, government regula-
tors, and citizens living downwind and downstream from nuclear weapons
operations.[11] Specifically, Kinsella traces a history of "discursive contain-
ment," in which the possibilities for citizen participation in the DOE's
nuclear policy making have been constrained by the rhetorical boundary
work of its officials. Those officials have invoked, for example, the warrant
of secrecy to restrict *the circulation* of nuclear information within a nar-
row, authorized audience, and have controlled *the meaning* of that informa-
tion by asserting preferred frames of technical expertise. Discursive con-
tainment thus frames public participation as a potential hazard to official
interests that should be minimized and controlled. The range and quality
of rhetorical *voice* in the metaphorical space of nuclear deliberation are, as
a result, significantly attenuated.

This first theme establishes space as an object of material and rhetorical
practices organized under a specific metaphor. Our second theme, however,
depicts space more generally as both the context and effect of rhetorical
practices that embody the tension between official and popular interests.
Here, we may begin with philosopher Michael Perlman's argument that nu-
clear officials and citizens have constructed the spaces of nuclear weapons
development as—alternately—"places" and "sites." Perlman's use of these
terms encourages us to appreciate the rhetorically constructed relationships
between nuclear subjects and their locales.[12] For Perlman, "place" describes
the historical, aesthetic, and spiritual integrity of nuclear locations as ob-
jects of cultural memory (and thus also of rhetoric). Many nuclear spaces
are profoundly poignant and volatile places of memory. The premier ex-
ample is Hiroshima on the morning of August 6, 1945. Another example
that is domestic—and thus less openly acknowledged—involves the 1950s-
era backyards of southern Utah "downwinders." Here, Mormon children
played in the radioactive fallout from aboveground explosions of nuclear

weapons at the nearby Nevada Test Site.[13] Representations of these places, Perlman argues, are not easily controlled or consumed. "Site," alternately, designates the technocratic organization of space for the purposes of nuclear rationality. Here, the spiritual and historical dimensions of nuclear places are rhetorically evacuated by officials in order to secure them as objects for the exercise of power. The depiction of Russian cities in U.S. nuclear targeting plans as overlying, concentric circles, measuring population fatality rates from ground zero outward, forms one example.[14] Drawing on this work, I have argued elsewhere that the spaces of nuclear "home" and "field" are alternately linked and opposed in cultural rhetoric that represents the consequences of nuclear professionalism for cherished domestic and communal spheres.[15]

Other scholars have similarly focused on conflicts between indigenous cultures and ecosystems, and postwar national security imperatives that animate nuclear spaces. Art historian Peter Hales, for example, has critiqued the rhetoric of space associated with the Manhattan Project's three principal operations in New Mexico, Tennessee, and Washington.[16] At each of these locations, Hales argues, government officials distinctively conflated the discourses of militarism, bureaucracy, utopia, science, and industrial engineering. This conflation facilitated their use of rhetorical strategies such as *condemnation* (the evacuation of value to legitimate the seizure of property), *compartmentalization* (the containment of nuclear knowledge to preserve official secrets), and *encryption* (the neutralization of problematic nuclear meaning through the use of arcane codes and jargon). These strategies redefined communal spaces for the purposes of an emerging, authoritarian nuclear regime. Once restructured, those spaces mandated obligatory performances from their inhabitants of (self-) surveillance, security, loyalty, conformity, patriotism, and productivity. Hales's study thus establishes the role of rhetoric in conceptualizing space for nuclear-instrumental purposes. Once it is so conceptualized, space can be configured and administered as a technology to control the nuclear experiences and activities of its inhabitants.

In a related study, cultural anthropologist Valerie Kuletz has documented "mechanisms of exclusion" by which DOE officials and their contractors render invisible and silent the aboriginal inhabitants of lands (principally in the American West) designated for nuclear testing and waste storage.[17] These mechanisms, Kuletz argues, are both material and rhetorical. Regarding the latter, she identifies premises of nuclear colonialism and environmental racism that circulate in official discourses (such as epidemi-

ology), rhetorical texts (such as environmental impact statements), and forums (such as public hearings). These discourses consistently assert the authority and legitimacy of federal interests, marginalize the interests of native populations (for instance, regarding the sacred status of appropriated lands), and distort the consequences of nuclear operations for public health and the environment.

In a final study, also of the nuclear West, sociologist Matthew Glass documents a struggle conducted during the late Cold War by Nevada residents and officials against the U.S. government's planned basing of the MX missile system.[18] Glass's study is significant here because it refracts the cultural geography of the American West through Habermas's spatial model of the public sphere. In that model, the cultural lifeworld represents traditional social knowledge that frames citizen understanding of and participation in political deliberation. That space, according to Habermas, is continually threatened by systems of money and power that seek through "steering media" to transform the lifeworld from a resource for authentic deliberation (and thus potential resistance) to a system of predictable conformity. Here, Glass documents the unique coalition of groups (including ranchers, the Mormon Church, and Native American tribes) that organized to protest this basing scheme. He argues that their collective experience of place enabled their development of a uniquely regional and oppositional rhetoric that proved sufficient to discourage the U.S. military from pursuing this basing plan. Interestingly, this rhetoric did not match that of traditional antinuclear and environmentalist groups. Instead, it framed the MX basing plan as an unwarranted disruption of the integrity of this regional lifeworld (for example, disrupting private property ownership and land use). As a result, Glass's study suggests how, even as nuclear officials seek to standardize nuclear space, it persists as an unpredictable source of rhetorical invention and resistance.

We may draw two conclusions from the discussion thus far. The first involves the role of rhetoric in alternately constituting and distorting the social and political diversity associated with nuclear space. Although nuclear weapons promise to radically silence that polyphony, it is typically official rhetoric that strikes first, preemptively, to legitimate the production and use of nuclear weapons, to produce the appearance of popular consensus and support, and to quell dissent. Once subaltern and oppositional narratives have been cleared (or at least subdued), nuclear space is secured for official operations. Nuclear rhetoric, however, is ideologically promiscuous. It may also serve the interest of realigning voice and space: to protect what

is threatened by a nuclear defense, to restore dialogue that has been suppressed, and to call into being alternate nuclear audiences and modes of inhabitation.

The second conclusion involves the challenges posed for oppositional rhetoric by the daunting magnitude of nuclear space. As David Nye has argued, the development of nuclear weapons partly disrupted the tradition of the American technological sublime. It did so by threatening the security of a safe vantage point from which audiences could commune through rhetoric with awesome power while also fantasizing about its appropriation. "To anyone who contemplates them," Nye argues, "nuclear weapons can only be a permanent, invisible terror that offers no moral enlightenment."[19] Nonetheless, that cultural tradition also offered postwar officials a resource to frame the discovery and harnessing of nuclear energy as a grand triumph of human will and scientific ingenuity. Represented in this rhetoric, these events appeared to confirm divine favor and national exceptionalism, and inspired patriotic pride. Nuclear weapons were subsequently promoted in a volatile cultural spectacle mixing terror and reassurance. In these spectacles, "empty" and "useless" landscapes were conscripted for the inscription of "victimless" nuclear test detonations, and thus made to testify to national power. In postwar cultural rhetoric, the iconography of the mushroom cloud was articulated with more mundane phenomena such as beauty contests and car dealership promotions in a new grammar blending potency, patriotism, and commodity exchange. Even as they wrestled with growing ambivalence, American citizens were asked to trust that elite nuclear stewards would manage this glossy spectacle to ensure that it did not breach its staging and engulf its audience. That propaganda cloaked, however, a subsequent withering of the public sphere. The discursive space available for democratic deliberation of nuclear policy was narrowed to channel the force of an authoritarian technocracy.[20]

The Rhetoric of Nuclear Museums

I now turn to discuss a specific type of nuclear-cultural space: that of the museum. In this process, I conceptualize American nuclear museums as reflexive spaces of "entangled" rhetoric. I will address these two qualities in turn.

First, nuclear museums are *reflexive* spaces, in that their rhetoric simultaneously shapes visitors' understanding and inhabitation of multiple nuclear spaces. This effect is produced as museum rhetoric alternately *embodies* and *represents* distinct yet related nuclear spaces. Embodiment is achieved mate-

rially, in that many nuclear museums in the United States are located either on or near the past, present, and (planned) future spaces of nuclear weapons production. These spaces are alternately secured, monitored, contaminated, and forbidding. As a result, associated museums exploit the compelling authenticity of immediate place (in other words, the aura of historicity), but also invite visitor unease about uncontrolled contact with both ominous symbolism and residual radiation from weapons production operations. Here, the physical intransigence of ionizing radiation is a perceived risk which threatens to dissolve the boundary between original and "museumified" nuclear artifacts. If, as media ecologist Lance Strate argues, communication is less about the creation of ex nihilo meaning than about the mutation of material phenomena (for example, to produce "new" media formats),[21] then we may understand how nuclear museum audiences do not wish to be transformed too much, in the wrong ways. They would rather leave this nuclear text in place than have their bodies be materially enrolled in its expansion and circulation.

Second, American nuclear museums are spaces of *entangled* rhetoric, in that they uniquely configure the dense (and often agitated) relationships among the cultural discourses of nuclear history, memory, and heritage.[22] That is, the institutional rhetoric *of* nuclear museums (such as their exhibits) and stakeholder rhetoric *about* them (such as visitor evaluations of those exhibits) typically represent a heteroglossic mélange of discursive fragments. These interanimating fragments (such as factual claims, vivid impressions, official rationalizations, and utopian visions) are drawn from rhetors' interaction with three evolving genres. The first genre involves formal, professional, and evidence-based arguments about the past (history). The second involves partial and interested recollections of the past that are performed by both individuals and groups as authenticity (memory). The third involves the advocacy of popular movements that are concerned with preserving and interpreting the past during periods of intensive change (heritage).

Historically, the interaction between these genres has been shaped by the competition between two master-ideological narratives of American nuclear culture. This competition shapes all aspects of the nuclear museum as a rhetorical site, ranging from its members' collection, selection, and display of artifacts, to the design, construction, and promotion of exhibits, and, finally, to include the interpretive practices of museum visitors as they reconcile these texts with their "excess" lived experience of nuclear space. These two master narratives represent highly opposed and moralized orientations to the figures, events, institutions, technologies, and poli-

cies constituting nuclear history; each is capable of inspiring deep identification by audiences. In the first, dominant narrative promoted by Cold War patriots, the Bomb is depicted as a heroically constructed technology that was justly used against a vicious wartime enemy, that successfully inhibited Soviet expansionism during the Cold War, and that is still required to deter evolving threats to U.S. national security. In a second, less-popular, but also persistent narrative (promoted, for instance, by New Left historians and antinuclear activists), the Bomb is framed as an unnecessary (and perhaps barbarous) device whose wartime use against Japan commenced a profoundly irrational and dehumanizing chapter in the evolution of military strategy and international politics, and whose compulsive production has significantly damaged the global economy, public health, and the environment.

Subsequently, within the reflexive and entangled space of the nuclear museum, powerful cultural myths about science, technology, and the nation-state are promoted, negotiated, and contested via the rhetorical configuration of nuclear-historical, memory, and heritage discourses.[23] By exhibiting and framing nuclear artifacts, nuclear museums make nuclear-ideological narratives visible and discussable. By attributing responsibility for related events to various figures and institutions, they *inevitably* reproduce nuclear-cultural politics. By representing actual nuclear pasts and potential nuclear futures, their rhetoric evokes visceral feelings of pride, reassurance, awe, fear, and resentment in their audiences.[24] By instructing visitors in what to believe about, and how to feel and act toward, nuclear weapons institutions, these museums model nuclear comportment—and perhaps consent.

Historically, the rhetoric of American nuclear museums has accommodated—if not endorsed—the preferred narratives of its institutional patrons, including the federal agencies and military services who have overseen the development and use of nuclear weapons, and the corporate contractors who have been profitably employed in the manufacture of nuclear warheads and their associated "delivery systems"—and increasingly in the cleanup of related environmental contamination. In his late–Cold War assessment of these museums, Peter Kirstein described their rhetoric as "border[ing] on overt propaganda" in its demonization of the Soviet Union, its uncritical endorsement of the motives and operations of U.S. defense institutions, and its sanitizing of the consequences of nuclear weapons development and use.[25] This conclusion is supported by my own studies[26] indicating that American nuclear museum rhetoric typically emphasizes the national identity themes associated by historian Tom Engelhardt with U.S. "Victory Culture,"[27] including *progress, virtue, humility, rationality, innocence, strength,*

safety, and *control.* These themes predominate over problematic—and thus stigmatized—alternatives arising from the surplus experience of actual nuclear history, including *stasis, irrationality, guilt, weakness, arrogance, failure, danger, death,* and *chaos.*

In this process, American nuclear museum rhetoric has promoted the interests of particular groups (such as national security officials and corporate contractors) over their competitors. Two groups that have traditionally been marginalized in this process include: (1) environmentalists, manifest in museums' reluctance to critically depict issues of capacity, safety, and political opposition surrounding the generation of radioactive waste, and the related development of storage facilities;[28] and (2) the actual and potential victims of nuclear weapons development and use, manifest in an ongoing, convulsive struggle over museum exhibition of images and stories about their affected bodies and places.[29]

The marginalized interests of these groups evoke alternate rhetorical frames that reorient museum visitors to the phenomena of nuclear place. Potentially, these frames can restore a spatial sense of *connection*—and perhaps *identification*—between audiences in the United States and other social groups and life forms, including U.S. citizens affected by radioactive fallout from weapons testing,[30] nations seeking to develop their own nuclear weapons programs, and migrating species that spread radioactive contamination. These frames suggest that it is neither accurate nor sustainable for museum audiences to relegate the consequences of nuclear weapons development to the past, or to safely remote spaces. Instead, their rhetoric inconveniently restores the phenomena of nuclear weapons production to local and regional sites that may be uncomfortably familiar to those audiences.

Nuclear Museum Rhetoric in the Post–Cold War Era

I now turn to the question of how American nuclear museum rhetoric has evolved in the post–Cold War era—a period filled with turbulent developments that have both preserved and transformed key elements of the nuclear condition. Specifically, I argue that nuclear museums in the United States are currently faced with the rhetorical challenge of managing evolving nuclear ambivalence among their audiences and patrons.[31] As forces shaping that ambivalence, revived critiques of nuclear weapons as dangerous, useless, and illegitimate (combined with new claims that they are now anachronistic) compete with a powerful, residual Cold War fetish of those weapons as effective, necessary, and legitimate (that is, when exclusively possessed by the United States). In this process, nuclear museum rhetoric

advances a precarious post–Cold War project characterized by cultural anthropologist Joseph Masco as "radioactive nation-building." In this project, emerging cultural understandings of the "repressed spaces within nuclear modernism" interact with institutional reform and rhetorical revision deemed necessary by officials to serve the nation in a changing security environment.[32]

Available space does not permit a complete review of how post–Cold War developments have affected the perceived value of nuclear weapons for U.S. foreign policy and military strategy.[33] One relevant development for nuclear museums in the United States, however, involves the mixed legacies stemming from scandalous revelations, beginning in the late–Cold War era, of massive failures in the DOE's nuclear weapons production complex.[34] For five decades, the facilities in this complex prioritized the production of nuclear weapons over the interests of public health, worker safety, and the environment. During the 1980s and 1990s, however, the repressed legacies of those operations returned to national consciousness through images and stories promoted by institutional whistle-blowers and outraged stakeholders, subsequently appearing in media outlets. That coverage depicted absurd and tragic scenes such as blasted radioactive desert landscapes and corroding barrels of radioactive waste exposed to the open air. It emphasized the traumatized bodies of citizen downwinders, of nuclear workers exposed to occupational hazards while handling toxic and radioactive materials, and of the unknowing victims of covert medical experiments conducted using radioactive materials. These events were also represented in the rhetoric of congressional inquiry and related lawsuits. Collectively, this discourse attributed these scandals to a nuclear-institutional culture marked by arrogance, secrecy, and the "capture" of federal regulators by the interests of corporate contractors. This scandal led to a traumatic cultural shift in these institutions, involving (at least temporarily) increased openness, accountability, and public involvement in the planning of some operations. It also led the DOE to undertake a large, complex, and expensive remediation of environmental contamination generated by Cold War–era weapons production, including the containment and disposal of related wastes.

These developments obviously implicated the rhetoric of existing nuclear museum exhibits. As a result, these institutions responded to changing viewer expectations by incorporating—to various degrees—the images and narratives of groups that had been historically affected by these events. At the new Atomic Testing Museum in Las Vegas, for example, that institution's director recently attempted to disarm protestors by inviting them to join in its opening ceremonies and to use the facility as a forum for

their public events. Its exhibit materials include debates about the historical risk posed to public health by operations conducted at the nearby Nevada Test Site. Significantly, however, these partial concessions are overshadowed by—in the words of one observer—the institution's predominant "baldly neoconservative stance on the nuclear legacy"; representation of the Native American nuclear experience is completely absent.[35]

Additionally, cultural commemoration surrounding the fiftieth anniversary of the end of World War II proved to be a powerful source of controversy for those facilities. This controversy was most prominent at the Smithsonian Institution's National Air and Space Museum, located in Washington, D.C. There, curators proposed an exhibition of the *Enola Gay* aircraft that had dropped the first atomic bomb on Hiroshima. The curatorial narrative contained in that proposal was relatively comprehensive, if not detached, and sought to demonstrate the immediate and long-term results of that event. Its proposed use of images and stories associated with affected Japanese, however, enraged powerful military and political interests. Those groups subsequently mobilized American World War II veterans, and pitted their passionate memories against the museum's reputation. The resulting cancellation of the proposed exhibit, and its replacement with one more palatable, arguably constituted a tragedy of political censorship.[36] A related, comparatively minor, controversy occurred during the same period at the Los Alamos Bradbury Science Museum.[37] That controversy demonstrated how nuclear museum officials can employ objectivist historical discourse to marginalize oppositional narratives. There, Los Alamos officials demanded that an antinuclear group seeking to mount a "counter-exhibit" in the Bradbury Museum (that is, one that would critique and revise the museum's narrative of nuclear history) conform its text to the presumably consensual "facts" of nuclear history. This controversy suggested that opponents of traditional nuclear museum rhetoric are most effective (and controversial) when they expose and challenge the taken-for-granted processes by which apparent "facts" are selected, interpreted, and represented as evidence for claims.

These post–Cold War developments have dramatically affected the relationships between space and memory that animate the rhetoric of American nuclear museums. I discuss below three notable trends.

The first involves *the emergence of new "stakeholder" identities and narratives in nuclear museum rhetoric.*[38] These phenomena are "new" only in the sense that recent institutional changes have created increased opportunities for their expression in official forums of nuclear decision making. Inclusion of these groups in these forums has created precedents for Ameri-

can nuclear museums to initiate or increase consideration of their interests in the exhibit-development process. Three principal groups here include: (1) community members and their governments affected by the local and regional contamination of air, soil, and groundwater; (2) current and former employees of nuclear weapons production facilities (and also their surviving friends and family members) who urgently seek information about their exposure to workplace hazards and their subsequent risk of illness and death, as well as compensation for their related suffering and loss; and (3) indigenous groups (particularly Native Americans) voicing a history of exploitation, both as uranium mine workers and as the inhabitants of tribal lands appropriated for the siting of facilities.

Significantly, the narratives of these three groups do not conform to traditional conceptions of "pro-" and "anti-"nuclear rhetoric. Alternately, they express more nuanced and conflicted conditions of American nuclear ambivalence. In communities surrounding the DOE's Fernald, Ohio, facility, for example, workers and residents have expressed anger toward the irresponsible historical practices of corporate contractors, while patriotically endorsing the mission of nuclear weapons production.[39] In northern New Mexico, indigenous groups struggle to reconcile the concrete benefits of economic development surrounding the postwar growth of the Los Alamos Laboratory with its distortion of the familiar landscape.[40] And in Oak Ridge, Tennessee, the traditional culture of nuclear exceptionalism has paradoxically inspired some residents to view environmental and health activism as consistent with civic pride.[41]

This development is spatial in that it transforms the cognitive maps used by American nuclear museum officials to imagine their local and regional communities as a source of both visitors and "program content." As such, it encourages museum officials to build and maintain coalitions with these stakeholders. These coalitions—and the rhetoric that they produce—tremble, however, under the weight of multiple, conflicting stories. The form and content of that rhetoric (for example, the configuration of competing narratives in exhibition space) are subject to visceral judgment by the members of these groups, and by visitors sympathetic to each of their interests. This condition may lead nuclear museums to adopt innovative exhibition formats that embrace the productive tensions of mutually relativizing voices. One example involves the Los Alamos Bradbury Science Museum, where candidate groups may apply to participate in a lottery awarding them access to a dedicated space in that facility for mounting temporary, alternative exhibits. This trend is not universal, however. The controversy surrounding the Smithsonian's *Enola Gay* exhibit suggests that—

depending on situational elements such as exhibition timing and goals, venue location and reputation, stakeholder interests, and global political and military events—American nuclear museum rhetoric continues to be disciplined by the potent orthodoxy of Cold War triumphalism.[42]

A second trend involves *a struggle for control over the post–Cold War narrative of nuclear memory,* conducted between U.S. nuclear officials and their stakeholders. This struggle arises through rhetoric interpreting the nature and "legacies" of Cold War weapons production. Here, critics have analyzed how initial post–Cold War publications by the DOE depicted the controversial history of those operations as an imminent "closed circle."[43] Through use of this image, the agency implied that this cycle would be terminated—and its effects "contained"—through the successful remediation of environmental contamination. In this process, the DOE auditioned for institutional redemption by adopting a rational, resolute, open, accountable, and fiscally responsible persona.

This rhetoric was fraught with tension, however. Temporally, it banished the phenomena of militarism and environmental exploitation to the past. Spatially, it both alerted and reassured American audiences about risk associated with their proximity to nuclear weapons production activities, and suggested that, with the appropriate support, institutional authorities and technological solutions could enclose and subdue threats to public health. Yet this rhetoric also minimized contradictory and inconvenient phenomena, such as the DOE's deeply ingrained preference for unilateral communication, its simultaneous preservation of the existing nuclear arsenal, its plans to revive "new" nuclear weapons production, and the staggering challenges associated with the completion and "long-term stewardship" of environmental cleanup.[44] Arguably, this rhetoric distorted audience understanding of the nuclear condition, and the consequences of continued nuclear weapons development for future generations. As a result, even as it invited greater public participation in policy development, this rhetoric foreshadowed the resumption of nuclear-institutional secrecy and security—and the constriction of deliberative space—that would follow the terrorist attacks of September 11, 2001.[45]

Most relevant for our purposes, this struggle has circulated in and around the space of American nuclear museums. Elsewhere, Brian Freer and I have analyzed rhetoric surrounding a recent attempt to build a coalition of stakeholders endorsing an official historical account of the DOE's Hanford (Washington) facility[46]—a site where heritage groups currently seek to develop a decommissioned nuclear production reactor as a museum. Unfortunately, this attempt devolved into a struggle between contractors affiliated

with the interests of industrial heritage and scholars affiliated with interpretive and critical epistemologies. This struggle played out as the two groups argued over the selection and application of criteria used to produce and evaluate historical narrative, and over procedures for incorporating stakeholder "feedback" in official texts. In a related study of the DOE's Rocky Flats (Colorado) facility, environmental journalist Len Ackland has identified two opposing narratives of commemoration surrounding its recent demolition and closure. The first is a celebratory narrative depicting its workers as Cold War production—and post–Cold War cleanup—"heroes." The second is a narrative of "Insane Risk" held among antinuclear activists, and depicting those workers as "at best, pawns in the risky deadly chess game" of nuclear deterrence. In response, Ackland has proposed a third narrative of "Shared Responsibility" that would transcend the self-congratulation and Other-demonization displayed by the first two. Ideally, this narrative will encourage U.S. citizens to acknowledge their historical consent to nuclear weapons production, and their abdication of political agency to the workers who served as their proxies. In turn, those workers could acknowledge the risks created by their actions for their own safety, for public health, and for the environment. Most relevant for this essay, Ackland identifies the best possible site for the development of this narrative as a museum currently proposed for the Rocky Flats site.[47]

One implication of these studies is that critics should examine how American nuclear museum rhetoric influences audience understanding of the relationship between the "first" (that is, Cold War) and "second" (post–Cold War) nuclear ages.[48] Problematically, this rhetoric may depict the *completion* and *transcendence* of Cold War nuclear phenomena (such as exaggerated threat-assessment), while simultaneously promoting their *continuity* and *renewal*. In this critique we may better grasp how museum rhetoric articulates space and time in the service of nuclear politics. Here, for example, critics can focus on how museum officials conceptualize and manage networks of stakeholder groups as spatial phenomena (for example, in deciding who deserves "a seat at the table" of exhibit development).

As a final trend, we may consider *the recent emergence in U.S. culture of a nuclear heritage apparatus*. Elsewhere, I have discussed this development as part of a larger post–Cold War aesthetic of "repurposing," in which "icons of the Cold War nuclear system are currently being condemned, dismantled, recycled, commodified, and memorialized. This process involves distinct but related modes of transformation. As some of these icons are re-fashioned to assume new material forms, their symbolic meanings are also rearticulated. Potentially, the relationship between their old and new

forms generates reflection about the post–Cold War trajectories of the nuclear system."[49]

The rhetoric of the emerging post–Cold War nuclear heritage apparatus articulates a variety of discursive and nondiscursive phenomena.[50] These include: *bodies* (for example, of female hostesses at heritage events[51]); *sites* (for instance, of nuclear testing); *markets* (such as school district field trips); *institutions* (such as visitors centers); *social and occupational groups* (such as tour operators); *professional identities* (for example, "cultural resource managers" employed by DOE contractors occupying former tribal lands); *artifacts* (such as decommissioned structures and equipment); *promotional media and genres* (such as commercial Web sites and travel journalism); and finally, *interpretive practices* (ranging from dutiful visitor pilgrimages to adventurous "hacking" of secure abandoned facilities).

The configuration of these elements produces texts and contexts of American nuclear rhetoric. This rhetoric is polysemic—it shapes but cannot determine its reception by nuclear audiences, who bring complex affect-laced agendas mixing trauma, regret, anxiety, curiosity, detachment, pride, and enthusiasm. This rhetoric is significant in that it develops various types of relationships between cultural subjects and the imagined and actual spaces of nuclear weapons development. These relationships evolve as museum rhetoric organizes and disrupts its audience members' experience of motion, travel, journey, exploration, discovery, and encounter in nuclear spaces.

Two examples may illustrate this rhetorical accomplishment. The first involves the work of Canadian communication scholar Peter van Wyck, who has modeled how a postmodern, counter-hegemonic nuclear tourism might manifest in that nation.[52] There, van Wyck has traveled and documented a historical "Highway of the Atom" whose route connects a vast "inter-jurisdictional industrial-military complex." This complex extends from remote provincial sites where indigenous groups mined fissile materials before and during World War II, across the world to Hiroshima, where their refined product was delivered. Potentially, Canadian audiences for this work may progressively reimagine their shared nuclear space—and their spatial relationships to other nuclear-national groups. Its implications for the design rhetoric of an American nuclear museum exhibit seem clear.

The second example involves structures of navigation encoded in commercial multimedia CD-ROMs and Web sites that rhetorically shape audience knowledge of American nuclear space and memory. These structures evoke questions such as: What are the boundaries of virtual nuclear spaces? How are they organized as narrative places? How should critics

evaluate the relationship between nuclear space and intertextuality developed in the hypertextual formats of new media?[53] Len Ackland's "Rocky Flats Virtual Museum" Web site offers one text for consideration.[54] This site depicts the significance of spatial relations surrounding a dangerous fire that erupted at that facility on May 11, 1969. The site's rhetoric moves its visitors across spatial boundaries and scales associated with this event, ranging from the micro-local interaction between plutonium and oxygen that spontaneously combusted industrial rags, to the facility's interlinked ventilation and manufacturing systems that malfunctioned, feeding and circulating the fire, to a fireman who accidentally resolved this malfunction by backing his truck into an outside power pole, and finally to the plant's regional proximity to the city of Denver. Concerning this final metropolitan scale, the site displays subsequent testimony by a U.S. military official that "If the fire had been a little bigger . . . hundreds of square miles could [have been] involved in radiation exposure and involve[d] cleanup at an astronomical cost as well as creating a very intense reaction by the general public exposed to this." Here, Web-based museum rhetoric depicts the history of U.S. nuclear weapons production as interrelated scales of space to create a moralized narrative place of fallibility, vulnerability, black comedy, and nearly averted tragedy. It suggests how official fears about a material breach of containment in nuclear-industrial space were tied metaphorically to fears of a ruptured nuclear-public sphere (that is, "a very intense reaction" that would include oppositional rhetoric). Potentially, this rhetoric encourages audiences to question the development and administration of those spaces—historically, currently, and in the future.

Significantly, the post–Cold War U.S. nuclear heritage apparatus is not centrally organized or consistently funded. Instead, enterprising stakeholders at dispersed former weapons production facilities have responded to the closeout of their Cold War mission by developing and marketing projects such as museums.[55] They have worked to rescue local structures from the destruction of environmental cleanup, to collect the oral histories of aging and ill figures, and to develop mutually beneficial relationships with federal, nonprofit, and private-sector patrons.[56] If they are successfully developed, these proposed museums will join established facilities such as the National Atomic Museum in Albuquerque, New Mexico, and newcomers such as the Atomic Testing Museum and the Weldon Spring (Missouri) Site Interpretive Center.

In their development, these museums draw on—and modify—particular scenic features of the post–Cold War American nuclear landscape.[57] As dis-

cussed above, these features create a material resource that operates rhetorically on visitors' thoughts, feelings, and bodies, orienting them to the vast scales of space and time implicated by nuclear operations. These effects are alternately mundane, sublime, morbid, and absurd. They occur in and around visitor experiences at anticlimactic demolitions of structures at decommissioned facilities; at decrepit tombs of abandoned facilities (such as ICBM silos); at desolate and toxic landscapes created by weapons testing; at the sites of civil defense relics (such as bomb shelters); at monuments to nuclear command and control systems (such as antiaircraft missile installations); and at vast underground complexes for waste storage and remote war-fighting (such as the North American Aerospace Defense Command outside of Colorado Springs). For visitors, the significance of the artifacts displayed in these scenes arises as the artifacts materialize oppositions and paradoxes characterizing the nuclear activities that they facilitate. These thematic tensions include those between the conditions of life and death; offense and defense; security and insecurity; compartmentalization and integration; authority and democracy; routine and surprise; control and chaos; visibility and invisibility; and speech and silence. Nuclear rhetorical artifacts, in other words, speak both *in* and *of* their associated places, and also *of* and *to* public nuclear memory as an evolving cultural narrative. This condition is eloquently captured in Peter van Wyck's critique of instrumental rhetoric planned for an official, permanent warning marker located at the DOE's (radioactive) Waste Isolation Pilot Plant, located near Carlsbad, New Mexico:

> The future witness to [this] monument is called upon to understand only the site itself—not the reason that the wastes are there, not the reason that the wastes came to be wastes, and certainly not any sense of how we as *de facto* authors and custodians of this waste might feel about having been responsible in various measures for producing it. Nothing, in other words, that might convey the basic truth that were we to reflect upon it, we could only feel a profound shame and sorrow with respect to a toxified present *and* future. What remains at a distance in all of this is that the disaster is not in the future; it has already happened.[58]

Within the national space of the U.S. nuclear heritage apparatus, different museums find themselves differently positioned. In particular, new and existing museums that are not associated with original Manhattan

Project sites struggle for resources. This is because, in the nuclear-cultural imagination (and thus in the estimation of potential donors and sponsors), the wartime history of those facilities possesses considerable cachet. They are landmarks on the nation's preferred cognitive map of nuclear history. Their aura is stoked by tributes that persistently highlight the elite figures (such as Robert Oppenheimer[59]), professional communities (such as nuclear physicists), sites (such as Los Alamos), and events (such as the Trinity Test) associated with *scientific* research and development of nuclear weapons during World War II. To date, this condition has encouraged rhetors to minimize less glamorous but equally important stories involving the "hard hats and smokestacks" of other industrial facilities (located, for example, in Paducah, Kentucky). In the dominant narrative of nuclear heritage, these facilities are taken for granted as mundane infrastructure for attaining the glorious goals of national security.[60] In the rhetoric of some local heritage movements, however, they are being revised as "battlegrounds of the Cold War."[61] If successful, this rhetoric would transform the cultural maps of American nuclear-historical space.

In conclusion, the emergence of new stakeholder identities, the ongoing struggle for control of the nuclear-historical narrative, and the growth of a nuclear heritage apparatus all shape the texts and contexts of American nuclear museum rhetoric in the post–Cold War era. These conditions encourage museums to represent nuclear place and memory in new ways, and also to be themselves rearticulated in evolving nuclear-cultural geographies. What is at stake in this process is nothing less than the hegemonic structures of knowing, feeling, and acting that mediate nuclear governance and citizenship in a chaotic age of evolving national security threats (such as proliferation and terrorism) and strategic responses (such as preemptive war).

Coda: A Dream of the Nuclear Museum

It is night in the nuclear museum.

The season is autumn, and the mob of summer tourists is gone. In their place, during the day, comes a steady stream of schoolchildren, talking loudly, laughing, and misbehaving. Herded by their teachers from one exhibit to the next, the children seem alternately bored, disdainful, fascinated—and a little scared—by what they learn. Their noisy activity is balanced by the solemn dignity of retirees, who arrive in RVs with license plates from distant states. The men wear caps emblazoned with the names

of the World War II units they served in. Their wives wear sensible shoes. They lightly hold each other's arms as they work their way through the galleries, remembering. Occasionally, a local employee or resident comes in from the street. "I had no idea!" they are sometimes heard to say.

But now it is night again in the nuclear museum, and the artifacts have stepped out from their displays for a conversation. Nothing formal, really. More for the company than anything else. After a long day of being looked at and talked about, it feels nice to touch base. These are such confusing times, after all.

Tonight, Robert Oppenheimer's statue is sitting on the ledge of its display platform. His emaciated face is pale and melancholy. He crosses his long legs and lights his pipe. "I once said that the nuclear superpowers were like two scorpions trapped in a bottle," he muses, puffing. "Who knew you could get this many scorpions in a bottle?"

"North Korea and Iran wouldn't have happened if we'd had better security at Los Alamos!" snaps the statue of U.S. Army general Leslie Groves. "You wanted *openness*. Look where *that* got us!" He scowls at the paunch straining against his starched uniform. His voice turns wistful: "What I wouldn't have given to supervise the reconstruction of the Pentagon . . . It was *my* building, you know."

On the other side of the room, a Japanese child shares the contents of her lunchbox with an American sailor. The surface of her body is divided down the middle. On one side, the skin is smooth and unblemished. On the other, it is charred black. The sailor accidentally drops his fork, and apologizes for the clumsiness of his burned and mangled arms.

"*Kamikaze*," he explains to the child. "I hear your people called them 'The Divine Wind.'"

A passing fireman from Chernobyl bends down, coughing. He picks up the fork, smiling to reveal bleeding gums, and hands it back to the sailor.

In a third group, an antinuclear activist and a former weapons production worker are sharing a six-pack of beer. The worker is adjusting the tube leading to his nose from an oxygen tank. The activist wipes her hand across her mouth and points at the tank.

"Chronic beryllium disease?" she asks.

"Yep," the worker replies. He looks at the label on the beer bottle. "Did you know that the ceramics division of the Coors Company did fabrication work for the plutonium 'pits' made at Rocky Flats?"

The activist nods. She is silent for a moment, and then asks, "Any word from the government on your benefits claim?"

The worker frowns and looks away into the distance. He shakes his head.

On the wall behind them, scenes from the 1959 Hollywood film *On the Beach* flicker on a large screen. In these scenes, the film's Australian characters are anticipating their imminent deaths from the slowly approaching radioactive fallout from a global nuclear war. Deciding to end things on his own terms, a bon vivant played by Fred Astaire drives his race car over a cliff.

Two figures—a Pakistani nuclear scientist and a Swiss customs agent—briefly watch the film without interest. They return to negotiating a bribe for the customs agent. After the men agree on a price, the customs agent authorizes the illegal shipment of gas centrifuge components. The shipment will travel from an industrial firm located in Zurich to a medical research company (that is really something else), located in Tripoli.

The night passes.

In the morning, the museum's custodian enters to clean the gallery. He pushes a cart holding a trash barrel, a vacuum, and cleaning supplies. He likes the quiet of the museum early in the morning, before it opens and the visitors arrive. As he does every morning, he begins by walking the floor, bending down to pick up the waste and belongings left behind by visitors: empty soft drink cans, wads of chewing gum, the occasional wallet.

On this morning, however, he finds a sheet of paper lying flat in the center of the gallery floor. He picks it up, surprised at the thickness of its bond. It is smooth and strangely warm to the touch.

As he looks at the sheet, the custodian notices that it contains no identifying information, no title or heading. Only handwriting, in dark red ink.

The writing contains three questions. They are precisely phrased and numbered, as if for a discussion agenda:

1) How do museums represent the places of nuclear weapons design, production, testing, deployment, and use?

2) How do they depict the diverse voices associated with developing, inhabiting, destroying, restoring, and remembering nuclear places?

3) How can museum rhetoric articulate nuclear places and memories to serve a robust nuclear democracy?

The custodian scans these questions, and briefly considers them. He sighs and shakes his head. Maybe the museum director left it behind, he thinks. Or that student from the university, the one who was taking notes yesterday on the exhibits.

The custodian looks at the sheet of paper. He looks at the trash barrel on his cart. The gallery suddenly seems very quiet, and he feels uneasy, as if he is being watched. He looks around at the exhibits and chides himself for being foolish. Someone has moved the Oppenheimer statue again, he notices. I'll have to replace that bolt to the platform, he thinks, and adds this to his mental list of projects.

He carefully folds the sheet of paper and puts it in his pocket. I'll ask around, he thinks, in case anyone knows who it belongs to.

Notes

1. See Matt Wray, "A Blast from the Past: Preserving and Interpreting the Atomic Age," *American Quarterly* 58 (2006): 467–83, esp. 473–77; and Mark Williams, "On Display: The Unthinkable," *Technology Review,* July 2005, http://www.technologyreview.com/read_article.aspx?id=14612&ch=energy.

2. Bryan C. Taylor, " 'The Means to Match Their Hatred': Nuclear Weapons, Rhetorical Democracy, and Presidential Discourse," *Presidential Studies Quarterly* 37 (2007): 667–92.

3. Catherine Lutz, *Homefront: A Military City and the American Twentieth Century* (Boston: Beacon, 2001), pp. 88–94.

4. Lawrence Freedman, *The Evolution of Nuclear Strategy* (New York: St. Martin's Press, 1981), 220; Richard Rhodes, "Annals of the Cold War: The General and World War III," *New Yorker* (June 19, 1995): 47–48, 53–59.

5. See Robert Del Tredici, *At Work in the Fields of the Bomb* (New York: Harper and Row, 1987).

6. Hal Rothman, *On Rims and Ridges: The Los Alamos Area since 1880* (Lincoln: University of Nebraska Press, 1997).

7. Arjun Makhijani, Howard Hu, and Katherine Yih, *Nuclear Wastelands: A Global Guide to Nuclear Weapons Production and Its Health and Environmental Effects* (Cambridge, MA: MIT Press, 1995).

8. Paul N. Edwards, *The Closed World: Computers and the Politics of Discourse in Cold War America* (Cambridge, MA: MIT Press, 1997), 120. Emphasis added.

9. Jacques Derrida, "No Apocalypse, Not Now (Full Speed Ahead, Seven Missiles, Seven Missives)," *Diacritics* 14 (1984): 20–31; David Cratis Williams, "Nuclear Criticism: In Pursuit of a 'Politically Enabling' Deconstructive Voice," *Journal of the American Forensic Association* 24 (1988): 193–205.

10. Paul Virilio, *War and Cinema: The Logistics of Perception,* trans. Patrick Camiller (New York: Verso, 1989).

11. William J. Kinsella, "Nuclear Boundaries: Material and Discursive Containment at the Hanford Nuclear Reservation," *Science as Culture* 10 (2001): 163–94.

12. Michael Perlman, *Imaginal Memory and the Place of Hiroshima* (Albany: State University of New York Press, 1988).

13. Carole Gallagher, *American Ground Zero: The Secret Nuclear War* (Cambridge, MA: MIT Press, 1993).

14. Fred Kaplan, *The Wizards of Armageddon* (New York: Simon and Schuster, 1983).

15. Bryan C. Taylor, "Home Zero: Images of Home and Field in Nuclear-Cultural Studies," *Western Journal of Communication* 61 (1997): 209–234.

16. Peter B. Hales, *Atomic Spaces: Living on the Manhattan Project* (Urbana: University of Illinois Press, 1997).

17. Valerie L. Kuletz, *The Tainted Desert: Environmental Ruin in the American West* (New York: Routledge, 1998).

18. Matthew Glass, *Citizens against the MX: Public Languages in the Nuclear Age* (Urbana: University of Illinois Press, 1993).

19. David E. Nye, *American Technological Sublime* (Cambridge, MA: MIT Press, 1994), 253.

20. For general discussions of the postwar cultural assimilation of nuclear weapons, see Paul Boyer, *By the Bomb's Early Light: American Thought and Culture at the Dawn of the Atomic Age* (New York: Pantheon Books, 1985); and Spencer Weart, *Nuclear Fear: A History of Images* (Cambridge, MA: Harvard University Press, 1988). For specific discussions of nuclear testing, see Peter B. Hales, "The Atomic Sublime," *American Studies* 32 (1991): 5–32; and Scott Kirsch, "Watching the Bombs Go Off: Photography, Nuclear Landscapes, and Spectator Democracy," *Antipode* 29 (2002): 227–55.

21. Lance Strate, "Narcissism and Echolalia: Communication and the Construction of a Sense of Self," Colloquium for the University of Colorado-Boulder Department of Communication, March 14, 2007.

22. I affiliate here with the editors' characterization, contained in this volume's introduction, of Marita Sturken's argument: While history and memory may be heuristically distinguished as rhetorical genres, their textual manifestations are, in practice, inevitably multivocal, embodying dialogic responsiveness among and between the respective utterances and statements of those generic resources. For further discussion of these genres and their constitution of nuclear rhetoric, see Bryan C. Taylor, William J. Kinsella, Stephen P. Depoe, and Maribeth S. Metzler, "Nuclear Legacies: Communication, Controversy, and the U.S. Nuclear Weapons Production Complex," *Communication Yearbook 29,* ed. Pamela Kalbfleisch (Mahwah, NJ: Lawrence Erlbaum, 2005), 363–409,

esp. 391–97. For further discussion of museums as the sites of the confluence of history, memory, and heritage discourses, see Tamar Katriel, "'Our Future Is Where Our Past Is': Studying Heritage Museums as Ideological and Performative Arenas," *Communication Monographs* 60 (1993): 69–75; Susan A. Crane, "Memory, Distortion, and History in the Museum," *History and Theory* 36 (1997): 44–63; and Benedict Giamo, "The Myth of the Vanquished: The Hiroshima Peace Memorial Museum," *American Quarterly* 55 (2003): 703–728.

23. Howard Learner, *White Paper on Science Museums* (Washington, DC: Center for Science in the Public Interest, 1979); Michael McMahon, "The Romance of Technological Progress: A Critical Review of the National Air and Space Museum," *Technology and Culture* 22 (1981): 282–96; Arthur Molella, "Exhibiting Atomic Culture: The View from Oak Ridge," *History and Technology* 19 (2003): 211–26.

24. Barbara Kingsolver, *High Tide in Tucson: Essays from Now or Never* (New York: HarperPerennial, 1995), 220; David Wojnarowicz, *Close to the Knives: A Memoir of Disintegration* (New York: Vintage Books, 1991), 36–37.

25. Peter N. Kirstein, "The Atomic Museum," *Art in America* 71 (June 1989): 45–57. See also Hugh Gusterson, "Nuclear Tourism," *Journal for Cultural Research* 8 (2004): 23–31, esp. 24.

26. Bryan C. Taylor, "Make Bomb, Save World: Reflections on Dialogic Nuclear Ethnography," *Journal of Contemporary Ethnography* 25 (1996): 120–43; "Revis(it)ing Nuclear History: Narrative Conflict at the Bradbury Science Museum," *Studies in Cultures, Organizations and Societies* 3 (1997): 119–45; and "The Bodies of August: Photographic Realism and Controversy at the National Air and Space Museum," *Rhetoric and Public Affairs* 1 (1998): 331–61.

27. Tom Engelhardt, *The End of Victory Culture: Cold War America and the Disillusioning of a Generation* (Amherst: University of Massachusetts Press, 1998).

28. John May, *The Greenpeace Book of the Nuclear Age: The Hidden History, the Human Cost* (New York: Pantheon, 1989).

29. Bryan C. Taylor, "Shooting Downwind: Depicting the Radiated Body in Epidemiology and Documentary Photography," in *Transgressing Discourses: Communication and the Voice of Other*, ed. Michael Huspek and Gary Radford (Albany: State University of New York Press, 1997), 297–328; "Nuclear Pictures and Meta-Pictures," *American Literary History* 9 (1997): 567–97; and "Bodies of August."

30. "In a preliminary study that takes into account not only nuclear tests in Nevada but also nearly all American and Soviet nuclear tests conducted overseas until they were banned in 1963, the [U.S.] Centers for Disease Control and Prevention has found that virtually every person who has lived in the United States since 1951 has been exposed to radioactive fallout. . . . The new study,

which was completed in August 2001 . . . suggests that for all Americans born after 1951 'all organs and tissues of the body have received some radiation exposure.' The study says in highly guarded terms that the global fallout could eventually be responsible for more than 11,000 cancer deaths in the United States." James Glanz, "Almost All in U.S. Have Been Exposed to Fallout, Study Finds," *New York Times,* March 1, 2002, http://www.nytimes.com.

31. In June 2006, a DOE Museums and Visitor Centers Conference was held in Las Vegas at the Atomic Testing Museum. This event was the first gathering of institutions that preserve and interpret U.S. nuclear history, and that conduct public outreach and education about nuclear science and technology. As such, it provided a revealing snapshot of their rhetorical situations. Organizers identified and invited eighteen institutions from eleven states. Representatives from fourteen attended and presented (I attended as a member of the board of directors for the Rocky Flats Cold War Museum). They were joined by officials from the DOE's Office of History and Heritage Resources. Data reported from a preliminary survey, and the event's presentations and discussions, indicated that despite their similar missions these institutions differed in several dimensions, including: (1) *Life-cycle stage* (founding dates of established facilities ranging from 1949 to 2005; four facilities are still only proposed); (2) *Size* (ranging from 65 to 53,000 square footprints); (3) *Audiences and markets* (ranging from local K–12 schoolchildren to facility employees and regional tourists); (4) *Annual attendance* (ranging from 700 to 93,000); (5) *Type and size of staff* (ranging from 0–16 paid employees and 0–50 volunteers); (6) *Annual operating budget* (ranging from $0 to $1.7 million); (7) *Operational environments* (ranging from accessible and populated sites to remote, secured, and contaminated sites); (8) *Mission scope* (ranging from a single function to multiple goals); (9) *Holdings and exhibits* (including photographs, interactive media, and entire structures); (10) *Rhetorical punctuation of the nuclear scene* (ranging from coverage of the distant past to current events, and from local to international sites); (11) *Perceived accountability to official DOE rhetoric* (ranging from affirmations of independence to perhaps-ironic declarations that "We're part of its public relations face"); (12) *Governance structures* (ranging from DOE-owned and -operated to independent operations); and (13) *Financing models* (ranging from federal support to memberships and admission fees). Discussion among the attendees focused on a variety of shared concerns, including: (1) *Improving their relationship with the DOE* (e.g., clarifying policies and identifying opportunities for collaboration); (2) *Coping with challenges posed by the end of the Cold War* (e.g., declining and disinterested audiences, and the demolition of site structures); (3) *Updating exhibits and programs, and expanding facilities;* (4) *Achieving greater visibility with stakeholders;* and (5) *Achieving financial sustainability.* Associated themes

in this exchange included: (1) *Enthusiastic but vague endorsements by DOE officials* (those present clarified that their attendance was "off the record"); (2) *Heroic stories of entrepreneurial initiative in new facility development;* and (3) *Acknowledgment of political dilemmas in representing nuclear history* (e.g., in the words of one facility director, "It's a good story, it's a proud story, it's a dangerous story—we hurt people"). Generally, this event resembled an ambivalent dance performed between these institutions and a potential patron, with both groups weighing the respective costs and benefits of increased collaboration. The DOE seemed reluctant to assume additional, unfunded responsibility for uncontrollable and potentially controversial museums. As one attendee noted, "The agency has a responsibility to help future generations to understand this [history], but they don't see it that way. We're literally voices crying in the wilderness." At the event's conclusion, the attendees formally organized themselves as the "DOE Museum, Science, and Visitor Center Network." They approved the following statement, and offered it to the DOE as a bid for greater inclusion and support: "We provide a mechanism to engage and educate the public and preserve materials and memories that characterize the work of the Department of Energy, its contractors and predecessor agencies as initiators of science and technology that made history and continues [sic] to change the world. This organization serves the Department's interests in understanding and honoring its work in the past and its need for an informed public and capable future workforce."

32. Joseph Masco, *The Nuclear Borderlands: The Manhattan Project in Post–Cold War New Mexico* (Princeton, NJ: Princeton University Press, 2006), 25, 4.

33. See Bryan C. Taylor and William J. Kinsella, "Introduction: Linking Nuclear Legacies and Communication Studies," in *Nuclear Legacies: Communication, Controversy, and the U.S. Nuclear Weapons Complex,* ed. Bryan C. Taylor, William J. Kinsella, Stephen P. Depoe, and Maribeth S. Metzler (Lanham, MD: Lexington Books, 2007), 1–38, esp. 12–14.

34. Taylor et al., "Nuclear Legacies," 373–76.

35. Wray, "Blast from the Past," 477.

36. Taylor, "Bodies of August"; Brian Hubbard and Marouf A. Hasian Jr., "Atomic Memories of the *Enola Gay:* Strategies of Remembrance at the National Air and Space Museum," *Rhetoric and Public Affairs* 1 (1998): 363–85; Theodore O. Prosise, "'The Collective Memory of the Atomic Bombings Misrecognized as Objective History: The Case of the Public Opposition to the National Air and Space Museum's Atom Bomb Exhibit," *Western Journal of Communication* 62 (1998): 316–47.

37. Taylor, "Make Bomb," and "Revis(it)ing Nuclear History."

38. Taylor et al., "Nuclear Legacies," 376–79.

39. Jennifer Duffield Hamilton, "Convergence and Divergence in the Pub-

lic Dialogue on Nuclear Weapons Cleanup," in *Nuclear Legacies,* ed. Taylor et al., 41–72.

40. Joseph Masco, "States of Insecurity: Plutonium and Post–Cold War Anxiety in New Mexico, 1992–1996," in *Cultures of Insecurity: States, Communities, and the Production of Danger,* ed. Jutta Weldes, Mark Laffey, Hugh Gusterson, and Raymond Duvall (Minneapolis: University of Minnesota Press, 1999), 203–232.

41. Janice Harper, "Secrets Revealed, Revelations Concealed: A Secret City Confronts Its Environmental Legacy of Weapons Production," *Anthropological Quarterly* 80 (2007): 39–64.

42. Jason Krupar and Stephen Depoe, "Cold War Triumphant: The Rhetorical Uses of History, Memory, and Heritage Preservation within the Department of Energy's Nuclear Weapons Complex," in *Nuclear Legacies,* ed. Taylor et al., 135–66. See also Crane, "Memory, Distortion, and History," and Wray, "Blast from the Past."

43. Brian Hubbard, "Rhetorical Criticism after the Cold War" (master's thesis, Arizona State University, 1997); Kinsella, "Nuclear Boundaries."

44. Bryan C. Taylor, "'(Forever) at Work in the Fields of the Bomb: Images of Long-term Stewardship in Post–Cold War Nuclear Discourse," in *Nuclear Legacies,* ed. Taylor et al., 199–234.

45. Brian Costner, "Access Denied," *Bulletin of the Atomic Scientists* (March–April 2002): 58–62; and Joseph Masco, "Lie Detectors: On Secrets and Hypersecurity in Los Alamos," *Public Culture* 14 (2002): 441–67.

46. Bryan C. Taylor and Brian Freer, "Containing the Nuclear Past: The Politics of History and Heritage at the Hanford Plutonium Works," *Journal of Organizational Change Management* 15 (2002): 563–88.

47. Len Ackland, "Rocky Flats Bomb Factory: New Historical Narrative Needed" (unpublished manuscript, University of Colorado-Boulder, School of Journalism and Mass Communication, Center for Environmental Journalism).

48. Jonathan Schell, "The Unfinished Twentieth Century: What We Have Forgotten about Nuclear Weapons," *Harper's Magazine* (January 2000): 41–56. One symbolic site of this rhetorical articulation involves nuclear spies. See Masco, "Lie Detectors," and Bryan C. Taylor, "Organizing the 'Unknown Subject': Los Alamos, Espionage, and the Politics of Biography," *Quarterly Journal of Speech* 88 (2002): 33–49.

49. Bryan C. Taylor, "'Our Bruised Arms Hung up as Monuments': Nuclear Iconography in Post-Cold War Culture," *Critical Studies in Media Communication* 20 (2003): 17.

50. Jenna Berger, "Nuclear Tourism and the Manhattan Project," *Columbia Journal of American Studies* 7 (2005): 196–214, http://www.columbia.edu/cu/cjas/print/nuclear_tourism.pdf; Henry Fountain, "Strange Love," *New York Times* (January 5, 2007), http://travel.nytimes.com/2007/01/05/travel/escapes/05atomic.html; Gusterson, "Nuclear Tourism"; Molella, "Exhibiting Atomic Culture"; Phil Patton, "Going Ballistic," *Wired Magazine* (November 1999), http://www.wired.com/wired/archive/7.11/cheyenne.html.

51. Marc Lafleur, "The Bomb and the Bombshell: The Body as Virtual Battlefront," *InterCulture* 5 (2008): 23–32.

52. Peter van Wyck, "The Highway of the Atom: Recollections along a Route," *Topia* 7 (2002): 99–115. A similarly comprehensive and self-implicating map of Canadian nuclear-national space was created in Robert Del Tredici's "The Nuclear Map of Canada Project," photographic exhibition held at Confederation Center of the Arts, Charlottetown, Prince Edward Island, Canada, October 8, 1998–February 14, 1999.

53. See David Silver, "Interfacing American Culture: The Perils and Potentials of Virtual Exhibitions," *American Quarterly* 49 (1997): 825–50; and Tom Vanderbilt, "Not Your Typical Road Trip," review of James M. Maroncelli and Timothy L. Karpin, *The Traveler's Guide to Nuclear Weapons: A Journey through America's Cold War Battlefields* (CD-ROM), *Bulletin of the Atomic Scientists* (November–December, 2003): 74–75.

54. http://www.colorado.edu/journalism/cej/exhibit/.

55. See Krupar and Depoe, "Cold War Triumphant."

56. Significant institutional players in this scene currently include the Congress; DOE's Offices of History and Heritage Resources (http://www.energy.gov/about/history.htm) and Legacy Management; the National Park Service (Department of the Interior); the Atomic Heritage Foundation (http://www.atomicheritage.org/); the President's Advisory Council on Historic Preservation; the Smithsonian Institution; the "Save America's Treasures" grants program; and the Energy Communities Alliance. The activities of these players are shaped by the contingencies of existing federal regulations (such as the National Historic Preservation Act), by limited available funding, and by growing stakeholder support for nuclear heritage. Current initiatives include documenting preservation opportunities at the Manhattan Project Signature Facilities (perhaps leading to the creation of a National Park), and also at the DOE's Cold War–era sites.

57. See Hales, *Atomic Spaces;* and Tom Vanderbilt, *Survival City: Adventures among the Ruins of Atomic America* (Princeton, NJ: Princeton University Press, 2002).

58. Peter C. van Wyck, *Signs of Danger: Waste, Trauma, and Nuclear Threat* (Minneapolis: University of Minnesota Press, 2005), 78.

59. See Bryan C. Taylor, "The Politics of the Nuclear Text: Reading Robert Oppenheimer's *Letters and Reflections,*" *Quarterly Journal of Speech* 78 (1992): 429–49.

60. See John M. Findlay and Bruce Hevly, *Nuclear Technologies and Nuclear Communities: A History of Hanford and the Tri-Cities, 1943–1993* (Center for the Study of the Pacific Northwest, University of Washington, Seattle, 1995).

61. U.S. Department of Energy, Office of History and Heritage Resources, "Cold War Preservation Initiative," http://www.energy.gov/about/coldwar.htm.

2
Sparring with Public Memory
The Rhetorical Embodiment of Race, Power, and Conflict in the *Monument to Joe Louis*

Victoria J. Gallagher and Margaret R. LaWare

In the city of Detroit, located at the terminus of Woodward Avenue as it intersects with Jefferson Avenue, resides a sculpture of a "black" forearm and fist, hung by what appear to be chains or cables from a triangular frame. This sculpture, representative yet also abstract in its disembodied form, and referred to in the vernacular of the city simply as *The Fist,* is more formally known as the *Monument to Joe Louis.* It is sited directly across from a classical, allegorical statue known as *The Spirit of Detroit,* thrusting toward the futuristic pylon of Hart Plaza. What is the meaning, the significance, the potential, and the reality of a huge bronze fist in the middle of a downtown intersection, in the heart of a city radically reconfigured by the effects of racial strife? It has been likened to the Black Power salute, but it is horizontal rather than vertical, a prizewinning punch forever suspended in time, its target only imagined (figure 2.1). As Donna Graves points out, there are only "a handful of monuments that honor African Americans in the urban public realm," and certainly no single monument can fill in the gaps of the memory and history of African Americans and racial relations in the United States.[1] However, while most Detroit residents agreed that Joe Louis, the nationally recognized heavyweight champion who inspired both black and white Americans, was a fitting figure to commemorate, the sculpture has become a source of controversy and a locus of divergent interpretations and reflections on both the past and the present. At a time when a growing amount of scholarly attention is paid to memorials and monuments of all types,[2] the *Monument to Joe Louis* is thus particularly fascinating to consider. It is heroic in scale yet antiheroic; it honors yet cautions; it evokes memory and provokes debate; it is both glorious and grim. The goal of our work is to examine the rhetorical aspects of this memorial to determine how, as suggested in the introduction to this volume, the memories evoked and referenced by it achieve durability over time and a compelling force in a particular context. Specifically, we examine the extent to which the *Monument to Joe Louis* functions as a resource for: (1)

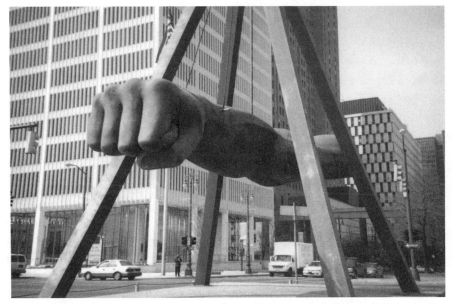

Figure 2.1. *"The Fist"*: close-up view of the *Monument to Joe Louis*. (Photograph courtesy of Julie Robertson.)

public memory, in its reflection and evocation of fundamental issues regarding the city in both its social and material manifestations, and (2) cultural projection, providing the rhetorical means, the materiality, through which social groups seek to further their own interests and assert some control over public space.[3]

In focusing on the rhetorical elements of the monument, its evocation of public memory, and its functioning as a resource for cultural projection within the context of downtown Detroit, we concur with Rosalyn Deutsche's view of the city as a "product of social practice," a concept she borrows from Raymond Ledrut. As Deutsche explains, "Describing the city as a social form rather than as a collection and organization of neutral physical objects implicitly affirms the right of currently excluded groups to have access to the city—to make decisions about the spaces they use, to be attached to the places where they live, to refuse marginalization."[4]

There are two other scholarly treatments of *The Fist,* one that provides a close reading of the sculpture as a public art text and the other that considers it as a rhetorical figure and uses it as the basis for elaborating a material theory of rhetoric.[5] Little attention is paid in either of these articles to the relationship between public memory and public art, the *rhetorical* character

of public art, or the role of material artifacts in creating, evoking, or simulating public memory by referencing significant individuals, events, and experiences in a community's history. Through our analysis, then, we seek to demonstrate how the monument's symbolic, material, and contextual/geographical resources reference and make present the cultural experiences and memories of African Americans in America and in Detroit. In this way, our work responds to Deutsche's call to "erode the borders between the fields" of critical urban studies and aesthetics to critically comprehend how public art can function to participate in, as well as provide a means for resisting, efforts at urban redevelopment and domination by elite groups seeking to control and homogenize public spaces and, as a consequence, public memory. Rhetoric operates at the nexus between critical urban studies and aesthetics, providing an additional resource for understanding the discourses and the audiences engaged as the "public" within the framework of public art and public space. Specifically, we argue that *Monument to Joe Louis* operates as a resource for public memory and cultural projection in three significant ways. First, it highlights certain values and experiences, making those values concrete and visible to a wide audience. As a consequence, it evokes and intensifies emotions. Indeed, as we shall demonstrate, *Monument to Joe Louis* is both the result and the focus of deeply felt reactions and responses, particularly because it evolved from and evokes a painful history of racism, discrimination, and racial division. Second, the values and meanings of the work are not universal, but are contingent on location and audience, the product of a complex physical—as well as historical, political, and social—context, which adds to its rhetorical power and potential as a means for public memory and cultural projection.[6] Finally, it invites judgment, not only by art world elites, but by the public at large because of its location outside of a museum or gallery and by the implication that it is meant to benefit or edify a local populace. As Deutsche points out, "space is . . . political, inseparable from the conflictual and uneven social relations that structure specific societies at specific historical moments."[7] Soon after its installation, *Monument to Joe Louis* became the subject of editorials and comments by the Detroit community and provoked a countermovement, which resulted in the siting of a representational memorial statue of Louis in nearby Cobo Hall, Detroit's convention center.

While other civil rights and African American related museums and memorials (not to mention American history museums) may tend to emphasize progress and a kind of resulting amnesia at the expense of contestation and debate, the arresting material and symbolic qualities of *The Fist* are hard to ignore.[8] Examining the materiality of the monument it-

self, along with its context, reveals the extent to which the *Monument to Joe Louis* began as an attempt to inscribe a particular aesthetic and vision onto a city and its citizens but became, in addition, a rhetorical resource for both public memory and continued engagement.

The Fist as Resource for Cultural Projection and Public Memory

Making Values Concrete and Visible

What are the values made visible in and through *The Fist?* The *Monument to Joe Louis* is connected to a larger social discourse involving the struggle over defining and representing public memory in the form of local and national histories, particularly ones that evoke painful memories of racism, marginalization, and injustice. Further, it is connected to the communities marginalized and made invisible by urban redevelopment policies as those communities struggle to regain their control over and access to public space. The latter is particularly significant given that in the contemporary era, public space that is not controlled by private and/or corporate interests is increasingly limited. The *Monument to Joe Louis,* commissioned by *Sports Illustrated,* was created during the late 1980s when corporations became heavily involved in the arts and in financing public art commissions as a form of public relations and investment. As a consequence, corporate sponsorship influenced the form and placement of art in the public sphere, and in certain ways reflected efforts to control and influence the development of public culture. Corporations looked to art experts for advice, which, as Erika Doss points out, makes the process more bureaucratic and less likely to incorporate or account for the interests and concerns of the local public who is on the receiving end of the commission.[9]

In many ways, these material circumstances, including the use of public space as a form of urban investment and "revitalization" for the prime benefit of corporate and government elites, were reflected in the Joe Louis commission. While the monument was described from the outset as a public art sculpture, no aspects of the artist selection process, the design selection process, or the site selection process involved the public. Instead, *Sports Illustrated* representatives chose Robert Graham, the sculptor of the *Monument to Joe Louis,* from a shortlist provided by the Detroit Institute of Arts (DIA) museum staff, and the design was approved by the DIA and the mayor's office without any input from citizens or other representatives of the public. Graham worked secretly, refusing to talk about his concept and the form the sculpture would take.[10] Graves describes the three main parties whose

values dominated the decision processes related to *The Fist:* Time Incorporated (*Sports Illustrated*'s parent company), whose representatives claimed altruism as the motivation for the gift but whose interests would also be served by maintaining a positive profile with the magazine ad–buying auto industry in Detroit; staff and board members of the Detroit Institute of Arts, who wanted to improve their relationship to the city's black population and power structure in the face of a municipal investigation for mismanagement; and Coleman Young, who wanted the city and his administration to have greater control over the DIA's large state appropriations.[11] The decision process thus reflected the aesthetic and corporate/institutional values of economic and political elites whose perspective of having the will and the power (and perhaps even the duty, in the wake of the racial strife of the 1960s) to impose an aesthetic vision on the city became the "common sense" that underlay decision making in relation to the project.

Additionally, as Harriet Senie and Sally Webster point out, public art projects in the last half of the twentieth century are also characterized by modernist aesthetic values: "To a great extent the emergence of large-scale sculpture in conjunction with modern architecture in the 1960s may be seen as an attempt to ornament after the fact. What made this development even more problematic in terms of public art was the abstract style practiced by the most important artists of the day, an artistic vocabulary difficult for many museum audiences, and completely foreign for large segments of the public who now had to contend with it in the spaces they used daily. In a museum it could be ignored; in a public space it clearly could not."[12] This type of aesthetic came to dominate the "public" art scene in Detroit during the 1970s. In the aftermath of the rebellions or riots of 1967,[13] civic and corporate leaders attempted to rejuvenate the city of Detroit by instituting a reinvigorated public art program.[14] Indeed, urban public art programs were somewhat common during this time period as a part of urban renewal programs. And, according to Senie and Webster, public art programs had been used to similar ends in centuries past, "functioning as an emblem of culture and a manifestation of economic wealth, a sign of the power of its patron."[15] In Detroit, various works of art were sited in downtown public spaces, including geometric wall paintings and murals by various local and not-so-local artists, a twisted steel pylon and a steel fountain (shaped like a donut held up by two steel straws) designed by Isamu Noguchi, and various other abstract steel sculptures including ones by Alexander Calder and John Piet. To the extent that the concept of public art presupposes a fairly homogenous public and a language of art that speaks to all, the motive for and the aesthetic style and timing of De-

troit's public art campaign during the 1970s were at least somewhat ironic. The campaign demonstrates the extent to which a few (in this case, political and economic elites) attempted to control the look and spaces of the city, and thereby impose their values on it. Despite or perhaps even because of the rebellions/riots, they neglected the views and values of their fellow citizens, whose perceptions of the art being installed around the city were likely to be quite different from those of the elites, as Senie and Webster point out: "Seen from the vantage point of economic under classes, public art is affirmation of their exclusion from power and privilege. Art in the public domain, a sign of the power of its patrons, frequently becomes the focus for discontents that often have nothing to do with art. Small wonder that public art and controversy seem to have been joined at birth."[16] While clearly the creation of a small group of elites in the corporate, government, and art world who sought to control and revitalize the image of Detroit and its public spaces, the *Monument to Joe Louis,* through its material and symbolic presence in a central public space, at the same time invited response from diverse publics, and thereby opened a rhetorical space for also challenging the discourses of control, redevelopment, and homogenization of public space. To understand, therefore, its rhetorical function, it is first important to better understand its material and aesthetic form.

The sculpture itself is a twenty-four-foot bronze arm and fist suspended by cables from pyramidal support beams that stand twenty-four feet tall. While anatomically precise, it is disembodied, abstracted, and decontextualized—an arresting combination that is symbolically and interpretably open. It is perhaps not surprising that upon seeing the sculpture for the first time, Joe Louis's widow murmured, "It could be anybody's arm."[17]

Robert Graham's comments about his work affirm this description of *The Fist:* "People bring their own experiences to the sculpture. I wanted to leave the image open, allowing it to become a symbol rather than make it specific." According to Graham, "Making a statue of a fighter would have been a limited image of Joe Louis."[18] Indeed, the disembodied forearm and fist function as a metonym for Louis, a kind of shorthand sign of a larger meaning, functioning efficiently to stand for the whole (figure 2.2). Unlike metaphor, which draws our attention to similarities in dissimilar things through direct comparison (for example, that man is a lion), metonymy relies upon the use of a single characteristic to identify a more complex whole, or the use of a single attribute to create identification with a larger whole. In the case of *The Fist,* Louis's muscle and brawn used to defeat opponents in the boxing ring serve as shorthand for the larger struggles of African Americans to attain greater equality in society, struggles in

which Louis himself played a significant part. As Thomas R. Hietala argues, Louis's knockout punch resonated throughout the African American community in the 1930s, because African Americans "relished those rare moments when one of their own shattered white pretensions to superiority."[19] However, from another standpoint, as Graves argues, "the arm is severed from the brain that lends intelligence and intention to its driving force."[20] There is thus a disturbing side to *The Fist* as a visual metonymy in that, by elevating or foregrounding one attribute, the forearm, it seemingly downplays other attributes, separating a physical attribute that represents power and force from those attributes that are considered essential to one's humanity, such as intelligence and feeling which are often sculpturally represented by the head and the upper body in the form of a bust. Given that the body part is attributed to a black man and given the history of lynching and other forms of violence enacted against blacks during Joe Louis's lifetime and career, *The Fist*'s formal dimensions are also inextricably tied to "a set of cultural and visual stereotypes borne of denigrating racial ideologies."[21] Using one body part to symbolize the complex whole of a person objectifies and dismembers that person, both figuratively and literally. As such, the sculpture is both a grotesque caricature of the man and a glorification of his limb. It is a piece of a (subhu)man, whose life can be reduced to one limb, to be held up for the gaze of the "public"—a curiosity, a carnival sideshow, a burlesque oddity. The fact that *The Fist* is hung from a tripod, shackled by cables, simply underscores such a reading (see figure 2.1). Louis's brawn is both mighty and constrained, daunting and caged, an emblem of the black body writ large and the families torn apart and dismembered by slavery, violence, and poverty. Indeed, Richard Marback pushes the metonymic possibilities of *The Fist* even further, arguing that "The body of Joe Louis, or at least the part of his body monumentalized on the corner of Woodward and Jefferson, has become 'urbanized,' a metropolitan body, or more specifically, the body of Detroit, a fist inscribed with racial violence, agonized memories of racial injustice, and hopes for democratic citizenship. At the same time, the city itself has become a spatialized simulacrum of an African-American body fighting against, while living within, embodiments of racial injustice and the geographic limitations of democracy."[22]

As the discussion above indicates, *The Fist* makes visible the hegemonic processes and values of political, corporate, and cultural elites (the material circumstances), the modernist aesthetic values of much urban public art (its specific aesthetic properties), and the metonymies of racial and racist images and ideologies (rhetorical figures/resources).[23] In so doing, it functions

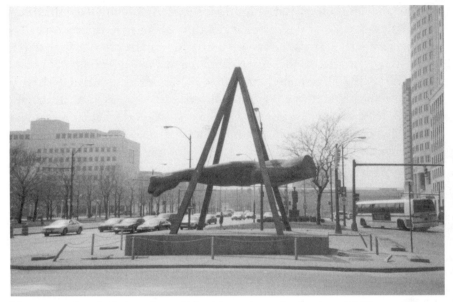

Figure 2.2. South-facing view of the *Monument to Joe Louis* and Jefferson Avenue. (Photograph courtesy of Julie Robertson.)

rhetorically to evoke and intensify emotions and responses. For example, in February 2004, two men from suburban Detroit, one a suburban parks commissioner, used mops to whitewash the statue and left photocopied pictures of two slain Detroit police officers (both white), whose "alleged killer" was black. They also left a note with the inscription "Courtesy of Fighting Whities."[24] This act of vandalism provided a visible rhetorical manifestation of, in Marback's terms, the pain of the urban body and an effort to both call attention to and alleviate the pain through a public statement. In an attempt to defend and explain their motivation, the two men, who both lost their jobs as a result of the vandalism, argued that the act was not racially motivated, but rather a plea "to stop the violence."[25] They saw the violence in Detroit echoing the violence in Iraq, and they sought to express their feelings of pain, frustration, and outrage. Thus vandalism of *The Fist* became their rhetorical response to the situation. *The Fist* was cleaned, and the two vandals were charged with "malicious destruction of property."

The men's account of their actions suggests that *The Fist*—to the extent that it symbolizes, in its abstracted form, violence without a context or framework (that is, random violence)—evokes an intensified experi-

ence of the emotion that accompanies awareness of such violence, namely fear: fear of racialized violence, fear of otherness within urban spaces. The public sculpture provided a space to articulate those fears visually. In a sense, whitewashing the sculpture also rhetorically referenced efforts to whitewash, through redevelopment efforts, underlying struggles within the urban context and the realities of communities separated by racial and economic boundaries. Without an understanding of who *The Fist* belongs to (there is nothing to connect the sculpture to Joe Louis, as indicated above, if one does not know the original title of the work as opposed to its reference as *The Fist*), it can also be seen as a sign of warning or danger, as it hangs firmly resolute and faceless, suspended over those who pass by and below its imposing form. It is contained within the pyramidal structure from which it is hung by steel cables, but it also projects outward from the pyramidal form. It thus seems on the verge of breaking through invisible barriers, suggesting the illusion that it could actually move, swinging out like a missile without warning (see figures 2.2 and 2.3). Such a reading of danger is underscored by the public awareness of another monumental sculpture featuring disembodied arms, namely Baghdad's triumphal arch, titled *Hands of Victory,* constructed by Saddam Hussein, which features Hussein's forearms holding swords over the roadway.[26] The first and second Iraq wars made this sculpture a potential reference point in the public imagination, underscoring both the hegemonic force of *The Fist* and the fear and discomfort it might invoke in viewers. However, the fist featured in the *Monument to Joe Louis* holds no weapons and, as Marback argues, presents an alternative rhetorical figure that may better illuminate the state of contemporary civic life than the Ciceronian open-handed gesture. Marback writes: "as an icon of protest and cultural turmoil and racial tensions of the last three decades, the fist figures forth spatial interactions embodied in claims to contested cultural and physical terrains on which memories of racial injustice and hopes for democratic citizenship are written."[27]

As this discussion indicates, the sculpture highlights the tensions of the urban experience of Detroit—an urban history, as we shall demonstrate below, involving economic downswings, rioting/rebellion, white flight to the suburbs, and social and urban planning policies that left African Americans with few choices, locking them into increasingly depressed and deteriorating communities. The symbolic and material aspects of *The Fist* suggest both efforts to literally break out of such a downward spiral and the fears of those outside the city that African American individuals and communities will indeed break out and enter their own predominantly white, middle-class havens. It therefore evokes, among other things, anger, frus-

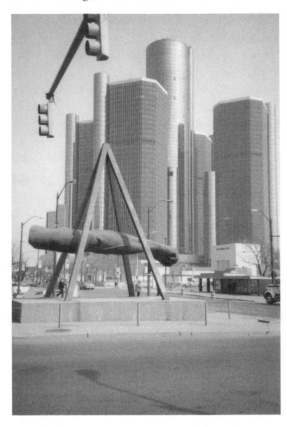

Figure 2.3. The *Monument to Joe Louis* against the backdrop of the Renaissance Center. (Photograph courtesy of Julie Robertson.)

tration, pain, determination, and hope on the part of African Americans as well as fear and efforts at containment on the part of whites and their political representatives. In terms of representing "hope" for African Americans, one supporter of the monument saw the monument as symbolizing the black community "fighting against all odds, rising out of obscurity, refusing to be a passive victim of an unjust system."[28]

Location and Meaning Making

As our discussion so far makes clear, race is an important aspect of the signification of the monument. Given the man being memorialized and the location of the memorial, this is hardly surprising; however, the rhetorical import of these factors is worth careful consideration. In his detailed historical and cultural analysis of the social impact of three famous African American boxers in the twentieth century, Frederic Cople Jaher describes the pivotal role Joe Louis played in the developing racial conscious-

ness of the nation. Unlike the earlier black heavyweight champion Jack "Little Arthur" Johnson, who Jaher claims was seen as a provocateur because his behavior "presented demands for the elimination of the color line in everything from boxing to the bedroom," Louis was one of the country's first black heroes. Indeed, Jaher argues that, "Although he accommodated to the racial stereotype of the submissive Negro, Louis (partly as a result of this accommodation) became the first black national hero. This achievement represented a new role for blacks and a major concession by the dominant race. Most white Americans now altered their vision of their national identity to include Afro-Americans. Louis convinced whites that blacks could be virtuous as well as virtuoso athletes and, by extension, worthy citizens. By alleviating Caucasian anxieties regarding changes in race relations and black patriotism, Louis' example regularized black contention for the heavyweight crown."[29]

Through both his fist and his persona, then, Louis made a claim for equality that resonated with the white community. And in his triumph over German opponent Max Schmeling, he served as a symbol of America overcoming the destructive forces of Nazism in Europe. If we accept Jaher's account, then Joe Louis's public image, as crafted by himself and his handlers, might be read as an example of a shared or conciliatory cultural projection, wherein dominants and subordinates exchanged and accepted the images and perspectives of the other.[30] However, despite Louis's hero status and the acceptance of black contenders for the heavyweight-boxing crown, his life and that of other African Americans, particularly in the city of Detroit, continued to be characterized by political, economic, and cultural struggles, not least having to do with access (or lack thereof) to spaces and places. This history is inscribed into the physical landscape of the city and, in turn, plays an important role in understanding the rhetorical significance of the *Monument to Joe Louis,* of the memories and emotions it evokes on the part of different publics as a result of its material location in the heart of the redeveloped downtown and its aesthetic realism and abstraction.

Recent scholarship on architecture and race suggests some of the difficulties in representing black social memory spatially and materially. Nathaniel Belcher describes the often-devastating impact of federal interstate transportation system initiatives during the 1960s and 1970s on African American urban neighborhoods around the country:

The most active years of highway construction coincided with a general relocation of population along racial and economic lines. This quasi-desegregation of shopping, residential, educational, and cultural

facilities through both legal and spontaneous actions came on the heels of many Interstate constructions through formerly segregated districts. . . . In many of these areas the traditional African-American community was unprepared for these simultaneous occurrences and simply could not withstand such an onslaught; neighborhoods quickly fell into disrepair as uprooted residents moved to more accommodating suburbs.[31]

And Kenrick Ian Grandison argues, in his work on black college campuses as cultural records, that historical meaning "resides not so much in autonomous objects or 'things' but rather in how spatial relationships change over time."[32]

The connection these scholars draw between spatial relationships and historical events and meanings are particularly relevant to Detroit, where, according to June Manning Thomas, inner-city redevelopment projects that further reduced the already inadequate housing supply open to blacks as well as the rebellions/riots of the late 1960s effectively destroyed black communities, tearing apart the social fabric of African American neighborhoods in Detroit. The riots resulted in increased white flight and the necessity of black communities to attempt to rebuild neighborhoods with few resources and poor existing facilities. As Thomas points out, "Commercial owners hesitated to reinvest in areas where the residents were likely to burn down their buildings."[33] White flight from the city multiplied in the years following the riots, jumping from an average of 22,000 whites leaving the city each year in the early 1960s to a high of 80,000 leaving in 1968.

Indeed, by 1990, four years after the unveiling of *The Fist,* only 1,027,000 people lived in the city, a loss of 800,000 people in forty years. As then-mayor Coleman Young noted, "If you keep the same city limits as we have, if half the population is gone, then half of your buildings are going to be deserted."[34] The loss of formerly thriving urban neighborhoods, let alone poverty-stricken neighborhoods or middle-class black communities, in the aftermath of the rebellions/riots has had a profound effect on the city. According to Mindy Fullilove, a direct result of this loss is a deep and wounding psychological state she refers to as "root shock": "the traumatic reaction to the destruction of all or part of one's emotional ecosystem. . . . Shock is the fight for survival after a life-threatening blow to the body's internal balance." Fullilove argues that the effects of root shock will last for a lifetime and can affect "generations and generations of people."[35]

The devastating and long-lasting transformations in Detroit's scenic components (which speak to both the material aspects and the rhetorical

context of the monument) and the disparate impact on blacks and whites who were forced to move (but generally in different directions) leads to a rhetorical reading of *The Fist* from within a psychological framework of place, or, more accurately, of loss of place. *The Fist* is what remains when the body is torn asunder. It strikes out, but with no clear opponent; it struggles, but never achieves resolution. Instead, it remains suspended in air. The cables holding the bronze fist are significant here because they set boundaries in a manner metaphorically related to the boundaries set by housing policies, urban development policies, and economic policies, as well as related to the boundaries of the physical scene.

In the *Monument to Joe Louis,* then, the past and present are brought together in a visualization of the relationship between power and force as they have played out in Detroit. The monument displays black embodied power that is visible and tangible: it is, of course, no accident that the forearm and fist are cast in bronze, a material that resembles dark skin with varying degrees of darkness and ashiness, particularly as it ages. Nor is it an accident that the fist is pointed horizontally rather than vertically, providing a somewhat different sense of black power than the raised fist that became associated (particularly for whites) with militant elements of the civil rights movement during the 1960s.[36] Indeed, attitudes toward the monument reflect divergent perspectives on the notion of "black power," which, as political scientist Michael C. Dawson explains, for most African Americans suggests "fairness or black unity" and for whites represents "blacks' demands that white supremacy be replaced by black supremacy."[37] At the same time, the monument calls attention to the constraints of the existing social system, and the unique historical realities of Detroit, that have, at different points in time, contained and undermined that power. The monument references the positioning of African Americans as "other" yet also symbolizes the "fight" to move beyond imposed limits that have become concretized in the form of urban planning that constrained the movement of African Americans both within and outside the city limits and that aided and encouraged the movement of whites to suburban areas.[38]

The surrounding physical/material context is rhetorically significant in several other ways. In addition to the public art projects described earlier, members of the economic and political elite also undertook urban redevelopment projects as a means to re-exert themselves upon the city. The ultimate symbol of this "renaissance" is the aptly named Renaissance Center, a privately financed project on the riverfront in downtown Detroit proposed and pushed through by Henry Ford II. The resulting complex, designed by John Portman (who also designed the Peachtree Center in Atlanta), is made

up of a central, seventy-three-story cylindrical tower, surrounded by four additional thirty-nine-story towers and base floors laid out in a mazelike pattern meant to accommodate conference rooms, restaurants, retail shops, theaters, and other commercial facilities. Resembling a fortress of steel and glass and completely protected from the surrounding environment, the Renaissance Center (known as RenCen to Detroiters) provides a visual and physical backdrop for *The Fist* (figure 2.3). Its gigantic scale and "cold," difficult-to-navigate interior, plus its inaccessibility from the street (the complex was originally surrounded by huge, plant-covered berms with no visible street entrance), made it virtually inaccessible and/or unattractive to potential patrons.[39] As a result, it has changed owners multiple times, each one struggling to attract and keep tenants and patrons.[40]

Not to be outdone by the city's economic elites, Coleman Young, Detroit's first African American mayor, took a similar tack in his efforts to revitalize the riverfront and, also by extension, he hoped, the city. One of Young's first downtown development projects was, interestingly, the Joe Louis Arena. As Thomas recounts, "The city had already lost one of its major sports teams, the Detroit Lions football club, when the Pistons basketball team and Red Wings hockey team also threatened to leave. Young resolved to build a new arena for them. Finding no buyers for municipal bonds, he convinced the Carter administration to lend the city $38 million. This was, up to that time, the largest loan of its kind and the only one given for a sports facility. Most of the money for repaying the loan came from the city's parking revenues."[41]

This type of deal characterized Coleman Young's leadership style as mayor: he used highly visible redevelopment projects—such as the Joe Louis Arena, the Detroit People Mover, and developer Max Fisher's Riverfront Towers apartment complex—to cover up deep-seated social and economic decline.[42] One observer summed up Detroit's redevelopment projects of the 1970s and 1980s as follows: "Riverfront and RenCen were to be Max and Henry's bookends. It went all the way back to the riots and their vision of a new Detroit. You could look at Detroit from [Canada] and see Henry's RenCen and Coleman's Joe Louis Arena and Max and Al's [Taubman] two apartment towers and understand Detroit pretty much at a glance."[43] The physical context of *The Fist* is thus marked by "new" buildings in a shrinking downtown center, buildings which, despite their grand scale and design, do not hide the city's many persistent problems and aborted initiatives.

What is striking about the physical location of *The Fist,* then, is the extent to which it reflects both the car culture and the racial culture of De-

troit. The mix of shiny, modern buildings surrounding the monument was made possible by the car industry both figuratively and literally: Detroit is, after all, the "Motor City," a city whose fortunes have depended upon those of the American car industry's, and Henry Ford II (RenCen) and Max Fisher (Riverfront Towers) were the heirs to the car companies and/or fortunes of their fathers and grandfathers. And, as mentioned previously, Coleman Young was the first black mayor of the city, elected within six years of the 1967 rebellion/riot, a period during which Detroit went from having a majority of white residents and a largely white administration to a black majority and a black administration. Thomas provides a useful discussion of the extent to which these two cultural components have impacted the lived experience of Detroiters: "in Detroit, events conspired to leave the city uniquely impoverished, abandoned, and militant. The bottom fell out of the auto industry, causing mass unemployment. The abundance of land beyond the municipal boundaries [and the inability of the city to annex it] enabled suburbanites to create an alternative downtown in the suburb of Southfield. And the new mayor, Coleman Young, elected in 1973, did not come from the Southern Christian Leadership Conference. He was a militant former union man who consolidated power by adopting a confrontational policy toward the city's suburban neighbors."[44]

Given the influence of the automobile on Detroit, both in terms of its economic impact on the city and the enabling force it represented in the creation of the surrounding suburbs and metropolitan areas and the increasing isolation of the central city, it is perhaps not surprising that the sculpture itself is sited on a cement island in the middle of a turnaround on Jefferson Avenue, which, as the major thoroughfare along the riverfront, is ten lanes wide (figure 2.4). As a result, most people experience *The Fist* by car, many on their way to work at one of the surrounding office or government buildings, having driven in from the suburbs. At the driving speed on Jefferson Avenue, the monument appears, looms, and recedes in the rearview mirror within the duration of a minute or less. Despite this hurried pace, it is arresting enough to register, to disrupt, even to antagonize and, in so doing, reveals the potential rhetorical power of public art to problematize urban living. The symbolic and material aspects of *The Fist* take a mundane, ordinary experience of driving and unlock the rhetorical potential of our day-to-day mental and physical meanderings. It thus demonstrates the potential for memorials to reactivate rather than cover the debates and contests of history, keeping them fresh in our memories (and providing one possible answer to the question "what sticks and why?"). Because it is located right in the center of a major thoroughfare in the center

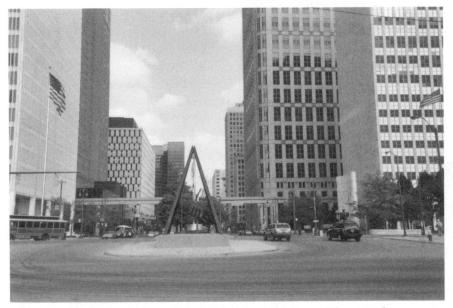

Figure 2.4. Street-level view of the *Monument to Joe Louis*. (Photograph courtesy of Julie Robertson.)

of a city, the tension of power and power constrained, the tension between the part and the whole, is inescapable.

For employees in the surrounding buildings, *The Fist* stays potentially within their gaze for longer periods. Indeed, Coleman Young depicted *The Fist* as his own personal co-optation of the efforts of the dominant elites. As both an elite, by virtue of his role as mayor, and a self-proclaimed representative of the black community, he encouraged siting *The Fist* where he could see it from his office at City Hall. *The Fist* was an "in your face" reminder of his connection to the black constituency. It also served as an emblem of the ongoing challenge his administration posed, his assertive stance over and against the white establishment with whom he was in constant and direct opposition.

Within a cultural context marked by race, therefore, the physical location and particularly the issues related to access and planning of place and space are important factors in the signification of a commemorative site. Due to the complexity and divisiveness of race relations in the United States in general and Detroit in particular, characteristics that translate into how space is allocated, who lives where, and the "good" and "bad" parts of cities, artifacts that memorialize individuals and events that are "raced,"

are essentially complicated, unfinished texts that, as we have demonstrated here, "draw from outside the structures of the memorials themselves to form the character of the structure."[45] Unlike the recognizable "memory places" described in the introductory essay (museums, preservation sites, battlefields, and so forth), the *Monument to Joe Louis* creates a place and occupies a space that is ambiguous yet recognizable and, ultimately, rhetorical.

Inviting Judgment

Increasingly, in the world beyond one's private and constrained spaces of home and work, public art sculptures and installations are some of the few symbolic markers where there is a larger sense of visibility as well as strangeness. Amid the modernist, faceless buildings in the revitalized section of downtown Detroit, including the imposing dark glass and steel structure of the Renaissance Center, toward which the sculpture directs its closed fist, the *Monument to Joe Louis* provides one of the few human reference points, a contained space of expressiveness and meaningfulness however abstract and symbolically open it may be. As Richard Sennett points out, writing about contemporary urban planning and architecture, modern public space "prompts people to think of the public domain as meaningless."[46] Further, instead of providing visual cues that could help individuals understand and embrace the social diversity of the city, urban planners often build physical barriers to "seal off conflicting or dissonant sides."[47] Works such as *The Fist* provide, then, an opportunity or a vehicle for public expression of various sorts, an opportunity for both connection and conflict as different historically and racially located social memories are invoked and brought to bear on judgment and response. These expressions, as indicated earlier, include frustration, resistance, even outrage.

Certainly public art has had a mixed history in the United States, and the modernist design aesthetic, as described earlier, has caused controversy in other cities in regard to other installations because of the aesthetically difficult and literally imposing bulk of large, modern steel sculptures. As Doss explains, "controversies over public art style really unmask deeper concerns Americans have regarding their voice in the public sphere. . . . If the mercurial complexity of contemporary life seems unfathomable, if real-life problems seem insurmountable and experts appear irresolutely unresponsive, the simple presence, the 'thereness' of public art is a solid, knowable target."[48] Similarly, art critic Amy Golden notes that "public art addresses its audience as participants in a public world. Sympathetic attention is not enough. We are encouraged to take sides."[49] In the case of *The*

never make claims about audience ? apply back to self

Fist, audiences of various types expressed frustration, took sides, and used the monument to make judgments and to lay claim to a voice in the public sphere. Some of these judgments indicated a conciliatory reading of the monument, while others indicated a more clearly polarized reading.[50] For example, when asked by a local newspaper columnist to respond to the question "What's in *The Fist?*" readers from the Detroit metropolitan area sent in a variety of responses, from cynical and divisive to conciliatory and hopeful: "M&Ms," "A squashed palm reader," "[it's] spring loaded to release a certain digit every time Mayor Young attacks the suburbs," "Hope," "Tolerance," and "What will it take to open *The Fist* and spread it [hope] around?"[51]

A more polarized set of judgments regarding the monument is also indicated by the fact that *The Fist* has been subjected to vandalism (in reality as well as in fictional scenarios) as a form of rebellion and protest by local, suburban white individuals who seek to express yearning for transformation in the character of Detroit city life. Paul Clemens, in his memoir about growing up as a white Catholic on Detroit's east side, created a fictional incidence of vandalism with overtones similar to the February 2004 incident described previously:

> [T]he three [white] kids, still armed to the teeth with dairy products after egging houses in wealthy Grosse Pointe, drive downtown and park near *The Fist,* intent upon egging the shit out of it. They fit nowhere—the suburbs, the city—and so are reduced to this impotent gesture. "We should have bought yolkless eggs," one of them remarks. Though it had made no difference in Grosse Pointe, the symbolism of the all-white egg would have been better downtown.
>
> And so they begin, to the accompaniment of alphabetic swearing. "Asshole!" one of them hollers, letting the first egg fly. "Bitch!" And so on, until they get to the letter *n,* when the scene fades out.
>
> They were picked up by the Detroit police, the narrator says in a postscript, on charges of drunk and disorderly [conduct] and destruction of public property. But nothing had been destroyed—the eggs washed right off—and there's nothing disorderly, the narrator asserts, about civil disobedience executed in alphabetical order.[52]

Both the fictional and the actual attempts at vandalism indicate a struggle by (formerly) politically and economically dominant whites to render judgment, to reject or reinterpret the perceived symbolic aspects and values inscribed in the materiality of *The Fist.*

A potentially even more significant response, given the material outcome, came in the form of an anonymous donor who started a countermovement in 1984 to site a representative sculpture honoring Joe Louis in Cobo Hall, Detroit's downtown convention center. The donor's gift was "matched by Detroit citizens, Louis's family, public school students, teachers and staff."[53] The stated purpose of the commission was to site a sculpture that "the community could identify with," one that would serve as a corrective to *The Fist*. The result was a twelve-foot bronze statue of Louis in a boxing stance created by Ed Hamilton, an African American sculptor who won the design competition.[54] Of course, as indicated in this book's introductory essay, this is not the only example of a countermovement developing around a controversial public art sculpture: consider, for instance, the countermovement that resulted in the siting of the representational sculpture and flag pole adjacent to the Maya Lin–designed portion of the Vietnam Veterans Memorial (VVM), or the countermovement that resulted in the removal of Richard Serra's sculpture *Tilted Arc* from the plaza in New York City.

The case of the VVM indicates that countermemorials may serve at least three functions: as a corrective, as a supplement, and/or as a contradiction. Considered in this light, the statue of Joe Louis in Cobo Hall may be understood to function as a corrective to: (1) artist Robert Graham's claim that a statue of a fighter would be too limiting, and (2) his use of an abstracted, interpretably open aesthetic. It does so by evoking instead the tradition of the "great man" in commemorative art—exemplified by representational sculptures that are larger than life, that concentrate on capturing a likeness so that the great man becomes the stand-in or embodiment of the community's best hopes and aspirations. Indeed, because the largely African American community chose this traditional, honorific style of commemoration, associated with dominant-group memorializing of the past, and because the political and economic elites accepted the community's right to participate in public representation of history, the representational statue of Joe Louis, despite its oppositional character, may be read as a conciliatory cultural projection.

In a manner similar to the representational elements of the VVM, the representational statue of Louis in Cobo Hall also may be understood to function as a supplement, providing another way by which people may participate in remembering a person and/or event(s). The addition of the Hamilton memorial has meant that Joe Louis's memory is now inscribed into the visual and material landscape of modern Detroit in three distinct ways, with the third being the Joe Louis Arena, the sports stadium

(also referred to as "The Joe") where the Red Wings hockey team plays. Of these three, *The Fist* remains the most publicly visible and provocative commemorative form. However, each form of memorializing represents different interests and needs, different communities tied to Detroit, and different moments in contemporary history fraught with tensions and with desires for transformation, renewal, and restoration of community and prosperity. Taken together, these commemorative projects evoke memories of Joe Louis as a man, a legend, and a symbol, memories that continue to have an impact both locally and nationally. *The Fist* has, therefore, brought about (in the case of the Hamilton statue) and become part of (in the case of the arena) a more extensive field of memory and commemoration, reflecting and engaging the complexities of Detroit's history and of racial histories throughout the country. As Blair, Jeppeson, and Pucci read the three parts of the Vietnam Veterans Memorial together as symbolizing conflict and the lack of resolution over the conduct of the Vietnam War,[55] we can read the three Joe Louis commemorative projects together to see them symbolizing the complexity and partisan nature of public memory and the inevitability of conflict and contestation over how events and individuals are represented materially within the public realm.

As this analysis has shown, the rhetorical impact of the artifact's specific physical location, the aesthetics and the history of the surrounding built environment, and the multiple modes by which people both experience and engage it are significant factors in developing an understanding of the monument's rhetorical and commemorative power. Examining these factors as we have done here provides a clearer sense of how and to what extent *The Fist* functions rhetorically to provide a space of attention to which individuals respond, both emotionally and rationally, by articulating a position and by further identifying themselves as members of the public being addressed by the monument.

Conclusion

The *Monument to Joe Louis* has evoked strong emotional reactions and invited a variety of responses and judgments from different publics because of the historical, social, and psychological experiences it references through its material presence in the heart of Detroit and through its resulting rhetorical force. Its aesthetic qualities and surrounding context (both physical and historical) provide the resources from which controversy, debate, and other forms of material rhetoric have emerged. The common reference to the sculpture as *The Fist* suggests the rhetorical meaningfulness of the

sculpture: its combination of realist and abstract elements; the power, threat, and anger it evokes; and the sense of brokenness and loss it displays through its metonymic qualities, referencing bodies and communities torn asunder. The memories evoked are much broader and more scattered than one might suppose from a sculpture titled for a specific person. Indeed, without it being designated as *Monument to Joe Louis,* its connection to the boxing champion—who helped to positively transform white perceptions of African Americans and helped African Americans imagine the possibilities of achieving parity with whites—is tenuous.

To the extent that most people experience the materiality of *The Fist* as a disembodied arm with multiple references, our analysis suggests this is *because* of its physical location, its connection to other works of public art and urban redevelopment commissioned around the same time, the dispersal of communities along the lines of race and class, and the shifting over of political power to the African American majority who remained within the city limits. Indeed, the hegemonic process by which the sculpture came into being, the conciliatory nature of the countermemorial in Cobo Hall, and the polarized cultural projections the sculpture evokes may be more apt, when taken together, to result in a counter-hegemonic discourse regarding the redistribution of power than any number of representational sculptures celebrating civil rights and/or the African American experience.[56]

The sculpture, as material rhetoric, opened opportunities for discussion and reflection on the history of Detroit as well as the appropriate forms of commemoration for a significant figure whose prominence in the world of boxing became symbolic of the potential for greater feats and more successful struggles for power by African American communities around the United States. The memorial delineated the tensions and the jockeying for control of Detroit's public spaces by corporate, cultural, and political elites, bringing these groups head to head with each other and with the publics located both within and outside of the city limits. The countermemorial reflected a desire to take the memorializing process out of the hands of the cultural elites and corporate control, making the memory of Joe Louis into something more reflective of the community's perception of appropriate memorial sculpture. While more traditional in nature because of its representational form, this countermemorial served as both a corrective and a supplement, expanding the field of memory and ensuring the enduring presence of Joe Louis in the history of Detroit for audiences in the present and in the future.

In revealing the rhetorical, contingent nature of the monument, this

analysis provides a clearer understanding of how and to what extent *The Fist* serves as a resource for public memory by examining what "makes it stick," as well as how and with what effect. As we demonstrate, citizens of Detroit continue to be emotionally engaged by this monument, taking on the role first of critic, then of agent, and, ultimately, experiencing the *Monument to Joe Louis* as a resource for cultural projection and continued engagement, most recently in response to the economic recession. Indeed, in spring 2009, NPR did a series of stories about Detroit and Michigan as the "national leader in recession," because the city and state experienced the economic downturn earlier and more deeply than other states. One of the pieces of the series featured a journalist recorded while standing on Jefferson Avenue by the *Monument to Joe Louis,* talking about why she loved Detroit and why she loved the sculpture. Regarding the symbolism of the sculpture, she remarked, "I don't see violence in this sculpture; I see a bull-headed determination. Joe Louis, like many Detroiters, took his blows. But, Louis endured, and he did it with style."[57]

Notes

1. See Donna Graves, "Representing the Race: Detroit's 'Monument to Joe Louis,'" in *Critical Issues in Public Art: Content, Context, and Controversy,* ed. Harriet Senie and Sally Webster (New York: HarperCollins Publishers, 2002), 221.

2. See, for instance, among others, Barbara Biesecker, "Remembering World War II: The Rhetoric and Politics of National Commemoration at the Turn of the Twenty-first Century," *Quarterly Journal of Speech* 88 (2002): 393–409; Carole Blair, "Contemporary U.S. Memorial Sites as Exemplars of Rhetoric's Materiality," in *Rhetorical Bodies,* ed. Jack Selzer and Sharon Crowley (Madison: University of Wisconsin Press, 1999), 16–57; Carole Blair, Marsha S. Jeppeson, and Enrico Pucci Jr., "Public Memorializing in Postmodernity: The Vietnam Veterans Memorial as Prototype," *Quarterly Journal of Speech* 77 (1991): 263–88; Carole Blair and Neil Michel, "Reproducing Civil Rights Tactics: The Rhetorical Performances of the Civil Rights Memorial," *Rhetoric Society Quarterly* 30.2 (Spring 2000): 31–55; Roseann Mandziuk, "Commemorating Sojourner Truth: Negotiating the Spaces of Public Memory," *Western Journal of Communication* 67 (2003): 271–92; Kirk Savage, "The Past in the Present: The Life of Memorials," *Harvard Design Magazine* (Fall 1999): 14–19; Mabel Wilson, "Between Rooms 307: Spaces of Memory at the National Civil Rights Museum," in *Sites of Memory: Perspectives on Architecture and Race,* ed. Craig Barton (New York: Princeton Architectural Press, 2001); James E. Young, "The Counter-

Monument: Memory against Itself in Germany Today," *Critical Inquiry* 18 (1992):267–96.

3. "Cultural projection" is a term used by political scientist Richard Merelman in his book *Representing Black Culture: Racial Conflict and Cultural Politics in the United States* (New York: Routledge, 1995). Merelman defines cultural projection as "the conscious or unconscious effort by a social group and its allies to place new images of itself before other social groups, and before the general public" (3).

4. Rosalyn Deutsche, *Evictions: Art and Spatial Politics* (Cambridge, MA: MIT Press, 1996), 52–53.

5. See Graves, "Representing the Race," and Richard Marback, "Detroit and the Closed Fist: Toward a Theory of Material Rhetoric," *Rhetoric Review* 17 (1998): 74–92.

6. Graves concludes that the sculptor, Robert Graham, "ignored the monument's audience and the fact that such a commission must be read against the complex reality of social, political, urban, and institutional history" ("Representing the Race," 255). We counter her argument by showing how the monument highlights, and makes culturally and rhetorically present, significant aspects of that complex reality.

7. Deutsche, *Evictions,* xiv.

8. See, for instance, Victoria J. Gallagher, "Reconciliation and Amnesia in the Birmingham Civil Rights Institute," in *Rhetoric and Public Affairs* 2 (Summer 1999): 303–320 and Victoria J. Gallagher, "Memory as Social Action: Cultural Projection and Generic Form in Civil Rights Memorials," in *Communities, Creations, and Contradictions: New Approaches to Rhetoric for the Twenty-first Century,* eds. Steven R. Goldzwig and Patricia A. Sullivan (Sage Publications, Inc., 2004).

9. Erika Doss, *Spirit Poles and Flying Pigs: Public Art and Cultural Democracy in American Communities* (Washington, DC: Smithsonian Institution Press, 1995).

10. This information, along with images and descriptions of some of Detroit's more famous sculptures and monuments, may be seen at http://apps.detnews.com/apps/history/index.php?id=165.

11. See Graves, "Representing the Race," 217–18.

12. Senie and Webster, eds., *Critical Issues in Public Art,* xii–xiv.

13. The use of the terms *rebellion* and *riot* is loaded as June Manning Thomas observes in *Redevelopment and Race: Planning a Finer City in Postwar Detroit* (Baltimore: Johns Hopkins University Press, 1997): "Official investigations concluded that the riots were cries for help, protests against the cumulative effects of discrimination, and demands for greater assistance. But they were also state-

ments of frustration with the existing social order, expressions of community pride and assertiveness. Hence, the insistence of many that these were urban rebellions or civil disorders rather than riots. Even their label is volatile" (127).

14. For a complete description of this campaign and the artworks that were sited during the period, see Dennis Alan Nawrocki and Thomas J. Holleman, *Art in Detroit Public Places* (Detroit: Wayne State University Press, 1980).

15. Senie and Webster, eds., *Critical Issues in Public Art,* xiv.

16. Ibid., 172.

17. Shirley Carswell, "Neat Statue, Strange Fist, She Decides: Joe Louis' Widow Sees His Monument for First Time," *Detroit Free Press,* November 10, 1987, 1A.

18. See "The Monuments of Detroit," http://apps.detnews.com/apps/history/index.php?id=165.

19. Thomas R. Hietala, *The Fight of the Century: Jack Johnson, Joe Louis, and the Struggle for Racial Equality* (Armonk, NY: M. E. Sharpe, 2002), 10.

20. Graves, "Representing the Race," 222.

21. Ibid., 225.

22. Marback, "Detroit and the Closed Fist," 85–86.

23. We are using the term "hegemonic" consistent with Merelman's definition: "dominant groups control the flow of cultural projection" enabling a "dominant group's cultural imagery to become the 'common sense' for all groups," thereby undercutting "the ability of subordinates to resist domination" (Merelman, *Representing Black Culture,* 6).

24. Ben Schmitt, "Man Accused of Defacing Joe Louis Monument Resigns Township Post," *Detroit Free Press,* March 2, 2004, http://www.freep.com.

25. See Jeffrey Zaslow, "Controversial Sculpture Is Defaced with Paint; Vandals Deny Racism," *Wall Street Journal,* March 4, 2004, http://archives.econ.utah.edu/archives/marxism/2004w09/msg00187.htm.

26. Images of the arch can be seen on http://www.globalsecurity.org/military/world/iraq/baghdad-monuments.htm. See also Kanan Makiya, *The Monument: Art, Vulgarity, and Responsibility in Iraq* (Berkeley: University of California Press, 1991).

27. Marback, "Detroit and the Closed Fist," 18.

28. Graves, "Representing the Race," 220.

29. Frederic Cople Jaher, "White America Views Jack Johnson, Joe Louis, and Muhammad Ali," in Donald Spivey, ed., *Sport in America: New Historical Perspectives* (Westport, CT: Greenwood Press, 1985), 181.

30. Merelman would refer to this as syncretic cultural projection, which he defines as a form of "mutual projection" that occurs when "dominants accept some of the subordinate cultural projection and subordinates accept some of

the dominant projection." Because it incorporates subordinate (as well as dominant) cultural imagery, syncretism may work to "weaken the cultural foundations of political domination in a society" (*Representing Black Culture,* 5).

31. Nathaniel Belcher, "Miami's Colored-Over Segregation: Segregation, Interstate 95 and Miami's African-American Legends," in Craig E. Barton, ed., *Sites of Memory: Perspectives on Architecture and Race* (New York: Princeton Architectural Press, 2001), 50.

32. Kenrick Ian Grandison, "Negotiated Space: The Black College Campus as a Cultural Record of Postbellum America," in Barton, ed., *Sites of Memory,* 58.

33. Thomas, *Redevelopment and Race,* 130.

34. Qtd. in Thomas, *Redevelopment and Race,* 174.

35. Mindy Fullilove, *Root Shock: How Tearing Up City Neighborhoods Hurts America, and What We Can Do about It* (New York: Ballantine Books, 2005), 11.

36. Interestingly, both Graves and Marback read *The Fist* as a black power fist. Graves, for instance, argues that it evokes the black power fist's emphasis on self-defense as "a crucial tenet of African American political theory from the Harlem Renaissance through the Black Panthers" ("Representing the Race," 222).

37. Michael C. Dawson, "Black Power in 1996 and the Demonization of African Americans," *PS: Political Science and Politics* 29 (September 1996): 456.

38. For a discussion of how federal policies and money (or lack thereof) for highways, home loans, and public housing impacted the fate of Detroit and its suburbs, see Thomas, *Redevelopment and Race.*

39. The information about the specific design aspects and the architect of the Detroit Renaissance Center summarized here is taken from Thomas, *Redevelopment and Race,* 156.

40. However, during a recent renovation of the complex spurred by new ownership, the berms were removed in the hopes of making it more accessible from the street. The entrance is on Jefferson Avenue and features a curved driveway and portico reminiscent of fine hotels.

41. Thomas, *Redevelopment and Race,* 157.

42. Ibid., 151 52.

43. Qtd. in Thomas, *Redevelopment and Race,* 158.

44. Thomas, *Redevelopment and Race,* 22–23.

45. Ibid., 270.

46. Richard Sennett, *The Fall of Public Man* (New York: W. W. Norton, 1976), 12.

47. Richard Sennett, *The Conscience of the Eye: The Design and Social Life of Cities* (New York: W. W. Norton, 1990), 201.

48. Doss, *Spirit Poles and Flying Pigs,* 21.

49. Amy Golden, "The Aesthetic Ghetto: Some Thoughts about Public Art," *Art in America* 62 (May–June 1974): 31–35.

50. Our use of the term "polarized" draws upon Richard Merelman's definition of polarization as a failed form of cultural projection that occurs when groups both "experience the pain of having their own projections rejected by others" and "struggle to fight off the projections of these same others" (*Representing Black Culture,* 6).

51. Bob Talbert, "Here's a Giant Fistful of Reasons to Hope," *Detroit Free Press,* October 29, 1986, 15B.

52. Paul Clemens, *Made in Detroit: A South of Eight Mile Memoir* (New York: Doubleday, 2005), 190–91.

53. Graves, "Representing the Race," 223–24.

54. Ibid.

55. Blair, Jeppeson, and Pucci, "Public Memorializing in Postmodernity."

56. Our use of the term "counter-hegemonic" is drawn from Richard Merelman's definition of counter-hegemonic cultural projection as a form of cultural projection that involves the conversion of "dominants to subordinate versions of the world," leading to dominants gradually becoming more accepting of subordinates and thus beginning to adopt a worldview "which immediately and definitively questions their right to power and which demands they cede power to subordinates" (*Representing Black Culture,* 6).

57. Celeste Headlee, "Why I Love Detroit, and This Sculpture," NPR *Morning Edition,* April 24, 2009.

3
Rhetorical Experience and the National Jazz Museum in Harlem

Gregory Clark

Aesthetic experience . . . is always more than aesthetic. In it a body of matters and meanings, not in themselves aesthetic, *become* aesthetic as they enter into an ordered rhythmic movement towards consummation.

—John Dewey, *Art as Experience*

Art, at least in the great periods when it has flowered, was the conversion, or transcendence, of emotion into eloquence, and was thus a factor added to life.

—Kenneth Burke, *Counter-Statement*

John Dewey and Kenneth Burke both understood the aesthetic to be rhetorical and the rhetorical to be a kind of experience. In Dewey's conception, the aesthetic realm reaches well beyond conventional notions of art to encompass the work of enabling people to inhabit "a body of matters and meanings" that constitute an assertion of what is or ought to be. That is why in *Art as Experience,* Dewey's key chapter on "Having an Experience" is followed immediately by a chapter on what necessarily follows from that experience: "The Act of Expression." And while Burke's discussion of the aesthetic doesn't develop from the word *experience* as Dewey's does, his well-known description of aesthetic form is itself inherently experiential: "an arousing and fulfillment of desires" that prompts a person to "be gratified by the sequence."[1] This is that "ordered rhythmic movement towards consummation" Dewey described as the experience of the aesthetic.[2] And for Burke, that kind of "consummation" is an encounter with "eloquence."[3] Eloquence is an experience that prompts people to change understanding, attitude, or intention, changes that are the ends of rhetoric. For Dewey and Burke both, people change in understanding, attitude, or intention in response to essentially aesthetic experience.

Although the work of both ranged widely, Dewey and Burke can be read as concerned primarily with the powers of rhetoric to prompt people to such change. That concern seems rooted in the recognition they shared

that in the twentieth century the American democracy with which each was fully identified might not thrive or even survive. And both understood that democracy to reach well beyond the realm of electoral politics to encompass the project of sustaining community through the ongoing rhetorical work of influence. So while neither of them wrote much about oratory or direct and deliberate persuasion, they both provided rich descriptions of the powers and the problems that are inherent in that work of influence, and they were interested particularly in the kind that is indirect and even unintentional—assertions of influence that take the form of experiences, experiences that when shared shape individual attitudes and actions in ways that enable people to construct and maintain their common life. In a democratic culture, some of this is public and even political work, but much of it is done informally and interpersonally. It occurs in the context of government, but we engage in most of our democratic work at home, on the job, at church, and among neighbors, family, and friends.

My project is to follow Dewey and Burke in examining the rhetorical power of the shared experiences that enable the work of maintaining a democratic culture to proceed. These experiences are best described as aesthetic, particularly those that contribute to the essentially civic project of shaping the identities of good democratic citizens. To do this, my essay needs to be more theoretical than others in this collection because its primary goal is to describe the rhetorical power inherent in cultural experiences that are essentially aesthetic in their form. Rhetorical critics have done extensive work describing a wide variety of discursive as well as nondiscursive rhetorical artifacts as rhetorical. But we have not followed far enough the suggestions of Dewey and Burke that *experiences* are rhetorical. Specifically, we have not considered sufficiently the theoretical implications for rhetoric that follow from their observations that experiences can be understood as rhetorical artifacts in which aesthetic form has rhetorical effect. This primarily theoretical essay explores some of those implications toward the end of contributing to the work of this volume to explain how the experiences people have in museums and at memorials have rhetorical effect. At that end, it converges with the primarily critical work of the other essays in this collection by engaging with them in helping us understand the rhetorical power that resides in the melding of memory and place.

The essay proceeds in three parts. First, I present an outline of a theory of rhetorical experience that follows from Dewey's and Burke's work on aesthetics as well as from Mark Johnson's much more recent description of the aesthetic as an encounter with embodied—which means, necessarily, experienced—meaning. Then I offer a description of the work of the

National Jazz Museum in Harlem (NJMIH) as an example of this theory put into practice. As I write in early 2009, this is a museum without an exhibit space. In the absence of exhibits, the NJMIH provides its patrons with experiences that enable them to encounter for themselves in Harlem people who made, and make, jazz music in this particular place. Using terms derived from Dewey, Burke, and Johnson, I describe the intention and the structure of some of the programmed experiences that do the commemorative work of this museum. I then conclude the essay by considering how this concept of rhetorical experience can broaden our understanding not only of the work of memorials and museums in particular but also of rhetoric in general, and in ways that might extend the reach of rhetorical criticism.

Toward a Theory of Rhetorical Experience

In his elegant study of *John Dewey's Ethics,* Gregory Fernando Pappas observes this: "To convince someone that, through a process of democratization, our life *can* become more aesthetic and intelligent, or that we *can* both secure freedom and organization, stability and openness, or that order and stability *can* be preserved in a way of life that is also open, free, and flexible, requires more than argumentation in today's complex conditions."[4] That statement, from a book subtitled "Democracy as Experience," summarizes how Dewey perceived democracy—as expansively cultural rather than merely political—as well as how he perceived rhetoric—as far more pervasive in that culture than instances of deliberate persuasion. The concept of experience is central throughout Dewey's work, and implicit in his use of that concept is the assumption that experience always does rhetorical work. Dewey insisted that experience is what does in a democracy the rhetorical work that prompts people to learn and to change, and in ways that help them sustain their identity and their action as a community. That is why he could write, "Shared experience is the greatest of human goods."[5]

So what, exactly, is experience? Dewey defined it as "the result, the sign, and the reward of that interaction of organism and environment which, when it is carried to the full, is a transformation of interaction into participation and communication."[6] As "the result, the sign, and the reward" of our interaction with our environment, experience is, in a word, a composition that we create for ourselves—on our own or using others' composition work as a guide—from otherwise inchoate encounters. "Carried to the full," this process of composition results in new understanding, new atti-

tudes, and even actions. For Dewey, experience is thus made meaningful in a moment of "consummation" that occurs when the elements of the experience coalesce into a unitary impression that prompts a response that is felt as well as thought—like one's response to a satisfying object of art. Such responses, in one way or another, are always expressed. Meaning prompts attitudes, and attitudes find expression in words or actions, however subtly. For Dewey, meaning is made from the raw materials of experience in an aesthetic process, and when those materials and that meaning are shared, when that meaning enters collective life, it becomes rhetorical. As he put it, "A piece of work is finished in a way that is satisfactory; a problem receives its solution; a game is played through; a situation, whether that of eating a meal, playing a game of chess, carrying on a conversation, writing a book, or taking part in a political campaign, is so rounded out that its close is a consummation and not a cessation. Such an experience is a whole and carries with it its own individualizing quality and self-sufficiency. It is *an* experience."[7]

Individualized and self-sufficient, experience is always located. It is a construct made from our encounters with places—including the people and events those places comprise—that gives us essential elements of identity and purpose. Creating that construct by organizing sensations and impressions into coherent and meaningful forms is the essence of aesthetic work. As Dewey persistently maintained, what we call art is but the most obvious instance of this kind of aesthetic work that we all must do to make sense of our lives. And like artists, we find that the experiences we compose express whatever sense it is that we are able to make. Whether we express that sense in words or in wordless actions, those expressions are made available by that act of expression to do the rhetorical work of influence. So experiences form and transform the attitudes, words, and actions that are the matter of our own encounters with others, and we necessarily express those to others. We make our own experiences from our encounters in particular places at particular times. But we also encounter experiences that have been composed for us to experience, that have been designed to influence and even direct the outcome of our own composition process. Particularly, these encounters—these rhetorical experiences that are provided for us more or less ready-made—should be objects of our rhetorical criticism.

While John Dewey helps us understand how experience is aesthetic in its form and effect, Kenneth Burke's insight that rhetoric does its work of influence by prompting changes in identifications helps us understand how the aesthetic—which, remember, Burke understands formally as an experience—does rhetorical work. Indeed, his insight that rhetoric does its work

by prompting identification first suggested to me the possibility that experience itself is rhetorically powerful and merits the closer attention of rhetorical critics. Consider this notion of a rhetorical experience in terms of Burke's description of the function of the rhetorical as a prompt to identification: "With [the term *identification*] as instrument, we seek to mark off the areas of rhetoric, by showing how a rhetorical motive is often present where it is not usually recognized, or thought to belong. In part, we would but rediscover rhetorical elements that had become obscured when rhetoric as a term fell into disuse, and other specialized disciplines, such as esthetics . . . came to the fore."[8] If the rhetorical motive of influence is put to work by a prompt to identification, the realm of the rhetorical does indeed encompass experience, especially if we consider the possibility that most of our experiences work rhetorically by prompting us to adopt, at least temporarily, a new identity.

Because he considered identity to be constituted of attitudes, Burke located the work of influencing attitudes in both the aesthetic and the rhetorical realms, a placement that undermines conventional distinctions between aesthetics and rhetoric. And undermining those distinctions was, apparently, always one of Burke's pet projects.[9] For example, he once explained how even lyric poetry is essentially rhetorical by focusing on the sort of experience it prompts in a reader. Functionally, he observed, the lyric "*strikes an attitude.*"[10] That is because "a lyric may be, on its face, but a list of descriptive details specifying a scene . . . [but in their effect] these images are all manifestations of a single attitude." So, too, with oratory. And even with visual images. Indeed, a very wide variety of expressions prompt those who encounter them with the same rhetorical appeal, the same attempt to influence, that the lyric presents to its reader. It is, in Burke's phrase, "'Come attitudinize with me.'"[11] Experiences extend the same invitation.

But how, exactly, does rhetoric proceed in prompting one to adopt an attitude? In Burke's early book *Counter-Statement,* aesthetic form is explicitly an experience: "A form is a way of experiencing; and such a form is made available in art when, by the use of a specific subject matter, it enables us to experience in this way."[12] That this experiential aesthetic is inherently rhetorical, that aesthetic artifacts do the work of rhetoric, is the argument—the counter-statement—of that book. Here is that argument in a summary statement Burke offered after the first forty pages: "We have made three terms synonymous: form, psychology, and eloquence. And eloquence thereby becomes the essence of art." Or, putting it another way, "Art, at least in the great periods when it has flowered, was the conversion,

or transcendence, of emotion into eloquence, and was thus a factor added to life." Consequently, "eloquence is simply the end of art, and is thus its essence." And by "eloquence" Burke means "a frequency of Symbolic and formal effects" that a reader, auditor, or observer encounters,[13] with a symbol being defined—and this brings us full circle—as "the verbal parallel to a pattern of experience."[14]

Two decades later, in *A Rhetoric of Motives,* Burke defined the rhetorical as an encounter that "seeks to have a formative effect upon attitude" as well as on action.[15] This explanation of rhetoric begins with the idea that attitude is the primary target of a rhetorical motive. Burke's readers know of his confession, made more than once, that "if I were now to write my Grammar over again, I'd turn the pentad into a hexad, the sixth term being attitude."[16] That is because attitude propels the other five terms of act, scene, agent, agency, and purpose in the formation of rhetorical motives. And Burke's work on the aesthetic as well as on rhetoric puts both in the service of prompting the adoption of an attitude. What I am calling a rhetorical experience most often takes the form of an encounter with a text in Burke's work, but not always—he uses music and visual art as examples as well. But the essential concept is this: aesthetic encounters take the form of experiences that are rhetorical in their effect as they prompt attitudes. Those encounters become civic in their consequences when those attitudes affect identities—when they prompt people who share the same experience to share, as well, a sense of who they are, individually and collectively.

In *A Grammar of Motives,* Burke described people who share attitudes as sharing the same "placement"—as inhabiting together a particular place in their common environment.[17] That alone prompts a sense of shared identity if not common purpose. And the sort of identity that he meant, as he put it later, is the kind that is shared "not just with mankind or the world in general, but [with] some kind of congregation that also implies some related norms of differentiation and segregation."[18] It is a civic identity, encompassing loyalties and boundaries and even responsibilities. Experienced in this way, identity is a set of attitudes held in common with others. And an experience that prompts that kind of identity becomes, in Burke's words, a kind of "unifying force" among people that "'sums up'" in action individual thoughts and feelings in ways that align them with common "'sentiments'" that "express and evoke a unified attitude" that is shared.[19] Rhetoric, then, transforms identity; identity is an expression of attitude; attitude develops out of experience; and experiences are aesthetic in their form. Further, experiences designed to be available to many, that

are made to be shareable, do the rhetorical work of prompting people to adopt for themselves a common—even a civic—identity.

Burke described this power of an aesthetic or rhetorical encounter to transform the attitudes that constitute an identity as its "poetic meaning."[20] Poetic meaning enables people to inhabit attitudes rather than merely understand them, because it has "not only a descriptive function, but also a normative function." In his obtuse explanation, poetic meaning is "hortatory"[21] as it considers "the complexities of moral growth."[22] By contrast, a merely "semantic" meaning would "cut away" and "abstract" every element of an experience that would "complicate the objective clarity of meaning"—it would describe your home by simply repeating the address of your house. But poetic meaning would attempt to encompass the life of your home by "heaping up these emotional factors, playing them off against one another, inviting them to reinforce and contradict one another, and seeking to make this complicating engagement itself a major ingredient of the vision."[23] This effort to invite, and even to require, the "active participation of those being addressed" emotionally and intellectually is an effort to communicate something well beyond information. It is presentation of an experience. Burke described poetic meaning as "obviously aesthetic." By contrast, he considered semantic meaning "anesthetic."[24] Interestingly, Dewey used the same set of opposing terms to describe what was, and was not, to be counted as an experience.[25]

In *Art as Experience*, Dewey described aesthetic experience in a rhetorical way that anticipates Burke's idea that rhetoric prompts people to identify with others: "Instead of signifying being shut up within one's own private feelings and sensations, . . . [experience] signifies active and alert commerce with the world; at its height it signifies complete interpenetration of self and the world of objects and events."[26] As a result, "we are carried out beyond ourselves to find ourselves."[27] This last phrase echoes what Kenneth Burke wrote about aesthetic form and the transformation of identity: that art does the work of "conversion, or transcendence, of emotion into eloquence, and [is] thus a factor added to life." In *The Meaning of the Body*, philosopher Mark Johnson explains how experience does indeed carry us beyond ourselves and, in doing so, he describes how experience can have rhetorical effect. For Johnson, the transformation of meaning—and consequently of understanding, attitude, and, ultimately, action—that is the effect of rhetoric follows directly from experience. By experience, Johnson means "our visceral connections to life and to the bodily conditions of life,"[28] connections that come, following Dewey, to "consum-

mation" when we compose them into a structure that brings the new meaning we are encountering to a "satisfactory conclusion." This work of composition is, for him as well, an aesthetic act.[29] Johnson understands the aesthetic to include "everything that goes into human meaning-making" and notes, as Dewey did, that "its traditional focus on the arts stems primarily from the fact that arts are exemplary cases of consummated meaning."[30] He insists that the primary materials we use to do this aesthetic work of meaning making are not conceptual. Rather, they are experiential. We gather them from the impressions and sensations we encounter as we inhabit, bodily, particular situations where we encounter particular people and events. "Human meaning," Johnson contends, "concerns the character and significance of a person's interactions with their environments. The meaning of a specific aspect or dimension of some ongoing experience is that aspect's connections to other parts of past, present, or future (possible) experiences."[31]

For Johnson, too, meaning is what we make out of experience. When fully composed—"consummated," in Dewey's term—its elements link present, past, and future. Burke would add that such linkages express attitudes. Johnson is explicit about what Dewey and Burke both differently imply: that experiences are inherently meaningful and, consequently, that meaning is itself inherently aesthetic. That is, our experiences express who we are and what we value in the same way that art expresses the identity and values of the artist. My point is that this aesthetic project of making experience meaningful is inherently rhetorical in both motive and effect. Experiences once composed, whether by us or for us, assert meaning. And when we find ourselves identifying with that meaning because we have adopted as our own the attitudes it expresses, we have been transformed. Such transformation is the work of rhetoric.

Designing a Rhetorical Experience:
The National Jazz Museum in Harlem

The National Jazz Museum in Harlem is still being created. In early 2009, its physical location is on the second floor of a building on 126th Street in Harlem in an administrative office and a small adjoining visitors center. There is not yet a dedicated exhibit space, though planning for one proceeds on the promise that the NJMIH will eventually occupy a prominent public space in the historic Victoria Theater on 125th Street, slated for redevelopment. Indeed, planning for an exhibit space has been ongoing since the inception of the museum in 2002, but in the meantime its lead-

ers have developed a rich array of programs that do not rely on exhibits for their success. For now, these programs—designed to provide locals and visitors alike with opportunities to encounter notable people whose lives are entangled in this place and its music—constitute the work of the National Jazz Museum in Harlem. The NJMIH locates these programs throughout Harlem: in its own office and visitors center, in nearby churches and schools, in local performance spaces, and even in parks. So the museum's exhibits are, for now, Harlem itself—or, rather, people of the Harlem community who embody the musical heritage as well as the contemporary jazz culture of this place. My purpose here in describing these programs, as well as those planned for proposed exhibit space in the Victoria Theater, is to present them as examples of deliberately designed rhetorical experiences. They are deliberately designed because the work of the NJMIH is, finally, rhetorical: to offer encounters with jazz music that change people's attitudes toward both that music and the musicians who make it. People experience that influence aesthetically in two ways: the subject matter of those experiences is music, and the experiences themselves affect people as Dewey and Burke described—through the rhetorical function of their aesthetic form. These events are intimate, friendly, and joyful as the residents of Harlem and visitors alike share an experience of the music. Here, patrons of the museum are invited by these encounters to share an identity as they understand themselves—at least temporarily—to be at home in this place.

On its Web site, the National Jazz Museum of Harlem describes its purpose and project in these terms: "Outside of its native New Orleans, no community has nurtured jazz more than Harlem. Duke Ellington, Benny Carter, Thelonious Monk, Charlie Parker, Charles Mingus, Count Basie, John Coltrane, Billie Holiday—all of their unique sounds reverberated throughout these fabled streets. Their legacy continues as the jazz musicians of today have also found a home in this community for their own contemporary sounds. The National Jazz Museum in Harlem is dedicated to fostering this spirit—the music as a living, breathing entity that looks as far into the future as it does into the past."[32] This project—to present Harlem as a home not only for jazz but also for people who enjoy it—is engaged in the work of changing identities. Harlem has been identified for nearly a century as an African American enclave, and most of that time as one that is perpetually depressed. The people who live there have been identified as marginal participants in the national community. The rhetorical project of the National Jazz Museum in Harlem is to change that identity by presenting this place and its people as vibrant contributors to the nation and its culture. And that project proceeds through a set of carefully designed

experiences with jazz music in Harlem that are made readily available to both residents and visitors. According to the design, what should follow for those who share the experiences is a change of attitude toward Harlem. The Harlem they are able to experience through this encounter with jazz music, the people who know it, and the musicians who make it is a community in which each jazz fan can feel welcome and at home.

This project began with a handful of influential New Yorkers who shared the concern that as development moved north from midtown Manhattan into Harlem, much of the heritage of the place would be lost. As jazz fans and students of American history and culture, they considered Harlem's twentieth-century role as the primary incubator of jazz music to be of national significance, and they developed the idea of a jazz museum that would preserve and present that significance to the public. In time, they were able to appoint a board of directors and an executive director to implement the idea, and the first act of the newly organized jazz museum in Harlem was to hold a planning conference.[33] Thirty prominent jazz musicians, writers, and educators gathered in Harlem for three days in early December 2002 to "lay out the shape of the Museum to come" in full acknowledgment of the rich history they would commemorate. They documented that acknowledgment in a group photograph (figure 3.1) posed at the site of that famous 1958 portrait of jazz greats, "Great Day in Harlem." But they wanted to do more than just preserve. The museum would attempt to teach people about jazz music and its significance in American culture as well. As the participants put it in their joint report, "the Museum has important archival functions to perform, [but] its main purpose is to make the jazz experience accessible to people with a wide variety of tastes."[34]

From its beginnings, then, this museum has been deliberately engaged in educating people about jazz and about Harlem, and doing so by providing its patrons with opportunities to encounter both subjects for themselves. As jazz historian Dan Morgenstern had reminded the participants in the planning conference, "There are dozens of [jazz] archives, [but] we're talking about a museum, with people walking in the door and all sorts of ways of educating them. That's our mission."[35] Jazz scholar Gerald Early added the point that "Jazz education is not about telling people what the music is. It's about telling people what the experience of listening to this music is and what the music does for them."[36] But as its work proceeded, the museum went beyond the telling of those things to helping people experience them. The chair of the board of the NJMIH at the time was Leonard Garment, a prominent lawyer and diplomat perhaps best known

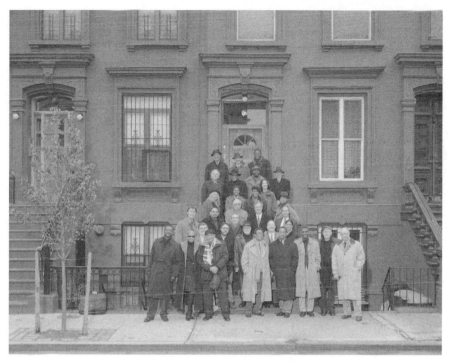

Figure 3.1. Participants in The National Jazz Museum in Harlem's First Planning Conference stand for a portrait at the 126th Street site of Art Kane's "Great Day in Harlem" photograph of 1958. (Photograph courtesy of the National Jazz Museum in Harlem.)

as an independent counselor to Richard Nixon in the last years of his administration. Garment told the *New York Times* that the work of this museum would be to "illuminate" for its patrons "jazz as an art form, jazz as a teaching instrument, jazz as a model of combined discipline and improvisation, and jazz as a supreme narrative, literary and musical, that has flowed through virtually every capillary of the nation's culture and set the mood for what we Americans think and feel about ourselves."[37] The work of the museum would go beyond the preservation and presentation of aesthetic artifacts, then. It would enable people to encounter jazz and the people who make it in light of their significance in American culture and their contribution to American national identity. This is rhetoric that does civic work.

Garment's statement recalls Kenneth Burke's description of aesthetic experience as the "conversion, or transcendence, of emotion into eloquence"

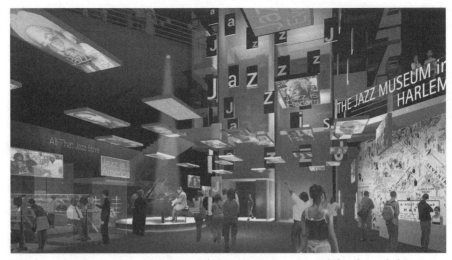

Figure 3.2. The media and music-rich Jazz Way as projected for the exhibit space of the National Jazz Museum in Harlem. (Photograph courtesy of The National Jazz Museum in Harlem.)

by asserting that the rhetorical outcome of the aesthetic work of jazz is, essentially, the transformation of identity—finally, of national identity.[38] Garment's language articulates the civic consequence of the rhetorical project of the National Jazz Museum in Harlem, a consequence that directs the museum to treat jazz as a means rather than as an end. It should preserve and present the music in ways that work aesthetically to the rhetorical end of transforming what this museum's patrons understand to be American. When they encounter jazz as an expression of the community of Harlem that, in turn, epitomizes the community of the nation, people change what they think Harlem is, what they think America is, and who they think they are in relation to those two collective identities.

After the planning conference, initial work did begin on concepts for an exhibit space. What resulted from this work was a design for a space that would provide patrons with experiences. Described as the "Jazz Way," this space would immerse people in the history of jazz in Harlem and enable them to move through it as they encounter both mediated historical performances of jazz as well as live performances by working Harlem musicians (figure 3.2).

Each stop along the Jazz Way would immerse patrons in the music, images, and artifacts of an era in the jazz life of Harlem. Interactive media would represent the history while local musicians working as docents would

Figure 3.3. Another stop along the Jazz Way. (Photograph courtesy of The National Jazz Museum in Harlem.)

both converse and perform (figure 3.3). In the space representing the 1930s, for example, patrons would examine instruments used by notables from the period, listen to early radio and record productions, and, in the centerpiece exhibit, actually inhabit music that emanates from archival video footage of a historical big band performance projected around them. As a patron approaches the image of an individual performer, she would hear his separate contribution to the ensemble, and moving back to the center of the space she would hear the separate parts blend. Audio and video would combine to locate patrons in the center of the band, enabling them to inhabit the music as an environment.

That is the plan. But the exhibit space has been slow in coming. The National Jazz Museum in Harlem has been promised significant space in the restored and expanded Victoria Theater, but it is not certain when that redevelopment project will proceed. In the meantime, the museum continues the slate of public programs it has been developing since its inception in 2002, the programs that make Harlem itself the museum's exhibit. By offering people opportunities to encounter jazz music as it has been and continues to be nurtured by the Harlem community, and by doing so within that community itself, the museum's aesthetic and rhetorical work becomes civic in its context and effect. Its project, as articulated in the planning conference, involves "tell[ing] about the music itself in an experiential, hands-on way."[39] That telling proceeds experientially through

Figure 3.4. A direct-mail postcard listing ongoing National Jazz Museum in Harlem events. (Photograph courtesy of The National Jazz Museum in Harlem.)

free performances, lectures, open interviews with notable people in jazz and Harlem, film screenings, and free classes presented by established and emerging musicians, dancers, critics, and producers (figure 3.4). And the people who gather at each of these events—events advertised widely beyond Harlem—create together a welcoming community, a feeling of being at home in a place that the NJMIH works to make available to anyone to inhabit—if only temporarily.

The program that has been around longest is "Harlem Speaks," a series of open interviews and discussions with people who have lived and worked with jazz in Harlem. Here, twice a month, musicians and other figures associated with the music and the place talk with an audience gathered in the museum's visitors center. The people featured in this series have lived a significant portion of the history of jazz as well as the modern history of Harlem, and they have national prominence. Their stories document important elements in the cultures—local and national—that this museum would preserve and perpetuate. The discussions are video recorded and archived, creating a growing collection of oral histories pertinent to jazz and Harlem in the twentieth century. So far this program has featured many important figures in the music, some of whom have since passed on. Among many others, people such as Milt Grayson (vocalist with Duke Ellington), drummer Roy Haynes, singer Bobby Short, pianist Billy Taylor, trumpeter Clark Terry, saxophonist Benny Golson, dancer and choreographer Mercedes Ellington, historian and civil rights activist Paul Robeson Jr., basketball great Kareem Abdul-Jabbar, and Harlem's congressman, Charles Rangel have participated.

Another program, "Harlem Swings," is a series of biweekly free concerts which alternates with the "Harlem Speaks" discussion series. "Harlem Swings" offers live performances from local musicians who play in a variety of jazz idioms. It is often located in an airy performance space above one of the new independent bookstores where the exuberant musical culture of contemporary Harlem is made freely available in a context that acknowledges its roots in jazz. A third program, "Jazz for Curious Listeners," is a series of free courses held once a week at a church in central Harlem and, more recently, in the NJMIH visitors center. These courses focus on how to listen to jazz, on classic jazz albums, and on particular figures central to Harlem's jazz legacy, like Duke Ellington. Taught by jazz musicians and critics, the courses involve live performances. "Jazz for Curious Readers" is a free course on the literature of jazz. "Jazz in the Parks" offers concerts in parks throughout Harlem, and "Harlem in the Himalayas" is a monthly series that takes contemporary Harlem jazz downtown to an acoustic performance venue in the Rubin Museum of Art. "Harmony in Harlem" is a partnership program designed to bring Harlem teens together to learn and play Harlem's jazz (figure 3.5).

These events do more than commemorate what Harlem has been. They attempt to present contemporary Harlem to residents and visitors alike as a community continuing to perpetuate a culture that produced a quintessential American music. But they also attempt to change the way that community is identified; and that change occurs when the museum's patrons find

Figure 3.5. A poster announcing the "Harmony in Harlem" youth band. (Photograph courtesy of The National Jazz Museum in Harlem.)

themselves feeling a part of that community as they attend these events. As the museum's executive director, Loren Schoenberg, has explained, these events are designed, finally, to prompt people to consider more carefully some difficult realities that are inherent both in this place and in this nation, but in ways that leave patrons more realistic as well as more hopeful about the future of both.[40] Jazz, then, is explicitly made the aesthetic means to that rhetorical end, an end that is reached as patrons find themselves identifying with this place. The aesthetic experience of inhabiting Harlem enables this identification and the changes of attitude that can follow from it. That change manifests what Mark Johnson, following Dewey, calls "consummated meaning" of the aesthetic experience: where "the meaning of something is a matter of how it connects to what has gone before and what it entails for present and future experiences and actions."[41] That is fundamentally rhetorical because, as Johnson puts it, "the meaning of a thing is its consequences for experience—how it 'cashes' out by way of experience, either actual or possible experience."[42] So there is more going on in these experiences than just these experiences—other rhetorical experiences can follow from their influence.

Rhetorical Lessons from the National Jazz Museum in Harlem

I offer this description of the plans and programs of the NJMIH to help explain how experiences do rhetorical work, and to enrich a theoretical study that can inform the work of rhetorical criticism. The work of this museum implements an explicitly rhetorical intention: to change attitudes toward jazz music and Harlem, toward African Americans, and toward America itself. Changing these attitudes changes identities—of the place, of its people, and of the nation that has treated both as marginal for so long. For this purpose, the NJMIH uses the aesthetic materials of Harlem's jazz heritage to do rhetorical work that is intended, finally, to "cash out" in civic consequences. The NJMIH makes freely available to anyone who can get to Harlem—or, in a form once removed, to anyone who views the growing gallery of photos and videos available on its Web site—an array of experiences with music and people that inhabit this place. These experiences are designed to immerse people for a time in the life of the community that each of these events constitutes, communities that invite them to feel at home there.

The identity that should follow from these experiences is essentially civic. Focused as they are on jazz, each of these events necessarily involves discussion, or enactment, or both, of democratic values. Jazz music

is often described as an aesthetic expression of democracy. That is because at its best the music emerges from the cooperation of equals each asserting unique individuality, but in the service of an ensemble performance. This is democracy in its ideal form. Performances of jazz that enact that kind of cooperation, and discussions of jazz that analyze the elements of such cooperation, can prompt people to consider more carefully than they might have before the problems and promises of a democratic culture. That consideration—whether in response to an aesthetic experience of the music or a rhetorical engagement in the discussion of the music—might render people more democratic in attitude and action. Those "difficult realities" that Schoenberg hoped the museum events might prompt people to consider are democratic matters. For both jazz and Harlem can be understood to be studies in democracy—in its successes as well as its failures. Contemplating the elements of those successes and those failures in the company of others—which the events of the National Jazz Museum in Harlem prompt people to do—might lead to more democratic attitudes and identities. For the leaders of this museum, that is the intention and persistent hope.

This intention to assert democratic values and this hope that people might be rendered more democratic in attitude and action by that assertion are both, as I have suggested, inherent in jazz music. Jazz is a collaborative music that must accommodate conflict without resolving it. At once highly structured and immediately improvised, intensely cooperative and yet individually expressive, the best jazz respects these opposites yet renders them harmonious. Essentially, jazz manages aesthetically the same problems that must be managed rhetorically by people who work together to sustain political communities. Without the final authority of a score, jazz musicians have considerably more freedom in an ensemble than musicians whose parts are fully written—freedom to challenge the authority of a composer or leader, to interject new ideas, to express their own emotions, to provoke conflict. Such is life in a democracy. To play together well, jazz musicians listen, always, very carefully to each other and then adapt at any moment of performance to the ways that others choose to play. Each individual's choice can create an aesthetic problem that the ensemble must work through on the spot with faith and grace and purpose. Good jazz succeeds at that, and there is lots of good jazz. But life is not very often like that in a democracy. Thus jazz has some lessons to teach us.

Jazz requires particular attitudes of its players then, attitudes that comprise a particular identity which is essentially civic in its role. As they cooperate in the moment of performance by listening and responding in ways that serve the aesthetic quality of the ensemble's performance, jazz musi-

cians come to value at once a fierce independence and a principled sense of accountability to others. They experience these values as attitudes, the foundational attitudes that aspiring jazz musicians must learn. Even technical skills and the jazz repertoire must be learned within the context of these attitudes. And these attitudes become an identity. I like the way ethnomusicologist Paul F. Berliner describes the process of learning to be a jazz musician in terms that suggest this development of an identity: "The value that the jazz community places on personal responsibility is especially appropriate for the artistic growth of initiates. Self-reliance requires them to select their own models for excellence and to measure their abilities against them. It enhances their powers of critical evaluation, cultivates their tastes, and provides them with an early sense of their own individuality. Overall, the jazz community's educational system sets the students on paths of development directly related to their goal: the creation of a unique improvisational voice within the jazz tradition."[43]

So there is much more going on at the National Jazz Museum in Harlem than music. This is the civic work of making a place for an individual in a group—which is also the essential work of rhetoric. In jazz, that work proceeds conspicuously as musicians learn, sometimes through harsh consequences, that individual freedom has value and meaning—and can be fully realized—only in the context of an ensemble project. It is in this way that jazz music can be experienced as an aesthetic expression and a rhetorical assertion of democratic culture.

The National Jazz Museum in Harlem uses music and talk in its events to aesthetically present experiences that do rhetorical work which is civic in its effect. And jazz scholars Daniel Fischlin and Ajay Heble note that there is nothing new about the idea of jazz music doing civic work: "Jazz has always been about animating civic space with the spirit of dialogue and collaboration, and . . . the innovative working models of improvisation and collaboration developed by creative practitioners have helped . . . to develop new, socially responsive forms of community-building across national, cultural, and artistic boundaries."[44] Using jazz to develop a new and socially responsive form of community building across the boundaries that separate Harlem and what it represents from the rest of America is the civic project of the National Jazz Museum in Harlem. Those who attend NJMIH events are immersed in communities where democracy is practiced with all the grace and beauty that follow from art, and it is hoped that people come away from that experience with attitudes and identities changed.

John Bodnar describes public memory as "a body of beliefs and ideas about the past that help a public or society understand its past, present,

and by implication, its future," an understanding that is "fashioned ideally in a public sphere in which various parts of the social structure exchange views." Ultimately, though, the purpose of the exchange is to address "serious matters in the present."[45] The work of the National Jazz Museum in Harlem is to create such a public sphere, but it is important for students of rhetoric to note that this rhetorical work is aesthetic in its form. Here the work of commemoration has its rhetorical effect through the aesthetic experience John Dewey called "consummation"—where an encounter with a composition of ideas and insights results in new understanding, a new meaning. Kenneth Burke would describe this as an encounter with eloquence, and would remind us that we experience eloquence as an encounter with "aesthetic truth."[46]

This language suggests that a rhetorical experience might be understood in traditional rhetorical terms as epideictic. The function of an epideictic speech is, as Gerard A. Hauser describes it in his discussion of Aristotle, to enable "virtue to make its appearance in civic life" by "celebrating the deeds of exemplars who set the tone for civic community."[47] Epideictic rhetoric calls attention to the community values it would assert by portraying them enacted. The rhetorical effect of that portrayal, as Chaïm Perelman and Lucie Olbrechts-Tyteca characterize it, is to bind people together in an experience of shared identity that works by "increasing adherence to the [common] values it lauds." They note that an increased adherence to particular values—Burke would describe this as a change in attitude—is prerequisite to collective decision making and action.[48] Further, Aristotle described epideictic presentation as a kind of narration—as the story of an enactment of those values rendered particularly vivid. As Hauser puts it, "Other modes of presentation might tell the community what a great person has done. . . . But the rhetorical version, along with the *mythos* of poetic, must concretize these virtues by displaying their manifestations in a distinguished life. The epideictic speech does not seek to *tell* what a person did, but to *display* nobility at the level of praxis."[49] A rhetorical experience, however, goes beyond this rhetorical work of display by enabling those addressed by the rhetoric to encounter that nobility, firsthand, for themselves—indeed, to inhabit that identity bodily. This is epideictic intensified. Here is Hauser's description of the rhetorical work of the epideictic, using terms that seem relevant to this concept of rhetorical experience:

> Commemorating a specific excellence makes its virtuosity intelligible to the community. The shared testimony of audience members both certifies the reality of this excellence as a civic virtue while

joining community members with bonds of affiliation to the celebrated values and deeds. Political actors cannot unite out of common interest without first recognizing shared bonds of community that transcend individual differences. A rhetoric celebrating the golden mean encourages tolerance and makes common action conceivable. It makes a public sphere a rhetorical space where community is invented and shared in performances of virtue through stories of significant individuals and momentous events.[50]

I think this describes quite precisely the work being done by the National Jazz Museum in Harlem.

So how does all this "cash out"? Perhaps that question has been answered already by the epigraphs with which I began this essay. "Aesthetic experience is," as John Dewey insisted, "always more than aesthetic." That is because it changes us—our attitudes, as Kenneth Burke taught us, and, consequently, our identities. We change as we experience through an aesthetic presentation what Dewey described as a "body of matters and meanings" moving us in "ordered rhythmic movement towards consummation."[51] That consummation is new understanding, new meaning, new insight felt as well as known. Felt and known at once, it satisfies. That is how aesthetic experience becomes, as Burke wrote, "the conversion, or transcendence, of emotion into eloquence." New understanding, new meaning, and new insight, felt and known, change us—our attitudes, our identities, and even our actions. That is why eloquence is experienced as "a factor added to life."[52] My point, then, is this: rhetorical critics might well take notice of the rhetorical power inherent in the essentially aesthetic encounter that is a rhetorical experience.

Notes

1. Kenneth Burke, *Counter-Statement* (Berkeley: University of California Press, 1968), 124.

2. John Dewey, *Art as Experience* (New York: Perigee Books, 1980), 326.

3. Burke, *Counter-Statement*, 41.

4. Gregory Fernando Pappas, *John Dewey's Ethics: Democracy as Experience* (Bloomington: Indiana University Press, 2008), 308. Emphasis in original.

5. John Dewey, *Experience and Nature* (Carbondale: Southern Illinois University Press, 1981), 157.

6. Dewey, *Art as Experience*, 22.

7. Ibid., 35.

8. Kenneth Burke, *A Rhetoric of Motives* (Berkeley: University of California Press, 1969), xxxi.

9. In conversation in 1989, Burke told me that his work was engaged throughout in breaking down distinctions between rhetoric and poetic.

10. Kenneth Burke, "An Eye-Poem for the Ear, with Prose Introduction, Glosses, and After-Words (Eye-Crossing from Brooklyn to Manhattan)," in *Late Poems, 1968–1993: Attitudinizings Verse-Wise, While Fending for One's Selph, and in a Style Somewhat Artificially Colloquial,* ed. Julie Whitaker and David Blakesley (Columbia: University of South Carolina Press, 2005), 25. Emphasis in original.

11. Burke, "Eye-Poem," 26.

12. Burke, *Counter-Statement,* 143.

13. Ibid., 165.

14. Ibid., 152.

15. Burke, *Rhetoric of Motives,* 50.

16. Burke, "Eye-Poem," 24.

17. Kenneth Burke, *A Grammar of Motives* (Berkeley: University of California Press, 1969), 24–28.

18. Kenneth Burke, "The Rhetorical Situation," in *Communication: Ethical and Moral Issues,* ed. Lee Thayer (London: Gordon and Breach Science Publishers, 1973), 268.

19. Burke, "Eye-Poem," 25.

20. Kenneth Burke, "Semantic and Poetic Meaning," in *The Philosophy of Literary Form: Studies in Symbolic Action,* 3rd ed. (Berkeley: University of California Press, 1973).

21. Ibid., 146.

22. Ibid., 147.

23. Ibid., 148.

24. Ibid., 149–50.

25. Dewey, *Art as Experience,* 47.

26. Ibid., 25.

27. Ibid., 199.

28. Mark Johnson, *The Meaning of the Body: Aesthetics of Human Understanding* (Chicago: University of Chicago Press, 2008), ix.

29. Ibid., 97.

30. Ibid., xi.

31. Ibid., 10.

32. The National Jazz Museum in Harlem, "Overview," http://jazzmuseuminharlem.org/overview.html.

33. Ron Scott, "Jazz Notes: Jazz Museum in Harlem," *New York Amsterdam News* 94.40 (October 2–October 8, 2003).

34. "Harmony in Harlem: The Jazz Museum in Harlem's First Planning Conference," December 11–13, 2002 (The Jazz Museum in Harlem), 1.

35. Ibid., 8.

36. Ibid., 16.

37. Leonard Garment, "The Changing Look of Harlem," *New York Times,* February 10, 2002.

38. Burke, *Counter-Statement,* 41.

39. "Harmony in Harlem," 21.

40. Loren Schoenberg, personal conversation, June 6, 2005.

41. Johnson, *Meaning of the Body,* 265.

42. Ibid., 10.

43. Paul F. Berliner, *Thinking in Jazz: The Infinite Art of Improvisation* (Chicago: University of Chicago Press, 1994), 59.

44. Daniel Fischlin and Ajay Heble, eds., *The Other Side of Nowhere: Jazz, Improvisation, and Communities in Dialogue* (Middletown, CT: Wesleyan University Press, 2004), 24.

45. John Bodnar, *Remaking America: Public Memory, Commemoration, and Patriotism in the Twentieth Century* (Princeton, NJ: Princeton University Press, 1992), 15.

46. Burke, *Counter-Statement,* 37, 41, 42.

47. Gerard A. Hauser, "Aristotle on Epideictic: The Formation of Public Morality," *Rhetoric Society Quarterly* 29 (Winter 1999): 14.

48. Chaïm Perelman and Lucie Olbrechts-Tyteca, *The New Rhetoric: A Treatise on Argumentation,* trans. John Wilkinson and Purcell Weaver (Notre Dame, IN: University of Notre Dame Press, 1969), 50.

49. Hauser, "Aristotle on Epideictic," 14 15. Emphasis in original.

50. Hauser, "Aristotle on Epideictic," 19.

51. Dewey, *Art as Experience,* 326.

52. Burke, *Counter-Statement,* 41.

II
Memory

4
Bad Dreams about the Good War

Bataan

John Bodnar

(argument)

The public memorials dedicated to World War II and to the Vietnam War on America's National Mall could not be more different. The first is cast in the aesthetics of the traditional memorial and works assiduously to diminish the legacy of individual suffering and proclaim the unity and victory of the nation. Ideas of unity and victory are eliminated in the latter memorial, which is dominated by the names of the American dead. Many Americans would probably accept the point that tradition as a frame of remembrance has come to dominate the public memory of World War II in our times but not the remembrance of Vietnam. And many might assume that this difference is at least partly attributable to the fact that Americans in the 1940s were part of a generation that was more willing to accept the huge sacrifices asked of them and move on with their lives than generations that followed them. Yet, a brief survey of the memorials citizens erected to the memory of a central event of World War II—the capture of American forces at Bataan in 1942—suggests that even in the '40s citizens were prepared to question the need to sacrifice for their nation and interpretations of the war that were grounded solely in the language and aesthetics of tradition. When it came to remembering Bataan, individuals who experienced it revealed that they too could insist that the costs of war not be forgotten.

Wars bring to nations not only hardship and death but massive cultural struggles over meaning. The public memory of such events is invariably central to any sense of a common past citizens hold and the definition of who they think they are as a group. World War II, therefore, has often served as a symbolic statement of how courageous and virtuous Americans think they are because it ostensibly demonstrated that the affiliation they felt for their country was so powerful that they eagerly lined up to join the fight against evil regimes in the world. Vietnam questioned that virtuous identity and unshakeable sense of belonging and raised questions about the nation's unity. The memory of the world war tended to foster a sense of honor; the remembrance of the Vietnam War created for many feelings of

shame and regret. The fact that these two conflicts have achieved differing symbolic meanings, moreover, is a vivid reminder that the public memory of a nation is susceptible to disagreement, varying layers of meaning, and conflicting emotions. Such debates reveal just how "public" is the process of creating a shared past in any nation and just how many interests have to be served. Thus, any analysis of the nature and fashioning of this public memory, as Carole Blair, Greg Dickinson, and Brian Ott make clear in the introduction to this volume, must ultimately be seen as rhetorical. It must focus on the various discussions, aesthetics, voices, and practices that attempt to bring order and—what they call—"legibility" to a past that ultimately no one can know for sure.

(arg.) For centuries, tradition has served as a powerful device to organize knowledge about the past. Because images and words cast within the frame of tradition seek to aim the lens of remembering toward the sacred and the mythical and away from the literal and the tragic, they have served well the interests of nation-states that have waged war and those people within the nation that seek to find in war's tragic aspects some noble purpose. Encounters with state-sponsored trauma—as Jenny Edkins has argued—usually serve as a "revelation" to people because such events "strip away" the faith many have in their political community and expectations that belonging to such communities or nations will provide them with a safe and stable home and, for that matter, a future. Grievous losses in wartime can undermine the bonds of loyalty individuals have to a nation-state. That is why the public remembrance of war is such an important subject in postwar cultures. The meaning of violent conflicts has to be cast in the most virtuous of terms if the destruction and ruptures that war brings to towns and families are to be accepted as a legitimate policy of the nation and if sacrifices are to be seen as redemptive rather than regrettable. The remembrance of World War II in our times has suggested that the rhetorical work involved in casting its public remembrance in a traditional mold was not that difficult. The aim of this essay is to suggest, however, that it was and that many individuals were not prepared to forget the war's tragic aspects.[1]

(arg.) "Traditional motifs," as historian Jay Winter has called them, were not simply used to serve the interests of state power. They have enjoyed a good deal of popularity over time and in many nations because they tend to explain well why some have to die and suffer in war.[2] Citizens are invariably drawn to notions that dying in war is noble and patriotic more than they are to ideas that such losses were simply futile or lamentable. Tradition is deployed not simply because of its noble and popular appeal, however, but

because it has to work—culturally speaking—to erase sentiments of sorrow and regret that people experience when they face the loss of those that are near and dear. In a sense, a traditional frame on remembering war is necessary to heal the breach that war creates between a nation and its citizens. Listing the names of the dead can be seen in patriotic terms. As long as they remain visible, however, they sustain a critical take on the past as well because they signal a refusal to forget a sense of loss. Historically, the listing of the dead has been more central to the way local communities recall wars than to national images and memorials. Names invariably appear on markers in parish cemeteries or on plaques on town monuments and civic buildings and, by their very nature, raise questions of whether the tragic aspects of war were justified. Generally, they are placed alongside markers of tradition such as national flags or statues of heroic soldiers, which are meant to reassure publics that they were. The Vietnam memorial did not invent this form of commemoration but simply brought it to a national "place." Few understand, however, that long before the debates over Vietnam, the generation that fought World War II resisted efforts to have the public discussion of that conflict efface the complex set of feelings that remained on the local level, and they insisted that the dead not be omitted from public memory.[3]

Traditional images certainly marked the most famous national memorials Americans built to World War II. The first instance of this was to be found in 1954 with the dedication of the United States Marine Corps War Memorial, which celebrated both the contributions of the Marines and the ideals of national unity and national victory. Indeed, the Marine memorial was reproduced in countless ways in American culture after 1954 and appeared on everything from tourist mementos to textbook covers in public schools. Inspired by the famous photograph of the raising of an American flag during the battle on Iwo Jima in 1945, this monument was notable not only for the central place it came to occupy as a cultural icon in the patriotic story of America's victory, but because it managed to evoke the memory of one of the bloodiest battles of the Pacific war without any hint that there was an enormous loss of life on the island. No names of dead soldiers appear here. One can see the names of pivotal battles Marines fought throughout American history around the base of the massive structure and an inscription proclaiming that American troops in these struggles exhibited "uncommon valor." Indeed, the representation of victory here without the spilling of blood so upset Dwight Eisenhower in later years that he cut short his attendance at the dedication ceremonies. Of course, the focus on valor, victory, and the image of national unity in the war endorsed by

the fusing of the statues of soldiers together in a common effort to raise the flag should not have been surprising. The entire effort to build this "traditional" memorial was led by the Marine Corps itself, which sought to ratify its importance in the postwar era when some military planners were beginning to think more of the importance of air and naval power. Thus, the corps hired the public relations firm of J. Walter Thompson to help promote the idea of the memorial and to raise the funds necessary to build it.[4]

arg.

In real life some of the men portrayed in the statue and their families carried emotional scars into the postwar era if they survived the war at all, something, of course, that the iconic memorial did not convey. Their private pain remained in private places. In his bestselling book *Flags of Our Fathers*, James Bradley describes how his father, who was part of the flag-raising team, returned to Wisconsin after the war to raise his family but grieved for years over the loss of one of his best friends on the island. The elder Bradley was haunted by the memory he carried of seeing the mutilated body of his comrade from Milwaukee and could not bring himself to talk about his experiences for the rest of his life.[5] Ira Hayes, a Pima Indian from Arizona, was also part of the flag-raising unit and had volunteered for the war because he felt the call of duty and the need to represent his tribe in a positive way after years of impoverished living on government reservations. After the war he lamented the loss of many of his friends and increasingly turned to heavy drinking, angry that despite his wartime service and that of others like him, the plight of the Pima community had not seemed to improve measurably. In 1955, he died alone in the Arizona desert with almost no money, just three months after attending the dedication of the Iwo Jima memorial in Washington.[6]

Another Marine who helped to raise the flag but died later in the fight for Iwo Jima was Michael Strank, the son of a Slovak-American coal miner from Franklin, Pennsylvania. In the public commemoration of the battle and in stories told by survivors, Strank was portrayed repeatedly as a model Marine. James Bradley called him the "prototype American fighting man" and a "consummate leader of men." When Strank was interred at Arlington National Cemetery in 1949, his family attended along with members of his hometown who traveled by a bus chartered by Sergeant Michael Strank Post, Veterans of Foreign Wars. At a ceremony in nearby Johnstown in 1985—where a replica of the Iwo Jima memorial still exists—Strank was referred to as a "rough, tumble, hard-nosed Marine" and "the kind of person everyone wished they could become." The following year this veneration of Strank continued when Joe Rodriguez, who served with him

on Iwo Jima, said in a speech that he was a "hero" and a "shining mentor." But in less formal remarks to a reporter, Rodriguez recalled seeing Strank's "mangled body" at his feet. And in the home of the Strank family, the soldier's parents continued to grieve long after the war. His father would never talk about his son's death. And Strank's sister recalled that her mother and Michael himself had seen his military career, one he began by enlisting in 1939, as an effort to help lift his family out of the lower depths of working-class life they had inhabited for years. Thus, Strank's mother took his death hard not only because it represented the loss of a beloved child but because it represented to some extent the end of a set of expectations. Today his sister still keeps what the Iwo Jima memorial does not show— the telegram that arrived at the family home in 1945 announcing the death of her brother.[7]

Five decades after the dedication of the Iwo Jima memorial, the World War II Memorial was dedicated in the middle of the Mall—the most sa-clrg. cred commemorative space in the nation. Most observers have noted how its classical design and celebration of national victory tended to invoke traditional ideals of patriotic honor and national unity and how the new site worked against the more ironic representations of the wars in Korea and Vietnam which are situated nearby. But this memorial should also be seen as a mode of public art that works diligently to forget much of what it promises to commemorate—the experience of America in World War II. Images of soldiers moving cautiously through a field of battle or the names of the dead that can be found at the Korean and Vietnam memorials are nowhere to be found at this site. There is no sign of "mangled" bodies or dispirited veterans such as Ira Hayes. Some 400,000 American deaths are now represented only by 4,000 gold stars. In the memorial's classical arches and columns, the sordid reality of war gives way to what Edkins would call an effort to "encircle" the legacy of trauma and loss or eliminate it altogether in order to restate the war in the sacred categories of honor and national unity.[8]

The idea for the memorial came from a veteran of the war—Roger context Durbin, a mail carrier from Ohio. On a visit to Washington in 1962, Durbin noticed that there was no national memorial to the war. He was aware that the Iwo Jima memorial was designed to honor the Marines, although it served as a national reminder of the American victory. Durbin had also been struck by the abundance of commemoration of the war in Europe and the recognition that many of his comrades were dying at an increasing rate and that the time to honor them was growing short. In 1987, just five years after the highly public response to the dedication of the Vietnam Vet-

erans Memorial, he told his congressional representative of his idea for a World War II memorial. An organizing effort led in part by Senator Bob Dole, a veteran of the war himself, and actor Tom Hanks managed to eventually raise some $190 million to build the new memorial. Hanks's star power and role in the fund drive was magnified substantially by the fact that he played the lead in the 1998 film *Saving Private Ryan*. Wal-Mart alone donated $14 million to the campaign, and substantial donations came from veterans groups such as the American Legion and the Veterans of Foreign Wars.[9] Ironically a film produced for the fund drive did depict the real pain and trauma suffered by some of the men who fought. In one scene Dole tells of his "near-death experience" when wounded by the Germans in Italy and how he had to struggle after the war to rehabilitate himself. In another scene Luther Smith, an African American veteran and member of the Tuskegee Airmen who flew missions over Europe, reminds viewers not only of black soldiers' sacrifices during the conflict but of the fight to integrate the armed forces after 1945. And a Japanese American describes how many of his people fought bravely in battle despite the fact that their relatives were imprisoned by the U.S. government in detention camps.[10]

cont.

Memorial designers and planners consciously opted to use classical rather than graphic images at the memorial. One plan they rejected simply because it was seen as too literal was based on the concept of an underground bunker and was intended to evoke the idea that during the war many had to find ways to survive the violence. In this plan, a museum was to be built within the bunker where visitors could view wartime newsreels, a statue of a grieving mother, and copies of Norman Rockwell's artistic renditions of the Four Freedoms. The winning design by Friedrich St. Florian, however, moved away from reminders of a complex past to focus on the more abstract idea of victory and national unity. His memorial is dominated by a series of fifty-six granite pillars representing the forty-eight states, seven territories, and the District of Columbia that constituted the nation in the early 1940s and the idea that Americans were united in their fight against a common enemy. Inscribed in front of the wall of gold stars is an inscription that says "here we mark the price of freedom." At each end of the pillars stand "victory arches," one for the Pacific theater and one for the Atlantic. St. Florian has explained that his classical forms would convey a sense of "timelessness" and the "essence" of the American victory—that it "allowed the free world to continue to be a free world." There are a few bits of "realism" in the memorial: small panels carved into the sides of the structure depict wartime scenes such as the attack on Pearl Harbor, the D–Day landing with a dead body on the beach, women working in a

war plant, and a war bond parade. Names of specific military operations are also to be found. But, ultimately, all of the words and images are dominated by a rhetoric of tradition designed to evoke a sense of honor and national pride. The communal, familial, and individual dimensions that were central to the experience of the wartime generation do not exist at this site. This is not meant to be a memory place where people can mourn the dead or lament all that might have been lost. In its effort to sustain the glory and the power of the nation itself, the World War II Memorial mimics the Lincoln Memorial, which contains little hint of the destruction of the South or the carnage of the Civil War and mostly celebrates the preservation of national power under the leadership of the godlike figure of the sixteenth president. The World War II Memorial continues the project to narrate the history of the United States as a powerful and virtuous nation. At its ceremonial entrance, words proclaim that "here in the presence of Washington and Lincoln . . . we honor those twentieth century Americans who took up the struggle during the Second World War and made their sacrifices to perpetuate the gift our forefathers entrusted to us: a nation conceived in liberty and justice."[11]

The power that tradition has exercised over national memorials to World War II in the nation's capital could not always be replicated in local places. Certainly Americans have revealed a sense of pride and patriotism when they memorialized World War II in their communities, but the point is that the more memorials were tied to local experiences the more they seemed reluctant to accept the idea that the tragic aspects of the war should be completely forgotten. At the very least, local memorials were more insistent about listing the names of the dead. This practice was widespread and well under way in places such as Omaha, Nebraska, which dedicated a memorial with over 900 names of those who did not come home in 1948. Local memorials were also more inclined to restate the war in terms that were more authentic and exact by displaying weapons from wartime battles or sentiments of regret or remorse over all that was lost. The remainder of this essay hopes to explore this point by concentrating on the particular experience of Bataan and the way it was memorialized in a number of locations. Space does not allow for a full consideration of how Americans memorialized the "good war," but the contrast between images deployed nationally and locally is suggestive of larger rhetorical differences within the wartime generation between those who wanted to frame the war in traditional terms and those who did not.

New Mexico is a good place to begin a discussion of the public remembrance of the American defeat and surrender at Bataan. In this southwest

context

ern state far from Washington, a sense of patriotic honor was evident but invariably had to share cultural space with powerful traces of anguish that marked the experience of many of the men who came home. In April of 1942, American troops in the Philippines were cut off from the outside world by Japanese forces. In the immediate aftermath of Pearl Harbor there was little the American government could do to help these troops. Thousands of American and Filipino soldiers were forced to surrender to the Japanese and set out on a death march to enemy prison camps. The captives were treated harshly, they were denied water in the hot sun, and stragglers were often bayoneted. Some 600 Americans and almost 10,000 Filipinos died on the Bataan death march alone. But the details of this horror emerged only slowly. It was not until early in 1944—as more American offensives were beginning in the Pacific—that the government released details of the brutal treatment American troops suffered during the march, a revelation that caused an angry outburst and calls for revenge among citizens on the home front and a spike in war bond sales.[12]

arg.

The surrender at Bataan affected some locales much more than others, moreover, because the American forces at this time consisted of many federalized National Guard units which were often made up of clusters of men from a particular community. Many of the men, in fact, had joined the National Guard before the war in the late 1930s as a way to earn some extra money when economic difficulties pervaded America. Thus, it was not unusual for large groups of men from one town to find themselves as prisoners of war. New Mexico was hit especially hard in this regard because two artillery units consisting of some 1,800 men—in a sparsely inhabited state—were now behind enemy lines. Ultimately about one-half of this entire group never came home.

Commemoration of the Bataan losses began almost immediately in New Mexico during the war itself and revealed that people were often likely to invoke traditional words and images without much prompting from higher authorities. In 1943, a local "mother's club" in Deming was organized to raise funds to build some sort of memorial. One announcement for the fund drive contained a poem which claimed that the sacrifices made by the men would lead to the spread of freedom around the world and that some of them had "fought and died in valor's name." A year earlier the city of Albuquerque had purchased land to build a "Bataan Park," which was officially dedicated four years later. In 1960, a monument was placed in the park by members of a "Bataan Club" composed of mothers and other relatives of the captured men who expressed "grateful appreciation" to the soldiers who fought and suffered. In 2002, twelve pillars were

built next to the monument listing the names of the 1,816 New Mexicans captured on Bataan and indicating which ones never returned home alive. The pillars were placed in a line to evoke again the memory of the death march the men were forced to make in 1942. An article in the *Albuquerque Journal* in 2002 said the "brave and heroic" actions of the men contributed to the war effort by helping to delay the advance of Japanese forces in the Pacific theater. In all of this commemorative work, it is apparent that traditional frames proved powerful and enduring but that there was also a strong resistance to forgetting the pain and the tragedy of the march and the subsequent loss of the men.[13]

Monuments dedicated to the men in Deming and Las Cruces paid considerable attention to the suffering soldiers endured. In 1991, on the fiftieth anniversary of the start of the war, Deming recognized its losses when it dedicated a monument focusing on the idea of the buddy system that helped the men as they endured the hardship of imprisonment. The men felt essentially that they had to rely on their comrades in order to survive. Two figures of the imprisoned men dominate the monument, with one man assisting another who appears to be emaciated. Behind them are barbed wire and a watch tower, and below them are the words "Bataan-Corregidor" (figure 4.1). Men are also seen comforting comrades on the death march in a monument dedicated in Las Cruces in 2002. In Santa Fe, a Bataan Memorial Museum has been created under the direction of Rick Padilla which offers even more details of local men's experience of the war. In one display a telegram from the War Department is presented informing parents that their son was killed. And in another exhibit a letter from a parent to a soldier is seen expressing the hope that the man would someday return home. Visitors are told the man did not.[14]

The actions of one survivor of the death march, Manuel A. Armijo, reveal how deep the feelings of loss and sorrow were in many of the men who returned. On the first anniversary of the surrender after the war in 1946, Armijo mounted his own commemorative event by lowering the United States flag that flew in front of the state capitol building in Santa Fe and replacing it temporarily with a white flag of surrender. He would repeat this ritual on the same date every year until he died in 2004. By 1975, in fact, this ceremony had expanded into a public event that included the attendance of other veterans and their supporters, the playing of music and the lighting of symbolic candles for the men who did not come home, and the reading of a story entitled "The Voice of an American Boy." The tale reflected the essential mixture of sorrow for the men who died with a refusal to forget them and a traditional affirmation that their service in World

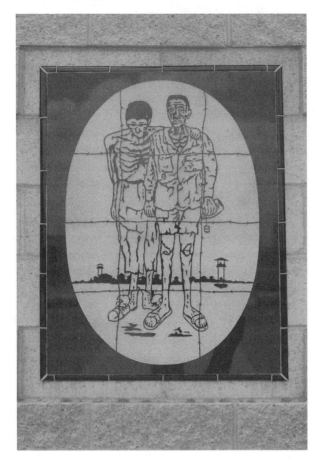

Figure 4.1. Bataan Memorial, Deming, New Mexico. (Photograph by Erin Michelle Photography.)

War II was virtuous and honorable. A speaker would read that the "American Boy" represented "the empty space" created by those who never returned. These men were portrayed as "happy" in their love of everyday life before the war when they played football or took part in normal family activities. It was also stressed that they did "not die in vain" but for "a cause, for the freedom of the greatest nation on the face of the earth." Armijo stated that he hoped the celebration would "keep history alive." But he had in mind not so much a glorious national history as one centered on the suffering and the death of these men from his home state. Today the Bataan museum in Santa Fe displays a piece of sculpture with the inscription "Lest We Forget," which depicts men walking on the death march and the figure of a GI lying on the ground with a Japanese soldier holding a rifle behind him.[15]

Indeed, Armijo's personal experience with the war and its aftermath had been quite painful. He had not only endured the infamous march but had been pistol-whipped by a Japanese guard while in a prison camp. In a documentary film entitled *Colors of Courage: Sons of New Mexico/Prisoners of Japan,* Armijo's daughter claims that for a time after he returned home he was despondent and felt that "God had abandoned him." And in the same film he is pictured returning to the Philippines and crying in front of a memorial to the prisoners at Camp O'Donnell when he sees the names of friends who never came back. Armijo himself exclaims that as a prisoner he felt both "helplessness" and "hopelessness." His wife also recalls that for many years after the war he would yell during the night.[16] And in 2004 Armijo told a reporter that he still had dreams of "prison guards" and still woke up "screaming" and "dreaming." "It just hasn't gone away. It never goes away," he exclaimed.[17]

Armijo was not the only one haunted by traumatic memories of the war. Hank Lovato was unable to sleep as well for years and claimed that he "just wandered around at night and slept on the floor." Don Harris had recurring dreams of bombs falling on him. James Gunter, another former POW from New Mexico, said he went to work each day mainly to avoid getting drunk. Others claimed they found it particularly trying to have to face the relatives of comrades who never did return. Gerald Greenman of Deming said he found his hometown to be "too depressing" after the war because so many friends had not come back—a point that suggested one reason why the horrors of war were more difficult to forget in local places. Many other veterans were so shaken by the experience in the Philippines that they could find little solace in the language of patriotism. These men felt they were simply lucky to be alive and wanted to thank God for their deliverance. Many of them joined a huge procession of veterans and other religious worshippers in 1946 on the annual walk and pilgrimage to a sacred chapel at Chimayo, north of Santa Fe, in order to give thanks for their very survival. Since 1816, descendants of Pueblo Indians and Spanish settlers had made the trek at Easter time to the sacred spot which was reputed to be a place where the sick could be healed and where those in distress could find consolation.[18]

The survivors of Bataan and their supporters expressed not only gratitude to God and sorrow for the death of comrades, but also signs of continuing anger toward the Japanese. In *Colors of Courage* Armijo recounts a story of meeting President Harry Truman after the war and telling the president that he very much appreciated the fact that he dropped the atomic bomb on his enemy. Truman hugged him and told him he never once re-

gretted the decision to use the new weapon. In 1999, many Bataan vet-
erans became outraged when the Santa Fe city council passed a resolution
to erect a historical marker at the site of a former internment camp for
Japanese Americans near the city. One man stated his intention "to defe-
cate" on the marker. Armijo's son-in-law, Clarence Lithgo, exclaimed that
the council had "just kicked the Bataan veterans in the teeth in the twi-
light of their years." Armijo himself asked why the council could not just
wait until he was dead, for the entire episode "opens up old wounds" and
"hurts." Some vets, however, were more forgiving, and one indicated that
when he had returned from the war he had noticed the guard towers at the
local internment camp because they reminded him of his own imprison-
ment at Camp O'Donnell and was willing to let a new marker stand.[19]

cont.

In 1982, a public television station in Albuquerque (KNME) produced
a documentary entitled *Memories of Hell* which offered the public more
recollections of the men from Bataan. Again the remembrance was domi-
nated not so much by victory or heroic accounts of war but by expressions
of sorrow and regret. A narrator opens the feature by saying that this story
is about a group of New Mexicans who lived with "painful and haunting
memories of a hell that dates back more than forty years." These guards-
men were referred to as the "cream of New Mexico's youth" and "patri-
otic boys." But the film also features a song composed by one of the sur-
vivors, Lorenzo Bangegas. It is essentially a straightforward rendition of the
experience of going to war and getting captured. The men sing of "days
of surrender" when they were "forced to march" and how vulnerable they
felt as prisoners because there was "nothing we could do." During the
song, producers inserted photographs of American prisoners in the Japa-
nese camps. Near the end of their musical story, the men talk about the
joy they felt in seeing loved ones again. For these veterans the war was less
about national unity and victory, and almost entirely about suffering and
surviving long enough simply to make it home.[20]

In some ways "traditional motifs" proved to be more powerful in shap-
ing the public account of the surrender during the war itself than they
were once the crisis had passed. This point can be made by looking briefly
at the experience of Harrodsburg, Kentucky, another community severely
impacted by the surrender and the march of prisoners to Japanese camps. In
this town sixty-six local men were suddenly reported as missing. *Life Maga-
zine,* always quick to see a good war story, sent a reporter to Harrodsburg
in the summer of 1942 to find out how the town was responding to the
news about Bataan. In the midst of the patriotic sentiment of wartime, the
article reported that local people remained certain the men would prevail—

with many putting their photos in storefronts—and that they continued to support the war itself. They were even making plans to build a new National Guard armory which the men could use when they returned home. *Life* did admit, however, that the "swallowing up of sixty-six of its young men in a single day is hard to bear."[21]

Efforts were quickly made in the town—before many of the details of what had happened were even known—to fold the emerging story of Bataan into a larger traditional narrative of the founding and history of Harrodsburg itself. In June 1942, just after the men were captured, speakers at the annual celebration of Harrodsburg's founding took note of the losses in the Philippines and compared the men of Company D, 192nd Tank Battalion to the "Mercer County Boys" who defended settlers on the Kentucky frontier some 150 years ago. The *Harrodsburg Herald* even claimed that captives "demonstrated that young American manhood is as good today as it was 150 years ago" and continued to carry on a tradition that began with "winning the West." Now, the paper felt they would help in the "winning of the Far East." Local editors also believed the men would still be fighting if they had not run out of food and ammunition—thus keeping alive a sense of them as brave and strong fighters. A reporter noted there was some sadness in the community during the June celebration "over the fate of the men" but that mostly people talked about the "valor, bravery, and sacrifice" the tank battalion manifested just as "the pioneers" did before them.[22]

During the 1942 anniversary parade, a special effort was made to see the men as heroic. A line of tanks from Fort Knox moved down the parade route suggesting military might instead of the tragedy that was taking place in Asia, and young girls placed flowers at a national monument to George Rogers Clark and other Kentucky pioneers "who died in the wilderness." The town's historical society even staged a program "in grateful recognition of the heroic soldiers of Mercer County" in front of a larger honor roll that contained the names of local men who were serving in the war. A reporter from the *New York Times* at the event learned that most local citizens actually had heard almost nothing about the captured men or their fate in the first few months after the surrender. One local man, however, believed that the local boys were most likely waging guerrilla operations against the Japanese, so strong was the idea that the men would surely be brave warriors and not vulnerable prisoners of war. Another local man with two sons in the armed services said that he did not want his boys to go off to war but that he also did not want a "slacker" in his family and that it was "right that these men should fight."[23]

Throughout the remainder of the war, information on the fate of the

men reached Harrodsburg only sporadically. In the fall of 1942, one mother reported that she had sent a cake to her son just to have it returned marked "suspended service." Inquiries to the War Department were often returned with only the information that a man's name did not appear on any casualty list. It was not until 1943 that reports from the International Red Cross carried the news that several men from Harrodsburg were being held prisoner by the Japanese. In January 1944, the mother of one prisoner of war received several messages from short-wave radio operators in the United States who claimed that they had picked up the voice and the name of her son and that he was "well" but in a prison camp. In both 1944 and 1945, through the efforts of the Red Cross, some local families received postcards from loved ones that reported on their incarceration and their desire for cigarettes.[24]

Some of the overlay of patriotic and militant language that dominated the public understanding of the capture during the war gave way as the reality of death and suffering reached Kentucky. In 1946 the local paper published a list of the names of eighty-three men from Mercer County who died in the war and several expressions of personal remorse. Now family members published sentiments—not so visible in the public events of wartime—that indicated a sense of regret over the death of loved ones and the inability of patriotic rhetoric to fully console. The family of a fallen sergeant wrote: "In loving memory of our son, Sgt. Jennings B. Scanlon, who died in the Philippine Islands, July 8, 1942, four years ago. Dear Son: four years ago today, God called you away to live in Heaven above. Where all is peace and love. No more wars to win. You have left this world of sin. But our hearts are sad within. When we think of the lonely grave, so many miles away."[25]

And another grieving family sent the following note to the *Herald:* "In loving memory of our son and brother, Sgt. Herbert Steele, who died in a prison camp in the Philippine Islands on June 14, 1942. Oh hear my prayer tonight for my son who was taken from me. So far away to fight. I loved my son, dear Father. And wanted him by my side. It was four years ago today that my dear son passed away. In that far-off land he fought so brave. For us, dear God, our lives to save."[26]

There is some support for the war in the statement from the Steele family, but overall the two expressions deviate considerably from the images and sentiments evoked by national memorials that tend to screen out the sense of pain and resentment that so many men had to fight and die. But the public commemorations in Harrodsburg never lost their attachment to the idea that the men were proud and brave warriors as well. Today,

on a small patch of grass along the main highway just north of Harrods-burg, stands the town's World War II memorial which was dedicated in 1961. No classical columns or arches stand on the spot, but rather the site contains a tank from the era, an American flag, and a plaque dedicated by the local Bataan Memorial Committee listing the names of the twenty-nine men who did not come home from the Philippines and the thirty-seven who did. An inscription pays tribute to the efforts of the men to "de-fend Bataan and Corregidor, one of the greatest battles of the world in the long protracted struggle to save the Pacific and Australia from enemy hands while the United States gathered the strength to resist." Literal reminders of men suffering on the death march are not visible here as they are in New Mexico, but it was also clear that local citizens were not prepared to relin-quish traces of the men they knew who never came home.[27]

Memories of Bataan also lingered in Janesville, Wisconsin. In 1947, a memorial to local "Bataan heroes" was dedicated which was dominated by a list of those who lived to tell about the war and those who died in Asia. A small replica of a tank was placed on top of the list of names be-cause the local unit was part of the same tank battalion in which the troops from Harrodsburg also served. The site of the memorial became a place where patriotic rituals were performed for decades after 1945. And yet its mix of sentiments—an unwillingness to forget the local dead, an acknowl-edgment of the survivors, and an affirmation of the fighting spirit of the men in an image of a tank—did not represent the full scope of how this particular war experience was remembered even in this one town. When historian Donald Knox interviewed survivors from Bataan throughout the United States nearly forty years after the death march, he heard extensive stories of suffering that took place not only during the war but after men came home as well. One of the accounts he collected came from a Janes-ville man, Forrest Knox. The Wisconsin veteran did not really talk of any honor he felt in enduring the death march or the Japanese camps, but he recalled watching many men tortured, seeing dead bodies, and experienc-ing the emotional distress of other survivors once back in Janesville. After 1945, Knox suffered from nightmares and explained that "a slight noise would wake me up and I'd find myself out of bed, standing, shivering, and not knowing where I was."[28]

Back home again, Forrest Knox was struck by the problems many of the local men from Bataan continued to experience. He admired Red Law-rence, who returned from the Pacific without eyesight, for telling a "big city hall meeting" about how extensively many of the men suffered, that the "war department never told the mothers anything" about how much

their sons endured, and how angry some local people were over what they thought was a lack of realistic information. Knox said that Lawrence never really left his home much after the war because he tired of people asking him to relive the horrors he had known. Knox felt that Lawrence "remained a prisoner in his own house." Knox recalled another local veteran from Bataan who drank constantly in order "to kill the headaches." Knox was particularly upset at the Veterans Administration for apparently telling this man that his medical issues developed only after he had come home and that they were not war related. His furor merely increased when the man died from a stroke after never having received—in Knox's view—sufficient medical attention. Knox also talked of another colleague from Bataan who suffered "an almost total memory loss" and another named Wes who walked with a cane and stumbled because he had lost feeling in one of his legs. Townsfolk, not knowing the extent of his injuries, actually thought he was drunk most of the time. And Knox could not accept the fact that the government offered the man only a "partial disability."

Knox, too, struggled in postwar life. He complained that a local General Motors plant would not hire him when he returned because they felt he was an "emotional wreck" and that he should not receive any preferential treatment because he was a veteran. In public Knox kept his discontent to himself. He frequently attended civic ceremonies at the Bataan memorial and "regularly met all the gold-star mothers" and served as a "pallbearer for every casket that came home." He noted also that some of the caskets he helped carry were empty but that "mothers wanted a grave and a marker to mourn over." At such times he recalled that he simply "closed his mind" so as not to reveal the true regret and anger he felt in his remembrance of the war and its aftermath.[29]

A notable feature of the local remembrance of Bataan was not only the constant invocation of the names of the dead and the survivors but the frequent use of military hardware. The 192nd Tank Battalion that was lost at Bataan was comprised of many guardsmen from Harrodsburg; Janesville; Maywood, Illinois; and Port Clinton, Ohio. Full-size tanks formed part of the memorials in Harrodsburg and Maywood, and a replica of one sat atop the list of the men who served in the Wisconsin city. A tank was also placed at Camp Perry, Ohio, to commemorate the men from Port Clinton. In Salinas, California, 105 men from the 194th Tank Battalion (58 of whom never came home) were commemorated in 2006. A half-track (half truck, half tank) was permanently installed near the local county historical society after a fund-raising campaign that had been initiated by local World War II veterans themselves who wanted "future generations" to

remember the "atrocities of war and work toward a better world." Tanks and weapons, of course, do not directly convey a sense of atrocities or suffering. In part, they suggest that the men had not only surrendered and died but that they had fought hard as well. And such images always represent an effort to resist a rhetoric of tradition that aspires ultimately to forget much of what a war was about. In Salinas, more of what the war was about was also preserved for future historians to read. Next to the half-track memorial in the archives of the Monterey County Historical Society can be found the diary of one of the survivors, Frank Muther, who died shortly after the dedication of the half-track. In his writings Muther tells how he was thrown into the hold of a Japanese ship and surrounded by suffering men and horrible smells of human excrement and how—after he came home— he had nightmares so intense that one morning he discovered that he had put his fist through a wall in a motel and was completely unaware of what he had done until he awoke.[30]

In the 1940s, Hollywood paid considerable attention to the struggle on Bataan and essentially framed the story in terms that were highly traditional. In the 1943 film *Bataan,* American men were depicted as stout defenders of the Philippines, willing to stand fast against a superior force of Japanese invaders. In this representation of the men and the event, Americans are inherent democrats willing to put the racial and ethnic differences that marked American society behind them and fight as one. Moreover, they are shown not only as defenders, but as strong adherents to American democratic ideology—a point that is not raised in hometown monuments. At the end of this movie a narrator makes it clear that "it doesn't matter where a man dies as long as he dies for freedom." The patriotic courage of the men is mirrored by women serving in the armed forces in the Philippines in two 1943 films, *So Proudly We Hail* and *Cry Havoc.* In these features women do not seem to regret the fact that they are trapped, and they do what they can to help their male comrades. One army nurse in *Cry Havoc* exclaims as the enemy approaches that "we'll hold them as long as we can."[31]

At the end of 1945, with the possibility of victory in sight, two more films returned to the subject of Bataan and the American surrender in the Philippines. Again, the anguish of defeat has been mitigated by stories that focus on acts of individual heroism and the fighting spirit of American men. John Wayne starred in both *Back to Bataan* and *They Were Expendable.* In the former he is a tough American officer who leads Filipinos in a guerrilla campaign against the Japanese after the surrender from jungle hideouts. Here the Japanese are seen as barbarians, but the Americans and their

Filipino allies appear as courageous and skilled warriors. This film actually begins with a reenactment of the plight of some of the men in Japanese prisons and how they were finally liberated by American soldiers. Faces of some of the actual survivors and their names are also presented, before the main narrative moves back in time to show the bravery of Wayne and his guerrillas. In the second movie, Wayne plays a dedicated PT boat commander who leads a daring raid against Japanese naval vessels in the waters off the Philippines.

The traditional images and words that dominated the great public memorials to World War II in the nation's capital—and even in the nation's wartime movie industry—encountered stiff resistance in local places where private sorrows ran deep and ties to the dead were personal. On the home front, tradition—in the form of the American flag and words about honor—was forced to share rhetorical space with feelings of mourning and grief that raised moral qualms about all that people were asked to relinquish. Commemoration in such places tended to be less abstract and less invested in the language of victory or in the greatness of the generation that fought. The remembrance of the war was forced to register at some level the pain and sorrow that was still felt in neighborhoods and towns. No rhetorical device communicated the local resistance to traditional forms of remembrance more than names of the dead. Certainly lists of those who served and those who died could convince all who saw them that these men met their patriotic duty to the nation. And sometimes the simple listing of names did not convey the full extent of personal suffering. But they always remained tied to the larger set of recollections that still lived in private homes and human hearts. They were complex symbols that both ratified and questioned the ideal of patriotic sacrifice. That is why the great memorials to the war in Washington failed to use them. But as long as the wartime generation lived, such names were always capable of making "legible" the sadness and the shock of surrender on Bataan and the experience of imprisonment and death so many encountered. Public memory in local places did not say that World War II was not worth fighting. It did affirm, however, that the wartime generation also had grave reservations about the struggle and its costs and tried to say as much in whatever public space it could find.

Notes

1. Jenny Edkins, *Trauma and the Memory of Politics* (Cambridge, UK: Cambridge University Press, 2003), 5–15. On the issue of how the past is employed

to persuade people in the present about specific meanings of historic events and the need to frame public forms of remembering, see Kendall R. Phillips, "Introduction," in *Framing Public Memory*, ed. Phillips (Tuscaloosa: University of Alabama Press, 2004), 1–8.

2. Jay Winter, *Sites of Memory, Sites of Mourning: The Great War in European Cultural History* (Cambridge, UK: Cambridge University Press, 1995), 1–26, 115.

3. See Paul Fussell, *The Great War and Modern Memory* (New York: Oxford University Press, 1975) for a powerful account of war as tragic and meaningless. Benedict Anderson, *Imagined Communities: Reflections on the Origin and Spread of Nationalism* (London: Verso, 1983), 9–11, argues that memorials that are more abstract in design best serve the interests of the nation to retain the loyalty of its citizens after war. On the power of local "communities of memory" to remember the loss of those who were "near and dear," see Avishai Margalit, *The Ethics of Memory* (Cambridge, MA: Harvard University Press, 2002), 7–9, 27. On controversies over remembering World War II in other nations, see Henry Rousso, *The Vichy Syndrome: History and Memory in France since 1944* (Cambridge, MA: Harvard University Press, 1999); Lisa Yoneyama, *Hiroshima Traces: Time, Space, and the Dialectics of Memory* (Berkeley: University of California Press, 1999); Ian Buruma, *The Wages of Guilt: Memories of War in Germany and Japan* (New York: Meridian, 1994).

4. Karal Ann Marling and John Wetenhall, *Iwo Jima: Monuments, Memories, and the American Hero* (Cambridge: Harvard University Press, 1991); Albert Boime, *The Unveiling of the National Icons: A Plea for Patriotic Iconoclasm in a Nationalist Era* (Cambridge, UK: Cambridge University Press, 1998), 181–82.

5. James Bradley, *Flags of Our Fathers* (New York: Bantam, 2000), 259.

6. Albert Hemingway, *Ira Hayes: Pima Marine* (Lanham, MD: University Press of America, 1988), 2–3, 149–50, 158.

7. Mary Pero (Davidsville, Pennsylvania), phone interview with author, June 1, 2006; also see *Washington Post*, February 18, 2005, B1.

8. Edkins, *Trauma and the Memory of Politics*, 15. For an interesting discussion on how the World War II Memorial works to represent national unity in the face of intense multiculturalism in contemporary America, see Barbara Biesecker, "Renovating the National Imaginary: A Prolegomenon on Contemporary Paregoric Rhetoric," in Phillips, ed., *Framing Public Memory*, 216.

9. Bob Dole, *One Soldier's Story: A Memoir* (New York: HarperCollins, 2005), 269–70; Nicolaus Mills, *Their Last Battle: The Fight for the National World War II Memorial* (New York: Basic Books, 2004), 1–2, 92, 105.

10. "Save Our History: The World War II Memorial: A History," History Channel video, 1999.

11. Douglas Brinkley, ed., *The World War II Memorial: A Grateful Nation Remembers* (Washington, DC: Smithsonian Books, 2004), 11–15; Christopher Thomas, *The Lincoln Memorial and American Life* (Princeton, NJ, Princeton University Press, 2002), 23; John Bodnar, "Monuments and Morals: The Nationalization of Civic Instruction," in *Civic and Moral Learning in America*, ed. Donald Warren and John J. Patrick (New York: Palgrave Macmillan, 2006), 215–18.

12. *New York Times*, January, 29, 1944, 1.

13. *Deming Headlight*, December 3, 1943, 1; *Albuquerque Journal*, March 8, 2002, 1.

14. Eva Jane Matson, *It Tolled for New Mexico: New Mexicans Captured by the Japanese, 1941–1945* (Las Cruces, NM: Yucca Tree Press, 1992), 95–97.

15. Ibid., 86.

16. *Colors of Courage: Sons of New Mexico/Prisoners of Japan*, VHS video produced by the Center for Regional Studies, University of New Mexico, copy at the Center of Southwest Studies, University of New Mexico. I would like to thank Nancy Martinez Brown for helping me locate this film.

17. *Albuquerque Journal*, April 10, 2004.

18. Dorothy Cave, *Beyond Courage: One Regiment against Japan, 1941–1945* (Las Cruces: Yucca Tree Press, 1992), 385–87; (Albuquerque) *Tribune*, April 15, 1946, 2, April 12, 1946, 1; *Pilgrimage to Chimayó: Contemporary Portrait of a Living Tradition* (Santa Fe: Museum of New Mexico Press, 1999).

19. *Santa Fe New Mexican*, October 28, 1999, A1–2; *Corpus Christi (Texas) Caller Times*, October 25, 1999, 1; Everett Rogers and Nancy R. Bartlit, *Silent Voices of World War II: When the Sons of the Land of Enchantment Met the Sons of the Land of Rising Sun* (Santa Fe, NM: Sunstone Press, 2005), 81–82; Matson, *It Tolled for New Mexico*, 82–86.

20. *Memories of Hell*, KNME-TV, Albuquerque, New Mexico, 1982. I want to thank John Nieto-Phillips for loaning me a copy of this video.

21. "Missing in Action," *Life Magazine*, July 6, 1942, clipping in Bataan file, Harrodsburg Public Library, Harrodsburg, Kentucky.

22. *Harrodsburg Herald*, May 8, 1942, 2; *Harrodsburg Herald*, June 19, 1942, 1; *Life Magazine*, July 6, 1942.

23. *New York Times*, June 18, 1942, clipping in Bataan file, Harrodsburg Public Library, Harrodsburg, Kentucky.

24. *Harrodsburg Herald*, May 1, 1942, 1; October 16, 1942, 7; June 18, 1944, 1; January 26, 1945, 1; February 2, 1945, 1.

25. *Harrodsburg Herald*, June 14, 1946, 4.

26. *Harrodsburg Herald*, July 12, 1946, 6.

27. For more on the way Bataan was remembered in Harrodsburg, see James Russell Harris, "The Harrodsburg Tankers: Bataan, Prison, and the Bonds of

Community," *Register of the Kentucky Historical Society* 86 (Summer 1988), 23–79; *Lexington Herald*, May 25, 1981, clipping in Bataan file, Harrodsburg Public Library, Harrodsburg, Kentucky; Studs Terkel, *"The Good War":An Oral History of World War II* (New York: New Press, 1984), 69–79.

28. Donald Knox, *Death March: The Survivors of Bataan* (New York: Harcourt Brace Jovanovich, 1983), 472, 478–80.

29. Ibid., 478–81.

30. "The Diary of Frank Muther," unpublished manuscript, 28–29, Monterey County Historical Society, Salinas, California. I would like to thank Mona Gudgel for bringing this diary to my attention. The *Californian* (Salinas), January 7, 2004, 1; May 18, 2004, 1. See the excellent account of the history of the 192nd Tank Battalion created as a high school project in East Proviso Township, Illinois, at www.proviso.k12.il.us.bataan. Also see http://mbdo.org for information on the annual parade to honor those who never returned from Bataan in Maywood, Illinois, until 1987.

31. On "heroic last stands" as mythic tropes that simplify reality, see Richard Slotkin, *Gunfighter Nation: The Myth of the Frontier in Twentieth Century America* (New York: Harper, 1992), 13–14, 319.

5
You Were on Indian Land
Alcatraz Island as Recalcitrant Memory Space
Teresa Bergman and Cynthia Duquette Smith

Why do some memories "stick" with us, while others are more ephemeral or utterly lost? This chapter explores the complicated relationships between place, memory, and forgetting at one of the most striking tourist destinations in the United States, Alcatraz Island. We offer this research as a case study through which we can think about the staying power of memories and examine how memories can be made more engaging and enduring. We also delineate the consequences for collective memory when significant events fall short of affixing themselves. Alcatraz Island, located in the San Francisco Bay, is "one of San Francisco's must-see attractions,"[1] primarily because of its colorful history as a federal penitentiary. But there is much more to Alcatraz than Al Capone and the Birdman, and much that makes it an ideal site for contemplating how memory works at locations with multiple noteworthy historical events.

On Alcatraz Island, Native Americans staged one of the most important civil disobedience events in their contentious history with the U.S. government. The nineteen-month occupation of the island by the Indians of All Tribes remains unmatched in terms of improving U.S. government policies toward Native Americans. Yet, the fact that Alcatraz is hardly remembered for this momentous event is stunning. Approximately 1.3 million tourists visit the island annually, anticipating a tour through the bleak and cavernous once-notorious prison. They bring little, if any, understanding of the importance of this site in Native American history. Once visitors begin their boat ride to and tour of Alcatraz Island, they encounter multiple rhetorical elements and explore prison spaces that produce a compelling official memory of Alcatraz Island. Through a variety of mediated and direct experiences, visitors encounter historically accurate and politically sensitive interpretations of the island's many previous uses before it became a national park in 1973. Even though Alcatraz's varied historical past is well represented in banners, exhibits, and film, there are several powerful physical elements that work to diminish any memory of the site's history as other than a federal penitentiary. This is particularly alarming

because Alcatraz Island is one of few nationally preserved locations where one historical event ran counter to a U.S. historical narrative of "progress" or "triumphalism." Many Native American scholars and activists credit the Native American Occupation of Alcatraz Island that took place on November 20, 1969, through June 11, 1971, as being decisive in changing and improving U.S. governmental relations with Native Americans. For instance, Troy Johnson, professor of history and American Indian studies, describes the Occupation as "the most symbolic, the most significant, and the most successful Indian protest in the modern era . . . and [it] remains one of the most noteworthy expressions of patriotism and self-determination by Indian people of this century."[2] Why, then, does the experience of Alcatraz fail to make this memory, and its significance, linger?

In this chapter, we investigate the memory and meaningfulness of this particular symbolic protest and what we believe is its troubled relationship to the present-day tourist experience on Alcatraz. Throughout the chapter we call attention to the importance of the visitors' sensory, embodied experience of the island and its spaces. Ultimately, we argue that the visitors' lack of any physical access to the island spaces inhabited during the Occupation seriously and negatively affects both attention to and the staying power of Occupation memories. While visitors can directly engage with the prison by moving through it, walking into cells, and even touching objects, there is no parallel experience of the Occupation available. Clearly the Native American Occupation of Alcatraz is a counternarrative that could offer contemporary audiences particularly affective and resonant messages of nonviolent collective civil disobedience and empowerment; however, we argue that despite the National Park Service's efforts at preservation and representation of the Occupation, this is not the message or memory that tourists take from their Alcatraz Island experience. In spite of the progressive possibilities afforded by Alcatraz's history, the tourist experience at Alcatraz Island—including the island's location, the exhibits, and the architecture—reinscribes respect for government's coercive authority. Alcatraz is an especially recalcitrant location for the inclusion of Occupation memories, even though those events took place on this very site.

One of the challenges for historical representation on Alcatraz Island is that this location is now considered a "fun" family tourist destination. For those visiting San Francisco, not only is the Alcatraz Island tour a history lesson, but it also offers tourists a chance to get on a boat and journey into the scenic San Francisco Bay. On a clear day, the views of San Francisco, Marin County, the East Bay, and the Golden Gate Bridge are breathtaking. Once on the water, tourists encounter seabirds, waves, and a bracing wind.

The Alcatraz Island tour is part outdoor adventure and part history lesson, and it is this experiential combination that informs our research in analyzing not only *what* but also *how* tourists understand and remember this location's history.[3] The materiality of an Alcatraz tour, characterized by the visitor's physical and sensory engagement with the island's spaces, overpowers attempts at remembering the counternarratives of resistance available on the island in its visual exhibits and orientation film. Without significant changes to the Native American Occupation representation on the island, Alcatraz as a memory site is a missed opportunity to encounter and retain messages of successful self-determination, empowerment, and civil disobedience.

In order to illustrate how the materiality of Alcatraz dominates its rhetorical messages, we first give a brief outline of the island's history. We then discuss how memory sites work symbolically and materially in the construction of a national identity. This is followed by an analysis of the Alcatraz Island tour, including the boat ride, the orientation film, the cellhouse architecture, and the audio tour, and how these elements affect the memory of the Native American Occupation and privilege the memory of the island's use as a federal penitentiary. We conclude with a discussion of the consequences of losing the memory of the Native American Occupation at Alcatraz Island, as well as the implications of perpetuating the understanding of Alcatraz Island as primarily a location of coercive incarceration. We finally reflect on the implications of the loss of this liberatory message and its effects in constructing a U.S. national identity.

The Evolving History of Alcatraz Island

Until the nineteenth century, Alcatraz Island's history was one that included little, if any, human habitation. Alcatraz Island is accessible only by boat,[4] the soil is primarily rock, there is no source of drinking water, and the island is approximately twenty-two acres in size.[5] Although pre-Colombian settlement in the San Francisco Bay Area region included the Miwok and Ohlone tribes, "no archeological evidence exists that these tribes ever inhabited Alcatraz Island."[6] Spain claimed the entire area, including Alcatraz, from 1542 until Mexican independence in 1822. The first *recorded* sighting of the island was by Spanish soldiers in 1769 under the direction of Juan Manuel de Ayala. The island's pelicans were its most remarkable feature, and it thus received its European name, Isla de los Alacatraces—the Island of Pelicans.[7] However, there is some scholarly dispute as to whether Ayala reached Alcatraz or Yerba Buena Island because "[a] Mexican map

of the Bay Area dated 1825 continued to identify Yerba Buena as Alcatraz."[8] One of the first "uses" envisioned for Alcatraz Island was to provide navigational direction for ships, and in 1846 Julian Workman, a naturalized Mexican citizen, obtained a land grant on the condition that he establish a navigation light on the island (which he never installed). When the Mexican-American War ended in 1848, the island became U.S. government property, and a lighthouse was built in 1854.[9]

With the discovery of gold and the resulting migration to California, President Fillmore ordered fortification of the San Francisco Bay, which included erecting a fortress on Alcatraz Island. Prescient in retrospect, upon the fortress's completion in 1859, Alcatraz also imprisoned eleven soldiers of Company H in the basement cell room of the guardhouse.[10] The island continued its dual usage as a fort and jail by serving as a prison for Confederate soldiers during the Civil War. After the war, the building's double duty persisted, and Alcatraz Island prisoners were made to level the island's 125-foot peak down to 60 feet for a cannon installation.[11]

One of the first instances of U.S. and Native American interaction on Alcatraz was in 1873 when a Native American from the Paiute tribe was incarcerated, which was followed by dozens of Native Americans imprisoned in the fortress/jail.[12] In 1900 Alcatraz became an official Army military prison, and in 1907 Alcatraz's use as a fortress ended, but its use as a military prison continued. In 1933, Alcatraz was transferred to the federal Bureau of Prisons and thus began its twenty-nine-year stint as "the federal system's most vaunted penitentiary."[13] Most of the Hollywood films that have been made about Alcatraz concern this particular time period of the island's history when FBI director J. Edgar Hoover selected the "most dangerous and notorious inmates already housed in other federal prisons" to be Alcatraz's first inmates.[14] This group included Robert "Birdman" Stroud, George "Machine Gun" Kelly, and Al Capone, all of whom contributed to Alcatraz's becoming a national symbol of "mystery and fear."[15] The island did briefly resume its dual use as a fort and prison in 1942 when anti-aircraft mounts were installed, but they were ultimately removed at the end of World War II.[16]

One of the ongoing difficulties of running a fort/prison at Alcatraz Island was the extraordinarily high cost of daily operations in addition to maintenance. All water and supplies had to be ferried over by boat, and the upkeep of the buildings was staggeringly difficult due to rust and concrete deterioration. "By the early 1960s, Alcatraz required at least $5 million for maintenance and repairs," and in 1962, "U.S. Attorney General Robert Kennedy announced that Alcatraz would be phased out of the penitentiary

system."[17] In essence, the impenetrable fortress of Alcatraz fell victim to the island's extraordinary location and isolation; the very things that made the island so appealing as a prison site in the first place eventually led to its demise.

In 1963 Alcatraz was declared U.S. excess property, and in 1964, the Department of the Interior began holding a series of meetings to determine its future use. Concurrently, several Native American individuals and groups began to see Alcatraz as a potential site for their uses. The original rationale for the Occupation overtly recognized the symbolic importance of the island, and intended to focus U.S. national attention on the plight of Native Americans. The idea to occupy Alcatraz was Belva Cottier's, who remembers: "One morning I was reading the newspaper there was this story that the government didn't know what to do with Alcatraz, which was surplus land after the federal prison was discontinued. So I thought about the old Sioux Treaty of 1868 which entitled us to claim surplus land."[18] These discussions resulted in three different attempts by Native Americans to take over the island, with the third attempt resulting in the nineteen-month Native American Occupation.[19]

Approximately one year after the Occupation ended, on October 12, 1972, the U.S. Congress passed Public Law 92–589 that created the Golden Gate National Recreation Area, which included Alcatraz Island. In October 1973, Alcatraz Island opened as a national park with daily National Park Service (NPS) ranger-led dock tours[20] that portrayed the accretion of historical events on the island; however, not all events are weighted evenly. In the next section, we analyze how and why the Occupation, even with its tremendous significance for Native Americans and their governmental relations, is an event that does not stick either during or after an Alcatraz visit.

Constructing Identities through Memory Sites

Alcatraz presents us with an excellent opportunity to explore how public memories are constructed and shaped by historic sites. Public memory is understood as "a body of beliefs and ideas about the past that help a public or society understand both its past, present, and by implication, its future."[21] With this in mind, Alcatraz Island makes a contribution to a U.S. national identity through the public memory it fosters. At Alcatraz Island, this public memory is inextricably tied with the concept of identity where "the core meaning of any individual or group identity, namely, a sense of

sameness over time and space, is sustained by remembering; and what is re-membered is defined by the assumed identity."[22] Both our individual iden-tities and our national identity are shaped in part by the intersection of what we postulate about the past, the people who lived it, and the significance of the event at that time.

Gregory Clark offers the concept of "public experience" as a way to understand the complicated rhetorical operation of visiting and experiencing particular landscapes in America.[23] Public discourse, including popular cultural representations, about significant locations like Alcatraz prepares visitors in part for their experience of those locations. Visitors then encounter "the symbols that are material in the landscape itself," and that *public experience*—while not immediately discursive—prompts a transformation of individual identity in ways that enact considerable rhetorical power by shaping the attitudes and, whether immediately or eventually, the actions of people who come to understand themselves as a community."[24] Most visitors to Alcatraz have some familiarity with the island's use as a federal penitentiary, which is amplified through the shared public experience of touring this memory site. The rhetorical operation of spatial dynamics, discourse, and interaction with their fellow tourists defines visitors' relationships to a community and to the nation. At Alcatraz, visitors are positioned to experience themselves not only as Americans, but more importantly as well-behaved, law-abiding Americans who exist in contrast to those incarcerated in the prison. A self-guided printed tour brochure of Alcatraz points out that "Alcatraz has become a symbol of America's dark side."[25] The public experience of visiting Alcatraz and inhabiting its spaces serves as a reminder of governmental authority and the consequences of criminal activity. At the same time on Alcatraz, visitors are denied the opportunity to publicly experience spaces relevant to the Native American Occupation. In the absence of such experiences, visitors are unlikely to identify with those who occupied the island or with the counternarrative offered by their story of civil disobedience as a response to the governmental abuse of power.

The idea that collective memory is *spatial* and *material* is, then, critical to this study.[26] Memories are anchored in space and location, which Pierre Nora has called "sites of memory."[27] Places like Alcatraz Island occupy physical space and therefore provide tangible evidence of the past with which visitors can interact. Such sites can also increase the durability of memory because memories can be embedded in an enduring space that visitors can see, smell, and touch. Theoretically, although the space itself is fixed, the

nature of public memory related to the site is malleable and can change over time. Alcatraz, however, complicates this assumption. At Alcatraz, the malleability of public memory spaces comes into question. Despite the significance and long-term effects of the Native American Occupation, the public memory of this activism slips through the cracks of the formidable prison setting. Efforts of the NPS to update the many historical layers of Alcatraz and enrich their coverage of the Occupation still fall short of making a memory of those events that sticks. We argue that the additional rhetorical "information" about the Occupation, in exhibits and in a looping documentary (described below), is insufficient to forge a lasting connection between the Occupation's people and events and the Alcatraz visitor.

Kenneth Burke observed that any given scene contains "the quality of the action that is to take place within it."[28] Careful to point out that setting never "determines" behavior, Burke nonetheless recognizes that it provides a contextual boundary within which various acts make sense. At Alcatraz, there is no mistaking that the setting is a prison, and we would therefore expect this fact to shape its narratives. Nevertheless, this is not an insurmountable obstacle to the meaningful portrayal of the Occupation. There are at least two factors that must be considered. One is the U.S. impulse to omit successful domestic acts of civil disobedience from its typical historical narratives. Second, Alcatraz Island is a particularly difficult location in which to convey narratives other than those related to its life as a penitentiary. For audiences seeking to understand a particular memory place, it is important to recognize that *techné* of memory are differentially weighted. At Alcatraz, visitors see graffiti, watch a film, and look at exhibits, but they also hike to the top of the island and move about inside the prison itself. Our examination of the Alcatraz tour and its relationship to the Native American Occupation suggests that the stickiest memories are those most fully experienced at the site with our bodies and senses.

Departing for The Rock

All tours of Alcatraz Island begin with a ferry ride over from the San Francisco docks. Because of popular films and images of Alcatraz, most Americans have a sense of what they will see even before their visit.[29] However, Alcatraz is a place that is most fully experienced through direct physical contact with the site. On the island, visitors' memories become embodied, and in essence, inseparable from themselves. Beginning with the usually

chilly ferry ride to the island, continuing with an NPS tour-guide welcome on the dock far below the cellhouse, and culminating in one's eventual arrival atop the island at the "prison" portion with its audio tour, the visitor is acutely aware of his/her physicality.

The visitors' experience begins on the San Francisco dock, where they are able to see the island across the bay and its relationship to the mainland on which they stand. Part of the rhetorical power of Alcatraz lies precisely in this visible juxtaposition between a life of freedom on the mainland and a life of rigid incarceration on the island itself. Whether they are on the mainland looking across to the island, or on the island taking in the amazing views of the city across the bay, visitors are reminded of Alcatraz's isolation from the rest of society.

The ferry dock area itself can be extremely crowded, particularly in the summer months with hundreds of visitors waiting in lines for tickets and boat departures. Tourists first encounter the site's scripting through the organization and decoration of the lines in which they wait to buy tickets and board their boat. Hal Rothman notes how "this process of scripting space, both physically and psychically, defines tourist towns and resorts."[30] The lines themselves control the passage of visitors, in an orderly manner, to the ticket windows and then to the ferries. The National Park Service's decorative banners in this waiting area feature Al Capone, a former penitentiary guard, the Native American Occupation, the Civil War Fortress, an anonymous penitentiary inmate, George "Machine Gun" Kelly, and Juan Manuel de Ayala's quote upon his discovery of Alcatraz. Five of the seven banners relate to the island's use as a federal penitentiary. Because of the subjects they depict, the banners prepare tourists for the feelings of physical isolation that begin once they step aboard the ferry for their seven-minute journey to the Alcatraz Island dock.

The evolution of the NPS script for Alcatraz Island is evident in planning documents that initially do not mention representation of the Native American Occupation.[31] Plans to include representation of the Occupation begin appearing in planning documents in 1980 regarding the adaptation of buildings for "exhibits relating to the prison era, military era, natural history, and Indian Occupation of the island."[32] One of the most interesting proposed scripts for Alcatraz Island that incorporated the Occupation was in a 1992 architectural history report: "Alcatraz is the only prison owned by the National Park Service, which is open to the public, and is therefore probably the only site where the history of American prisons and the developments of U.S. penology can be brought to public awareness.

The Occupation of the Island by the Native Americans, an act of civil disobedience, which is also an American invention, meshes smoothly with this concept. *The broad theme which this structure represents is American Justice, both civil and military.*"[33] Aside from the ethnocentricity and the injunction for critical tourism, the goal of integrating the Native American Occupation into the island's scripting is one to which the NPS adheres. We argue, however, that the cumulative experience of Alcatraz is one that positions visitors to be complicit in supporting military justice with very little engagement of civil justice.

Once the boat departs the San Francisco dock, visitors see the comforts of the city fall away and an announcement regarding water safety regulations booms over the ship's speaker system.[34] The boat trip is generally calm even though there is often a combination of a strong westerly wind and fog that forces many of the passengers inside the boat's quarters. Although the island is only a mile and a half from the shore, visitors become acutely aware that the bay's frigid waters truly isolate Alcatraz.

As visitors turn away from the San Francisco shore and face the island, the prison comes clearly into focus and its size dominates the island (figure 5.1). Although the lighthouse is not part of the prison complex, from the water it appears clearly against the background of the sand-colored cellhouse. The size and arrangement of these structures, looming over the island, make a striking early impression on visitors. To the right of the lighthouse, visitors can see the skeletal remains of the Spanish-style warden's house. Smoke damage to the white stucco exterior is visible, making it clear that this building did not merely decay but instead was destroyed by fire. For visitors whose primary understanding of the island has come from Hollywood movies, the shell of the warden's house suggests a more complicated history of the site's multiple uses.

As tourists approach the island on the boat, the first printed information they encounter is a large weather-worn sign posted on the southern side of the island stating: "*WARNING* PERSONS PROCURING OR CONCEALING ESCAPE OF PRISONERS ARE SUBJECT TO PROSECUTION AND IMPRISONMENT." With this none-too-subtle reminder of the island's former use as a penitentiary, visitors disembark and an NPS ranger awaits the passengers on the Alcatraz dock with a megaphone summoning everyone over for an introduction to Alcatraz Island. As tourists gather around the ranger, they encounter the second piece of written information above the ranger on the former barracks building. The government sign reads:

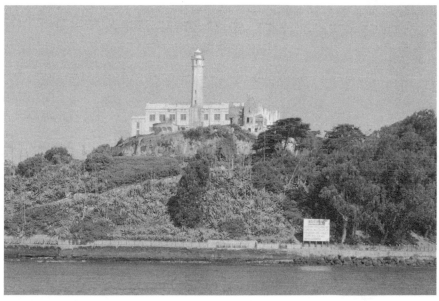

Figure 5.1. The Alcatraz penitentiary as seen from the tour boat on a sunny day in 2007. (Photograph by Teresa Bergman.)

UNITED STATES
PENITENTIARY
Alcatraz Island Area 12 acres
1 ½ miles to transport dock
Only government boats permitted
Others must keep off 200 yards
No one allowed ashore
without a pass.

In fading red paint surrounding this sign, graffiti many times larger than the official sign text reads: "Indians Welcome" and "Indianland" (figure 5.2). It is beneath this graffitied sign that NPS rangers conduct their welcoming orientation speech to Alcatraz Island. The color and size of the graffiti draw the attention of visitors to this alternative use of the island, even if they had no prior knowledge of the Occupation. Here, also, the differing material nature of the competing memories on the island first becomes apparent. The prison's history and its ideology of incarceration are instantiated through the multitude of buildings on the island; the Native

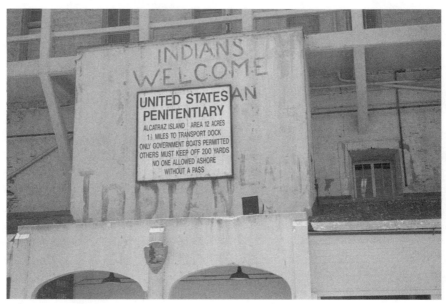

Figure 5.2. Graffiti from the Native American Occupation of 1969–1971. (Photograph by Teresa Bergman.)

American history of the island is represented by painted graffiti. These material traces of the past on Alcatraz are by no means equally compelling rhetorical resources.

"Dock Talk"

All visitors are strongly urged (via megaphone) not to ascend the walkway to the cellhouse but to assemble on the dock around the NPS ranger for an orientation speech called the "Dock Talk."[35] Directly adjacent to the ranger is an informational kiosk where visitors can purchase the self-guided brochure "Discover Alcatraz: A Tour of the Rock" in several different languages.[36] The NPS rangers take turns giving this five- to seven-minute talk that includes where to pick up the audio tour, where the orientation film is shown, where the historical exhibits are located, where water is sold, where the two public restrooms are, and that there is no food available on the island. Visitors quickly learn through this talk what they can and cannot do on the island. Each ranger brings her or his own flair to the speech. Through our interviews we found that no ranger works from notes but that each has developed a speech that, in addition to covering the basics listed

above, provides some history about the island and also engages the visitors by asking questions such as, "How many of you have seen *The Birdman of Alcatraz* or *The Rock*?"

After this extremely brief introduction, visitors walk up an incline toward the guardhouse and sally port leading to a more steeply inclined walkway that eventually arrives at the cellhouse. About one hundred yards up the walkway, and before the guardhouse, tourists encounter a sign that points into the barracks on their left for the orientation film and historical exhibits. If they miss this first point of entry, they will find another tunnel off to their left after the guardhouse, which will take them into the screening room. According to interviews with both NPS rangers John Cantwell and Craig Glassner, about half the tourists make a turn into the screening room, with the other half proceeding directly up the hill and through the guardhouse and sally port for the audio tour of the cellhouse.

Alcatraz . . . Stories from the Rock

In the barracks building, visitors sit in the cannon bays, now bricked over to provide a backdrop for several projection screens on which the film is displayed. The visitor here is already "inside" Alcatraz, surrounded by its history, occupying this awkward, low-ceilinged space. The juxtaposition between the room's function as a theater and the visible evidence (arched ceilings and support columns) that it was used as a cannon bay in the past, offers the visitor an intriguing experience. This is not a typical screening room at a historical site, and the awkwardness of the space for its current use can prompt the visitor to think *more* about its original function.

The cannon-bay theater screens light up every twenty minutes with an orientation film entitled *Alcatraz . . . Stories from the Rock*. This film premiered in October of 2005, replacing the first orientation film, *Secrets of Alcatraz* that had been showing since 1991.[37] *Alcatraz . . . Stories from the Rock* is just under sixteen minutes long and employs a "layer cake" approach to Alcatraz's history.[38] The metaphor refers to both the actual layers of buildings on the island, and the fact that the island's history is deeper than what can be seen at first glance. The film begins with a very short montage of the federal penitentiary years followed by a recounting of the major uses of the island, including a fortress, Confederate prison, lighthouse, federal prison, site of the Native American Occupation, and a national park. This opening is less than one minute long and leads into the titles. The body of the film falls into the following sections: island's geologic formation, fortress construction, fortress and Civil War prison, military prison, federal

penitentiary, families of guards and administrators who lived on the island, Native American Occupation, national park, natural habitat, and conclusion. The experience of watching the orientation film takes the tourist out of the primarily physical experience of touring Alcatraz Island and into a mainly intellectual understanding of the island and its history.

Alcatraz . . . Stories from the Rock borrows from the documentary film tradition by using an expository format that employs a host of filmic rhetorical devices to tell the "story" of Alcatraz. An expository documentary "facilitates generalization and large-scale argument,"[39] and uses any means possible to convince the audience of its argument or point of view. An expository format does not invite the audience to query the information presented; rather, the audience is positioned to accept unquestioningly the story presented. The advantage of using this format is that it is generally engaging for audiences because there is a narrative thread to hold it together as opposed to simply listing historical facts. Another reason this format can be so engaging is that it can make use of every filmic device available to filmmakers in order to make its rhetorical points.[40] *Alcatraz . . . Stories from the Rock* uses historic re-creations, computer graphics, old Hollywood film clips, historic footage, current film footage, black-and-white photos, interviews, and narration. Although the expository format can be informative and entertaining, one of the main disadvantages of using this form is that the attribution and causality of historical events may or may not be accurate. Expository documentaries are particularly problematic in this area due to their use of an omniscient narrator which works to represent information as "objective" and not from a particular point of view. The use of the expository format combined with the film's location in a National Park compounds the orientation film's reception as "objective."

In terms of the film's representation of the Native American Occupation, this format raises concerns. This section of the film lasts just under three minutes and begins by locating the Occupation during "the 1960s, the age of peace, love, war, and protest" with images of the Summer of Love and civil disobedience. The Native American Occupation is depicted as a direct result of the social upheaval of the 1960s rather than within the trajectory of Native American oppression and resistance. In the 1950s, there were more than twenty major demonstrations or nonviolent protests by Native Americans aimed at ending further reductions in the Indian land base, stopping the termination of Indian tribes, and halting insensitivity and brutality toward Native Americans. In the early 1960s, Native Americans organized fish-ins in Washington to support fishing rights, and these events in particular gave rise to pan-Indian organizations.[41] Not only is this

history entirely absent from the film, this absence fails to properly contextualize the Occupation's roots and its place in Native American history.

Although the orientation film disregards the Native American roots of the Occupation, it does provide justification for the Occupation by highlighting original occupiers Ed Castillo (in a contemporary interview) and Richard Oakes (in historic film footage). The narration briefly alludes to the U.S. government's policy to terminate tribal reservations and relocate Native Americans to urban centers. The orientation film neither condemns the occupiers' actions nor describes the Occupation as a failure. Instead, the narrator articulates the long-range impact of the Occupation: "While the island never became Indian land, the government ultimately changed its policy and started returning tribal lands to American Indians."

Many scholars have written on the impact of the U.S. government policy of relocation that the film describes as the main reason for the Occupation. Professor Troy Johnson describes the depth of despair caused by this program: "Indians who had been promised job training, employment, and housing assistance soon found themselves without skills, unemployed, and living in poverty in rat- and roach-infested housing."[42] Indians of All Tribes Inc., the group that occupied Alcatraz, defended their actions in articles written during the Occupation by stating that the Native American suicide rate is ten times higher than the national average, and that their education is at the fifth-grade level.[43] Native American activists and government officials echo the final message of this sequence in the film, which frames the Occupation not as a failure but as a turning point for improving government policies toward Native Americans. Leonard Garment, White House Special Counsel during the time of the Occupation, observed that, "although the protest failed to achieve its goals, it proved the catalyst for a historic change in American Indian life."[44] The Bureau of Indian Affairs wrote, "The present Administration rejects both termination and paternalism in favor of new federal Indian policy of self-determination without the threat of termination for American Indians."[45] The film is clear that the Occupation of Alcatraz was a potent symbol for the cause of Native American activism and inspired the revival of Native American identity among a new generation of Native Americans nationally.[46]

The final three minutes of *Alcatraz . . . Stories from the Rock* cover the island as a national park, and its function as a natural habitat for plants and birds. This ending moves visitors from an intellectual understanding of the island and connects them back to their current physical experience of Alcatraz. The audience then has two options for exiting the cannon bays—either going through the back doors, which lead across a tight, moss-

covered alleyway to the exhibits, or retracing their steps through a bookstore and beginning their walk uphill to the cellhouse.

Exhibit Alley

Three tiny rooms accessible via narrow arched doorways housed three exhibits during the time of our research: "We Hold the Rock," covering the Native American Occupation; "Prisoners of Age Exhibit," describing various historic inmates; and "Alcatraz and the American Prison Experience," illustrating the history of U.S. penology. The "We Hold the Rock" exhibit occupied a room roughly ten by ten feet in size with two benches and a continually looping one-hour documentary video about the Occupation. As mentioned earlier, less than half of the tourists who go to Alcatraz Island stop to see the orientation film and less than a third of this group visits these exhibits. Indeed, in several days of observations, a maximum of eight visitors were present at one time in the "We Hold the Rock" video room. Much more typically, we noticed one or two visitors at a time who glanced at the video for a few minutes before moving out of the exhibit area. The cramped room is the only three-dimensional, inhabitable space on the island with a connection to the Occupation. Unlike the prison, however, this room has no direct historical relevance to the events of the Occupation. That is, there is no evidence that any of the Native American activists lived in or otherwise inhabited this space. It functions, therefore, as just another museum exhibit and engages the audience primarily by the film rather than providing a more direct and somatic connection to this historical event on the island. Although spaces do exist in the more remote and off-limits areas of the prison (such as the basement and an upper level of the cellhouse) where both graffiti and material artifacts attest to the very real use of these spaces by Native Americans during the Occupation, visitors do not know this and are never presented with the opportunity to "tour" or "inhabit" those spaces as they do the cells in the prison. Thus, even though visitors are on the island where the Occupation took place, most of their understanding is shaped through the more distant experience of watching either the orientation video or the film in this small room.

Once visitors leave the orientation film and exhibit areas, the unguided experience of Alcatraz includes the visitors' physical progress to the top of the island and through its buildings, and the self-guided audio tour. In their "Interactive Experience Model" of the museum experience, John H. Falk and Lynn D. Dierking make a distinction between the overlapping areas of the personal context, social context, and physical context that contribute

to a visitor's experience. They explain that "The physical context includes the architecture and 'feel' of the building, as well as the objects and artifacts contained within. How visitors behave, what they observe, and what they remember are strongly influenced by the physical context."[47] It is this physical context of Alcatraz, and how it works to overwhelm the history that they have just learned about in the orientation film, that will be our focus here.

The Path to the Cellhouse

Leaving the theater, the visitor encounters another off-limits area, where a metal stairway leading to the second level of the barracks is chained off and marked "Area Closed: Wildlife Preservation." With no other path available, the visitor makes a sharp left to continue up the steep, zigzag walkway to the cellhouse. Visitors with disabilities can take an electric tram to the top of the island and the cellhouse. As they move up the hill, visitors walk past the lichen-covered metal roof of one of the guardhouse buildings and the Spanish-style Military Chapel with its traces of decaying stucco. A solid metal railing prevents visitor access to these structures. Next, they see the gutted Post Exchange/Officers Club with rooflines echoing those of the Chapel. The building's top level is even with the walkway and its bottom level and foliage-covered floor are visible far below through chain-link fencing. Past this structure, a warehouse and the Power Plant tower are out of reach beyond more barricades which function as another disciplinary reminder of the government's ever-present coercive authority at this site.

The ghostly outlines of the island's eviscerated buildings—the Post Exchange and the warden's house—call the visitor again to contemplate the current state of these structures in opposition to what they may have looked like during the active years of the penitentiary. These two structures, as well as the Chapel, provide an interesting counterpoint to the more austere, barracks-like architecture of the majority of the island because they resemble buildings we may have seen elsewhere (particularly in California, given their Spanish mission style). Looking at the buildings, visitors may wonder how families lived on the island, raised children, and tended gardens. The ongoing appeal of Alcatraz as a tourist location is shaped in part by the tension between everyday life and prison life. It is difficult to contemplate living in this relationship to a prison today, but all the material evidence we see on the island suggests that these families led perfectly "normal" lives despite the unique location.

Ultimately the visitor arrives (possibly out of breath) at the island's sum-

mit, adjacent to the lighthouse and to the warden's house, one of the structures that burned during the Occupation. Along the path to the top of the island, visitors also see additional graffiti from the Native American Occupation. In fact, the National Park Service has adopted a policy of graffiti preservation, which accounts for some of the painted slogans still being legible despite the unrelenting weather conditions promoting their wear.[48] Even with this laudable preservation effort, graffiti does not exert the same rhetorical impact that three-dimensional space provides. Inside the warden's house, by contrast to the two-dimensional graffiti samples, the original fireplace and mantel are clearly visible, although overrun with weeds and flowering plants. Evidence of life on the island is evocatively conveyed by such glimpses into spaces like this house, with its readily recognizable features. Also visible is the steel reinforcing frame added inside the building to keep its exterior walls from collapsing.

Some confusion persists to this day as to why several buildings on the other side of the warden's house, closer to the edge of the hilltop, lie in demolished heaps. On June 1–2, 1971, a fire took place during the Native American Occupation that demolished four buildings including the warden's house. The lighthouse was also damaged in this fire.[49] Although the fire's cause has never been resolved definitively, the houses that currently lie in ruins were demolished *after* the Occupation by the General Services Agency (GSA), who controlled the island before and after the Occupation. The GSA began demolition of the structures for safety and cleanup; however, the NPS stopped their removal for historic preservation. NPS ranger John Cantwell indicated that over the years he had heard many tourists inaccurately assume that the Native Americans caused these ruins.[50]

No matter the season, it is typically at this point in a tour of the island that one is overtaken by the strength of the winds gusting around the top of Alcatraz. If the visitor had previously gotten the impression—climbing past the more domestic buildings on the sheltered side of the island, observing the seagulls and pelicans, looking at the picturesque moss on the metal roofs of some structures, admiring the trees and foliage—that Alcatraz might have been a lovely place to live, one is quickly disabused of this hospitable image on the cellhouse level. Signs now direct the visitor into the structure that physically dominates Alcatraz Island.

The Cellhouse Tour

The appeal of Alcatraz as a tourist destination clearly is drawn not from the innovation of its architectural design but rather from its stunning lo-

cation in the bay and its ubiquity in popular culture. Many informational sources exist about both prison architecture in general, and the prison architecture and history of Alcatraz specifically. Norman Johnston, in his well-respected book *Forms of Constraint: A History of Prison Architecture,* offers the representative observation that "Although it has little architectural significance, the prison on Alcatraz Island in San Francisco Bay is well known to Americans."[51] Johnston goes on to dedicate just a single paragraph to the discussion of Alcatraz. Michael Esslinger remarks that "The thrill of touring Alcatraz derives both from the awareness of its historical significance, and from the various portrayals of prison life that have been popularized through Hollywood motion pictures."[52] What could be more compelling than an actual prison that was later a Hollywood movie set? As the epitome of prison life, the cellhouse is both the ultimate destination of Alcatraz visitors and the place where they spend the bulk of their time on the island.

Throughout their tour of Alcatraz, but especially and most vividly during their tour of the cellhouse, visitors come to understand Alcatraz as a place that constrains thought and behavior—not only the thoughts and behaviors of its former inmates, but also those of contemporary visitors to the prison. As Foucault observes in *Discipline and Punish,* "Power has its principle not so much in a person as in a certain concerted distribution of bodies, surfaces, lights, gazes; in an arrangement whose internal mechanisms produce the relation in which individuals are caught up."[53] The Alcatraz tour itself functions in just this way to reinforce governmental coercive authority through the visitor's somatic engagement with the site. It invites a sensation of discipline, control, and surveillance that powerfully overwhelms messages about liberation and social dissent. At every turn of their visit, tourists are informed what they can and cannot do, what they can consume (water, not food), where they should and should not be, what path they should be following, what they should be looking at, and finally that their behavior will be electronically monitored if they should attempt to steal the tour's audio device. The ultimate civic lesson provided by Alcatraz is therefore obedience to the law and conformity with behavioral standards rather than any message about the value of social protest or resistance. That this is the result of visiting Alcatraz is not unexpected, but what bears further examination are the specific methods by which this effect is achieved. Of critical importance is the visitor's bodily experience of the prison spaces (combined with the lack of similar access to any spaces of the Occupation) during the guided audio tour of the cellhouse.

The award-winning Alcatraz Cellhouse Tour, narrated by a former cor-

rectional officer and incorporating the testimony of both officers and former inmates, directs the visitor's experience of the cellhouse. The tour does not discuss the Native American Occupation, but focuses instead on the prison and its occupants during the penitentiary years. Visitors acquire a digital audio device and headphones as they enter the cellhouse. The thirty-five-minute audio recording regularly indicates to visitors where they should be located and what they should be seeing, controlling their experience of the prison even though the tour is "unguided."

The audio on the tour creates the convincing ambiance of an occupied prison. It does this by including the sounds of prison life, such as distant conversations, guard whistles, slamming cell doors, and footsteps presumably belonging to either prisoners or guards. The tour heightens visitors' engagement with the prison and its former occupants by directly appealing to sensory experiences as participants move through the prison. During the audio tour, visitors feel as if other people are there, even though today it would be only the other visitors shambling along as they listen to their own audio tours. The unmistakable cocking of a weapon marks the transitions between segments of the audio tour.

On the audio tour one's attention is called to the notorious inmates of Alcatraz, to the barbershop, to a typical cell as it would have looked during the prison's operation, to the gun gallery where guards walked their rounds so as to have every prisoner directly "under the gun," to the dining room, to the library area, and eventually to "D Block," also known as "The Hole," where the solitary confinement cells were located.[54] There is coverage of the prisoner riot on Alcatraz and the resulting assassination of eight prison guards. The visitor is told of the most famous escape from Alcatraz, chronicled in the movie of the same name. Throughout the tour, visitors simultaneously hear documentary audio and occupy key physical locations in the cellhouse. Those two embodied experiences solidify memories of the history of the prison and its inmates by connecting them to the visitor's memories of the physical spaces themselves. Ultimately, the story of Alcatraz conveyed through the audio tour and the visitor's direct experience of the cellhouse vividly brings to life the power of authorities to discipline those who break society's rules.

Some of the interpretive techniques used by the NPS during the cellhouse tour are typical in historic house museums more broadly. In a way, Alcatraz "is" a house museum—or a "Big House" museum. Part of the attraction to Alcatraz lies in tourists' ability to "see" how people lived there, even to the point of physically occupying, however briefly, the same cells where people once lived or where they were temporarily housed (for ex-

ample, in "The Hole"). In her book on house museums, Sherry Butcher-Younghans explains that a primary interpretive approach used by house museums is to restore period rooms using objects that actually belonged to the inhabitants, or to use representative furnishings. Butcher-Younghans points out that "exhibits can also be combined with existing period rooms" to offer a fuller interpretation of the house.[55] Given its depictions—especially in a large exhibit displayed in the prison's shower room at the time of our visit—of well-known inmates (such as Al Capone) and its restoration of a number of typical cells complete with bedding, one is made aware of both the people who used to live in Alcatraz, and the manner in which they lived. Alcatraz teaches visitors how a prisoner's every waking moment was regulated as visitors hear about regulations on the audiotape and see signs posted throughout the cellhouse, such as a list of "Hospital Rules and Regulations," and they see and inhabit the very spaces where prisoners were confined. Further, the audio tour reinforces the privileges and lack thereof afforded to prisoners for "good" behavior. Even within this disciplinary environment, increasing levels of behavioral control are operating.

Equally important here is what visitors do *not* get to experience. There are no cells on the "tour" outfitted as they were during the Native American Occupation, even though they do exist in off-limits locations. For instance, during one of our tours of the island, an NPS ranger took us "behind the scenes," and we saw the basement of the penitentiary where the walls are covered with graffiti from the Native American Occupation. We also were taken to the upper levels of the penitentiary where we saw that members of the Occupation had painted names over several jail cells that included "Nixon" and "Reagan" (figure 5.3). Neither of these locations has been accessible to visitors. Sounds and narratives from the time of the Occupation are also absent from the audio tour, which focuses solely on the prison years of the cellhouse. Without more direct access to the people of the past who inhabited the island during the Occupation, the connections visitors form to those people are tenuous if they form any connections at all. Instead, they are better able to relate to Al Capone and other notables whose cells they can actually peer into or enter.

As visitors continue the audio tour, ambient noises are persistently incorporated under the narration, and prisoner and guard commentaries further enliven the prison experience. One hears prison cell doors slamming shut, the pacing of guards, conversations, distant thunder, the sizzling of the metal detector and clacking of typewriters, even the sound of a shiv (a makeshift dagger) stabbing another prisoner in the back. Even though spaces like the Dining Room are empty of everything but other tourists

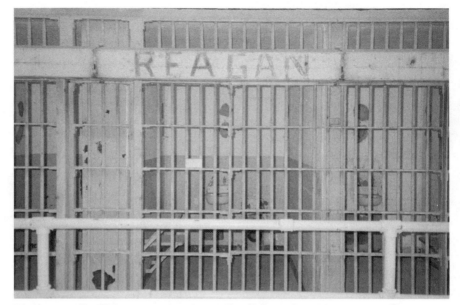

Figure 5.3. Graffiti on a penitentiary jail cell from the Native American Occupation of 1969–1971. (Photograph by Teresa Bergman.)

and a handful of wooden benches, they seem to be inhabited as the visitor hears silverware, inmate conversations, the clanking of dishes, and so on. Later in the tour we hear gunfire during the discussion of the Alcatraz uprising, and we hear what we surmise is Frank Lee Morris chipping away at the plaster in his cell prior to his escape. Throughout the tour, one also hears sounds from across the bay, sounds evocative of the outside world that prisoners were denied. Visitors can hear the surf, the seabirds, the foghorn, and the buoy bells as clearly as the inmates could during their incarceration. Thus visitors are reminded again, this time aurally, of the freedom/incarceration dichotomy that permeates Alcatraz.

Most critically, the cellhouse tour brings the visitor into physical contact with the prison, and indeed explicitly *invites* the visitor to experience the prison directly. For example, while illustrating the difference between the flat steel bars used in the military prison and the more rugged bars of the civil prison, the tour exhorts the visitor to "put your hands on the bars," "go ahead and touch the bars." As the first direct suggestion to the visitor to touch something in the facility, this dialogue has to encourage him or her (no doubt accustomed to the no-touching injunction almost universal to museums) that it really is okay to touch things at Alcatraz.

Other examples of these directives include: "A few steps to your right are some open cells. You may step into one if you like," and "Feel free to walk around the dining room," as well as "Please take a seat." On D Block, the tour advises that "you may enter one of the solitary confinement cells if you wish" (followed by the audio sound of a door slamming shut and the sound of a howling breeze). Each injunction to touch and experience the prison functions to heighten the perceived authenticity of the tour and ingrain its lessons into the visitor's memory. Because the audio tour does not provide similar sensory access to the spaces of the Native American Occupation, visitors lose the opportunity to forge a more durable connection to that portion of the island's history.

As visitors prepare to return their audio devices, they are warned that the device is protected electronically against theft, and that if they attempt to take it on the boat with them an alarm will sound. Again they are reminded, this time explicitly in the audio tour itself, of the distinction between good behavior and criminal behavior, of the distinction between themselves as law-abiding Americans and those who broke the law and were imprisoned at Alcatraz. The essence of the public experience of Alcatraz is precisely this identification with law-abiding fellow Americans, and division from the incarcerated criminals who inhabited the prison. Based on their vivid physical and emotional experience with what was once the ultimate model of coercive incarceration in the United States, it is difficult to imagine that visitors would retain messages about the Native American activism on the island from the orientation film, exhibit room, and periodic examples of graffiti.

Before the visitors leave the cellhouse, they can visit one of the island's three bookstores, which each contain essentially the same collection of books, videos, posters, and bookmarks. Unlike the mainland "gift shop," these stores are focused on reading material, even though a "piece of the rock" or a prison "key" can be purchased at either the cellhouse or dockside bookstore. Further tying their experience to tangible objects, the stores let the visitor take a physical reminder of this historical site home with them.

Either before or after their visit to the cellhouse, visitors also experience a commanding view of the San Francisco Bay and the city beyond, including the Golden Gate and Bay bridges on a clear day. Below them on the slope are the remains of the demolished houses mentioned above. Visitors take photographs here, bracing themselves against the gusts of wind as they snap pictures of family and friends using the city as a backdrop. As it was on the mainland and on the dock level of the island, the contrast between the freedom of the city and the isolation of the island is physically

experienced by the visitor at the cellhouse level. This occurs both through the visual perception of the island and the city, and through the transition that visitors' bodies must inevitably make between the outdoors and the confined cellhouse (or vice versa). After wandering through the cellhouse for thirty minutes surrounded by crowds of other visitors, the sensations of space, light, and air afforded by the exterior of the cellhouse and its city views are especially welcome.

Back to the Mainland

Finally, visitors descend from the cellhouse level back to the dock below. They pass the public restrooms and one last gift shop on the way. Boats depart regularly, so the wait is short. As the ferry returns to the mainland, visitors catch their last close-up glimpses of Alcatraz, often aiming their cameras over the stern of the boat to snap photographs of the island as it retreats into the distance. As it did on their way to the island, the boat provides visitors with a transitional experience—a place to prepare for arriving at Alcatraz to see something special, and a place to make lunch or dinner plans and to turn their attention back toward the comforts of San Francisco itself. Visitors have had the opportunity to "experience" prison life and its social lessons, and now they are able to return to life on the "free" side of the bay.

Conclusion

Ultimately, we believe that Alcatraz's function as a memory site is completely bound up with one's ability to have direct physical contact with the site. At Alcatraz, the memories that "stick" are embodied in its buildings, made tangible in its cell bars, and enlivened by the vivid audio tour visitors hear as they walk through the prison. The more fully engaged visitors are with the spaces and experiences of the island, the more likely they are to leave with a lasting impression. More "traditional" museological methods that focus on presenting visual evidence, whether through documentary film or through exhibits behind glass, are unlikely to foster the kind of connection that rivals the physical interaction with this historical space. At Alcatraz Island, the physical and sensorial experience strongly shapes the constructed historical memories and focuses visitors toward the disciplinary power of the state rather than the resistance efforts of the Native Americans. While one can have embodied historical experiences at other places (for instance, living-history museums like Colonial Williamsburg),

many of those places were deliberately designed from their inception for that purpose and with an eye toward public consumption. Alcatraz, as the most notorious and mysterious American prison, isolated on a rocky island in the middle of one of the most beautiful bays in the country, is naturally a more furtive and off-limits location. Going "behind the scenes" of this facility, occupying its cells, "hearing" inmates roaming the halls and taking their meals, standing in a solitary confinement cell and imagining what it would have been like, leaves a powerful impression. That impression, though, is certainly more about the prison, the novelty of touring a prison, and the relationship between law-abiding citizens and criminals than it is about Alcatraz's complicated social history and role in the Native American Occupation. Here the opportunity to put visitors into direct contact with the island's Native American activist past, readily available at this striking location, is missed.

What can be done to provide visitors to Alcatraz more meaningful and lasting access to the history and people of the Native American Occupation? As it stands, we believe this liberatory event that does not fit neatly into the U.S. progressivist historical fabric is ultimately lost. NPS ranger Craig Glassner is optimistic that there are other places where Native American history can be learned, observing, "I don't think there is a definitive place to learn about this." He explains that Native American history is "taught a lot better in schools" today, and points to the concerted efforts that have been made in the national parks throughout the West to include the Native American perspective that had been previously absent.[56] Ironically, the Occupation seems to have made more of a mark on institutions outside of the island than on the island itself. But there is still the stubborn experience of visiting Alcatraz and not remembering the Occupation. If one cannot have a memorable public experience of the history of the most significant, politically influential Native American protest at the location where that drama was played out, where can it be had? One of the broader lessons learned from this case study of Alcatraz is the incumbency to integrate intellectual and physical experiences at critical historic locations. A more somatic experience of what it was like to live and protest on the island—conveyed via material experiences similar to those provided in the existing cellhouse tour—is required in order to bring Occupation memories more fully to life. For example, by using a more detailed audio tour method, these additional layers of life on Alcatraz could be revealed. Often tours of historical sites provide more than one audio narration for some or all of a site. Using this method, visitors could access as much or as little information about a given room as they wished by press-

ing additional buttons on their audio device. This alternative could provide a method for creating a more lasting memory of other aspects of Alcatraz's history that work in concert with the visitor's physical experience of the site. The tour can, and should, provide access to key locations on the island where the events of the Occupation took place and where its supporters lived. Without such changes, the memory of the Occupation at Alcatraz will continue its slippage against the memory of Alcatraz as a penitentiary.

Perhaps this outcome was inevitable from the moment the idea of Native American ownership of Alcatraz was conceived. Due to the island's physicality, it was inevitable that U.S. coercive authority would be the dominant public memory experienced at Alcatraz and not its tenure as Indianland unless the entire penitentiary was torn down. Although Alcatraz's location, terrain, and prison architecture suited the Native Americans' symbolic needs at the time—it was an attention-getting location to highlight the mistreatment of Native Americans—these same appealing material elements continue to dominate the site and the visitor's experience. In our view, the physical and architectural backdrop of the prison is critical to the allure of Alcatraz. It is this material rhetoric in combination with the cellhouse audio tour that comprises Alcatraz's primary methods of communicating a message that sticks. In order to cultivate visitors' memories of the Occupation, then, it is necessary to similarly tie such narratives to the physical spaces of the island either through an alternative audio tour, or through some other combination of space and history that focuses on the Native American experience of the island, and the history of oppression that led to the Occupation. In terms of the meaningfulness of this memory site, it is unquestionable that at the time the Occupation was very effective in changing U.S. policies regarding the treatment of Native Americans. Moreover, it was an example of a successful, nonviolent collective action. In its present form, contemporary audiences are denied this potent message of liberation, and they instead experience memories of U.S. coercive authority. In order for the memory of the Native American Occupation to endure, this memory site must be mediated at the same level as the cellhouse tour and not relegated to banners, exhibits, and video. If visitors could walk through the same physical cellhouse spaces as the Native American occupiers with an audio tour, in their voices, providing descriptions of their time on Alcatraz and their reasons for this action, then perhaps this memory space could stick as one of the most significant historical sites of successful civil disobedience and Native American protest. Overlooking the memory of the Native American Occupation at Alcatraz

Island is a missed opportunity to incorporate a definitive counternarrative of effective civil rights struggles in U.S. history.

Notes

1. Laura Hilgers, "Escape to Alcatraz," *Via* (2004): 42.

2. Troy R. Johnson, *The Occupation of Alcatraz Island: Indian Self-Determination and the Rise of Indian Activism* (Urbana and Chicago: University of Illinois Press, 1996), 220–21.

3. Roy Rosenzweig and David Thelen, *The Presence of the Past: Popular Uses of History in American Life* (New York: Columbia Press University, 1998), 3.

4. There are annual "Escape from Alcatraz" swimming events.

5. John A. Martini, *Fortress Alcatraz: Guardian of the Golden Gate* (Kailua, HI: Pacific Monograph, 1990), 6.

6. James Barter, *Alcatraz,* Building History Series (San Diego: Lucent Books, 2000), 12.

7. Martini, *Fortress Alcatraz,* 11.

8. Erwin N. Thompson, "The Rock: A History of Alcatraz Island, 1847–1972, Historic Resource Study, Golden Gate National Recreation Area, California" (Denver Service Center: National Park Service, Department of the Interior, 1979), 4, Alcatraz Island Archive Library, Alcatraz Island, CA.

9. Martini, *Fortress Alcatraz,* 13. "Alcatraz became, and forever would be, government property."

10. Ibid., 29.

11. Barter, *Alcatraz,* 30–32.

12. Martini, *Fortress Alcatraz,* 80–81.

13. Hal K. Rothman, "The Park That Makes Its Own Weather: An Administrative History of Golden Gate National Recreation Area" (San Francisco: Golden Gate National Recreation Area, National Park Service, U.S. Department of the Interior, 2002), 213, Alcatraz Island Archive Library, Alcatraz Island, CA.

14. Barter, *Alcatraz,* 62.

15. Rothman, "The Park That Makes Its Own Weather," 16.

16. Martini, *Fortress Alcatraz,* 129.

17. Rothman, "The Park That Makes Its Own Weather," 16–17.

18. Johnson, *Occupation of Alcatraz Island,* 17.

19. The first plan to occupy Alcatraz Island was on March 9, 1964, and the second attempt occurred on November 9, 1969 (Johnson, *Occupation of Alcatraz Island,* 17, 50).

20. National Park Service ranger John Cantwell described these initial tours,

in which "we would split them up into groups and then lead them through the island . . . about an hour and a half of talk and we did three of those a day and that was basically the Alcatraz Tour" (John Cantwell, personal interview, August 2005).

21. John Bodnar, *Remaking America: Public Memory, Commemoration, and Patriotism in the Twentieth Century* (Princeton, NJ: Princeton University Press, 1992), 15.

22. John Gillis, *Commemorations: The Politics of National Identity* (Princeton: Princeton University Press, 1994), 3.

23. Gregory Clark, *Rhetorical Landscapes in America: Variations on a Theme from Kenneth Burke* (Columbia: University of South Carolina Press, 2004), 27.

24. Ibid. Emphasis in original.

25. Golden Gate National Parks Conservancy, "Discover Alcatraz: A Tour of the Rock," n.p., 1996.

26. Barbie Zelizer, "Reading the Past against the Grain: The Shape of Memory Studies," *Critical Studies in Mass Communication* 12.2 (1995).

27. Pierre Nora, "Between Memory and History: Les lieux de mémoire," *Representations* 26 (1989).

28. Kenneth Burke, *A Grammar of Motives* (Berkeley: University of California Press, 1969), 7.

29. *Escape from Alcatraz, Birdman of Alcatraz,* and *The Rock* are a few of the more popular films about Alcatraz Island's penitentiary.

30. Hal K. Rothman, *Devil's Bargains: Tourism in the Twentieth-Century American West* (Lawrence: University Press of Kansas, 1998), 12.

31. U.S. Department of the Interior/National Park Service, "Assessment of Alternatives for the General Management Plan" (Golden Gate, Point Reyes: National Recreation Areas/National Seashore/California, 1977).

32. U.S. Department of the Interior/National Park Service, "General Management Plan Environmental Analysis," Golden Gate, Point Reyes, National Recreation Area, National Seashore, CA, 1980, 37.

33. Architectural Resources Group, "Alcatraz Main Cell House H.S.R." (San Francisco, CA: 1990), 34. Emphasis added.

34. According to NPS ranger Craig Glassner, there is discussion about adding announcements about Alcatraz on the boat ride over, but as of this writing, only open-water safety rules were announced. Craig Glassner, personal interview, 2006.

35. The "Dock Talk" is so named by the NPS rangers at Alcatraz.

36. There is also an NPS brochure available in multiple languages for purchase (donation) that opens to describe four historic uses of Alcatraz: "Alcatraz,

The Fort," "Alcatraz, The Prison," "The Native American Occupation," and "Natural Alcatraz." The brochure unfolds into a map of the island with brief descriptions of the dock, guardhouse and sally port, post exchange/officers' club, military chapel, barracks/apartments, warden's house, lighthouse, cell-house, and the gardens.

37. Before the 1991 orientation film, a slide show was offered to orient visitors to Alcatraz Island. We were unable to locate a copy of the slide show.

38. All unmarked citations in this section are taken from the orientation film *Alcatraz . . . Stories from the Rock*.

39. Bill Nichols, *Introduction to Documentary* (Bloomington and Indianapolis: Indiana University Press, 2001), 105–9. There are several other forms of documentary films that restrict the use of particular images in their films, for example, some documentarists will not use historical re-creation under any circumstances.

40. "Fiction may be content to suspend disbelief . . . but non-fiction often wants to instill belief" (Nichols, *Introduction to Documentary*, 2).

41. Johnson, *Occupation of Alcatraz Island,* 38–39.

42. Ibid., 11.

43. Indians of All Tribes Inc., "Why We Are on Alcatraz," *San Francisco Magazine* (undated); Alcatraz Island Archive Library, Alcatraz Island, CA.

44. Leonard Garment, *Crazy Rhythm* (Toronto, CA: Random House, 1997), 225.

45. Bureau of Indian Affairs, "Federal Indian Policy," Department of the Interior (undated), 2; Alcatraz Island Archive Library, Alcatraz Island, CA.

46. Johnson, *Occupation of Alcatraz Island,* 220; Vine Deloria Jr., foreword to *Heart of the Rock: The Indian Invasion of Alcatraz* (Norman: University of Oklahoma Press, 2002), x.

47. John H. Falk and Lynn D. Dierking, *The Museum Experience* (Washington, DC: Whalesback Books, 1992), 3.

48. Anne Rosenthal, "Conservation Evaluation: Alcatraz Island Graffiti from the Native American Occupation, 1969–1971" (San Rafael, CA: 1996), 3; Alcatraz Island Archive Library, Alcatraz Island, CA. Several of the report's recommendations have been adopted. A binder in the Alcatraz Island archive documents all of the Occupation's graffiti, and some shelters have been built to protect graffitied surfaces from the weather.

49. Igler, "'This Is My Land': The Indian Occupation of Alcatraz, 1969–1971," 45–46; Alcatraz Island Archive Library, Alcatraz Island, CA. The cause of the fire has been debated, with Native Americans claiming that government agents started the fire and government representatives in turn denying any part

in starting the fire and blaming the Native American occupiers. For further thoughts on the fire, see also Adam Fortunate Eagle, *Heart of the Rock: The Indian Invasion of Alcatraz,* and Johnson, *Occupation of Alcatraz Island,* 167–68.

50. Cantwell, personal interview with Teresa Bergman, October 2005.

51. Norman Johnston, *Forms of Constraint: A History of Prison Architecture* (Urbana: University of Illinois Press, 2000), 144.

52. Michael Esslinger, *Alcatraz: A Definitive History of the Penitentiary Years* (Carmel, CA: Ocean View Publishing, 2003), 420.

53. Michel Foucault, *Discipline and Punish: The Birth of the Prison,* trans. Alan Sheridan (New York: Vintage, 1979).

54. Golden Gate National Parks Conservancy, "Alcatraz Cellhouse Tour."

55. Sherry Butcher-Younghans, *Historic House Museums: A Practical Handbook for Their Care, Preservation, and Management* (New York: Oxford University Press, 1993), 207.

56. Glassner, personal interview.

III
Place

6
Tracing Mary Queen of Scots

Michael S. Bowman

During a tour of Scotland in 1856, Nathaniel Hawthorne made a pilgrimage to Abbotsford, the former estate of another great romantic novelist, Sir Walter Scott. Among the several paintings that Scott had collected, Hawthorne later confessed that "the one that struck me most . . . was the head of Mary Queen of Scots, literally the head cut off, and lying on a dish. . . . The hair curls or flows all about it; the face is of a death-like hue, but has an expression of quiet, after much pain and trouble—very beautiful, very sweet and sad; and it affected me strongly with the horror and strangeness of such a head being severed from its body. Methinks I should not like to have it always in the room with me."[1] During a trip to Scotland in 2005, I, too, was arrested by the sight of Mary's disembodied head. In a dimly lit room of the Mary Queen of Scots House in Jedburgh, protected by Plexiglas and hauntingly illuminated, rested the painted and bewigged death mask of Mary Stuart on a black pedestal, looking as beautiful, sweet, and sad as she does in the painting mentioned by Hawthorne. Like Hawthorne, I was struck by the horror and strangeness of it, both repulsed and intrigued by the idea of having it always in the room with me.

That ambivalent desire to have Mary "in the room" with us, as it were, is evident today in Scotland and also beyond its borders. Few historical figures have captured the popular imagination as the Queen of Scots has, and nearly everyone who reads or writes about her is struck by the prophetic nature of her personal motto: "In my end is my beginning." Executed in February 1587 at the age of forty-four on the orders of her cousin, Queen Elizabeth Tudor of England, the end of Mary Stuart's relatively brief life was only the beginning of her long afterlife as an icon, a voyeuristic image to be acquired, savored, and re-embodied at periodic intervals during the last four centuries. A celebrity before the age of mass culture, Mary's image has continued to circulate widely, prolifically, in the absence of her person for over four hundred years.

Today, Mary Queen of Scots still seems to be everywhere in Scotland. She is a major topic in contemporary national education, in historical research, and in many of Scotland's museums and heritage sites. She also appears in a broad spectrum of cultural productivity outside those more con-

ventional historical/educational domains, including politics, religion, art, literature, theater, film, and television. As "the patron saint of the Scottish heritage industry,"[2] images of and relics associated with her seem nearly as prevalent in the country as The Saltire itself. Any physical site associated with her is prominently marked as such in plaques, signs, and tourist literature, not only in Scotland but also in England and France, the two other countries in which she resided. In Edinburgh, tours of two of its more popular attractions, Edinburgh Castle and Holyrood Palace, are designed to reach their climax by taking visitors into rooms she once occupied. At Linlithgow Palace, where Mary was born, schoolgirls dressed in sixteenth-century–ish "Mary Queen of Scots" garb give tours to school groups and other visitors, and at other venues young women embody Mary in living-history presentations and pose for photos with tourists. Indeed, monuments to her memory are everywhere, as Jayne Elizabeth Lewis has remarked, "be it the veritable shrine of her tomb in Westminster Abbey or the ubiquitous bookshop pyramid built from copies of Antonia Fraser's romantic biography, *Mary Queen of Scots.*"[3]

Widely regarded in her own time as a murderess, adulteress, and traitor—and still dismissed by some historians today as an abject failure as a monarch[4]—the fact that she has sparked such a prodigious output of memorial activity is in itself remarkable. While the purposes of the various memorial sites and activities vary from the earnestly educational to the entertainingly kitschy, such distinctions have become increasingly fuzzy due to the mediated production of place at most tourist and heritage attractions and Mary's omnipresence in popular culture, literature, art, heritage industries, and museums. In this essay, I explore what power of fascination directs people's imaginations and travel itineraries to the sites associated with Mary Queen of Scots. Is it a quest for the romantic? Is it a desire for edification and authenticity? Is it a matter of amusement or entertainment? Or do we have to address more complex issues about how history, memory, pleasure seeking, tourism, and identity formation intersect?

This chapter is based on two field studies in Scotland in July 2005 and September 2006 of select heritage sites and tourist venues where Mary figures prominently. The principal site on which I focus here is the Mary Queen of Scots House and Visitor Centre (MQSH) in Jedburgh, where I spent a week examining the objects, images, and information presented at the site and observing and talking to visitors and staff. The building itself is a listed sixteenth-century "T"-plan fortified tower house (also called a corbel house) under the care of the Scottish Museums Council and the Scottish Borders Council (figure 6.1). It contains a number of artifacts associ-

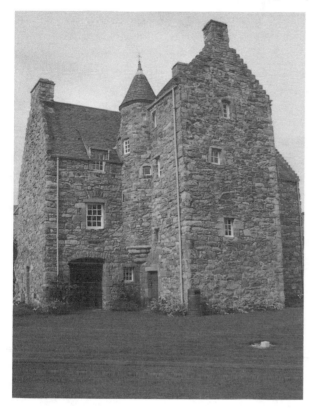

Figure 6.1. Mary Queen of Scots House, Jedburgh. (Photograph by author.)

ated with the Queen of Scots, including the aforementioned death mask, and a few pieces of replicated Renaissance furniture, but it is otherwise unfurnished. Yet, like other buildings associated with well-known historic persons, the principal attraction is ostensibly the house itself as a memorial to Mary and an indexical sign of her, a trace left from a time when she presumably resided here. The building was modified on several occasions over the centuries with changes in ownership and usage, and extensive alterations were made in 1929–30 in order to restore it as closely as possible to its original condition and appearance prior to its opening as a public museum in August 1930. Other structural and cosmetic changes to the building were made in 1987, 1997, and 2003 to create a new doorway for the visitors entrance, to enable wheelchair access to the ground floor, and to enhance the experience for visitors through a redesigned presentation of the artifacts, imagery, and information for the tour of the house.[5]

Debates over heritage tourism generally and sites like the MQSH in particular often revolve around concepts of "authenticity" and "commodifi-

cation." Many of these debates falsely present the matter as one of either/ or, suggesting that such places are serious or frivolous, educational or entertaining, authentic or inauthentic, and historically accurate or devoted to nostalgia and kitsch, thus neglecting how visitors ascribe meaning to and inscribe their own practices within heritage sites. In what follows, I move from examining the rhetorical performance of the MQSH as a site of memory and heritage to the practices and performances of remembrance by tourists. In doing so, I approach the MQSH as a site of interpretation and meaning effects, certainly, but also one of affect and presence effects.[6] The first section outlines the principal themes and presentational modes of the MQSH, while the second examines how visitors encounter and interpret the site and its rhetoric. In the final section, I suggest a framework for understanding how material encounters and imaginative fantasies intersect in the performance of this site and suggest that such performances transform Mary Queen of Scots from mere romantic icon into a "destination."

Unanswered Questions: Narrating between Memory and Myth

The Mary Queen of Scots House and Visitor Centre specifically commemorates a time in the year 1566 when the queen and her entourage made a procession to the Scottish Borders region, then called Teviotdale, so that Mary could see (and be seen in) this part of her realm and hold a series of circuit court proceedings. Mary arrived in Jedburgh on October 9, 1566, to an enthusiastic reception by the locals, and she departed a month later on November 9. During her month in the region, however, Mary became severely ill and nearly died, and the MQSH invites visitors to imagine the building as the scene of her near-death and convalescence. Furthermore, within a year of her visit to Jedburgh, Mary's life and personal reign had unraveled completely: her second husband and king consort, Henry Stewart, Lord Darnley, had been spectacularly murdered; she had first defended and then rather hastily married James Hepburn, Earl of Bothwell, the man believed to have been responsible for Darnley's murder, thus leading many to suspect that Mary herself had been involved in the death of her husband; and a coalition of Scottish nobles, many of whom were probably involved with Bothwell in Darnley's murder, had revolted against Mary, imprisoned her in Lochleven Castle, and forced her to abdicate the throne in favor of her infant son, James. "Would that I had died at Jedburgh," Mary reflected some years later, and the central idea that the

MQSI I seeks to convey to visitors is that Mary's visit to Jedburgh in 1566 marked the turning point in her life.

The audio and printed tour narratives articulate this theme in terms of Mary's personal motto or *impresa,* "In my end is my beginning." The MQSH booklet explains that the motto

> can be read as a religious belief in the eternity of life or as a reference to the lineage of British sovereignty, sprung from Mary herself. We choose to interpret the motto as meaning the myth and argument that has surrounded her story since her death. With her end began a debate which has engaged historians, scholars and novelists alike for four centuries. Much has been written about Mary Queen of Scots; the tragedy is undisputed but there remain many unanswered questions which continue to perplex us all. . . . Mary's life and her charisma also gave rise to something approaching relic-mania, with a mass of collected objects, cherished because of a possible connection with her, and occasionally regarded as having almost saintly significance.[7]

Although the audio narrator says "we'll try to find answers" to those "unanswered questions" as we move along on the tour, the MQSH does not, in fact, attempt to answer them or resolve the debates, choosing instead the more modest and seemingly impartial aim of outlining the plot, major characters, conflicts, dramatic climax, and denouement of Mary's life story. But another central focus of the tour is the "cult" of Mariolatry that developed after her death, that thrives to this day, and that the MQSH itself participates in, albeit self-consciously and somewhat ironically.

The tour begins on the ground floor in a barrel-vaulted stone room that once was the kitchen but is now the reception area. After paying the modest £3 admission fee, visitors receive a handheld, English-language audio guide wand (or "phone," as many of them call it) and are instructed how to use it. Visitors usually ask for printed information, too, and the MQSH sells an inexpensive double-sided information sheet in English, French, Italian, German, and Dutch, as well as the aforementioned booklet in English. Along the walls of the kitchen/reception area are two long tables covered with various souvenirs, ranging from scholarly books on Mary and Scottish history to such items as coffee mugs, refrigerator magnets, and key chains that bear Mary's image or the image of the house. In a corner of the kitchen/reception area stands a computer terminal that offers an interactive, touch-screen virtual tour designed for wheelchair-bound visitors

who would be unable to climb the steep, narrow winding staircase in the building.

The first two "stops" on the audio tour are in the kitchen/reception area. The first provides a brief welcome to the MQSH and an introduction or prologue to Mary's story, and the second informs visitors about the kitchen area and the typical diet in sixteenth-century Scotland. From the kitchen, visitors proceed up the main staircase to the first floor and the beginning of the tour proper. The presentation takes the form of a mixed-media experience that visitors negotiate as they move through the rooms of the old building. In addition to the audio narrative that visitors listen to on their "phones," they read printed text on the information sheets or booklets they carry with them, as well as on panels and plaques that are installed in the various rooms; they gaze at objects and artifacts displayed behind glass-enclosed cases and at different architectural features of the house; they look at images of Mary and other figures in her story on painted murals, in framed portraits, and, in one instance, in a large abstract sculpture or installation.

The biographical narrative is structured chronologically and organized into several discrete segments or chapters. The stairwell up to the first floor features a brightly colored mural depicting Mary as a girl, along with other figures from her childhood and adolescence, while the audio narrative accompanying the ascent recounts Mary's somewhat idyllic "Early Years" from her birth in 1542 to her childhood and adolescence in France to her decision to return to Scotland at the age of eighteen following the death of her first husband, King Francis II of France, to assume personal rule of her own country. At the top of the stairs, visitors enter the Banqueting Hall, where they learn of Mary's early popularity with her subjects, conflicts with the belligerent Calvinist minister John Knox and other Protestant lords, and her stressful, though largely successful, first years of reign. In the adjacent Forechamber, the tour interrupts the chronological narrative to show us what it calls the "Rogues' Gallery."

The Forechamber's paneled walls are painted with portraits of the major players and plotters during Mary's life in Scotland. The introduction of these "rogues" is designed in the audio portion of the tour (for no information about them is presented in the visual display) to illustrate a quotation from historian Gordon Donaldson that is etched on a plaque that hangs on the wall and that someone, presumably Donaldson himself, speaks on the audio: "To say that Mary's life was largely determined by events over which she had no control is not the same as saying she was a victim of circumstances, for her biography is the study of the interplay between her, as

woman and Queen, and the national and international situations. But she must never be thought of as the maker of her own destiny, for her fortunes were shaped at least as much by events as by qualities or defects in her character, or by anything she did or left undone."[8] The audio narrative glosses the different relations among the various "rogues" and the "national and international situations" quickly and in a manner that scholars such as Donaldson might find almost meaningless.[9] However, the presentation effectively conveys the impression that the Queen of Scots had many powerful enemies and few friends, and one leaves the room with a sense of impending disaster.

Support arg

Display cases in both the Banqueting Hall and Forechamber contain a number of objects associated with Mary and develop the "cult" theme. In them are such items as a communion set that reportedly belonged to her, a lock of her hair, a shoe that she abandoned because of a broken heel, a wood chip from the boat she used to escape from Lochleven Castle, and a nineteenth-century medal bearing her image that had been cast to feed the relic market. An important characteristic of the tour's rhetoric becomes apparent here, insofar as several of these items are displayed alongside mini-narrative texts that seek to authenticate them or establish their provenance. Such mini-tales are interesting in themselves as tales, but each of them fails in some more-or-less obvious way to prove the authenticity of the object in question. There are holes in the stories or gaps in the chain of evidence too large to miss, or else the narrative leads one to draw the inference that the item must be genuine while cagily avoiding making any such claim, save for the identifying caption. At such moments, the MQSH's narrative rhetoric becomes double-voiced, insofar as the "voice" of the MQSH reiterates the "voices" of others, thus establishing a possibly ironic distance from them. Each of these tales comes with a kind of loophole that allows the MQSH to pass on stories about the artifacts while disclaiming authority for them: to say, in effect, "Here is the story we've heard about this item; we leave it to you to decide whether it is true or not."

Returning to the Banqueting Hall and exiting to the stairway, visitors ascend a steep, narrow winding left-handed staircase. This architectural feature is another good case in point regarding the MQSH's double-voiced rhetoric. Although there are no surviving records of the original construction or ownership of the building, the left-handed staircase is interpreted as evidence that the house was originally built and owned by the Ker family, who were apparently a left-handed bunch and who would want a left-handed stairway to make it easier for them to wield their swords in case of an attack on the building. Surviving records do indicate that Mary

Cont

rented a fortified tower house like this one somewhere in Jedburgh from a Lady Ferniehirst for £40. Because Lady Ferniehirst was the first wife of Sir Thomas Ker, because Ker was one of Mary's staunchest supporters, and because of the left-handed staircase, one is led to draw the inference that this really was the house in which Mary resided. Yet, the MQSH studiously avoids making that claim explicitly, and visitors are quick to notice that.[10] In addition to inviting visitors to question the authenticity of the objects it displays, the MQSH, in effect, ironically distances itself from itself, too. It reports stories about what locals came to call "Queen Mary's House" while inviting visitors to question those stories.

Even so, the stairway leads to a room marked with a sign that proclaims it to be "Mary's Bedroom." The room is very small and unfurnished, save for a small cannon, an apparent gift from Mary to Sir Thomas Ker, that rests below a display case filled with more relics—and more stories about them. Here, the story reaches what it calls "The Turning Point," the "fateful year" of 1566. The narrative tells of her deteriorating relationship with Darnley and of the murder of David Riccio, her Italian secretary and most trusted advisor at that time, by a group of nobles led by Darnley. In June of that year, Mary gave birth to her son, James, and in October she made her procession to Jedburgh.

The main story told in Mary's Bedroom, however, concerns a trip she made to visit the Earl of Bothwell, who had been badly injured in a fight with a band of reivers he had attempted to arrest and bring to court while Mary was in the region. The only momentous aspect of the trip itself was that Mary's horse tripped and fell in a bog during her return to Jedburgh, throwing her from the saddle. When she and her retinue returned to Jedburgh, Mary quickly fell ill, leading some to speculate that her near-fatal illness was the result of internal injuries she may have suffered in the fall. Following Darnley's murder and Mary's subsequent involvement with Bothwell, however, this polite state visit to a trusted noble who had been injured in her service was re-presented by Mary's enemies in a much more lascivious and damning narrative, with Mary galloping in a lust-driven frenzy across the boggy heath to have a sixteenth-century version of a "quickie" with her illicit lover.

At this point, the audio guide instructs visitors to continue up the stairs to learn the "Epilogue" to Mary's story. A few short steps up from Mary's Bedroom, we enter another large room, the "Guard Room," that contains two parallel rows of display panels hung between stark wooden poles reaching from floor to ceiling in the center of the room. Moving counterclockwise around the room, the panels offer a terse, episodic review of

Mary's swift downturn in fortunes, beginning with her near-fatal illness in Jedburgh to her fateful decision to flee to England after her defeat at the battle of Langside a year and a half later. On the walls of the room hang a variety of old weapons—swords, dirks, daggers, pikes—that remind us of the room's original purpose and add an atmospheric touch to the stories of murder and battles presented in the narration. The island of poles and panels in the middle of the large room, together with the stark, dramatic lighting and the military hardware, gives the room a bold, striking visual appeal that contrasts sharply with the relative bareness and simple décor of the other rooms. Rhetorically, the narrative sacrifices exegesis for engagement: it still refuses to delve into those "unanswered questions," most of which concern precisely the events between October 1566 and May 1568 that are summarized in this room, but it effectively sweeps visitors along from panel to panel, from one outrageous event to the next, viscerally pulling them along in Mary's swift and sudden downfall.

Stepping through a wide doorway into the adjacent room, the "Last Letter Room," the narrative quickly summarizes the final nineteen years of Mary's life when she was held captive by the English and finally executed. In the center of the room stands a large plaque with a facsimile of the letter Mary wrote on the morning of her execution to her former brother-in-law, King Henry III of France, together with an English translation of the letter. The audio narrator asserts that it is "one of the most poignant [letters] ever written," before yielding the narration to another voice actress who reads excerpts from the letter, poignantly, in French-accented English. The room is dimly lit, and a bench rests against the wall, offering the visitor his or her only chance to sit during the tour and, perhaps, meditate or reflect on the "lessons" of Mary's life. In a corner niche of the room opposite the bench, staring blankly back at those who sit there, is Mary's ghostly head, which seems to hover in the air about four feet off the floor in the form of the death mask (figure 6.2).

Exiting the "Last Letter" room back onto the stairway, there is one final stop on the tour at the top of the house, the "Maries Bedroom," named for the four women who were Mary's attendants and friends throughout much of her life, Marys Seton, Beaton, Livingston, and Fleming. While Mary's Bedroom appears much too small for a queen to have occupied, this equally tiny room appears impossibly so for four grown women to have used. Unlike most other rooms in the house, which are painted and paneled in a manner suggestive of the period, the Maries Bedroom is painted a stark white. Installed in the room is a large, modern, abstract white sculpture made of glass, steel, wood, and paper evocative of Mary's tomb in

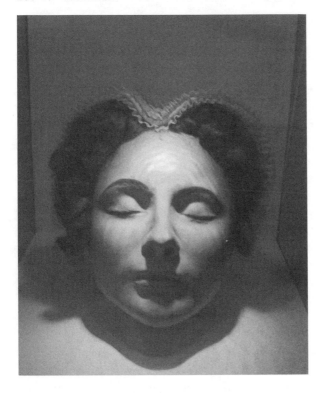

Figure 6.2. Mary's death mask. (Photograph by author.)

Westminster Abbey. The sculpture extends across the entire room just inside the doorway, blocking the visitor from entering more than a step or two into the room. Etched in the glass top of the sculpture is Mary's recumbent image, one that recalls elements from both a well-known portrait of her and the effigy on her tomb, along with the words "Dignity Restored" and "In my end is my beginning." The narrative material covers her execution at Fotheringhay Castle in England in 1587 and explains how her son, James, had her remains moved from Peterborough Cathedral, where she was first interred, to Westminster after he acceded to the English throne. The narrative concludes by reiterating the dynastic interpretation of Mary's motto, noting that all English monarchs since James trace their lineage to her, rather than to her nemesis, Elizabeth.

Reading Mary's Traces

I have described above the major themes through which the figure of Mary Stuart is presented at the MQSH, together with the several media used in

that presentation, with a specific focus on the narrative offered in the audio "phone" presentation, a technology that has become fairly standard now at many museums and heritage sites. I have suggested that in its use of ironic, double-voiced rhetoric, in its refusal to answer the many questions surrounding Mary's life, and in its mixed-media format, the MQSH presents a number of interpretive and performance challenges to visitors.

Most visitors who come to the MQSH have some knowledge of Mary Queen of Scots—some image, anecdote, historical outline, or fragment of information—that they acquired from their schooling, family, or popular culture. "Everyone knows the story" and "everyone knows about Mary Queen of Scots" were the two most common refrains I heard when I asked visitors whether they knew much about her before they took the tour. Everyone knows the name, at least, and most recall the final gesture that ended her life. Many know quite a bit more: that she was related somehow to Elizabeth Tudor; that the two women ruled their neighboring countries at roughly the same time; that there was some controversy regarding their competing claims to the English crown; that Mary was Catholic and Elizabeth Protestant; and that Mary was imprisoned in England for several years before she was eventually beheaded. However, few of them know how Mary's story connects to the town of Jedburgh or this particular building, and many are curious to find out what the "Mary Queen of Scots House" might be—and what it might be doing in this unlikely spot.

Hence, an important context for understanding the MQSH is its location in the Scottish Borders region and the small town of Jedburgh. Neither are themselves major international tourist destinations so much as they are way stations—a bathroom and petrol stop, say—between major destinations in England and Scotland. The rolling Cheviot Hills and wooded Teviot and Tweed river valleys certainly do attract domestic tourists from both England and Scotland for hiking, hunting, and fishing holidays or weekends, and other visitors are drawn to the area for the cultural heritage attractions of Scott's Abbotsford and the ruined medieval abbeys at Jedburgh, Dryburgh, Kelso, and Melrose. However, the main stop for the package bus tours that roll through the region on their way to or from Edinburgh is the Jedburgh Woolen Mill retail outlet that lies on the outskirts of town along the A68 bypass.[11]

Many of the visitors I spoke with had no idea that the MQSH existed prior to their arrival in town to visit Jedburgh Abbey, and "discovering" it for themselves seemed to enhance their appreciation for both the region and the MQSH itself. Several comments left by visitors in the house's guest book, for instance, referred to it as an "undiscovered gem" or a "hidden

treasure." Those people I spoke with echoed such sentiments and wondered why the Borders area in general and the MQSH in particular were not better promoted as tourist destinations. Like many tourists, visitors to the MQSH find value in experiences that occur "off the beaten track," in places the so-called mass tourist never sees, and this small building in a small town in a corner of Scotland most tourists merely pass through certainly qualifies as a site that offers visitors the thrill of discovery and unanticipated pleasures.

While the MQSH has the reputation of being something of a pilgrimage site for "fans" or devotees of Mary's "cult," only three of the seventy-four individuals I interviewed at any length identified themselves as such or expressed any special affection for her. In addition, I spoke briefly with probably another hundred individuals and reviewed hundreds of visitor comments in the house's guest book. A handful described their visits as "a dream come true" or "the most memorable moment of my life," but most comments were of the sort given by the visitors I interviewed personally: eagerly positive about their experiences at the MQSH, laudatory toward the quality of the information and exhibits, curious to learn more, and a bit surprised to have found this little gem tucked away in a small town like Jedburgh.

When I asked visitors to elaborate on what they enjoyed about the MQSH and their impressions of the house, their comments clustered around one or more of three main themes: history, tragedy, and religion.

"History—We Love It!"

A woman from North Yorkshire had just finished touring the MQSH with her two great-grandsons and sat in the kitchen/reception area with me while the boys played with toy swords from the souvenir table. She told me that she had visited the house twice before and wanted her great-grandchildren to see it. She was not an atypical visitor. Many of those who come to the MQSH are self-identified "old-age pensioners" who ask for and receive the concession price for admission. They usually come in pairs or trios—a man and woman, two women, two women and a man, or three women—but there were several occasions when they brought children. It wasn't unusual to see three generations of a family represented in larger groups of four to six touring the site together, with one or more of them having been to the house before. The Yorkshire woman said that she liked the MQSH very much, and that she enjoyed taking her grandchildren and now great-grandchildren to places like this to "give 'em a bit of heritage." When I asked her why she liked the house so much, she thought for a mo-

ment and then replied, as if there could be no other answer, "Well, it's history, innit? You've got to."

Indeed, the endorsement of "history" or "heritage" by visitors was nearly unanimous. Because history is seen as a subject of self-evident value and intrinsic interest, there is an imperative to "preserve" or "save" or "care for" or "look after" it, to borrow some of their phrases, as well as to visit it. Several commented approvingly on how clean and well maintained the building was, as if that demonstrated that "history" were being shown the proper respect and care at the MQSH. Metaphorically, at least, "history" appears to have liquid properties. Visitors commented that the MQSH was *filled, drenched, soaked, oozing,* and *dripping* with history, as if it were an oasis in a desert of modernity. Others extended this praise to the Borders region or to Scotland generally. "The place is just drenched in history," one English woman told me, "not just this place, but the whole Borders area, with all the fighting and problems back and forth, Henry VIII coming in and destroying all those abbeys. It makes you think. And here they haven't done anything to it—they've left it as it was." As one English couple put it, "The Scots are so much better at preserving history than we are." Visitors from the United States and Australia were equally enthusiastic about the value of history and its preservation, and in a couple of instances they lamented that their nations didn't have "as much history" as England or Scotland had.

Critics of heritage tourism are often quick to dismiss such sentiments as part of that popular intellectual pastime that Raphael Samuel dubbed "heritage-baiting."[12] Because the views expressed here appear somewhat romantic or nostalgic, and because Scotland's talents for historic preservation, such as they may be, undoubtedly owe as much to economic incentives as to some innate Scottish genius, it would be tempting to join the chorus of disdain that accuses heritage of travestying the past by offering its ersatz and kitsch in place of "real" history, of commodifying it in neat, generic "history" packages that tourists can consume on the fly, and of turning people and places into theme park–like cartoons of themselves.

The visitors I spoke with about such matters would have none of it, perceiving it as an insult to their intelligence—which of course it is. At the same time that visitors claimed already to "know" or "know about" Mary and often expressed their enthusiasm for "history" and "heritage" in vague or clichéd terms, they always remarked on how much they learned about Mary from the tour. Those who had studied her in school praised the MQSH experience as being "better" than what they had learned in school—because the house "brought it to life," as many of them put it—

although the older ones confessed that they had studied history long ago and had forgotten much of what they had learned.

Furthermore, the tour also created an appetite to learn even more about Mary. One woman's story typified the responses of several women I interviewed: "I know I read a book about her once, maybe twenty years ago—I don't remember which one, probably Antonia Fraser's, or it might have been just one of those Jean Plaidy[13] novels—but it didn't have much of an impact. Now I want to go back and read it again." Because they evidently perceived me as an authority on the subject, my interviewees frequently interviewed me as well, asking me to clarify parts of the story that were unclear to them on the tour, to elaborate on episodes of the story that intrigued them, and to recommend other books for them to read. Indeed, if I stationed myself in a given room for any length of time, I inevitably would be approached with questions as if I were a docent or staff member, and their questions were often quite good ones, picking up on the ambiguities in both the historical narrative and the rhetoric of the tour to probe the same issues that have puzzled historians and biographers for centuries.

"Poor Mary!"

As visitors descended the stairs following their tours of the house, I would often hear them utter a brief comment to their partner about how "sad" or "tragic" Mary's life was. On numerous occasions, visitors would reach the bottom of the stairs and blurt out such statements to MQSH staff member Pat McNab and me, like moviegoers exiting a theater. Pat had told me early on that the comment she hears most frequently when visitors return to the reception area after completing the tour is "Poor Mary," and, as if on cue, a woman trundled down the stairs, stepped into the reception area where we were standing, and uttered those very words to us. Scores of entries in the MQSH guest book consist of simple exclamations like "Tragic!" or "How tragic!" or "What a tragedy!" as if offering a choral endorsement of the site's claim that Mary Stuart was "one of the most romantic and tragic figures in history."

These are not eccentric judgments. A vivacious and, by all accounts, charming, beautiful, and talented young queen, unlucky in love and yet ready to risk everything for the men she loved, is undone either by some fatal flaw or miscalculation or by forces beyond her control. What better plot could there be for a tragedy? "You couldn't make this up," one visitor pointedly remarked, echoing the view expressed by any number of Mary's biographers that one reason for her enduring appeal is that her life story is a better tragedy than most fictional ones. Whether one views her as the

scheming femme fatale or the beautiful but naïve princess is largely irrelevant, for the story works as tragedy either way.

The transformation of Scottish history into romance and tragedy is a complicated and vexing issue, and Mary Queen of Scots is undoubtedly the poster child for this "disease," along with her great-great-great-grandson, Bonnie Prince Charlie. Richard White, an assistant curator with the Scottish Museums Council, could have been speaking for many historians and present-day Scots when he candidly told me, "To tell the truth, I'm sick of Bonnie Prince Charlie and Mary Queen of Scots." While he noted the significant role that Walter Scott played in reinventing Scotland as an imaginary landscape where our passions for romance and tragedy could be exercised, he acknowledged that "we [Scots] like dead ends." Historian Jenny Wormald, too, has lamented "the peculiar tendency of the Scots to follow the lead given by Sir Walter Scott and turn their history into tartan romance, making folk-heroes of failures and thugs, be they Mary Queen of Scots, Rob Roy or Bonnie Prince Charlie. No amount of scholarly history . . . will ever combat it completely. . . . Mary is not just part of the problem, but compounds it; for it has not been unknown for normally sober historians to lose their scholarly heads when in her presence."[14] The role of the MQSH in reinforcing or perpetuating certain romantic images of Mary and, hence, Scottishness can be divorced neither from the (re)production of other historical representations of Mary, in her day or our own, nor from the use of Mary in material and popular culture and in other forms of ritual and performance like tourism. One senses the frustration of historians like White or Wormald in combating this "problem," as if history ought to be able to overcome popular memory, to give us the truth about figures such as Mary, to disentangle *history* from *romance* and *tragedy* and thus end our fascination with them.

Yet, if history has been unable to give us the truth about Mary—to answer all those unanswered questions and resolve the debates once and for all—perhaps Mary and her story give us a truth about history. As Lewis has remarked, Mary's various incarnations and iterations over the last four centuries "expose the violence that makes modern history. . . . But specific as applications at individual historical moments might be, Mary has always also been a door to what isn't exactly there, in history—into the non-historical experience of self-induced and eternally lamented loss."[15] Moreover, like all good tragedies, Mary's story invites us to *speculate*, to imagine "what might have been," as several visitors put it, and to deliberate those many "unanswered questions" about her character and her actions— as well as those of her allies and antagonists—that have preoccupied histo-

rians, biographers, poets, novelists, and playwrights for so long. "Elizabeth was brilliant," one woman noted, "but so was Mary. I see that now. To think of the timing of the two of them at once—and 'what if' . . . ?" Her voice trailed off, leaving the many "what ifs" unarticulated, before reaching the conclusion that all tragedies invite us to reach: "Well, things might have been very different."

"Religion—That's the Bugbear"

One of the things that might have been different had Mary succeeded in her bid for the English throne was the religious makeup of Scotland and England. Like most other European nations in the sixteenth century, Scotland and England suffered tremendous social upheaval in the wake of the Protestant Reformation. The fear of a return to Catholicism—and with it a stronger Continental influence in England—fueled the animus driving the persecutors and plotters against Mary Stuart, especially with "Bloody" Mary Tudor's reign so fresh in English minds. Furthermore, the historical ties between Scotland and France, the "Auld Alliance," had been a thorn in England's side for centuries. Because Mary was herself half-French, a Queen Dowager of France and Queen Regnant of Scotland, and because her powerful Guise relatives in France ruthlessly prosecuted the fight against Protestantism in the French Wars of Religion, such fears were not unwarranted. In Scotland, moreover, the Protestant Lords of the Congregation had seized considerable power from the monarchy during Mary's minority years in France and had elevated the Kirk to the official state religion, seizing property from the Catholic Church and individual Catholic nobles, and they were understandably reluctant to give it all back. That Elizabeth, her advisors, and her largely Protestant Parliament would not recognize Mary's claims to the English throne is not surprising; that they often worked clandestinely with various forces in Scotland and elsewhere to control or overthrow her in her own country is another story altogether.

The MQSH does not dwell on the intricacies of that story, but visitors were quick to point to religion and religious differences as perhaps the major "event" or "force" over which Mary had no control and that led to her downfall. "It was religion," one gentleman declared bluntly, shaking his head in disgust. He paused for a moment, then shrugged his shoulders and added, "Well, it always is, isn't it? It's no different today—it's all over the telly, all the troubles now." Another man, a retired lawyer from New York, surprised me with his comment that Mary "should have been executed twenty years earlier." Given the pro-Marian sentiments expressed by most visitors, this comment took me aback. "She was Catholic," he explained,

seeing my befuddlement. "People have a hard time understanding that, but that was it. And with the succession problem, of course there's going to be one side plotting to do away with the other. That's the way it was done back then." He went on to say that Mary wasn't innocent in such matters either: "Someone would write her a letter [seeking Mary's endorsement of some Catholic plot to overthrow or assassinate Elizabeth and put her on the throne] and she'd say 'go.' Babington proved that."[16]

With many of the visitors from the United Kingdom, I suggested that the Catholic/Protestant conflict seemed a bit remote to me, an American who grew up in the late twentieth century, although I could relate to the general "bugbear" of religion, as one woman called it, because of the current "troubles" between certain Islamic groups and Western, largely Christian nations like the United States and the United Kingdom. Initially, many of them agreed, speaking much like one young Welshman did, haltingly, as if dumbfounded by the vigor of religious conviction and conflict: "To think you can believe in something that strongly to want to kill or go to war . . . of course it's going on today . . . I don't know, I don't know . . . I just don't know." Inevitably, though, many of them would remind me of those other "Troubles" in Northern Ireland as evidence of the persistence of the Catholic/Protestant conflict in their nation. These reflections usually prompted others, and they would begin to reminisce about their own experiences with sectarian prejudice growing up in Scotland or England. They recalled segregated neighborhoods, streets they were not permitted to cross, people they were not allowed to have as friends. One woman spoke movingly of a cousin who never married and died a spinster after her father forbade her to marry the Catholic man with whom she had fallen in love. On a different note, a Scottish gentleman reminded me of something I already knew: that the sectarian divide is also enacted and reinforced today in Scottish football insofar as the fans (and, historically, the players) of several of its clubs are identified with the Protestant and Catholic sects. The matches often become occasions for expressing hatred not merely for the opposed clubs but for the opposed religions via chants, fight songs, signs, effigies, and hooliganism.[17] As one visitor wryly concluded after recounting her own story of sectarian prejudice, "It's like a curse, like a racial memory with us."

The Mary Queen of Scots House and Visitor Centre affords a variety of interpretive possibilities. People engage in different practices as they tour the house, and there is a wide range of options for linking up with other aspects of Mary Stuart's life and the imagery and mythology that now seem almost indistinguishable from that life than those themes I have discussed

above. However, there is always a dynamic interplay between an interest in the real, historical woman and the romantic iconography and tales that people carry with them from other contexts and media. The tragic and romantic figure of their imaginations goes hand in hand with the tracing of their own pasts, both personal and national, and has significant implications for how they interpret the narratives, images, and artifacts at the site. The play of fantasy and personal memory, and the search for knowledge or information about a historical figure and Scottish or British cultural heritage intersect and blend in important ways in visitors' evaluations of the site. And these evaluations have as much to do with the performances of remembrance they enact on the site as with the rhetorical performance of the site itself.

Destination: Mary Queen of Scots

In much the same way that Pierre Nora distinguishes between *memory sites* and *memory environments* on the basis of the artificiality of the former and the authenticity of the latter,[18] critics of heritage tourism frequently use a similar jargon of authenticity to condemn sites like the MQSH on the basis of their rhetoric, artifice, or "staged authenticity" on the one hand, or for their glib or ironic attitude toward their own inauthenticity or constructedness on the other.[19] As Edward Bruner has argued, however, such criticism is misplaced. It betrays an essentialism that assumes "authenticity" is a stable, pure, prediscursive quality or state rather than an emerging, shifting, differentially constructed one. Moreover, it often begs the question of whether "authenticity" is what a heritage site should strive for, or whether it is in fact what visitors and tourists actually seek from heritage sites.[20] Along with Bruner and others in contemporary tourism studies, I have argued elsewhere that we need to question this static notion of place and objects and rhetoric in tourism, which always seems to rely on tacit notions of self-presence, in favor of a more mobile, contingent, and performance-oriented conception.[21] In this particular case, I want to suggest that such an orientation allows us to focus less on the epistemological issues of what a particular site "says" or "knows" or on the ontological question of the site's "authenticity" and to consider instead what might be called the "hauntological" question of how the site recruits and mobilizes bodies to perform acts of remembrance.

The term "hauntology" is, of course, a neologism coined and deployed by Jacques Derrida to supplant ontology and the concern for Being and presence with the figure of the ghost as that which is neither present nor

absent, neither dead nor alive. In Derrida's hauntology, the ghost figures as an irrecuperable intrusion of the past as Other into the present, one that is not comprehensible within our available intellectual frameworks. The ghost "*is* something that one does not know, precisely, and one does not know if precisely it *is,* if it exists. . . . One does not know: not out of ignorance, but because this non-object, this non-present present, this being-there of an absent or departed one no longer belongs to knowledge. At least no longer to that which one thinks one knows by the name of knowledge."[22] As Fredric Jameson explains, the concern for hauntology has little to do with whether one believes in ghosts or the more banal assertion that "the past" is still "alive" in the present: "all it says, if it can be thought to speak, is that the living present is scarcely as self-sufficient as it claims to be; that we would do well not to count on its density and solidity, which might under exceptional circumstances betray us."[23] Hauntology offers us a far more generous way of understanding visitors' expressions of fondness for and interest in history and heritage than dismissing their remarks as mere nostalgia. While they may leave the MQSH without the sort of knowledge and understanding that might satisfy a historian, their performances of remembrance enact an affective and ethical relation to history as something about which we should be concerned—precisely because it invites us to question the density and solidity, as well as the inevitability, of the present.

As Simon Coleman and Mike Crang point out, "The spaces of tourism do not comprise a Euclidean grid around which self-present actors move, but rather a crumpled space where people and places are in process."[24] Indeed, as the MQSH example illustrates, even objects are in this sense "in process," and whatever stability of meaning space, objects, and actors achieve is accomplished provisionally, ephemerally, via a self-conscious performance of identification, an *articulation,* that may leave a lasting trace on the visitor—just as many visitors leave their own traces in the Mary Queen of Scots House most visibly by signing the guest book. While some of those traces consist of the pleasures of learning, gaining an interesting history lesson, hearing a compelling romantic and tragic tale, and reflecting on the issue of religion, others derive from the experience of "just being" in the house, as many visitors put it.

In oral comments to me and in written remarks left in the guest book, visitors were nearly unanimous in their praise for the MQSH's audiovisual presentation. Most would begin with some reserved comment, such as "informative" or "well-presented," but then quickly supplement it with a variety of superlatives: *brilliant, excellent, outstanding, great, wonderful, fascinating, magical,* and *cool* were terms I heard and read repeatedly. Implicit in several

of these evaluative remarks, however, is a trace of a more affective than intellectual or cognitive response to the "history lesson" they received—a kind of magic or conjuring trick—as of course were the many previously mentioned remarks about the MQSH's ability to "bring history to life." As they move about the house, interacting with space and the house's challenging mixed-media, mixed-aesthetic format, visitors give a complex performance that one described as "multitasking"—listening, reading, gazing, walking, reminiscing, daydreaming—and that produces a multilayered and polysemic experience. Visitor performances are partly grounded in the world of corporeal, physically encountered reality and partly in the workings of fantasy and the imagination, creating an experience that Bærenholdt and Haldrup call "fantastic realism"—a haunting—where objects and spaces and images and stories in heritage sites lose their aura and become *traces,* in Benjamin's sense, allowing visitors to be at once possessed by the site and to take possession of it.[25] Like the death mask, which draws its power and appeal more from its indexical relation to the deceased than from its iconicity, the house, too, holds visitors in thrall because they experience it as a trace that Mary herself walked here, dined here, slept here, climbed these same staircases. But another part of them knows full well that this trace may be a dead end.

Indeed, the MQSH tour creates enough doubt and dissonance to make visitors aware that it probably was *not* the house in which she stayed, just as it invites them to question the authenticity of many of the artifacts on display. When I asked visitors if there were particular rooms or displays in the house that they found especially compelling or interesting, there was no real consensus. Each room, as well as virtually every item on display in those rooms, was mentioned as a personal favorite by one visitor or another. Yet, in describing particular instances of absorption or fascination, visitors always signaled their distance from their own absorption to me. "Oh, I loved the lock of hair, of course," one woman enthused. She paused for a moment, then laughed. "Well, I liked the *story* about the hair just as much—who found it, et cetera—who knows if it's really hers or not?" Another visitor shared my morbid fascination with the death mask. While we both wanted to yield to its fetishistic power, we signaled our mutual skepticism by joking grotesquely about the practical difficulties of casting a death mask from a severed head and talking about how "fake" it looked with the makeup and wig. Finally, one of the visitors who said that her main pleasure derived from "just being" in the house said, "To think that you're walking where she walked, touching the same walls, be-

ing in the same rooms, looking at—." She stopped herself mid-sentence, then laughed. "Well, not 'the same,' of course—and I don't know really if she ever was *here*." We discussed the question of the house's "authenticity" for a few moments, enjoying the discussion rather than being frustrated by its lack of resolution. When she took her leave, she smiled and said, "Well, now I'm going to go out into 'her garden' and walk in 'her footsteps' there, too," making sure to place those intonational quote marks around her words to signal the reflexive nature of the performance she was about to give.

As visitors tour the building, they tack back and forth between a state of flow and reflexivity—that doubled consciousness inherent to performance—where one part of them is walking in Mary's footsteps, following her trail, while another is wholly aware that Mary may never have walked here at all. This is a far more complex kind of engagement with the past and a more complex set of pleasures than the cartoonish image of cultural dopes consuming "history-lite" packages on the fly that the heritage-baiters have propagated. And while many historians still have reservations about how "memory" or "collective memory" or "popular memory" may relate to or best inform historical study, the example of Mary and "her" house suggests that part of the answer lies not simply in separating the historical truth from the distortions of memory or popular culture but in discovering truths contained in our affective relations to the past, the ways in which our performances of remembrance make the past *present*—albeit the kind of presence governed by the differential logic of the *trace*.[26] Such performances of remembrance displace ontological questions of authenticity and epistemological questions of information and knowledge with a hauntological concern for ethics and justice.

One of the qualities for which Mary Stuart was both admired and reviled was her charm. To be in her presence was to be enchanted. Even some of her most bitter opponents grudgingly admitted as much, although they usually interpreted this as another sign of how dangerous she was, either morally or politically. One of the mysteries of her relationship with Elizabeth concerns the fact that the two women, cousins and sovereigns of neighboring countries, never met. Mary was convinced that if the two could ever meet face to face, they would resolve their differences quickly and easily. Elizabeth would never agree to such a meeting, however, and numerous commentators have speculated over the centuries that the reason why Elizabeth would not meet her cousin is that she feared that Mary was probably correct—that Elizabeth, too, would be seduced by Mary's charms.

If, as Wormald has it, even "normally sober historians" can still "lose their scholarly heads when in her presence"—four centuries after her death— what chance do the rest of us mortals have?

But whereas Wormald sees this as a barrier to a more authentic engagement with Scottish or British history, the MQSH enables, by virtue of its space and rhetoric, an experience that allows people to perform in such a way as to "lose their heads," albeit in a figurative and reflexive way, by imagining themselves as in some sense co-present with Mary. By telling a story that puts the historical truth about Mary in play, that puts its own authenticity in doubt, the MQSH enables a performance that achieves an authenticity of affect that, in Derrida's words, "grants [her] the right . . . to a hospitable memory . . . out of a concern for justice."[27] That ambivalent desire to have Mary Queen of Scots "in the room with us" is a testament not only to the compelling nature of her tragic story or her particular gifts and talents but to our need to visit and re-visit her as we continue to work through the real and vexing historical problems—as well as our fantasies, fears, and desires—concerning women, sex, power, religion, and history itself.

Notes

1. Nathaniel Hawthorne, "Abbotsford," *Passages from the English Note-Books of Nathaniel Hawthorne,* ed. Sophia Hawthorne (1883; Eldritch Press, 1999), http://www.eldritchpress.org/nh/pfenb01.html#d1856.

2. Gillian Glover, "There's Something about Mary," *The Scotsman* (July 27, 2005), http://heritage.scotsman.com/topics.cfm?tid=1462&id=1685982005.

3. Jayne Elizabeth Lewis, *Mary Queen of Scots: Romance and Nation* (London: Routledge, 1998), 2.

4. See, e.g., Jenny Wormald, *Mary Queen of Scots: A Study in Failure* (London: George Philip, 1988). Wormald's book was reissued in paperback with a "kinder and gentler" title, but no less harsh verdict, as *Mary, Queen of Scots: Politics, Passion and a Kingdom Lost* (London: Tauris Parke, 2001).

5. I am indebted to Zilla Oddy, an assistant curator with the Scottish Borders Council, for her research and information regarding the history of the building. See her *Mary, Queen of Scots' House, Jedburgh: A Look at the Building and Its Inhabitants* (Galashiels: Teviotdale Press, 2004).

6. The distinction I draw here between "meaning effects" and "presence effects" is indebted to Hans Ulrich Gumbrecht, *Production of Presence: What Meaning Cannot Convey* (Stanford, CA: Stanford University Press, 2004).

7. Scottish Borders Council Museums and Galleries, *Mary Queen of Scots House and Visitor Centre* ([Jedburgh]: Jedburgh Press, 1997), [3–4].

8. The source of Donaldson's remark is not cited by the MQSH, but both the general topic covered in the Rogues' Gallery and the specific theme of his comments are the subject of his *All the Queen's Men: Power and Politics in Mary Stewart's Scotland* (London: Palgrave Macmillan, 1983).

9. Several of my interviewees confessed that they found the Rogues' Gallery presentation almost meaningless, too, complaining that the audio presented too much information too quickly and that they would have liked to have had that information in print form to peruse at their leisure. In July 2007, I made a brief stop at the MQSH during another field visit to Scotland. In the few months since I had conducted the fieldwork on which the present essay is based, two changes had been made in the presentation of the Rogues' Gallery: the plaque reiterating the Donaldson quote had been removed, and a new plaque had been installed that reiterates the information about the various "rogues" presented in the audio narrative.

10. Local lore has it that Mary originally stayed in the Spread Eagle Hotel, which is still operating in Jedburgh, but was forced to find new quarters after a fire broke out in her room. Given that Mary traveled with an entourage of several hundred people and that Lady Ferniehirst had her own castle just outside of Jedburgh, it seems more likely that Mary would have stayed in Ferniehirst Castle and rented the MQSH for some of those in her entourage.

11. Several residents of Jedburgh with whom I spoke lamented that the major tour bus operators had been given kickbacks from the Jedburgh Woolen Mill to make this stop. While many buses do stop in Jedburgh proper, they do so for only thirty to sixty minutes. Each day while I was at the MQSH, groups of fifteen to twenty passengers from such buses would traipse up Queen Street, jostle for position to take a photograph of the exterior of the building, and then hurry back to their buses. Occasionally, a group would enter the reception area en masse, do a quick circuit of the souvenir tables, and then depart. On only two occasions while I was present did passengers from a bus attempt to tour the MQSH, and both had to dash off to meet their groups long before they had finished touring the house.

12. Raphael Samuel, *Theatres of Memory* (London: Verso, 1994), 259–74.

13. Jean Plaidy was the pen name of Eleanor Hibbert, Britain's most popular author of historical romance novels in the 1950s and 1960s. My interviewee may have been thinking of Plaidy's *The Royal Road to Fotheringhay: The Story of Mary, Queen of Scots* (New York: Three Rivers Press, 1968). Mary has been a popular subject for such fiction since shortly after her death; see, e.g., James

Emerson Phillips, *Images of a Queen: Mary Stuart in Sixteenth-Century Literature* (Berkeley: University of California Press, 1964); and Lewis, *Mary Queen of Scots.*

14. Wormald, *Mary, Queen of Scots: Politics, Passion and a Kingdom Lost,* 8.

15. Lewis, *Mary Queen of Scots,* 230.

16. The Babington Plot to assassinate Elizabeth and crown Mary was discovered—or, arguably, engineered to entrap Mary—by Elizabeth's spymaster, Francis Walsingham. Mary's involvement in that particular plot led to her trial and execution after her years of imprisonment. The precise nature of her involvement in the Babington affair, however, is still debated by historians.

17. The subject of sectarianism in Scottish football was much in the news in summer and fall 2006 because of new initiatives by the governing bodies of the sport, both in Scotland and in Europe, and the Scottish government to try to end it via sanctions, fines, and penalties. See, e.g., "A Rivalry Tied Up in Religion," *BBC News,* August 26, 2006, http://news.bbc.co.uk/1/hi/scotland/5289202.stm; and Scottish Executive Publications, "Calling Full Time on Sectarianism," December 12, 2006, http://www.scotland.gov.uk/Publications/2006/12/11144623/0.

18. Pierre Nora, "Between Memory and History: *Les lieux de mémoire,*" *Representations* 26 (Spring 1989): 7–24.

19. The term "staged authenticity" comes from Dean MacCannell's seminal study, *The Tourist: A New Theory of the Leisure Class* (New York: Schocken Books, 1976), 91–107.

20. Bruner has published several essays questioning the "jargon of authenticity" in tourism and cultural studies, many of which are collected in his recent book, *Culture on Tour: Ethnographies of Travel* (Chicago: University of Chicago Press, 2005). See especially, however, chapter 5, "Abraham Lincoln as Authentic Reproduction: A Critique of Postmodernism," 145–68.

21. Michael S. Bowman, "Looking for Stonewall's Arm: Tourist Performance as Research Method," in *Opening Acts: Performance in/as Communication and Cultural Studies,* ed. Judith Hamera (Thousand Oaks, CA: Sage, 2005), 102–133. See also Simon Coleman and Mike Crang, eds., *Tourism: Between Place and Performance* (New York: Berghahn Books, 2002); Mimi Sheller and John Urry, eds., *Tourism Mobilities: Places to Play, Places in Play* (London: Routledge, 2004); and Jørgen Ole Bærenholdt, Michael Haldrup, Jonas Larsen, and John Urry, *Performing Tourist Places* (Aldershot: Ashgate Publishing, 2004).

22. Jacques Derrida, *Specters of Marx: The State of the Debt, the Work of Mourning, and the New International,* trans. Peggy Kamuf (New York: Routledge, 1994), 6. Although I do not discuss the matter in this essay, it is not surprising, given how I believe she functions hauntologically, that Mary is also Scot-

land's most frequently seen ghost (see, e.g., Jennifer Veitch, "Haunted Trail of Mary, Queen of Scots," *Scotsman,* December 8, 2005, http://news.scotsman.com/spookystories/Haunted-trail-of-Mary-Queen.2684937.jp).

23. Fredric Jameson, "Marx's Purloined Letter," *Ghostly Demarcations: A Symposium on Jacques Derrida's* Spectres de Marx, ed. Michael Sprinker (London: Verso, 1999), 39.

24. Simon Coleman and Mike Crang, "Grounded Tourists, Travelling Theory," in Coleman and Crang, eds., *Tourism: Between Place and Performance,* 11.

25. Jørgen Ole Bærenholdt and Michael Haldrup, "On the Track of the Vikings," in Sheller and Urry, eds., *Tourism Mobilities,* 85–88. Bærenholdt and Haldrup draw on Walter Benjamin's aphoristic distinction between the "aura" and the "trace" in regards to the "authenticity" of the art object: "Trace and aura. The trace is appearance of a nearness, however far removed the thing that left it behind may be. The aura is appearance of a distance, however close the thing that calls it forth. In the trace, we gain possession of the thing; in the aura, it takes possession of us." Walter Benjamin, *The Arcades Project,* trans. Howard Eiland and Kevin McLaughlin (Cambridge, MA: Harvard University Press, 1999), 447.

26. As Jacques Derrida notes, the trace is not a "presence but the simulacrum of a presence that dislocates itself, displaces itself, refers itself, it properly has no site—erasure belongs to its structure." *Margins of Philosophy,* trans. Alan Bass (Chicago: University of Chicago Press, 1984), 24.

27. Derrida, *Specters,* 175.

7
Memory's Execution
(Dis)placing the Dissident Body

Bernard J. Armada

execution n.: the action of executing a plan, order, legal instrument, etc.; the technique or style with which an artistic work is produced or performed.
> —*New Oxford American Dictionary,* 2nd ed., s.v. "execution"

execution n.: the carrying out of a sentence of death.
> —*Oxford American Dictionary of Current English,* s.v. "execution"

Today the man is here; tomorrow he is gone. And when he is "out of sight," quickly also is he out of mind.
> —Thomas à Kempis (1379–1471) *De Imitatione Christi,* in the *Oxford Dictionary of Quotations,* s.v. "out of sight, out of mind."

The double meaning of the word "execution" in this chapter's title refers to the simultaneous processes of creation and destruction, of utterance and silence, that inhere in all acts of remembrance. Whenever an act of remembrance is produced or performed, competing memories are issued a death sentence, deflected by the former unless someone else comes along to keep the latter alive. In their introduction to this volume, Professors Blair, Dickinson, and Ott astutely point out that "a failure to represent a particular content publicly is not a necessary, or even provisional, sign of forgetting." In this chapter, however, I wish to explore the ways in which memory is executed—created and destroyed—in the built environment, and consider the additive effects of such executions in reference to memory studies in general. The National Civil Rights Museum (NCRM) in Memphis, Tennessee, is the case study through which I will explore the role of material space in the simultaneous construction, maintenance, and destruction of memory. The museum was formerly the Lorraine Motel, on whose balcony Dr. Martin Luther King Jr. was shot to death in 1968.

In earlier research, I examined how the NCRM crafted civil rights memory and the ways in which that memory was challenged by Jacqueline

Smith, an African American woman who has lived on the street in protest since she was evicted from the Lorraine Motel in 1988.[1] I argued that the location of Smith's countermemorial, which was clearly observable to visitors standing near the balcony where King fell, disrupted the museum's seamless narrative and invited a more critical consideration of civil rights memory and memorial practices in general. Smith's countermemorial offered an alternative interpretation to the closed narrative suggested by the museum's climactic endpoint at the balcony, designed to appear frozen in time on April 4, 1968.

This chapter takes readers back to Memphis to reconsider the material texture of memory in light of the NCRM's $11 million expansion, completed in 2002. I focus specifically on the spatial and architectural modifications to the museum's exterior and the surrounding environment, which includes Smith's countermemorial. In this case, it is precisely the placement of bodies—those of visitors', that of Smith—that influences how memory is perceived in the museum. To ignore the museum's bodily placements and displacements is to overlook a central dimension of how memory is executed at the museum.

I argue that the new museum works to limit alternative readings of its memorialization of King and the civil rights movement by driving Smith's protest out to the periphery. The architectural sanitization of the area formerly occupied by Smith further deflects visitors' attention from alternative readings. This deflection sutures the symbolic wounds inflicted by Smith upon the museum to the extent that it minimizes her formerly potent challenge to citizens to question the museum's official narrative. Ultimately, the expansion's execution (read "performance") of one version of memory results in the execution (read "death") of another, leaving casual tourists as the stakeholders most severely shortchanged. In supporting this thesis, I deal directly with the remembering-forgetting relationship that this book's introduction identifies as an issue central to public memory studies. Specifically, this chapter embraces the editors' proposal that the remembering-forgetting dialectic "probably should be replaced by a more nuanced and evidence-grounded position that takes account of the status of particular memory articulations in relation to others, in particular contexts, with particular attention to the inventional operations that mediate that status." By focusing on the specifics of the drama between Jacqueline Smith and the NCRM, I hope to elucidate further the complex relationship between remembering and forgetting.

This chapter approaches the NCRM as an "experiential landscape," which Dickinson, Ott, and Aoki explain as a text's fluid, rather than self-

contained, physical and cognitive boundaries that position visitors in ways that shape their perceptions of memory sites.[2] Museums, memorials, and other material sites are spaces with imprecise beginnings and endings that are traversed, climbed, or otherwise consumed in a physical sense. They act "on the whole person, not just on the 'hearts and minds'" of individuals.[3] Before and after interacting with such sites, we read about them (or not), ponder them (or not), purchase products connected to them (or not), and consider them in light of other texts (or not), among other activities. Also, experiential landscapes possess elements that constitute visitors' selfhood in ways that encourage them to attend to some aspects of their physical and cognitive environments and not others.

The experiential landscape lens justifies examining multiple dimensions of the NCRM, some of which might appear to have little or nothing to do with the museum's official rhetoric. In this chapter, for example, I focus more on the exterior elements of the museum complex than I do on the formal exhibits housed in its interior. There are two reasons for this, both of which serve as a rationale for this study.

First, everyday museum visitors, myself included, more often lend their attention to formal exhibits than to exterior features. The exterior features do not usually call attention to themselves as overtly rhetorical as do some of the interior features, yet they play an important part in shaping memory. This chapter, then, responds to Carole Blair's proposition that we ask "not just what a text means but, more generally, what it does," which "open[s] a vast field for us to contemplate."[4]

Second, this chapter's corresponding focus on Jacqueline Smith's protest discloses the textual properties of a rhetorical phenomenon that appears to be vanishing from memory's landscape. Unless Smith discovers a new way to thrust her countermemorial upon the conscience of visitors in light of the expansion, she is in danger of being permanently silenced. Current visitors to the museum likely know nothing about Smith's original placement across from the balcony, nor the processes by which she was outmaneuvered. Another contribution of this chapter, then, is to disclose the rhetorical practices of domination and resistance or, more accurately in this case, resistance and domination. I invite readers to witness in slow motion how competing texts may become silenced and pushed to memory's backstage by those with the power to write the official story. Although failure to represent a particular memory content publicly does not necessarily suggest forgetting, the phenomenon at the NCRM demonstrates how one form of memory might be suppressed to activate or at least amplify another.

To explicate memory's executions, I first provide some background information on the NCRM, describing the differences between the original structure and the 2002 expansion. The analysis that follows this description will demonstrate how the expansion outmaneuvers Jacqueline Smith and minimizes her countermemorial practices while amplifying the museum's official rhetoric. I conclude with a consideration of the role the built environment plays in the destruction and creation of public memory and resume the remembering-forgetting discussion explored in the beginning of this book.

The National Civil Rights Museum: Then and Now

The NCRM opened its doors to the public in September of 1991. Formerly the Lorraine Motel, the museum is built around the site where Martin Luther King Jr. was murdered in 1968. The museum is the $9.25 million product of local African American community leaders' efforts to rescue the site from demolition during the early 1980s. Although the museum's exterior still resembles that of the Lorraine Motel—including the balcony upon which King fell—its interior showcases a chronologically arranged narrative of the major events of the African American struggle for civil rights from 1954 to 1968. Featured throughout the museum are collections of primary and secondary sources ranging from newspapers, court documents, and photographs to more interactive media such as audiovisual displays and original and replicated artifacts from the civil rights movement. By far the museum's most emotionally powerful feature—the one that has attracted countless King devotees since its days as the old Lorraine Motel—is the balcony upon which King fell and the room in which he ate his last meal. The latter, remodeled to look as it did when King was assassinated, offers visitors a simulacrum of the room as it appeared on April 4, 1968.

In 2002, the museum's boundaries grew to incorporate the Young and Morrow Building and the Main Street Boarding House across the street (figure 7.1). The $11 million project includes a new gift shop and a well-manicured pedestrian area known as "Freedom Plaza." The 12,800-square-foot expansion picks up where the original museum's narrative leaves off, covering civil rights activities in the United States and around the world since 1968. A tunnel leads visitors from the original museum into the heart of the expansion, where they eventually encounter "Lingering Questions," an exhibit featuring over two hundred pieces of evidence released from Justice Department files that invites visitors to ponder numerous unanswered questions surrounding King's assassination: Did someone else do

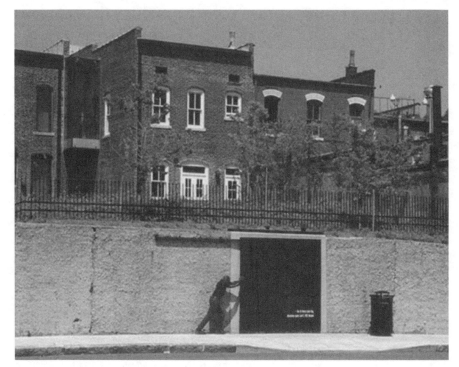

Figure 7.1. The National Civil Rights Museum expansion, including the gated tunnel entrance and the boardinghouse window from which James Earl Ray allegedly fired the fatal shot. (Photograph by author.)

it? Did James Earl Ray have help from the U.S. government? Was the mafia involved? Among the evidentiary artifacts on display are James Earl Ray's passports under three different names, the .30-06 Remington Gamemaster hunting rifle allegedly used in the murder, and two pillboxes containing bullet fragments removed from King's body. Consistent with the original museum's design strategy is the boardinghouse bedroom and bathroom that Ray allegedly used to carry out his assassination: both are designed to appear as they did on April 4, 1968. In the bathroom, visitors may look out the window to the balcony across the street. Whereas the balcony of the original museum offers visitors the perspective of a fallen hero, the bathroom window of the expansion offers them the view of an assassin's kill.

Although there is much to say about the exhibits housed in the museum's expansion, the present chapter focuses mainly on its exterior features as they exist in dialogue with Jacqueline Smith's protest. This dialogue

Conspiracy

does it though? NO.

alone offers a valuable example of the crucial, though often neglected, role played by material space in the construction of public memory.

Resolving Past Differences: Place and the Politics of Memory

I turn now to the experiential landscape of the NCRM to demonstrate how the new expansion's displacement of Jacqueline Smith's protest works to limit alternative readings of its memorialization of King and the civil rights movement. To facilitate this demonstration, the present section is divided into two parts: Smith's dialectic with the museum before the expansion, and the dialectic as it presently exists, after the expansion. My aim here is to answer a few of the important questions presented in this book's introduction as they pertain to the NCRM: What makes a particular public memory stick? How does it stick? And with what effects?

Jacqueline Smith's Placement: Then

Prior to 2002, Jacqueline Smith's protest site was a perfect illustration of Michel de Certeau's explanation of how the dispossessed may tactically maneuver "within the enemy's field of vision."[5] Smith situated herself where she could be seen at the precise temporal point of the museum's emotional climax—the balcony and King shrine—where visitors were confronted with two competing rhetorical visions: the museum's lamentation of King's death on the one hand, and Smith's indictment of the museum's economic exploitation of King's death site on the other (figure 7.2).

Smith's countermemorial, with its large sign reading "Boycott the National Civil Rights Wrong Museum—9 Million Dollar Tourist Trap Scam," was a clever appropriation of the museum's memorial to King. For one thing, she positioned herself so she could be seen clearly from both the window of the balcony and at the entrance/exit of the museum. She maximized her visibility by sprawling her belongings—banners, sandwich boards, a table, and sofa—along the sidewalk across the street. Further, as the museum's only visual outlet to the outside world (there are no other windows until this point), the window was likely to compel visitors to look out beyond the balcony to the surrounding landscape.[6] Regardless of her intent, Smith capitalized on the optical interior-exterior ambiguity of the museum's main attraction to impose herself upon the conscience of visitors.[7]

Smith's strongest statement against the museum, however, was/is made with her own body. As a black woman evicted from her residence over twenty years ago, she clung—and continues to cling—to her eviction as

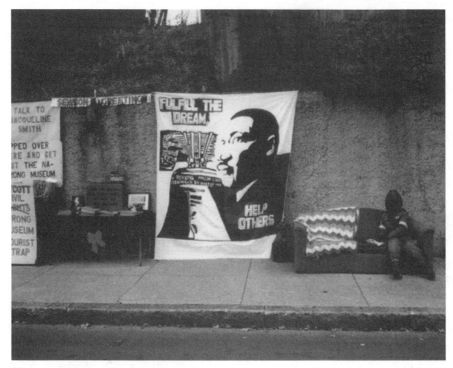

Figure 7.2. Jacqueline Smith's pre-expansion protest site across from the NCRM's balcony. (Photograph by author.)

though it happened only days before. Beyond merely protesting the museum's existence, she presented herself as proof that the museum corrupted King's memory by marginalizing the poor, the very people he tried to help. To this end, all the components of Smith's countermemorial served to amplify her victimized, low-other status: her plain clothing, her worn sofa, the rickety tables and flimsy banners, the graffiti on the wall behind her, and the decaying urban environment that served as her home. By assuming the posture of homelessness, she capitalized on her marginalization to amplify her appearance as a victim of the museum. And yet, as Smith herself claimed, she was "not a homeless person, I live[d] out here because I [chose] to do it."[8] Although Smith admitted she chose to live out on the street, her ability to *perform* indigence was important for garnering rhetorical leverage. Gerard Hauser explains that dissident bodies become "the very site— the place—of a political struggle, as they attempt to find their dissonant voices while the authorities use all available means to mute them. . . . As a

place, their resisting bodies also double as loci (sometimes their most potent loci) for inventing displays of conscience that, otherwise, would remain silent and concealed from view."[9] The performance of homelessness and destitution supports Smith's claim that the NCRM should be held accountable for her condition. Similar to the way the museum clung to the appearance of the Lorraine Motel to retain a sense of its authenticity as a site of memory, so, too, did Smith embrace the spectacle of homelessness to lend credibility to her countermemorial.[10] To influence their respective audiences, both Smith and the museum capitalized on what Gerard Hauser identifies as "the aura of self evidence . . . the presumption that whatever one is trained to observe and see is empirically real."[11]

Whereas the original museum's narrative left visitors in a kind of 1960s time warp, Smith exhorted them to consider the present-day civil rights challenges faced by street people like herself. Her presence also invited visitors to be more mindful of the subjective nature of history and memory. However, as the next section of this chapter will demonstrate, the 2002 expansion reconfigures place and the politics of public memory, changing altogether the dialogic force of Smith's protest.

Jacqueline Smith's Placement: Now

"What is socially peripheral is often symbolically central, and if we ignore or minimize inversion and other forms of cultural negation, we often fail to understand the dynamics of symbolic processes generally." So goes the oft-quoted passage from Barbara Babcock's book *The Reversible World: Symbolic Inversion in Art and Society.*[12] Whereas the previous section praised Jacqueline Smith's tactical appropriation of space, the present section illustrates the museum's strategic response to that appropriation with its 2002 expansion project, a response that effectively restores memorial harmony to the space by resituating Smith to the periphery. I will illustrate how, despite Smith's symbolic importance to the rhetoric of place and public memory, her relocation silences her countermemorial. Of particular significance here is the role of place in the rhetorical execution of public memory.

On Martin Luther King Jr. Day in 2001, forty-nine-year-old Jacqueline Smith was arrested for disorderly conduct following her refusal to move her belongings to make way for the museum expansion.[13] Shortly after her release from Shelby County Correction Center, bulldozers toppled the concrete wall on which Smith had hung her protest signs for so many years. Although museum officials claimed to move her because "her safety was at risk" during construction, Smith was not to return to her initial, highly

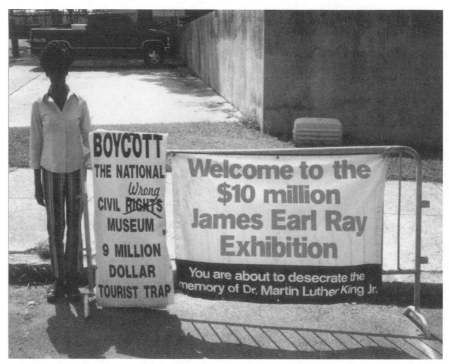

Figure 7.3. Jacqueline Smith's countermemorial, after the NCRM expansion. (Photograph by author.)

visible protest site.[14] She was moved to the corner of Mulberry and Butler streets, diagonally across from the museum's parking lot, where she has remained ever since (figure 7.3).

What prevented Smith from returning to her original protest site after the expansion was completed? The short answer is simple: that space became an official part of the NCRM so, like everybody else, she was not allowed on its premises without paying the admission fee. The longer answer is tied to the genesis of the museum and its role in reimagining the south side of Memphis. That is, the effort to convert the Lorraine Motel into a museum was simultaneously connected to revitalizing Memphis's south side, an area in steady social and economic decline since the late 1960s. Many Memphians expected the gentrified museum site to spark significant growth in the city's tourism industry. Elaine Turner, owner of Heritage Tours, predicted that the presence of the NCRM—not the old Lorraine Motel—would help expand her business: "People will be flocking to Memphis because there will be more in Memphis to see."[15] Additionally, a jour-

nalist for the Memphis *Commercial Appeal* deemed the museum "a corner-
stone in the restoration of the south side of Memphis."[16] Tens of millions
of taxpayer dollars were devoted to building an electric trolley system
that now runs north and south on the city's Main Street. The system was
designed to connect gracefully the historic district to downtown attrac-
tions such as the Pyramid Arena, the Peabody Hotel, Beale Street, and the
NCRM.[17] Furthermore, in recent years, warehouses on the south side have
been converted into loft apartments, old buildings have been restored, and
a growing arts community has established roots in the area. Ironically, this
aggressive urban renewal displaced many people of color, like Jacqueline
Smith, who lived in the area for years.[18]

As for the museum expansion, one of its primary goals was to create a
clear, clean visual path from the museum's balcony to South Main Street,
a literal and figurative sort of window dressing that would catch tourists'
eyes as they strolled by or rode the north-south trolley. Too, the trendy fa-
çade of the gift shop (part of the Young and Morrow expansion build-
ing) spills over onto South Main. The gift shop, which customers may
enter either from South Main or from inside the expansion, offers ex-
posure to the museum that was not possible at its former location in the
original structure. The museum's heightened visibility via the expansion
was part of a campaign to increase attendance figures, which were sig-
nificantly lower than projected—and steadily declining—since the muse-
um's opening in 1991.[19] As Beverly Robertson, the museum's executive di-
rector, said long before construction began, "SO MANY [*sic*] people have
told us they didn't know the museum was here, not just conventions and
tour groups, but Memphians . . . We're trying to broaden awareness of the
museum through aggressive marketing."[20] Moreover, the museum is now
a featured destination along chartered trolley tours that occur on the last
Friday of every month. Passengers are served complimentary champagne
and given a map of art-related businesses in the South Main Street His-
toric District.[21] The champagne-sipping art aficionados would seem to have
little in common with some of the locals who have resided on the streets
for years. Additionally, planners did not consider maintaining Jacqueline
Smith's makeshift countermemorial anywhere near its original location,
where the pristine Freedom Plaza promenade now exists. Smith did not
exactly provide the kind of visibility to which museum officials aspired.
She was, to state it plainly, bad for business.[22]

Smith is now located at the corner of Mulberry and Butler streets, di-
agonally across from the museum's parking lot. She is stationed on the south
side, next to the stanchions that were installed on both sides of Mulberry

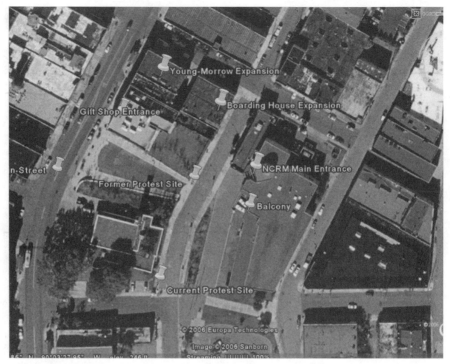

Figure 7.4. Aerial view of the museum complex, including Jacqueline Smith's current and former protest sites. (Photograph used with permission of Google Earth.)

to divert motor vehicle traffic from the museum (figure 7.4). She is no longer permitted to hang her signs on the nearby retaining wall, because that wall is now museum property. Regardless of intent, relocating Smith to the corner of Mulberry and Butler is a simple reconfiguration of space that alters the manner in which visitors are invited to engage civil rights memory in three significant ways. First, those who approach the King shrine and balcony of the original museum are no longer confronted with Smith's homeless presence and signs like "Poverty Is Violence" that for years had the potential to badger the conscience and encourage a consideration of alternative interpretations of King's legacy. Smith's repositioning drives her completely out of visitors' field of vision. She can be seen partially only by stepping up close to the window and looking sharply to the left, behind the small trees lining the museum's exterior (figure 7.5). Visitors are not apt to notice Smith's protest since their eyes likely would be drawn either straight ahead to the open courtyard or, equally plausible,

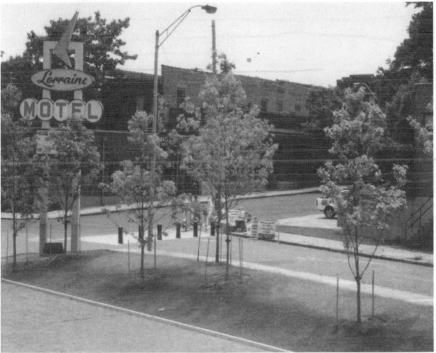

*Something hidden Peaks interest.

Figure 7.5. View of Jacqueline Smith's new protest site from the balcony of the NCRM. (Photograph by author.)

to the boardinghouse window to the right where they may trace the path of the bullet and get a sense of what it might have been like to be in the crosshairs of the assassin's rifle. The latter is encouraged by a photo next to the balcony window depicting the trajectory of the bullet from the boardinghouse to the balcony.

The communicative dimensions of Smith's peripheral designation are at least as important as its literal meaning, and they present some answers to a question posed in this book's introductory essay: "What particular memories or castings of a particular memory must be forgotten to activate others?" Maneuvering Smith out to the periphery calls up the familiar phrase "out of sight (site), out of mind." From the periphery, Smith is no longer able to thrust herself—visually—into the space of the official museum as she had done prior to the expansion's construction. In effect, then, pushing Smith out of sight also pushes her out of mind and discourages visitors from questioning the museum's hegemonic practices. Gone, or at least greatly diminished, is the agonistic clash between official and

vernacular memory that once fractured the museum's monolithic claim to King's legacy in Memphis. Hidden from view, too, is Smith's brash condemnation of the museum's displacement of poor black residents of the Lorraine Motel to turn King's death site into a revenue-generating tourist attraction.[23] Lawrence Prelli posits that to "demonstrate . . . is to enact a rhetorical performance that anticipates the presence of others; it is the staging of a spectacle to be seen."[24] Although Smith's former location guaranteed many curious spectators, her current placement away from the balcony and away from the museum's main entrance reduces her to that of a performer without an audience.

Second, the design elements that have replaced the perceptual field formerly dominated by Smith maintain the museum's harmonious civil rights memory while deflecting attention from any challenges to that memory. This is not surprising given institutions' tendency toward self-preservation.[25] At the balcony, instead of the cognitive dissonance aroused by Smith and the wild, unkempt brush that served as her backdrop, the green, ordered Freedom Plaza connotes peace, symmetry, and harmony. Equally important is that visitors' eyes are drawn *through* Freedom Plaza to South Main Street (figure 7.6). Even as visitors mourn King and ponder the racist climate of the 1960s that killed him, South Main Street's refurbished homes, coffee shops, and bistros serve as visual evidence of the progress that has since been made. If Smith and her dilapidated surroundings agitated awareness of the contemporary need for civil rights advocacy, then the new landscape, visually appealing as it is, communicates a sense that "that was then, this is now." Standing in stark contrast to the disturbing presence of a homeless black woman living on the street, the clear view of South Main Street reassures visitors that shopping, safety, and the trolley to their hotels are only a few hundred feet away. Freedom Plaza also allows visitors to bypass Smith altogether without ever knowing of her existence.

A third and most ironic silencing of countermemory demonstrates that the guardians of official culture, too, may use the tactics of the weak to suit their own ends. In the following illustration we may observe a literal rewriting of civil rights memory of which most future visitors to the museum will have no knowledge. To explain, however, it is necessary to take a second step back to Jacqueline Smith's pre-expansion protest site.

At her original location across from the museum's balcony, Smith posted a number of signs whose meaning was fashioned specifically from their dialectic with the King shrine. One such sign read "And we shall see what will become of his dreams," an artful appropriation of Ralph Abernathy's quote from the book of Genesis, once used to eulogize King, that is now

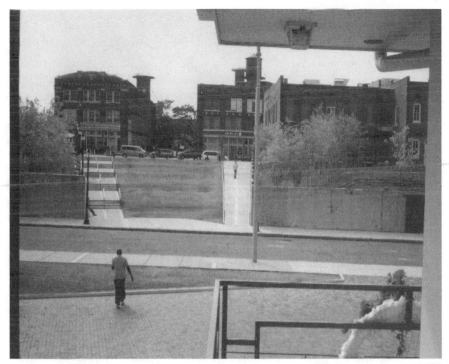

Figure 7.6. View of the Freedom Plaza walking area and South Main Street from the balcony of the NCRM. (Photograph by author.)

inscribed on the plaque under the museum's balcony. The full quote on the museum's plaque reads:

> They said one to another,
> Behold, here cometh the dreamer . . .
> Let us slay him . . .
> And we shall see what will become of his dreams

Abernathy originally used the quote to identify his auditors as the keepers of King's legacy. Appreciating Abernathy's sentiments, museum designers then used the quote for similar purposes, but also presented the renovated museum as material evidence of King's living legacy. In other words, the plaque may be understood as a proclamation that, despite the evils existing in the world, King's dream cannot be killed. Functioning as an enthymeme, the museum is presented as a self-evident, material embodiment of that dream (figure 7.7).

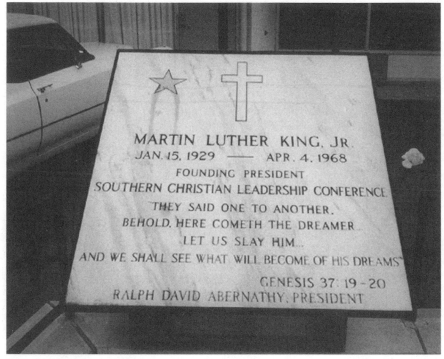

Figure 7.7. The NCRM's memorial plaque honoring King, under the infamous balcony. (Photograph by author.)

Smith's own use of the quote at her former protest site, however, functioned as an ironic commentary on museum founders' appropriation of King's legacy. Instead of restating the entire quote from the plaque, she repeated only the final line—"And we shall see what will become of his dreams"—as though she were muttering under her breath in a tone of sardonic disapproval. The museum's creators, she implied, disgraced King's memory by converting the site of his death into a tourist attraction. Smith's turn of the phrase embodies the "materially satisfying counter-meaning" produced from acts of rhetorical resistance (figure 7.8).[26]

With Smith out of the picture, however, museum designers had a fresh canvas on which to depict the past. To the right of Freedom Plaza, a tunnel was created to guide visitors into the expansion housed in the Young and Morrow and boardinghouse buildings. The entrance to the tunnel includes a black metal gate that is fashioned out of the prophetic conclusion to King's "Mountaintop" speech:

Figure 7.8. Jacqueline Smith's commentary on the museum's memorial plaque. (Photograph by author.)

I MAY NOT GET THERE
WITH YOU BUT I WANT
YOU TO KNOW THAT WE
AS A PEOPLE WILL GET
TO THE PROMISED LAND[27]

Delivered in Memphis on April 3, 1968, just a day before his death, King's words celebrate the vitality and persistence of the black struggle for civil rights. Anyone who has heard King deliver the speech can almost hear the climactic brilliance of his voice upon reading these words.

In essence, Smith's vernacular appropriation of "And we shall see what will become of his dreams" was replaced with the museum's official appropriation of "I may not get there with you." Rhetorically, the physical relocation of Smith erases her words and replaces them with a quotation that deflects attention from any challenges to the museum's version of memory, as well as any challenges to the ethics of its practices. The dissonance cre-

ated by Smith recedes into the background while the harmonious words of King dominate the scene in steely resilience. It would appear that museum designers took a page from Smith's own book by inserting a discursive message of their own into visitors' perceptual field.

Smith's replacement with a more official, institutionalized memory also calls to mind the notion of permanence and change. Blair notes that "[t]he kind of material the text is composed of must be a serious consideration. Some texts, by virtue of their constitutive material, are obviously intended to endure, and it seems a natural assumption, if not always a correct one, that such longevity is granted to texts that communities see as more important than others."[28] On the one hand, everything about Smith's countermemorial suggests its vernacular, ethereal quality: all of her materials—her banners, her sofa, the literature she distributes—corrode each day they are exposed to the outside elements. Smith's body—the most powerful dimension of her protest—will one day break down and exit the public stage. In her place will remain the official, more enduring materials of the museum: concrete, brick, steel. If the evidence of our eyes suggests anything, it is that the momentum of this contest has shifted dramatically in favor of institutionalized memory, and in holding the magnifying glass up to this process we witness memory's imminent death as much as we do its life.

At/In Memory's Wake

This chapter's explication of memory's execution at the NCRM follows Andreas Huyssen's suggestion that "we need to discriminate among memory practices in order to strengthen those that counteract the tendencies in our culture to foster uncreative forgetting, the bliss of amnesia, and what the German philosopher Peter Sloterdijk once called 'enlightened false consciousness.'"[29] We have observed here how the museum's reconfiguration of space outmaneuvers Jacqueline Smith, thereby screening out alternative readings of civil rights memory. This deflection diminishes Smith's invitation to question the official rhetoric of the NCRM in particular, and official museum practices in general. It would appear that by containing the counteractive force presented by Jacqueline Smith, museum designers have secured a victory for the institutionalization of civil rights memory. This victory, however, comes at the expense not only of Smith, but also of everyday citizens, who lose a remarkable and rare opportunity to enter an experiential landscape that memorializes the civil rights movement at the same time that it draws critical attention to its own memory practices.

The above critical analysis begs a return to the introductory chapter of

this book, in which Blair, Dickinson, and Ott problematize the relationship between remembering and forgetting. Rejecting the theoretical notion that remembering one set of contents automatically means all others are forgotten, the authors suggest that a more productive interpretation is the additive or cumulative effect, in which multiple, "even seemingly contradictory contents can be held in public memory simultaneously." Although the structural changes made to the NCRM clearly demonstrate the suppression of one form of memory so that another may be activated, the present analysis also discloses the fallaciousness of applying an either-or approach to public memorializing. That is, the clash of competing memories can produce additional memorial effects characterized by ambiguity and unresolved tensions that designate everyday citizen-tourists as the agents who must negotiate through the uncertainty. Some visitors may choose one side over the other, while others may embrace both as "correct" and will, therefore, experience the site from multiple perspectives. Still others may continue to be badgered by the dissonance, with the buzz of discontent remaining an indefinite constant. The latter suggests that an unorthodox kind of harmony can arise out of the dissonance, a harmony in which two or more interlocutors modify one another for the better, producing meanings neither had intended, but that in the end are quite possibly greater than the sum of the parts insofar as they centralize visitors' capacity to choose freely.

My valorization of memorial agon raises another question: <u>Does every act of public memory</u> need a Jacqueline Smith–type spoiler to stimulate the critical faculties of visitors? The answer, of course, is <u>no</u>: I would not argue that without such a presence, people would be mindless automatons unable to think beyond what others tell them to think. However, as Prelli accurately notes, "We always are potentially an audience to these multiple displays, sometimes as thoughtful witnesses but oftentimes as passive spectators of the passing show who hope, at best, to be amused."[30] It would be naïve to deny the human potential for independent thought in virtually any situation, but it would be just as naïve to ignore the contemporary human appetite for "the bliss of amnesia" as well. Thus, the benefit of a blatantly oppositional voice like that of Jacqueline Smith is that it can spur consideration of alternatives to monolithic memorials faster than if it were not present. If we consider a memory place as a kind of memorial screen— employing the resources of the built environment as well as language to direct attention to particular aspects of reality while deflecting attention from others—then oppositional voices can add to that which is reflected as well as what is deflected. The point at which two or more opposing views

ᵣsect has the potential to create an additional memorial screen, one that can sustain two, or perhaps even an infinite number of, memories at once. The value of this perspective is not simply that "more is better," but that it enhances the agency of visitors, better positioning them to choose freely among a wide range of alternatives. This was certainly the case with Jacqueline Smith's protest prior to 2002. The original site of her counter-memorial might have been bad for the museum's business, but to the extent that it encouraged citizens to exercise their capacity for critical thought, it was good for humanity.

On September 28, 2002, the newly expanded NCRM officially opened its doors to the public. On that day, Jacqueline Smith observed the grand opening festivities from her new protest site, the irony hanging in the air. "This is a day of victory and triumph," proclaimed museum board member Benjamin Hooks. "We celebrate those who have gone without so we might move forward. We stand upon their shoulders."[31] And so, indeed, we shall see what will become of his dreams.

Notes

Mic drop?

1. Bernard J. Armada, "Memorial Agon: An Interpretive Tour of the National Civil Rights Museum," *Southern Communication Journal* 63 (1998): 235–43.

2. Greg Dickinson, Brian L. Ott, and Eric Aoki, "Spaces of Remembering and Forgetting: The Reverent Eye/I at the Plains Indian Museum," *Communication and Critical/Cultural Studies* 3 (2006): 29–30.

3. Carole Blair, "Contemporary U.S. Memorial Sites as Exemplars of Rhetoric's Materiality," in *Rhetorical Bodies,* ed. Jack Selzer and Sharon Crowley (Madison: University of Wisconsin Press, 1999), 46.

4. Blair, "Contemporary U.S. Memorial Sites," 23.

5. Michel de Certeau, *The Practice of Everyday Life,* trans. Steven Rendall (Berkeley: University of California Press, 1984), 37.

6. Architectural theorist Rudolph Arnheim suggests that "a landscape seen through a window is essentially a backdrop, parallel to the wall, unless we step close to the window and thus leave the room visually to enter the outside space." Rudolf Arnheim, *The Dynamics of Architectural Form* (Berkeley: University of California Press, 1977), 93.

7. For a more detailed discussion of Smith's challenge to the museum's official rhetoric, see Armada, "Memorial Agon," 235–43.

8. William Thomas, "Sidewalk Protestor's 5-Year War on Museum Stands Firm," *(Memphis) Commercial Appeal,* January 17, 1993. Thomas also reports that Smith spends about twenty-two hours a day at the protest site, leaving only

twice to take bathroom breaks. She also rents a cheap room in a nearby hotel, where she stores the items from her countermemorial every night. Friends and relatives bring her meals regularly, and she sleeps under an umbrella at night. During the winter she wears a padded snowsuit and mittens to protect herself from the cold.

9. Gerard A. Hauser, "Demonstrative Displays of Dissident Rhetoric," in *Rhetorics of Display,* ed. Lawrence J. Prelli (Columbia: University of South Carolina Press, 2006), 236.

10. As far as I know, there are not many homeless people with their own personal Web sites and cell phones. Smith's online protest, www.fulfillthedream.net, features over two hundred photos documenting Smith's victimization at the hands of the museum. Many of the photos feature Smith posing with everyday citizens and celebrities like Bono, author Alex Haley, and former president Jimmy Carter. According to its home page, the site was "Donated for Free in the Hope of a Better Tomorrow." Also, when we last met in April of 2008, Ms. Smith was kind enough to share her cell phone number with me should I ever need permission to use photos from her Web site.

11. Hauser, "Demonstrative Displays," 234.

12. Barbara Babcock, *The Reversible World: Symbolic Inversion in Art and Society* (Ithaca, NY: Cornell University Press, 1978), 32.

13. Lela Garlington, "Rights Museum Critic Jailed; She Refused to Leave Construction Zone," *(Memphis) Commercial Appeal,* January 23, 2001.

14. NCRM executive director Beverly Robertson, qtd. in Garlington, "Rights Museum Critic Jailed."

15. Qtd. in Kevin McKenzie, "Economy: Expansion Is Iffy for Smaller Businesses; Recession Talk Creates Anxiety," *(Memphis) Commercial Appeal,* December 24, 1990.

16. Michael Kelley, "Rights Museum Emerging as Link to Racial Harmony," *(Memphis) Commercial Appeal,* September 26, 1996.

17. Patti Patterson, "City Needs $3 Million to Buy, Fix 10 Trolleys," *(Memphis) Commercial Appeal,* June 30, 1991.

18. Chris Davis, "And To Think That I Saw It on Mulberry Street: The Gentrification of a Historic Downtown Neighborhood Arouses Controversy," *Memphis Flyer Online,* November 8, 2001, http://www.memphisflyer.com/memphis/Content?oid=1776.

19. The original NCRM was plagued with financial difficulties since opening to the public. Although museum board member Charles Scruggs estimated in 1991 that the museum would attract over 250,000 paying visitors, it only attracted about 100,000 annually. See Jimmie Covington, "Rights Museum May Draw 250,000," *(Memphis) Commercial Appeal,* January 29, 1991. Also, con-

tributions to the museum, which averaged about $128,000 a year from 1985 to 1990, dropped to $13,900 in 1991 and $1,200 in 1992. See Joseph Conn, "Rights Museum Donations Can't Match Expenses," *(New Orleans) Times-Picayune,* December 19, 1993. As a result, the museum's admission fees have been raised four times since opening, from its original price of $4 for adults in 1991 to $6 in 1997 to $8.50, then $10, and $12, its current fee.

20. Qtd. in David Kushma, "Celebrate the Power of the Dream," *(Memphis) Commercial Appeal,* March 7, 1999. Another article in the *Commercial Appeal* reported that the promenade project, called "Civil Rights Plaza," "topped the list of downtown development projects prepared by the Center City Commission. It was described as a 'catalytic project' by commission staffers who are constructing a strategic plan for the enlarged Central Business Improvement District." See Deborah M. Clubb, "Rights Museum to Topple Wall, Open Plaza for More Visibility," *(Memphis) Commercial Appeal,* April 3, 1998.

21. Jerome Obermark, "Friday Night Trolley Tours Offer a Peek at South Main," *(Memphis) Commercial Appeal,* March 18, 2001.

22. In 1996 Smith found herself in accord with an unlikely participant in the struggle over King's memory. After five years of service to the NCRM, executive director Juanita Moore resigned from her post in December of 1996 over disagreements with board members about the museum's future directions. Because of the real need for the museum to be able to sustain itself financially, the board of directors wanted to more assertively market the museum as a tourist attraction. Even though attendance figures had dropped in previous years, Moore still disagreed. "The problem is that it is a museum," she said. "If you want to go and redefine it as something else, that's not my decision. Right now, it is a museum. That's how I operate it. Museums are educational institutions, first and foremost. They are not tourist attractions" (qtd. in "Broad Mission Marketing Has a Role at Civil Rights Museum," *(Memphis) Commercial Appeal,* December 16, 1996).

23. This has not, of course, prevented Smith from voicing her opinions at her current protest site. Also, Smith voices similar views on her personal Web site, www.fulfillthedream.net: "Just a couple of hundred feet away from where Dr. King was slain, poor Afro-American families are being given eviction notices. Why? Because opportunist developers have recognized that downtown Memphis holds great appeal to affluent house buyers. In effect, out go the poor blacks, in come the wealthy whites. But what happens to the evicted tenants? They are moved out of sight, out of mind to nondescript areas of North Memphis."

24. Lawrence J. Prelli, introduction to *Rhetorics of Display,* ed. Prelli (Columbia: University of South Carolina Press, 2006), 14.

25. See John Bodnar, *Remaking America: Public Memory, Commemoration, and Patriotism in the Twentieth Century* (Princeton, NJ: Princeton University Press, 1992), 13.

26. Peter Stallybrass and Allon White, *The Politics and Poetics of Transgression* (Ithaca, NY: Cornell University Press, 1986), 10–11.

27. The designers took a minor liberty with King's words. The literal transcription is "I may not get there with you. But I want you to know tonight, that we, as a people, will get to the Promised Land!"

28. Blair, "Contemporary U.S. Memorial Sites," 37.

29. Andreas Huyssen, *Present Pasts: Urban Palimpsests and the Politics of Memory* (Stanford, CA: Stanford University Press, 2003), 10.

30. Prelli, introduction to *Rhetorics of Display*, 9.

31. Qtd. in "Museum Offers Insight into King Assassination," *Los Angeles Times*, September 29, 2002.

8

The Master Naturalist Imagined

Directed Movement and Simulations at
the Draper Museum of Natural History

Eric Aoki, Greg Dickinson, and Brian L. Ott

The fifty-mile descent from the east entrance of Yellowstone National Park into Cody, Wyoming, is, by the standards of the West, short. But the scenery is breathtaking. Deep canyons, a rushing river that has carved caves in the rocks over millennia, rising mountains, jutting cliffs, and soaring eagles vie for our attention as we guide our rental car around the sharp curves. In our three visits as researchers to Cody and the Buffalo Bill Historical Center (BBHC) from Fort Collins, Colorado, we had never arrived at the BBHC from the east entrance of Yellowstone. On our final journey to Cody, we took the extra time to drive from the BBHC to the east entrance of the park and back again. Journeying through rustic mountainsides, around blue-toned lakes, and past bighorn sheep grazing along the western roadside, we arrived back at the Draper Museum of Natural History—the most recent of the five museums of the BBHC—having traversed the ecological wonders of nature. We had experienced the gusting winds and voluminous skies—skies complete with moving clouds that rustled up like cowboy dust upon the rugged land (see figure 8.1).

We were quiet during our drive back to the Draper, for there were vast landscapes, wild animals, and the hypnotic intrigue of nature to attend to, seen mostly from behind the protective glass of our car. This trip down the mountain to the museum functioned like a transformative channel that moved us from the awe of nature in the great outdoors to the awe of nature (re)created in the great *indoors*. With the humility of having immersed ourselves in the sublimity of nature, a basic question became central to our journey both outdoors and indoors at the Draper: What is our connection with nature?[1] This question regarding our connection to nature is at the heart of the museum's mission. The museum is designed *"to encourage responsible natural resource stewardship by promoting increased understanding of and appreciation for the relationships binding humans and nature in the Greater Yellowstone Region."*[2] The museum's rhetoric emphasizes "stewardship" of the earth's resources, urging visitors to see the earth as theirs to control and use.

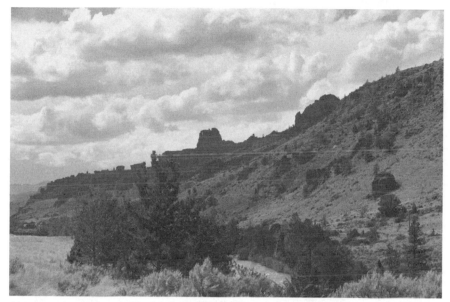

Figure 8.1. Driving to Cody, Wyoming, from Yellowstone National Park. (Photograph by Greg Dickinson.)

More specifically, the Draper is an epistemological and ontological machine working to produce what we term *master naturalists* through the rhetorical modes of directed movement and simulated environments. Crucially, the museum's directed movement and simulated environments emphasize space over time, producing the master naturalist as an ahistorical subject position and, in so doing, derailing critical engagement with the museum. "Master naturalist" as a phrase invokes quite precisely a way of *seeing* the world that constantly reminds us that not only is the world ours to use but nature is also defined by the master naturalist.[3] Understanding the Draper depends on recognizing that nature and culture are dialectically related: nature and culture depend on each other for their meaning. The Draper positions visitors as the fulcrum of this dialectical relation even as the museum itself embodies this dialectical struggle.

The material resolution of this struggle depends on the museum's spatiality. It is not simply that the museum arranges space—it clearly does that—but that the museum privileges space over time: the museum is a place *about* space. That the museum would engage its visitors in a pedagogy of space should not be surprising. As a natural history museum dedicated to explaining a particular region's nature, the museum emphasizes space

(nature) over time (history) and sutures the subject position of the master naturalist into an unchanging relation to space. Indeed, the Draper not only engages in questions of space, but it privileges space over time to the degree that time is erased. This is, of course, odd in a museum in which history (or the understanding of change over time) is a part of its title. This disjuncture between the "history" of the title and the "timelessness" of the museum serves as the point of entrance into the museum's rhetoric, the role of memory in the museum's rhetoric, and, more broadly, the rhetorical consequentiality of this spatial privileging. As we will see, privileging space over time can have the function of derailing critical engagement with the topics at hand by de-historicizing, naturalizing, and thus de-politicizing the concerns raised within the space. In privileging space over time, the Draper captures, slows, even stops time, and in so doing the museum hides or covers the ways human agency is always remaking the "natural" world.

This effacing of time is central to Michel de Certeau's distinction between "place" and "space." For Certeau, place halts change, setting ideas and concepts along with stones, trees, animals, and people into an "instantaneous configuration of positions."[4] As compared to place, space for Certeau "Exists when one takes into consideration vectors of direction, velocities, and time variables. . . . Space occurs as the effect produced by the operations that orient it, situate it, temporalize it and make it function in a polyvalent unity of conflictual programs or contractual proximities. . . . In contradistinctions to the place, it has thus none of the univocity or stability of a 'proper.'"[5] Where place is settled and stabilized, space—as "practiced place"[6]—emphasizes time. Instead of instantaneous positions characteristic of place, space is the performance of trajectories and movements. We can think of place as offering a set of resources or a grammar out of which actual users produce their own meanings or produce space.[7] The function of place is to solidify time and history and, thereafter, to solidify subjectivity or, put differently, to suture the subject into carefully constructed material narratives that limit agency. As we will argue in the rest of this chapter, the Draper is a place that limits visitors' agency in regard to its self and its rhetoric, while offering the position of the master naturalist as a subject position with nearly unfettered agency in regards to the natural world.

As the foregoing discussion suggests, the relations between place and time are intertwined. One may move through a place and consistently and constantly resist the demands for "proper" action (just as one can speak in ways that consistently break grammatical rules). On the other hand, one can move through a place in much the way the place's structures enable. The actions (in time), then, work to restabilize the place itself. Some places

work more assiduously to contain and restrain such action while others are more "open" to spatializing and temporalizing action. Those places determined to fully structure movement offer a materialized narrative that, to paraphrase Certeau, turns animals into taxidermied objects of study and humans into cadavers.[8]

In precisely this way—of narrating places in and through "death"—we can begin to imagine that we can "possess" the natural, Western world. At least since the Renaissance, European epistemologies have been deeply connected with the desire to possess.[9] This desire for possession often gets expressed in an aesthetic that destroys the subjectivity of an other, turning others into objects.[10] While representational strategies that turn others into objects serve numerous crucial rhetorical functions, for us the most important are the ways objectification allows viewers to imagine "possessing" those represented. Possessing others, however, can take a serious emotional toll—especially if the violence central to the possession is repressed, not recognized.[11] And so the act of possession must somehow be hidden.

Stephen Greenblatt, in his magisterial reading of early modern travel narratives—and in particular his reading of Columbus's journals and letters—argues that discourse of the marvelous and of wonder serves the function of hiding the violence of possession.[12] While a recognition of wonder and marvel could serve as a way for medieval and early modern European travelers and commentators to recognize in themselves the differences confronted in the New World, wonder more often was a way of creating a profound break or boundary between Europeans and the people, lands, and animals confronted in the Americas.[13] This "wonderful" break makes the other fantastic—meaning both astonishing and a fantasy that is somehow unreal—and in so doing makes them available for possession and control.

This marvelous possession Greenblatt identifies in Columbus's journals can be read as a historical grounding for nineteenth- and twentieth-century specular imaginations of nature.[14] In the newly founded zoos of the nineteenth-century capitals of Europe and the United States and in institutions like the American Museum of Natural History in New York City, we see the appearance of captured (in zoos) and dead (in natural history museums) animals.[15] Donna Haraway, describing the interaction between the taxidermied animals and the viewer in the American Museum of Natural History's Great Hall of Africa, writes: "The animals in the dioramas have transcended mortal life, and hold their pose forever, with muscles tensed, noses aquiver, veins in the face and delicate ankles and folds in the supple skin all prominent."[16] Crucially, the transcending of mortal

life is also a "transcendence" of time. It is the forever-ness of the animal's pose—or, differently, the arresting of change—that allows the taxidermied animal to transcend life and, at the same time, to become wonderfully spectacular.[17]

In the European desire to possess lands, people, and animals outside of Europe, a vision of wonder covered over the violence of colonization in part by placing the other in a timeless, deep past. In colonizing time, museums can visually and materially re-present the colonization of peoples and lands even as they claim to understand and explain them. It is in this sense that museums can be place and memory machines that teach audiences particular details not only about the museum's apparent subject but also about time and space, agency and power. As we will argue throughout the analysis, turning nature into an ahistorical object as the Draper does, allows the museum to inscribe nature in terms of exchange value. The narrative flow of the museum, as we will see, leads the audience from untouched nature to nature as resource for wealth production. Regardless, nature remains timeless and unchanging.

Into and through the Museum

Though we had visited Cody and the BBHC in years past and had often considered the location of the museum within the striking landscape of the West, we had never approached the museum from Yellowstone National Park to the west. Our travels had consistently brought us into the town through the wide-open spaces of central Wyoming. But, with this third trip and our specific goal of analyzing the museum that is most directly about Yellowstone and its environs, we realized we could not understand how visitors might see the Draper without also experiencing the route to and from the park. And so we headed up the canyon into the high Rocky Mountains. This trip, of course, was structured by our visits to Cody over the past few years, but also by our childhood memories of coming to Yellowstone, seeing grizzlies, bison, and Old Faithful.

Our journey was also influenced by our knowledge that this park was the first and remains one of the grandest national parks. On March 1, 1872, President Ulysses S. Grant signed the bill setting aside more than two million acres under the protection and control of the Secretary of the Interior who was charged with protecting the land against destruction and maintaining it for the benefit of "all people."[18] While the explicit goal of the bill and the subsequent founding of the National Parks Service in 1916 was the preservation of wilderness, one of the major proponents of the Yellow-

stone National Park was the Northern Pacific Railway. In the late nineteenth century, the Northern Pacific Railway was completing its tracks across Montana to the West Coast. The railroad's owners immediately recognized the advantage a major tourist destination like Yellowstone would be to train travel. And so Yellowstone, even as it was protected from logging, mining, and other extractive uses of the land, soon served as a key tourist site.

The park remains so to this day. Attracting nearly three million visitors a year,[19] Yellowstone National Park is one of the most heavily visited national parks and one of the most significant tourist destinations in the United States. Visits to Yellowstone inform nearly all tourist trips to northwestern Wyoming and southwestern Montana. Indeed, the park is one of the main reasons why tourists visit Cody, the Buffalo Bill Historical Center, and, by extension, the Draper Museum of Natural History. As much as the visits to the BBHC are influenced by vast plains and the rising foothills of central Wyoming, the BBHC and perhaps in particular the Draper need to be understood within an experiential landscape of Yellowstone.[20]

Not only does Yellowstone draw people to Cody, but Yellowstone and the national parks as a whole form the discursive, visual, and material context of the museum. As Richard Grusin argues in his book about Yosemite, Yellowstone, and Grand Canyon and, more generally, about U.S. national parks,

> National parks work to produce nature as a purified essence, distinct or separate from culture or society or technology, while simultaneously reproducing it as part of a complex and heterogeneous network of scientific, cultural, social, technological practices. From this perspective, Yosemite, Yellowstone, and Grand Canyon national parks consist not just in the natural objects and artifacts that one finds within the boundaries of the parks, but also in their representation and reproduction in the photographs, stereographs, paintings, prints, maps, illustrations, guide-books, laws, and scientific accounts that help to perpetuate the parks and enable them to circulate within the heterogeneous social, cultural, scientific, and political networks that make up America at any particular given moment.[21]

To this list of "artifacts" that make up Yellowstone, we would add the Draper. In this sense, the boundary between the Draper and Yellowstone is blurry.[22] The blurring of boundaries between Draper and Yellowstone is a clue to the museum's technology, for, as we will see, the museum consis-

tently blurs boundaries between inside and outside, real and simulated, nature and culture.

Out of the Park, into the Museum

The grand entrance of the BBHC is fronted by two-story-tall windows, a high ceiling, and, immediately after the ticket counter, a taxidermied bison family in a "natural setting." The bison family, as we have argued elsewhere, is a nearly perfect first vision for the collection of five museums that comprise the BBHC.[23] The bison are a visual literalization of Buffalo Bill's nickname and an introduction to the Buffalo Bill Museum—the entrance of which is to our left. Similarly, the bison are sacred to the Plains Indians who are "celebrated" in the Plains Indian Museum located down the long hall in front of us. The bison are the subject of much of the art in the Whitney Gallery of Western Art to the right and are themselves the result of art/ifice. They were shot and killed (often by Buffalo Bill himself) with the types of guns in the Cody Firearms Museum to the far right. And, of course, seeing bison in the mountains is one of the major tourist attractions of Yellowstone and introduces visitors to representations of and questions about the natural world.

The plaque on the bison display asserts the centrality of the bison to the western landscape: "The West is a land of symbols: the cowboy, the warrior of the plains, the horse and the six-shooter. But perhaps no more representative symbol of the West exists than the American bison, commonly known as the buffalo." Even before taking the hard left into the Draper, visitors are already introduced to a crucial rhetorical mode of the museum: representations of the natural world (and in particular the natural represented through taxidermied animals) are going to work as symbols and metaphors for human understanding and consumption of the landscape. That the western landscape is to be seen as a site/sight and resource for human consumption will be repeated throughout the Draper.

From the display of the bison, we made an acute left, taking us behind the Buffalo Bill Museum and down a long passageway into the Draper. Upon entering the Draper from the main floor entrance of the BBHC, we began to negotiate our expectations of what we believed the museum might be like with our actual experience of walking into the museum— perhaps in the process, we mistakenly privileged an emphasis on the term *natural* over the term *museum* found on the entrance sign. One of us commented on the dark aesthetic of the entrance hallway, absent much *natural* light, hence revealing an expectation that the museum might have had a more airy, open-light aesthetic than it did. Another of us commented on

how the colors of the entrance sign suggest early on in the journey the color scheme of what one might expect to experience throughout a natural history museum—that is, varying shades of rich and/or deep blues, greens, browns, and reds. The entrance hallway's brown-hued, tiled floor mimics the rugged layout of a rocky terrain; the tiles are of varying sizes and shapes, and they have been left a little rough to mimic the roughness of a nature trail. Some of the tiled pieces flow in grayish blues, creating the impression that one is walking near a winding stream.

The trail leads visitors to two single, room-sized, side-by-side cabins on the right, and a taxidermied tableau of packhorses on the left. The second cabin seems to serve as a classroom for arranged tours, and seldom engages other visitors to the museum. The first cabin, however, located near the very beginning of the trail, situates the interpretive framework for understanding and imagining the role of master naturalist. In this cabin, the visitor is informed that resident naturalist B. A. Ware is out in the field. In his absence, we are encouraged to explore the tools of the trade housed in the cabin. Immediately, one begins the educational journey by attending to the described role of the naturalists—to learn scientific names and identifications of plants, minerals, animals, and fossils as well as why these elements exist and what they mean *to humans*. This foundational rhetoric also appears at the museum's entrance: "The Draper Museum of Natural History promotes increased understanding of and appreciation for the relationships binding humans and nature in the American West. With the primary emphasis on the greater Yellowstone area the museum explores and interprets the ways nature and human cultures influence one another."[24] To add further ethos to the educational journey and role of the naturalist, the words of Theodore Roosevelt, a Native American Crow leader, and American scientist and writer Rachel Carson (located on the "Explorer's Listening Post" within B. A. Ware's cabin), extol the value of exploration and the wonders of nature. In front of the cabin is the first of several stamp machines that allow visitors to impress a passport-style stamp into a guidebook. The "Yellowstone Adventure" has officially begun, and it is an adventure that is legitimated by constant educational content and motivated by a central question: "Why do we explore nature?"[25]

To the question "Why do we explore nature?" the cabin offers five answers and thus encodes five ways of understanding nature: (1) as a way of knowing, (2) for finding new riches, (3) for expanding our world, (4) for living, and (5) for inspiration. Oddly, the visitors are differently invited to join in these five projects. The placards offering nature up for scientific exploration and artistic inspiration are written in the third person, remov-

ing the reader from direct address. Apparently, visiting the museum may teach us *about* but not involve us *in* science and inspiration. However, visitors are actively invited to join in the three projects of wealth extraction, curiosity fulfillment (a project that is related to but different from that of science), and consumer exploitation of the land. And so, while the scientist seeks knowledge and the artist seeks inspiration, visitors are invited to imagine the natural world for very direct exchange value. These five motives structure visitors' ways of looking and knowing. The museum rhetorically encodes these ways of knowing through directed movement and the celebration of simulated environments working to produce the master naturalist.

Directed Movement

As the three of us debriefed after our visit to the Draper, we each commented on the centrality of directed movement in the museum compared to some of the other museums housed in the BBHC. One of us noted how, unlike the Buffalo Bill Museum or Whitney Gallery of Western Art, there is not as much freedom to "zigzag" from exhibit to exhibit. Rather, the Draper directs the visitor through a spatial experience of descending elevation habitats—a top to bottom orientation, or Alpine to the Plains/Basins movement. The directedness of the movement through the space is first introduced at B. A. Ware's cabin. In front of the cabin is a trail sign much like a sign visitors would see in any national forest. The sign points museumgoers in the right direction, names the trail ("Expedition Trailhead"), and notes the type of movement to be expected (Alpine-to-Plains trail). B. A. Ware's cabin teaches us that we are in nature for a purpose; it "directs" our gaze. The trail sign indicates that our embodied movement through the space will be similarly directed. It is this extraordinarily careful orchestration of movement through the museum that most thoroughly privileges space over time and that most carefully sutures the subject into a preferred spectoral relation to nature.

In following the Alpine to Plains/Basins orientation, movement is directed so that the visitor circles down through the museum environments, while "hiking" on a spiraling ramp.[26] The circular movement not only provides the individual with a sense of journeying along a mountain trail, but it also employs movement that mimics the roundness—and hence completeness—of such natural elements as the planet, the sun, and the moon, or the cycles of the seasons, thus emphasizing the *natural* in a culturally constructed space. This proffered circularity implies a temporality different from or opposed to time as an agent of change.[27] Just as impor-

tantly, this directed, circular movement provides the museum with a narrative *telos*.[28] As we will argue below, the museum moves visitors from the deep "history" of the Alpine meadows figured as a space outside of human intervention to the final exhibits emphasizing resource and wealth extraction. The epistemology of the master naturalist is produced through the movement from scientific observation of and curiosity fulfillment about the natural world to the use of the land for consumption and accumulation.

As visitors move past the cabin, out of the hallway, and into the top level of the museum, they are confronted with a complex, fascinating set of displays. Immediately in front of them are a set of scrims[29] (to which we will return later in this chapter) that introduce visitors to the alpine environment with printed images of mountains and wildlife. But, because visitors can see through and beyond the scrims, they also get their first vision of the whole museum. With a little movement around this mountaintop, visitors have a bird's-eye view of the complex. Just to make this masterful positioning as clear as possible, a few steps from the entrance, visitors can look over a railing down into the center of the museum where, several stories below them, is a map of the greater Yellowstone region rendered in tile (figure 8.2). This panoramic view, as with the one Barthes describes from atop the Eiffel Tower, performs a double function, transforming "the touristic rite into an adventure of sight and of the intelligence."[30] On one level, the view, like similar outlooks in nature (those in Yellowstone, for instance), implies a "naturist mythology." Even though visitors to the museum are looking at simulated nature, the *mode of seeing*—the sensibility of vision—is akin to gazing at nature, thus naturalizing the simulation. On a second level, the view creates an "incomparable power of *intellection*"[31] because it invites visitors to make sense of the sights, to "read" them as signs, to render them intelligible. This bird's-eye view of the museum is the perfect embodiment of the master naturalist, who at once *perceives* nature and *reads* it, receives it and remakes it, occupies it and possesses it. The double function performed by this panoramic view is made material in the map of the region that lies at the very bottom of the museum. The map reproduces the visual logic of the museum itself, inviting visitors to see the natural world as a mappable space, an abstract vision of nature *and* a set of signs that point to human uses.

After exploring this mountaintop scene, tourists necessarily move to their right to follow the descending, winding path from the timberline environment of small rodents and hardy birds, into the more heavily forested lower elevations. Slowly visitors are led downward, from the inhospitable

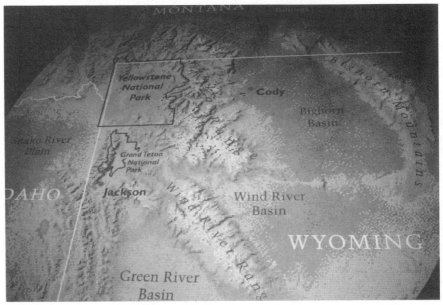

Figure 8.2 Map of the Yellowstone Basin, rendered in tile, as seen from the upper portion of the museum, looking down into the lower level. (Photograph by Greg Dickinson.)

mountain heights into increasingly comfortable parts of the wilderness. This downward descent also moves visitors from parts of the wilderness relatively untouched by humans (and not particularly useful economically) into images of interactions between humans and the wilderness. The theme of the journey shifts from scientific understanding of animals and plants to discussions about the controversial resurgence of wolves in the West and their conflict with ranchers, about the place of forest fires in the "natural" evolution of the forest and the responses by humans to fires, and finally, by the time the visitor reaches the Plains, to images of barbed wire and oil derricks. The directed and embodied movement shifts the visitor not only from high to low, from alpine to plains, but from wilderness to civilization. In other words, the journey begins with civilization's understanding of wilderness in B. A. Ware's cabin, moves to the scientifically knowable, panoptic, but untameable mountaintop, through the forests down to the plains, and so back to civilization. As visitors move down the pathway, they move through the ways of seeing the natural world. They shift from observer of nature, to manager and tourist, to user and extractor of natural resources.

Movement is also directed toward a stop that appears midway through the exhibition at the back of the complex that invites individuals to explore the Seasons of Discovery Gallery. In this gallery, visitors are encouraged to literally see the light (as this area is one of two areas where natural light from outdoors filters into the museum) and to become better educated about animal migration patterns in the fall and hibernation and food storing practices in the winter. As noted in the Draper's "Explorer's Guide for Families," "Spring is the time of the year that many naturalists and scientists go out into the field to observe, explore, and document spring activities," while "Summer is the time of the year many people go out and play in nature. Hiking, camping, fishing, and swimming are all activities that people participate in during the summer."[32] This seasonal information adheres to the Draper's foundational motives that "Exploration is a way of knowing!" and "Exploration is a way of living!" Just as importantly, it continues to divide the natural world into the cyclical experiences of the seasons as well as segment the audience by both time and function—with scientists working in the brisk spring weather and tourists playing in the warmth of the summer.

In addition to the focus on animal and human engagement of the land and its resources through the seasons, a laboratory area, reading area, tent area, and cabin area remind visitors that to know about and to survive the seasons, we must understand nature. Additionally, this marked educational space makes it clear that the role of the scientist helps advance our understanding of nature and, hence, our relationship to it. The directed movements into this educational space work to imagine further the role of master naturalist, for visitors mark their skills and learned knowledge more overtly in this designated space for learning. Finally, the "Please Touch" symbol (like in the B. A. Ware's naturalist cabin) reminds visitors that to be curious and to engage the designated objects are sanctioned and encouraged practices.

Simulated as Natural

The directed movement explored here moves visitors through simulated environments constructed of taxidermied animals, plasticized plants, and carefully rendered scenes of nature. The directed movement we have been exploring is a major rhetorical/material mode that privileges place over time. The simulated natural environment—wonderful in its technologies and beautiful in its renderings—performs the wonder that helps justify the possession of the land offered by the museum.

The Draper is a place where simulated and real become indistinguish-

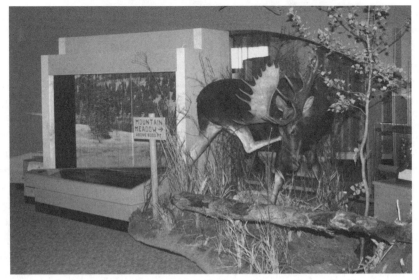

Figure 8.3. Detail of a taxidermied display with a trail sign leading visitors from the Alpine Environment to the mountain meadow. (Photograph by Greg Dickinson.)

able. What was once alive is now preserved in a taxidermied state; what was once an authentic animal sound heard in nature has now been perfectly recorded and released into the *new* museum wild. The scent of smoke indicates that something, perhaps the forest, is on fire while the burning orange neon lights help complete the visual experience of a fire off in the distance. Within a single visit to the museum, visitors can *experience* and become better *educated* on a vast array of nature's habitats and inhabitants. By the end of the Draper expedition, visitors will have journeyed through the Alpine Environment, Mountain Forest Environment, Mountain Meadow and Aquatic Environment, and down to the Plains/Basins Environment (figure 8.3). In each of these environments, the simulated and real cooperate to teach and (re)create a space where one is able to journey into many habitats in a brief amount of time.

These simulated environments participate in a double representational strategy. Writing about the representational technologies that first introduced mass audiences to Yellowstone in the nineteenth century, Richard Grusin argues that stereographic photographs were especially important. "These stereos operate according to a twofold logic of fidelity to nature, providing an accurate record or representation of the object photographed as well as an accurate reproduction of the experience or feeling of scientific

experience."[33] If black-and-white stereographic images viewed through a stereographic viewer can hope to capture the experience of scientific discovery, the fully immersive (if simulated) environments of the museum can reproduce this experience even more compellingly. The simulated environments powerfully efface the built and the natural and, in so doing, efface the distinction between the museum and non-museum experience. The museum's simulated displays serve as persuasive technologies in producing master naturalists.

As visitors journey the long, winding entrance hallway and hike past the two introductory cabins, they move toward an open rotunda area and somewhat circular museum space. This centralized museum space descends from the High Alpine Environment to the Plains/Basins Environment. Prior to even reaching this central area of the (re)created environments, visitors can hear perfectly recorded animal sounds that appear to be coming from nature's animals that are now preserved in a state of taxidermy; the sounds, visitors soon learn, are controlled through several "explorer's listening posts of forest sounds." As visitors press buttons corresponding to animals in various environments, they hear the sounds of animals as they walk from environment to environment. For example, at the beaver pond one can hear the sounds of the Boreal Toad, Red Wing Blackbird, and a beaver. The sounds of the animals are layered into the environments so that the imagined master naturalist becomes more competent in identifying and learning about what various animals sound like *in nature*.

"Scrims"—or digitally produced, hanging photos—provide landscape and skyscape to the open and airy space of the Draper; while simultaneously providing visual context for each of the natural environments, the scrims are sheer, allowing visitors to construct an imagined environment with the photograph on the scrim yet also with a masterful eye see through the image of a snowy mountainside, for example. The scrims also help to distract one's attention away from the ramp railings and more obvious "human-made" spiraling ramp used to descend into the various environments. One's attention is focused onto these digitized photos that help provide (and fill in) the aesthetic content and context for each of the environments.

It is a mistake to think of these simulated environments as "virtual" or as directly opposed to reality or real experience. As is most obviously the case in the forest fire display, these simulated environments offer fully embodied experiences and, in this sense "real," fragments of the natural world. From the moment visitors enter the alpine display at the top of the museum, the burnt umber of the forest fire displayed several yards away is

faintly visible. The color is not strong enough to capture visitors' full attention, serving instead as a background to the nature scenes immediately in front of them. But as visitors navigate down from the alpine heights, the ambient light lowers and the orange of the fires becomes more apparent and central. Approaching the display, the sounds of a roaring fire begin to drown out the chirps of birds and squeaks of chipmunks. Most evocatively, however, as the fire colors and sounds begin to predominate, visitors begin to *smell* the fire.

By the time visitors enter this display, they are surrounded by images of burning fires, crackling sounds, the smell of smoke. Information boards detail how early fire fighting was not as sophisticated as today's methods, how wildfires are a natural process, and how "Today Wildland Fires Are Fought Like Military Campaigns." In this smoke-scented area, there is a picture of an old firefighter in a black-and-white life-size photo standing next to a model of a contemporary firefighter outfit.[34] Several information boards declare that a big western fire is not a natural disaster but a normal event, that only individuals can prevent forest fires, and that there is one forest with many uses. As visitors walk out of the fire section, there is an information board that says, "A new forest is born." There are three billboards in this area that inform: The forest grows, the forest enters middle-age, and a new forest is born. As the "Explorer's Guide for Families" further details, "Eighty percent of the trees within Yellowstone National Park are lodgepole pine trees. Lodgepole pine trees have cones that depend on fire to open and release their seeds."[35] For visitors with a traditional viewpoint on forest fires, an imagined master naturalist role is fostered in this area. With no "real" threat of the power of fire in the moment, it becomes easier to understand how fires can be controlled for safety yet how wildfires are also a natural process. Moreover, visitors have in some small way *experienced* the fire's sound, scent, and color. With this "experience" in place, visitors can become competent members of a conversation about the role of fire in managing forests: in short, they can engage in the position of the master naturalist.

Simulated Tensions

The fire display—with its sounds, colors, images, and smells—points to a larger set of tensions within the museum between the real and the fake. Within the contemporary moment of aesthetic, economic, and political consumptions of faux fur, faux Prada bags, faux Dolce & Gabbana sunglasses, and faux home countertop finishes, the Draper materializes *simulated* (re)presentations of nature in *real* time. Within the immediate bor-

ders of the museum, the journey does not function as the actual experience of engaging *nature* or the *natural* as one might do *outside,* but rather, as we argued earlier, the journey involves "substituting signs of the real for the real itself; that is, an operation to deter every real process by its operational double, a metastable, programmatic, perfect descriptive machine which provides all the signs of the real and short-circuits all its vicissitudes."[36]

For example, the taxidermied animals central to the displays are frozen into a liminal state, a state where time itself stands still; the taxidermied animals are not strictly "real" or "fake" but rather caught somewhere betwixt and between. The taxidermied animals function in the museum like the stereographic photographs of Yellowstone in the nineteenth century. The stereographic image seems to have a real or analogical relation to the object photographed. Clearly the stereograph is not the same as the object, and yet there is some real relation that inheres between the stereograph and the object and, importantly, seems to place the viewer in the midst of the nature pictured. This strange relation is even more strongly felt with taxidermied animals. The beavers, bears, mountain lions, and birds that inhabit the museum once inhabited the natural world. The beaver building the dam in the museum may once have built dams on the rivers in Yellowstone. This dead, stuffed, but action-posed animal embodies the memories of nature, offering these memories of the real to the museum's visitors. It is very precisely this morbid mnemonic relation embedded in the dead animal that most completely realizes the museum's technological production of the master naturalist.

Significantly, however, visitors do not simply view the animals from afar but rather are walking among the creatures and within their environments. In this way, the Draper's exhibits are an "advance" over those in the American Museum of Natural History described by Haraway. In that museum, the audience and the dioramas are separated by glass. Between the visitor and the diorama, Haraway writes, "There is no impediment to this vision, no mediation. The glass front of the diorama forbids the body's entry, but the gaze invites his visual penetration. The animal is frozen in a moment of supreme life, the man is transfixed. No merely living organism could accomplish this act."[37] In the Draper visitors seem to walk in and among the animals, birds, and their natural settings. Thus the "communion" between the dead animal and the living human is even greater, even more wonderful.

Although the sensory content of the Draper echoes "real nature," the visitor is never fully vulnerable to the powerful vicissitudes of nature itself. Perhaps the variability of experience is disrupted within the cultured

space of the museum because "man" is in control of the museum's contents.[38] As visitors we are allowed to observe and interact safely within hyperreality while standing face to face with animals and elements of the taxidermied wild and their simulated habitats. Visitors to the museum are able to stave off the vulnerability inherent in actual experience where the primal instincts of animals to attack or protect and preserve their domain are suspended (at least as seen from our subjective stance); the animals are no longer life threatening.[39] Over the course of a visit, the veneer of a polished (re)presentation of nature's habitats may lose a bit of its luster as interpretive tensions between *natural* and *built* become more pronounced and more apparent. Regardless, the museum experience sustains force by impressively (re)presenting that which we know exists outside of the museum's walls.

Crucial as well is the interaction between the wonder of the simulated environments and the spatiality of directed movements. The simulated environments—and the simulated tensions between danger and safety—depend on already dead animals and plants. But the people traveling through these environments, because their journey is so sharply constricted, are not all that different from the animals. What we have, then, are people and "natural environments" arranged in space where neither the animals *nor* the people are agents of change or subjects of history.

Thus, the simulated as we use it here is not simply an opposite of the *real* thing in *real* time. In fact, the simulated may engage or disengage from the materiality of visual consumption and experience. As Baudrillard asserts, "to dissimulate is to pretend not to have what one has. To simulate is to feign to have what one doesn't have. One implies a presence, the other an absence."[40] And, perhaps because the museum is caught somewhere in between these processes of interpretation, the implications and material consequences of the *simulated* become central to understanding the erasure of the *real*.

In the examples that follow, we work to illustrate how and where the simulated articulates simultaneously a tension of presence and absence. In what is constructed as arguably the climax of the Draper journey, the visitor is visually invited to walk, literally, toward the light (that is, the natural light, in one of its rare appearances, filtering in from the great outdoors) and toward the enormously sculpted bronze bison falling over a ledge. The indoor cliff, the interior museum wall, and the architectural dig in the pit below provide an authenticity and pedagogical force to simulate the fall, particularly as the trees sway and the sky changes color just outside the borders of the museum's windows. As the environmental elements out-

side give light and backdrop to the bronze bison exhibit inside the museum, the visitor is asked to see the two spaces and the scene's contents as one and the same—a moment caught within simulation. In approaching this simultaneously natural-built scene, it becomes clear that the simulated elements gesture toward the *real* via the accoutrements of aesthetics and design and through its invitation into a moment of visual delight—a bronze bison defying gravity while frozen in the penultimate moment of the scene's resolution, just moments prior to any actual crash of the animal/sculpture.

Additionally, an information placard reads: "Once nearly exterminated the bison has become a symbol of North America, especially the American West." Photos of the "Bison Jump" and educational information on how young men imitated sounds of lost bison calves to draw the bison to the ledge, only to thereafter scare the herd from behind to drive the bison over the cliffs, actively stimulate the visitor into the imagined position of the master naturalist. Within the simulated fall of the bison/bronze sculpture and the informative placard telling of the symbolic importance of the bison to the American West, visitors are asked to reconcile their positionality in resolving the loss of or threat to bison. The more you look and learn, the more active the position of master naturalist is refined through the historical (re)telling of the bison jump practices. Despite the strengthening of this position, the visitor continues to simultaneously access the safety that lies within the simulated—a similar type of simulated outcome that works to make *faux* furs, for example, pronounced in aesthetics yet simultaneously stripped of its *vulnerable* consequences of association with *reality,* in this case, the *real* danger in performing bison jump practices in *real* time.

At the same time, even as the placard acknowledges the near extinction of the bison, the visually imposing image of the bison falling off the cliff is embedded in the narrative of Native American hunting and uses of the bison. The dramatic fall of the bison paired with the abstracted narrative of "near extinction" leads visitors to imagine that Native American practices were at least part of the reason for the bison's near-death experience. In this way, the changes wrought by Anglo-American colonizers are held at a double remove from the visitors. First, the rapacious hunting of the bison by whites is hidden behind the scrim of a "once upon a time" narrative. Second, the visual and material wondrousness of the sculpture and of the animal it memorializes overwhelms the plainly stated verbal message of loss. And so the bison, its near extinction, and the social relations that motivated and justified the mass killings are hidden behind a fairy-tale story and a powerfully moving image.

Further accentuating the tension between *natural* and *built* is the exhibit addressing the wolves in the greater Yellowstone region. An informative placard asks: "Is there room for wolves? Wolves are large predators that impact their environment and are impacted by it. People often portray wolves as 'good' or 'bad' animals. Nature, however, does not place value judgments on wolves or other creatures. Scientists work to understand how wolves interact with their environment, but policy makers determine if and how we will share that environment with wolves. Please share your opinions about wolves or other wildlife issues with us. Is there room for wolves in the greater Yellowstone region? Is there room for wolves?" Inside a glass display, about twenty or so selected notes respond to the question above, including the following responses: "Yes there is room for wolves. They are an important part of the ecosystem and must be preserved and protected." "No, they kill all the elk. They are evil." "No, we don't need wolves to kill our livestock." "I am a hunter who supports the reintroduction of all natural wildlife. The good Lord put them here for a reason." Despite the educational strength and variety of the responses, the (re)presentation of wolves through taxidermy and media images takes on its own simulation of nature devoid of any immediate threat and perhaps even with an enhanced fascination of the animals. Within this simulated habitat, and even outside of it, the wolves are controlled by humans. In the written responses that have been offered and within the placard that structures the debate, visitors are inscribed into the imagined position of master naturalist who can help reconcile the debate—"Please share your opinions about wolves or other wildlife issues with us."

Although the imagined position accentuates a tenet of exploration as noted in B. A. Ware's cabin—"Exploration is a way of knowing!"—it does not fully capture an underlying narrative of exploration as a way of *deciding* about the power relations between humans and animals. In this case, however, the debate, as centered within the simulated habitat and within the presence of taxidermied wolves looking on, works to potentially motivate the master naturalist into a state of final resolution before walking away. Despite the noted ongoing debate, the *real* work of addressing this issue can either be motivated into action or may be considered to be complete—that is, the master naturalist's work has been done.

Upon arriving at the simulated beaver dam exhibit, the visitor is enticed into a technological marvel of a life-size dam habitat. The visitor, with godlike presence, is able to stand above and see down into the underground habitat through a clear floor that illuminates the world of the busy taxidermied beaver. On the way down into the beaver dam habitat, televi-

sion monitors inform: "Beavers stay busy all year long." Not only do beavers, one learns, raise young and fell trees eight inches thick (the exhibit includes sounds of falling trees), but they also are given privileged position within nature: "Native Americans were perhaps the first to understand the ecological importance of the beaver, referring to this animal as the 'sacred center' of the land." The simulated habitat of the beaver dam takes on a shrine-like presence for the visitor to pay homage to these sacred animals and their sacred spaces. The beaver dam is perhaps the most physically interactive of the animal exhibits in the Draper. For example, during one visit, a young child went in and out of the dam habitat numerous times while laughing and engaging the technology and aesthetic design of the habitat, hence tapping into the master naturalist exploratory tenets of "Exploration is a way of expanding our world!" and "Exploration is a way of living!" As we watched the child engage the beaver dam exhibit/simulated habitat, the exploration outcomes of *curiosity* and *fun* as noted within the two tenets mentioned above were apparent in the child's experience within this simulated habitat.

Where the beaver dam invites visitors to experience nature as a scene of curiosity and fun, the final exhibits in the museum urge visitors to think about nature as a scene of wealth production. The simulated and highly nostalgic gas pump and windmill exhibit opens up the concerns and debates surrounding land use. As noted in the exhibit, "Windmills helped pave the way for Euro-American settlers." Noted accomplishments with the exhibit include the pumping of deep underground water for settlers and livestock. While noting that "Collaboration is better than conflict" to illuminate how coal has been used to light the West, questions that are raised include how we might reduce our dependence on foreign oil. Notations are also provided on how some people call for oil conservation and alternative energy sources to reduce dependence.

Most powerful in this display, however, are the nostalgically rendered technologies of resource extraction and wealth production. A large wood-framed windmill serves as the visual centerpiece of the display. The windmill, like the bison that looms above and behind the display, serves as a visual trope for the West. Unlike the bison's connection to the deep past of the prairie and its significance as a sacred animal for Native Americans, the windmill speaks of the effort in the nineteenth and early twentieth centuries to wrest more intensive agricultural gain from the arid land. Seen from afar, the windmill signifies the presence of a farm or ranch, the rationalization of the land into lines of individual ownership, and the production of cattle, sheep, and grains. Just to emphasize this rationalization

of the land, next to the windmill is a display of barbed wire, a technology that profoundly shaped the plains over the last one hundred and fifty years.[41] Surrounding the windmill is a vintage Husky Oil sign and images of coal mining. It is no mistake that this display serves as the last display in the museum.[42] For all of the circularity and emphasis on the cycles of life and on the seasons in the hike down to the plains in this final display, visitors are sutured into a linear narrative of progress. Technology, this final display asserts, allows humans to extract wealth and riches from the earth and, in exchange, humans tame, civilize, and rationalize the world.

Casting the changes wrought in the landscape by ranching, farming, drilling, and mining in a nostalgically imagined past has the crucial rhetorical effect of distancing visitors from the practices' destructiveness. By placing wealth extraction into the past, the museum removes the practices from the present and, thus, removes them from critical analysis. In this sense the museum argues that all the offered ways of seeing nature—but particularly constructing nature in terms of exchange value—are history. Rather than historicizing the decisions about and struggles over the western landscape, the museum situates these decisions into a place that stops time and asserts that nature, in some sense, always has been and thus always should be at the service of human needs. Rather than historicizing nature as wealth extraction, the museum naturalizes nature as exchange value thus removing the vision of extraction from critical engagement. In short, the Draper Museum of Natural History naturalizes history, thereby creating a place that stops time.

Remembering Nature

The rhetorics of directed movement and simulated environments together produce the master naturalist. The master naturalist has four major characteristics: (1) the master naturalist is an observer and explorer who can decipher nature's signs; (2) the master naturalist makes these observations at little risk—the bears do not bite and the fires do not burn; (3) these safely rendered observations provide the master naturalist with the necessary resources for making decisions about the natural world; and (4) the master naturalist's decisions will favor human control over the world and focus on human use and extraction of natural resources. In fact, this final characteristic most fully embodies the master naturalist's position—the master naturalist's job is to master nature.

The mastery of nature as offered to and by the master naturalist depends on the museum's privileging of space over time. The master natu-

ralist is trained to see the land for its exchange value. But in offering a place outside of time and thus outside of social production, the social nature of this exchange value is repressed. One of the crucial ways this repression is managed is through the technological and aesthetic simulation of the natural. This simulation at once offers and performs the marvelous, which, as Stephen Greenblatt argues, can serve the Western dream of possession.[43] The museum offers the visitor—the newly minted master naturalist—a vision of the natural world that they can fully possess, that they have always already possessed, and the possession of which is "naturalized" and mythologized through a displacement of time and history.

Crucially—and ironically—the museum and its visitors perform this possession through directed movement, which necessarily implies movement through both time and space. And yet, at each turn, the museum (re)places the master naturalist in some slightly removed past, a past that is at once removed from the present by some years; and yet, in the marvelous performance in/of the museum, this past is also the present (remember, of course, that memory is at once about the past and the present as argued in the introduction). In placing the visitor either in a cosmically ordered present/past in the Alpine Meadows, or in some moment in the nineteenth and twentieth century (through images of early fire-fighting gear, narratives of the huge Yellowstone forest fires of 1988, and the nostalgically rendered ordering of natural resources), the museum imagines time as a moment already gone. This spatialized past/present of the museum, then, refuses to engage in a critical examination of the present/future.

This dwelling in the past/present is the sense in which this is a "history" museum. It is not a history museum that narrates a story of change over time, but it implies the more commonsense version of "history" encoded in the phrase "it is history"—meaning, it is finished, gone, over, done. This "doneness" of history undermines the possibilities of agency or critical engagement. It is a shift, to paraphrase Roland Barthes, from lower-case "history" in which humans are agents of history to History in which History is turned into Nature.[44] Thus the relationship between the master naturalist and the natural world is History. This subject position is, in some ways, like the taxidermied animals and plasticized plants—dead, static, but marvelously beautiful for all of that.

The Draper is an indoor, built place that stories and simulates an outdoor, natural space. In doing so, it not only teaches visitors about the animals, processes, and environments of the greater Yellowstone region, it also shapes how they remember them. Unlike history or heritage museums such as the adjoining Buffalo Bill and Plains Indian museums, which remem-

ber specific people, events, or cultures, the Draper (re)collects the history of man's (the gendered language is intentional given the masculine character of the master naturalist) involvement with nature in one particular geographic region. Its rhetoric is so naturalized, however, that visitors are largely unaware that history is being told and memory is being activated. The invisibility of memory is due, in large part, to the highly structured organization of the museum and the way it directs visitors' movement.

Beginning as it does in the Alpine area where human involvement with the land is minimal, if not absent, the Draper fosters a sense of *space outside of time* and a view of nature as ahistorical. Thus, as visitors trek down the path (which has itself been disguised as natural rather than manufactured) and modernity comes closer and closer into focus, museumgoers have passed, rhetorically, through space but not time. This is the inverse operation of most history museums, which move visitors temporally—chronologically—through the past. By the time visitors reach the bottom (not the end!) and the Plains environment (a place, not an event!), they hardly notice that the sounds, sights, and smells of nature have steadily been replaced by windmills and gas pumps—both symbols of man's ability to harness nature for "productive" use. There is, in fact, very little "nature" at the ground level of the museum. It has been supplanted by man and modernity and situated as the spatial (and atemporal) outcome of the museum. Indeed, the *final* thing visitors encounter in the Draper is the tiled map of Yellowstone. There could be no clearer representation of man's desire to master space, to determine what is remembered and what is forgotten, than a map.

So, while the Draper is ostensibly a natural history museum, it really stories the history of man's involvement with nature, celebrating him as explorer and protector. Because this history is remembered spatially rather than temporally, however, it suggests that nature did not exist (or did not matter) when there were no humans present to study, enjoy, or use it. Though the Alpine region *appears* to be space untouched by man, visitors arrive here having *already* been equipped with the master naturalist perspective proffered in B. A. Ware's cabin. The sounds and sights one encounters in this region exist, then, only because they have been studied, gathered, and preserved by naturalists. Even here where it is challenging for the museum to construct a human history of the space, human exploration is encoded. The objects and artifacts collected in this space refer not simply to their real-life counterparts, but also to the experience of discovery. In this way, this first exhibit of Yellowstone's environment reminds us that nature *qua* nature does not exist (or is unimportant) outside of human interven-

tion. Nature makes the master naturalist possible, and, of course, the master naturalist makes nature possible.

The master naturalist is the hero remembered and reenacted in this story. The master naturalist is not simply a role produced in the museum to be enacted elsewhere; it is also a role that is produced and enacted within the walls of the museum itself. Certainly the museum would urge its visitors to embody the values of the master naturalist when they leave this space to visit Yellowstone National Park. But the Draper also affords its visitors the possibility of practicing and performing the role even as they learn about it. In fact, this is one of the powerful rhetorical consequences of memory places—they do not simply point outside of themselves to some other action, in some other place, at some other time. Instead, the site becomes a site of enactment and performance of the memories and the values memory encodes.

Notes

1. We use the "sublime" here in the sense articulated by Nathan Stormer. Sublime images of nature can serve, Stormer argues, to "demarcate the boundaries of the self" while at the same time creating "the space of the appearance for a *mass subject*." Nathan Stormer, "Addressing the Sublime: Space, Mass Representation, and the Unpresentable," *Critical Studies in Media Communication* 21 (2004): 219–20. Emphasis in original.

2. "Buffalo Bill Historical Center: The Voice of the American West," http://www.bbhc.org/dmnh/index.cfm (accessed January 18, 2007). Emphasis in original.

3. Donna Haraway, *Primate Visions: Gender, Race, and Nature in the World of Modern Science* (New York: Routledge, 1989), 1.

4. Michel de Certeau, *The Practice of Everyday Life,* trans. Steven Rendall (Berkeley: University of California Press, 1984): 117.

5. Ibid.

6. Ibid.

7. Certeau calls this "saying" of space an enunciation. See *Practice of Everyday Life,* 19 and 97–98.

8. Ibid. 118. In this evocative passage, Certeau writes:

In our examination of the daily practices that articulate that experience, the opposition between "place" and "space" will rather refer to two sorts of determinations in stories: the first, a determination through objects that are ultimately reducible to the *being-there* of something dead, the law

of a "place" (from the pebble to the cadaver, an inert body always seems, in the West, to found a place and give it the appearance of a tomb); the second, a determination through *operations* which, when they are attributed to a stone, tree, or human being, specify "spaces" by the actions of historical *subjects* (a movement always seems to condition the production of a space and to associate it with a history). Between these two determinations, there are passages back and forth, such as the putting to death (or putting into a landscape) of heroes who transgress frontiers and who, guilty of an offense against the law of the place, best provide its restoration with their tombs; or again, on the contrary, the awakening of inert objects (a table, a forest, a person that plays a certain role in the environment) which, emerging from their stability, transforms the place where they lay motionless into the foreignness of their own space. (Emphasis in original)

9. Stephen Greenblatt, *Marvelous Possessions: The Wonder of the New World* (Chicago: University of Chicago Press, 1991), 135.

10. John Berger, writing of the Renaissance European nude, argues that this new way of seeing women quite precisely objectifies them, turning women into objects to be surveyed and, in the surveying, judged. *Ways of Seeing* (London: British Broadcasting System, 1972), 46–47.

11. We explore the difficulties of hiding the toll of colonization in our analyses of the Buffalo Bill Museum and the Plains Indian Museum. See Greg Dickinson, Brian L. Ott, and Eric Aoki, "Spaces of Remembering and Forgetting: The Reverent Eye/I at the Plains Indian Museum," *Communication and Critical/Cultural Studies* 3 (2006): 27–47; and Dickinson, Ott, and Aoki, "Memory and Myth at the Buffalo Bill Museum," *Western Journal of Communication* 69 (2005): 85–108. In those museums, the colonization is more of people and less of land. Here, the possession is much more about land and "nature"; indeed, as we argue, people as either colonized or colonizer are absent in this natural history museum.

12. Greenblatt, *Marvelous Possessions,* 81–83.

13. Ibid. 135.

14. Greenblatt, *Marvelous Possessions,* 73. See also Berger, *Ways of Seeing,* 46–47.

15. On the appearance of zoos and their importance in modernity, see John Berger, *About Looking* (New York: Vintage International, 1980): 20–28; and Akira Mizuta Lippit, *Electric Animal: Toward a Rhetoric of Wildlife* (Minneapolis: University of Minnesota Press, 2000): 3–4.

16. Haraway, *Primate Visions,* 30.

17. For Haraway, taxidermy's "most *ecstatic* and skillful moment joins ape and man in visual embrace" (*Primate Visions,* 26; emphasis added). Note how, like Greenblatt's reading of early modern travel literature, the movement across difference (here, human and ape) is negotiated through ecstasy, which is related to the marvelous and wonder. The taxidermied animals are visually wonderful, allowing for an ecstatic communion that at once emphasizes similarity *and* difference.

18. Barry Mackintosh, *The National Parks: Shaping the System* (Washington, DC: The National Park System, 2000): 13.

19. Yellowstone National Park, "Historical Annual Visitation Statistics," http://www.nps.gov/yell/parkmgmt/historicstats.htm (accessed February 22, 2007). By comparison, over 4.5 million people visit the Grand Canyon National park each year (http://www.nps.gov/archive/grca/facts/yrstat.htm [accessed February 22, 2007]).

20. Elsewhere we argue that viewing historical and cultural sites as experiential landscapes rests on three interlocking principles: (1) historical and cultural sites are better thought of as diffuse rather than discrete texts, (2) historical and cultural sites are not just comprised of "the tangible materials available in that place, but also the full range of memorized images that persons bring with them," and (3) historical and cultural sites "offer fully embodied subject positions that direct particular ways of looking" (Dickinson, Ott, and Aoki, "Spaces of Remembering and Forgetting," 30–31).

21. Richard Grusin, *Culture, Technology, and the Creation of America's National Parks* (New York: Cambridge University Press, 2004), 13.

22. With regard to the blurring of boundaries, Victor Burgin writes: "The city in our actual experience is at the same time an actually existing physical environment, and a city in a novel, a film, a photograph, a city seen on television, a city in a comic strip, a city in a pie chart, and so on." Similarly about films, Burgin writes: "Collecting such metonymic fragments [of posters, reviews, trailers, conversations] in memory, we may come to feel familiar with a film we have not actually seen. Clearly this 'film'—a heterogeneous psychical object, constructed from image scraps scattered in space and time, arbitrarily anchored in a contingent reality (a newspaper interview, a review)—is a very different object from that encountered in the context of 'film studies.'" Parks, cities, films, and museums, then, in our "actual experience" are not simply our experience with the material text, but rather as an accumulation of memorized fragments. Burgin, *In/Different Spaces: Place and Memory in Visual Culture* (Berkeley: University of California Press, 1996), 28, 23.

23. Dickinson, Ott, and Aoki, "Memory and Myth," 94. On the importance of the family trope in museum exhibits featuring taxidermied animals, see Haraway, *Primate Visions,* 30.

24. The pedagogical mission of the museum is not unusual. For analysis of the pedagogical goals and design of other natural history museums, see Ann Reynolds, "Visual Stories," in *The Visual Culture Reader,* 2nd ed., ed. Nicholas Mirzoeff (New York: Routledge, 2002), 326, 330–31. As our analysis will show, however, while the museum certainly is pedagogical, it is less clear that the museum investigates "the ways nature and human cultures influence one another."

25. The BBHC Web site also makes clear that the role of the naturalist-researcher and education are central to the foundational platform of the Draper:

> Currently, the Draper houses adult and children's classrooms, education office spaces, a photography gallery, and approximately 20,000 square feet of highly immersive and interactive exhibits, titled *Greater Yellowstone Adventure* highlighting geology, wildlife, and human presence in the Greater Yellowstone region. Many individuals and organizations, including the National Science Foundation, generously supported initial development and implementation of *Greater Yellowstone Adventure.* In addition to exhibits, the Draper fulfills its mission through field research, collections development, and in-house and field-based educational programming.

26. It is possible to enter the museum from a lower entrance. In our experience, few visitors do so.

27. This circular vision of space and time intersects with one vision of time and nature in the Plains Indian Museum. In a multimedia presentation, a narrative of Plains Indian life is connected to cyclical time of the seasons. See Dickinson, Ott, and Aoki, "Spaces of Remembering and Forgetting," 36–38.

28. It is tempting to read "narrative" as necessarily transforming "place" into "space." And yet, as Certeau argues, "Stories thus carry out a labor that constantly transforms places into spaces or spaces into places" (118).

29. The BBHC Web site states that "the scrims were created from digital photographs. They were produced by a company called Color X, 33 East 17th Street, New York, NY 10003" ("Buffalo Bill Historical Center: Voice of the American West," http://www.bbhc.org/dmnh/index.cfm [accessed January 18, 2007]).

30. Roland Barthes, *The Eiffel Tower, and Other Mythologies,* trans. Richard Howard (New York: Hill and Wang, 1979): 8.

31. Barthes, *Eiffel Tower*, 9.

32. Kristin Atman and Gretchen Henrich, "Explorer's Guide for Families," Draper Museum of Natural History (Cody, WY: Buffalo Bill Historical Center, n.d.): 10–11.

33. Grusin, *Culture, Technology*, 81.

34. This is one of the few places in the museum that directly addresses change over time.

35. Atman and Henrich, "Explorer's Guide for Families," 7.

36. Jean Baudrillard, "Simulacra and Simulations," in *Visual Culture Reader*, ed. Mirzoeff, 146.

37. Haraway, *Primate Visions*, 30.

38. We use "man" here and later to indicate the role of patriarchy and masculinity in the kind of vision we are analyzing. See Haraway, *Primate Visions*, 26.

39. See Jean Baudrillard, *Simulacra and Simulation*, trans. Sheila Faria Glaser (Ann Arbor: University of Michigan Press, 1994): 134–35. In writing of "The Animals: Territory and Metamorphoses," Baudrillard asserts, "Those who used to sacrifice animals did not take them for beasts. . . . They held them to be guilty: which was a way of honoring them. We take them for nothing, and it is on this basis that we are 'human' with them. We no longer sacrifice them, we no longer punish them, and we are proud of it, but it is simply that we have domesticated them, worse: that we have made of them a racially inferior world, no longer even worthy of our justice, but only of our affection and social charity, no longer worthy of punishment and death, but only of experimentation and extermination like meat from the butchery."

40. Baudrillard, *Simulacra and Simulation*, 3.

41. On the importance of barbed wire fencing in the West, see Henry D. McCallum and Frances T. McCallum, *The Wire That Fenced the West* (Norman: University of Oklahoma Press, 1965); accessed online http://0-www.netlibrary.com.catalog.library.colostate.edu/Details.aspx (April 14, 2007).

42. This is assuming the visitor accepts the museum's invitation to travel from top to bottom.

43. Greenblatt, *Marvelous Possessions*, 135.

44. In *Mythologies*, Roland Barthes writes, "The myth of the human 'condition' rests on a very old mystification, which always consists of placing Nature at the bottom of History." Barthes, *Mythologies*, trans. Annette Lavers (New York: Hill and Wang, 1972), 101.

Selected Bibliography

Books

Ahmed, Sara. *The Cultural Politics of Emotion*. New York: Routledge, 2004.

Anderson, Benedict. *Imagined Communities: Reflections on the Origin and Spread of Nationalism*. 2nd ed. London: Verso, 1991.

Ariès, Philippe. *Images of Man and Death*. Translated by Janet Lloyd. Cambridge, MA: Harvard University Press, 1985.

Aristotle. *On Rhetoric: A Theory of Civic Discourse*. Translated by George A. Kennedy. New York: Oxford University Press, 1991.

Asen, Robert, and Daniel C. Brouwer, eds. *Counterpublics and the State*. Albany: State University of New York Press, 2001.

Assmann, Jan. *Religion and Cultural Memory*. Translated by Rodney Livingstone. Stanford: Stanford University Press, 2006.

Aúge, Marc. *Non-Places: Introduction to an Anthropology of Supermodernity*. Translated by John Howe. London: Verso, 1995.

Bachelard, Gaston. *The Poetics of Space*. Translated by Maria Jolas. Boston: Beacon Press, 1994.

Barton, Craig E., ed. *Sites of Memory: Perspectives on Architecture and Race*. New York: Princeton Architectural Press, 2001.

Benjamin, Walter. *The Arcades Project*. Translated by Howard Eiland and Kevin McLaughlin. Cambridge, MA: Harvard University Press, 1999.

Bevan, Robert. *The Destruction of Memory: Architecture at War*. London: Reaktion Books, 2006.

Berman, Marshall. *All That Is Solid Melts into Air: The Experience of Modernity*. New York: Penguin, 1988.

Bhabha, Homi K. *The Location of Culture*. London: Routledge, 1994.

Blight, David W. *Beyond the Battlefield: Race, Memory, and the American Civil War*. Amherst: University of Massachusetts Press, 2002.

Bodnar, John. *Remaking America: Public Memory, Commemoration, and Patriotism in the Twentieth Century.* Princeton, NJ: Princeton University Press, 1992.

Boime, Albert. *The Unveiling of the National Icons: A Plea for Patriotic Iconoclasm in a Nationalist Era.* Cambridge, UK: Cambridge University Press, 1998.

Booth, Wayne C. *The Rhetoric of Rhetoric: The Quest for Effective Communication.* Malden, MA: Blackwell, 2004.

Boyer, Christine. *The City of Collective Memory: Its Historical Imagery and Architectural Entertainments.* Cambridge, MA: MIT Press, 1996.

Brundage, W. Fitzhugh, ed. *Where These Memories Grow: History, Memory, and Southern Identity.* Chapel Hill: University of North Carolina Press, 2000.

Bruner, M. Lane. *Strategies of Remembrance: The Rhetorical Dimensions of National Identity Construction.* Columbia: University of South Carolina Press, 2002.

Burgin, Victor. *In/Different Spaces: Place and Memory in Visual Culture.* Berkeley: University of California Press, 1996.

Burke, Kenneth. *A Rhetoric of Motives.* Berkeley: University of California Press, 1969.

Calhoun, Craig, ed. *Habermas and the Public Sphere.* Cambridge, MA: MIT Press, 1992.

Carr, Stephen, Mark Francis, Leanne G. Rivlin, and Andrew M. Stone. *Public Space.* Cambridge, UK: Cambridge University Press, 1992.

Casey, Edward S. *The Fate of Place: A Philosophical History.* Berkeley: University of California Press, 1997.

———. *The World at a Glance.* Bloomington: Indiana University Press, 2007.

Certeau, Michel de. *The Practice of Everyday Life.* Translated by Steven Rendall. Berkeley: University of California Press, 1984.

Clark, Gregory. *Rhetorical Landscapes in America: Variations on a Theme from Kenneth Burke.* Columbia: University of South Carolina Press, 2004.

Clough, Patricia Ticineto, ed. *The Affective Turn: Theorizing the Social.* Durham, NC: Duke University Press, 2007.

Coleman, Simon, and Mike Crang, eds. *Tourism: Between Place and Performance.* New York: Berghahn Books, 2002.

Collins, Jim. *Architectures of Excess: Cultural Life in the Information Age.* New York: Routledge, 1995.

Colomina, Beatriz. *Privacy and Publicity: Modern Architecture as Mass Media.* Cambridge, MA: MIT Press, 1994.

———, ed. *Sexuality and Space.* New York: Princeton Architectural Press, 1992.

Conn, Steven. *Museums and American Intellectual Life, 1876–1926.* Chicago: University of Chicago Press, 1998.

Connerton, Paul. *How Societies Remember.* Cambridge, UK: Cambridge University Press, 1989.

Crang, Mike, and Nigel Thrift, eds. *Thinking Space.* London: Routledge, 2000.

Crouch, David, and Nina Lübbren, eds. *Visual Culture and Tourism.* Oxford, UK: Berg, 2003.

Davis, Mike. *Dead Cities, and Other Tales.* New York: New Press, 2002.

Desmond, Jane. *Staging Tourism: Bodies on Display from Waikiki to Sea World.* Chicago: University of Chicago Press, 1999.

Deutsche, Rosalyn. *Evictions: Art and Spatial Politics.* Cambridge, MA: MIT Press, 1996.

Dubin, Steven C. *Displays of Power: Memory and Amnesia in the American Museum.* New York: New York University Press, 1999.

Duncan, James, and David Ley, eds. *Place/Culture/Representation.* London: Routledge, 1993.

Edkins, Jenny. *Trauma and the Memory of Politics.* Cambridge, UK: Cambridge University Press, 2003.

Ellin, Nan, ed. *Architecture of Fear.* New York: Princeton Architectural Press, 1997.

Fabre, Geneviève, and Robert O'Meally, eds. *History and Memory in African-American Culture.* Oxford, UK: Oxford University Press, 1994.

Fahs, Alice, and Joan Waugh, eds. *The Memory of the Civil War in American Culture.* Chapel Hill: University of North Carolina Press, 2004.

Fine, Gary Alan. *Difficult Reputations: Collective Memories of the Evil, Inept, and Controversial.* Chicago: University of Chicago Press, 2001.

Foote, Kenneth E. *Shadowed Ground: America's Landscapes of Violence and Tragedy.* Austin: University of Texas Press, 1997.

Gillis, John R., ed. *Commemorations: The Politics of National Identity.* Princeton, NJ: Princeton University Press, 1994.

Glazer, Nathan, and Cindy R. Field, eds. *The National Mall: Rethinking Washington's Monumental Core.* Baltimore: Johns Hopkins University Press, 2008.

Goode, James M. *Washington Sculpture: A Cultural History of Outdoor Sculpture in the Nation's Capital.* Baltimore: Johns Hopkins University Press, 2008.

Gregory, Derek. *Geographical Imaginations.* Cambridge, MA: Blackwell, 1994.

Grossberg, Lawrence. *We Gotta Get out of This Place: Popular Conservatism and Postmodern Culture.* New York: Routledge, 1992.

Grosz, Elizabeth. *Architecture from the Outside: Essays on Virtual and Real Space.* Cambridge, MA: MIT Press, 2001.

Gupta, Akhil, and James Ferguson, eds. *Culture, Power, Place: Explorations in Critical Anthropology.* Durham, NC: Duke University Press, 1997.

Habermas, Jürgen. *The Structural Transformation of the Public Sphere: An Inquiry into a Category of Bourgeois Society.* Translated by Thomas Burger. Cambridge, MA: MIT Press, 1989.

Halbwachs, Maurice. *On Collective Memory*. Edited and translated by Lewis A. Coser. Chicago: University of Chicago Press, 1992.

Harries, Karsten. *The Ethical Function of Architecture*. Cambridge, MA: MIT Press, 1998.

Harbison, Robert. *The Built, the Unbuilt, and the Unbuildable: In Pursuit of Architectural Meaning*. Cambridge, MA: MIT Press, 1992.

Harvey, David. *Spaces of Capital: Towards a Critical Geography*. New York: Routledge, 2001.

Hauser, Gerard A. *Vernacular Voices: The Rhetoric of Publics and Public Spheres*. Columbia: University of South Carolina Press, 2001.

Hayden, Dolores. *The Power of Place: Urban Landscapes as Public History*. Cambridge, MA: MIT Press, 1997.

Heathcote, Edwin. *Monument Builders: Modern Architecture and Death*. West Sussex, UK: John Wiley & Sons, 1999.

Henderson, Amy, and Adrienne L. Kaeppler, eds. *Exhibiting Dilemmas: Issues of Representation at the Smithsonian*. Washington, DC: Smithsonian Institution Press, 1997.

Hirst, Paul. *Space and Power: Politics, War and Architecture*. Cambridge, UK: Polity, 2005.

Hobsbawm, Eric, and Terence Ranger, eds. *The Invention of Tradition*. Cambridge, UK: Cambridge University Press, 1983.

Hutton, Patrick H. *History as an Art of Memory*. Hanover, NH: University Press of New England, 1993.

Huyssen, Andreas. *Present Pasts: Urban Palimpsests and the Politics of Memory*. Stanford, CA: Stanford University Press, 2003.

Irwin-Zarecka, Iwona. *Frames of Remembrance: The Dynamics of Collective Memory*. New Brunswick, NJ: Transaction, 1994.

Jacobs, Jane. *The Death and Life of Great American Cities*. New York: Random House, 1961.

Jacobson, David. *Place and Belonging in America*. Baltimore: Johns Hopkins University Press, 2002.

Kammen, Michael. *The Mystic Chords of Memory: The Transformation of Tradition in American Culture*. New York: Vintage, 1993.

Karp, Ivan, Christine Mullen Kreamer, and Steven D. Lavine, eds. *Museums and Communities: The Politics of Public Culture*. Washington, DC: Smithsonian Institution Press, 1992.

Karp, Ivan, and Steven D. Lavine, eds. *Exhibiting Cultures: The Poetics and Politics of Museum Display*. Washington, DC: Smithsonian Institution Press, 1991.

Keith, William M., and Christian O. Lundberg. *The Essential Guide to Rhetoric*. Boston: Bedford/St. Martin's, 2008.

Kirshenblatt-Gimblett, Barbara. *Destination Culture: Tourism, Museums, and Heritage.* Berkeley: University of California Press, 1998.

Kohn, Margaret. *Radical Space: Building the House of the People.* Ithaca, NY: Cornell University Press, 2003.

Laguerre, Michel. *Minoritized Space: An Inquiry into the Spatial Order of Things.* Berkeley: University of California Press, 1999.

Lamont, Michèle. *The Cultural Territories of Race: Black and White Boundaries.* Chicago: University of Chicago Press, 1999.

Landsberg, Alison. *Prosthetic Memory: The Transformation of American Remembrance in the Age of Mass Culture.* New York: Columbia University Press, 2004.

Lasansky, D. Medina, and Brian McLaren, eds. *Architecture and Tourism: Perception, Performance, and Place.* Oxford, UK: Berg, 2004.

Latour, Bruno, and Peter Weibel, eds. *Making Things Public: Atmospheres of Democracy.* Cambridge, MA: MIT Press, 2005.

Lawson, Brian. *The Language of Space.* Oxford, UK: Architectural Press, 2001.

Lefebvre, Henri. *The Production of Space.* Translated by Donald Nicholson-Smith. Oxford, UK: Blackwell, 1991.

LeFevre, Karen Burke. *Invention as a Social Act.* Carbondale: Southern Illinois University Press, 1987.

Le Goff, Jacques. *History and Memory.* Translated by Steven Rendall and Elizabeth Claman. New York: Columbia University Press, 1992.

Leon, Warren, and Roy Rosenzweig, eds. *History Museums in the United States: A Critical Assessment.* Urbana: University of Illinois Press, 1989.

Levinson, Sanford. *Written in Stone: Public Monuments in Changing Societies.* Durham, NC: Duke University Press, 1998.

Lillyman, William J., Marilyn F. Moriarty, and David J. Neuman, eds. *Critical Architecture and Contemporary Culture.* New York: Oxford University Press, 1994.

Linenthal, Edward T. *Preserving Memory: The Struggle to Create America's Holocaust Museum.* New York: Viking, 1995.

——. *The Unfinished Bombing: Oklahoma City in American Memory.* New York: Oxford University Press, 2001.

——. *Sacred Ground: Americans and Their Battlefields.* 2nd ed. Urbana: University of Illinois Press, 1993.

Linenthal, Edward T., and Tom Engelhardt, eds. *History Wars: The Enola Gay and Other Battles for the American Past.* New York: Henry Holt, 1996.

Lipsitz, George. *Time Passages: Collective Memory and American Popular Culture.* Minneapolis: University of Minnesota Press, 1990.

Lloyd, David W. *Battlefield Tourism: Pilgrimage and the Commemoration of the Great War in Britain, Australia, and Canada, 1919–1939.* Oxford, UK: Berg, 1998.

Low, Setha, and Neil Smith, eds. *The Politics of Public Space*. New York: Routledge, 2006.

Low, Setha M., and Denise Lawrence-Zúñiga, eds. *The Anthropology of Space and Place: Locating Culture*. Oxford, UK: Blackwell, 2003.

Lowenthal, David. *The Heritage Crusade and the Spoils of History*. Cambridge, UK: Cambridge University Press, 1998.

Lucaites, John Louis, Celeste Michelle Condit, and Sally Caudill, eds. *Contemporary Rhetorical Theory: A Reader*. New York: Guilford, 1999.

Macek, Steve. *Urban Nightmares: The Media, the Right, and the Moral Panic over the City*. Minneapolis: University of Minnesota Press, 2006.

Massey, Doreen. *For Space*. London: Sage, 2005.

———. *Space, Place, and Gender*. Minneapolis: University of Minnesota Press, 1994.

Mayo, James M. *War Memorials as Political Landscape: The American Experience and Beyond*. New York: Praeger, 1988.

Middleton, David, and Derek Edwards, eds. *Collective Remembering*. London: Sage, 1990.

Miles, Malcolm. *Art, Space and the City: Public Art and Urban Futures*. London: Routledge, 1997.

Mitchell, Don. *The Right to the City: Social Justice and the Fight for Public Space*. New York: Guilford Press, 2003.

Mitchell, W. J. T., ed. *Art and the Public Sphere*. Chicago: University of Chicago Press, 1992.

Morris, Meaghan. *Too Soon Too Late: History in Popular Culture*. Bloomington: University of Indiana Press, 1998.

Olick, Jeffrey K. *The Politics of Regret: On Collective Memory and Historical Responsibility*. New York: Routledge, 2007.

———, ed. *States of Memory: Continuities, Conflicts, and Transformations in National Retrospection*. Durham, NC: Duke University Press, 2003.

Pevsner, Nikolaus. *A History of Building Types*. Princeton, NJ: Princeton University Press, 1976.

Piehler, G. Kurt. *Remembering War the American Way*. Washington, DC: Smithsonian Institution Press, 1995.

Phillips, Kendall R., ed. *Framing Public Memory*. Tuscaloosa: University of Alabama Press, 2004.

Pollock, Della, ed. *Exceptional Spaces: Essays in Performance and History*. Chapel Hill: University of North Carolina Press, 1998.

Prelli, Lawrence J., ed. *Rhetorics of Display*. Columbia: University of South Carolina Press, 2006.

Radstone, Susannah, ed. *Memory and Methodology*. Oxford, UK: Berg, 2000.

Ricoeur, Paul. *Memory, History, Forgetting*. Translated by Kathleen Blamey and David Pellauer. Chicago: University of Chicago Press, 2004.

Rosenzweig, Roy, and David Thelen. *The Presence of the Past: Popular Uses of History in American Life*. New York: Columbia University Press, 1998.

Rybczynski, Witold. *City Life*. New York: Simon and Schuster, 1995.

Savage, Kirk. *Standing Soldiers, Kneeling Slaves: Race, War, and Monument in Nineteenth-Century America*. Princeton, NJ: Princeton University Press, 1997.

Shackel, Paul A., ed. *Myth, Memory, and the Making of the American Landscape*. Gainesville: University Press of Florida, 2001.

Schudson, Michael. *Watergate in American Memory: How We Remember, Forget, and Reconstruct the Past*. New York: Basic Books, 1992.

Schwartz, Barry. *Abraham Lincoln and the Forge of National Memory*. Chicago: University of Chicago Press, 2000.

Senie, Harriet F. *Contemporary Public Sculpture: Tradition, Transformation, and Controversy*. New York: Oxford University Press, 1992.

Senie, Harriet F., and Sally Webster, eds. *Critical Issues in Public Art: Content, Context, and Controversy*. New York: HarperCollins, 1992.

Shaffer, Marguerite S. *See America First: Tourism and National Identity, 1880–1940*. Washington, DC: Smithsonian Institution Press, 2001.

Sherman, Daniel J. *The Construction of Memory in Interwar France*. Chicago: University of Chicago Press, 1999.

Sherman, Daniel J., and Irit Rogoff, eds. *Museum Culture: Histories, Discourses, Spectacles*. Minneapolis: University of Minnesota Press, 1994.

Sloane, Thomas O., ed. *Encyclopedia of Rhetoric*. New York: Oxford University Press, 2001.

Soja, Edward W. *Postmodern Geographies: The Reassertion of Space in Critical Social Theory*. London: Verso, 1989.

———. *Thirdspace: Journeys to Los Angeles and Other Real-and-Imagined Places*. Cambridge, MA: Blackwell, 1996.

Sorkin, Michael, ed. *Variations on a Theme Park: The New American City and the End of Public Space*. New York: Noonday Press, 1992.

Spillman, Lyn. *Nation and Commemoration: Creating National Identities in the United States and Australia*. Cambridge, UK: Cambridge University Press, 1997.

Sturken, Marita. *Tangled Memories: The Vietnam War, the AIDS Epidemic, and the Politics of Remembering*. Berkeley: University of California Press, 1997.

———. *Tourists of History: Memory, Kitsch, and Consumerism from Oklahoma City to Ground Zero*. Durham, NC: Duke University Press, 2007.

Taylor, Diana. *The Archive and the Repertoire: Performing Cultural Memory in the Americas.* Durham, NC: Duke University Press, 2003.

Tuan, Yi-Fu. *Space and Place: The Perspective of Experience.* Minneapolis: University of Minnesota Press, 1977.

Vale, Lawrence J. *Architecture, Power, and National Identity.* New Haven, CT: Yale University Press, 1992.

Vidler, Anthony. *The Architectural Uncanny: Essays in the Modern Unhomely.* Cambridge, MA: MIT Press, 1992.

———. *Warped Space: Art, Architecture, and Anxiety in Modern Culture.* Cambridge, MA: MIT Press, 2001.

Wallace, Mike. *Mickey Mouse History and Other Essays on American Memory.* Philadelphia: Temple University Press, 1996.

Wallach, Alan. *Exhibiting Contradiction: Essays on the Art Museum in the United States.* Amherst: University of Massachusetts Press, 1998.

Warner, Michael. *Publics and Counterpublics.* New York: Zone Books, 2002.

Winter, Jay. *Remembering War: The Great War between Memory and History in the Twentieth Century.* New Haven, CT: Yale University Press, 2006.

———. *Sites of Memory, Sites of Mourning: The Great War in European Cultural History.* Cambridge, UK: Cambridge University Press, 1995.

Wood, Andrew. *City Ubiquitous: Place, Communication, and the Rise of Omnitopia.* Cresskill, NJ: Hampton Press, 2009.

Yates, Frances. *The Art of Memory.* Chicago: University of Chicago Press, 1966.

Young, James E. *At Memory's Edge: After-Images of the Holocaust in Contemporary Art and Architecture.* New Haven, CT: Yale University Press, 2000.

———. *The Texture of Memory: Holocaust Memorials and Meaning.* New Haven, CT: Yale University Press, 1993.

Zelizer, Barbie. *Remembering to Forget: Holocaust Memory through the Camera's Eye.* Chicago: University of Chicago Press, 1998.

Zukin, Sharon. *Landscapes of Power: From Detroit to Disney World.* Berkeley: University of California Press, 1991.

Articles and Book Chapters

Armada, Bernard J. "Memorial Agon: An Interpretive Tour of the National Civil Rights Museum." *Southern Communication Journal* 63 (1998): 235–43.

Atwater, Deborah F., and Sandra L. Herndon. "Cultural Space and Race: The National Civil Rights Museum and MuseumAfrica." *Howard Journal of Communications* 14 (2003): 15–28.

Balthrop, V. William. "Culture, Myth, and Ideology as Public Argument: An

Interpretation of the Ascent and Demise of 'Southern Culture.'" *Communication Monographs* 51 (1984): 339–52.

Biesecker, Barbara. "No Time for Mourning: The Rhetorical Production of the Melancholic Citizen-Subject in the War on Terror." *Philosophy and Rhetoric* 40 (2007): 147–69.

———. "Remembering World War II: The Rhetoric and Politics of National Commemoration at the Turn of the 21st Century." *Quarterly Journal of Speech* 88 (2002): 393–409.

Bitzer, Lloyd F. "The Rhetorical Situation." *Philosophy and Rhetoric* 1 (1968): 1–14.

Blair, Carole. "Contemporary U.S. Memorial Sites as Exemplars of Rhetoric's Materiality." In *Rhetorical Bodies,* edited by Jack Selzer and Sharon Crowley. Madison: University of Wisconsin Press, 1999. 16–57.

Blair, Carole, Marsha S. Jeppeson, and Enrico Pucci Jr. "Public Memorializing in Postmodernity: The Vietnam Veterans Memorial as Prototype." *Quarterly Journal of Speech* 77 (1991): 263–88.

Blair, Carole, and Neil Michel. "The AIDS Memorial Quilt and the Contemporary Culture of Public Commemoration." *Rhetoric and Public Affairs* 10 (2007): 595–626.

———. "Reproducing Civil Rights Tactics: The Rhetorical Performances of the Civil Rights Memorial." *Rhetoric Society Quarterly* 30.2 (Spring 2000): 31–55.

———. "The Rushmore Effect: *Ethos* and National Collective Identity." In *The Ethos of Rhetoric,* edited by Michael J. Hyde. Columbia: University of South Carolina Press, 2004. 156–96.

Browne, Stephen H. "Reading Public Memory in Daniel Webster's Plymouth Rock Oration." *Western Journal of Communication* 57 (1993): 464–77.

———. "Remembering Crispus Attucks: Race, Rhetoric, and the Politics of Commemoration." *Quarterly Journal of Speech* 85 (1999): 169–87.

Burns, Lisa M. "Collective Memory and the Candidates' Wives in the 2004 Presidential Campaign." *Rhetoric and Public Affairs* 8 (2005): 684–88.

Connerton, Paul. "Seven Types of Forgetting." *Memory Studies* 1 (2008): 59–71.

Cox, J. Robert. "Memory, Critical Theory, and the Argument from History." *Argumentation and Advocacy* 27 (1990): 1–13.

Charland, Maurice. "Constitutive Rhetoric: The Case of the *Peuple Québécois.*" *Quarterly Journal of Speech* 73 (1987): 133–50.

Dickinson, Greg. "Joe's Rhetoric: Finding Authenticity at Starbuck's." *Rhetoric Society Quarterly* 32 (2002): 5–27.

———. "Memories for Sale: Nostalgia and the Construction of Identity in Old Pasadena." *Quarterly Journal of Speech* 83 (1997): 1–27.

———. "The *Pleasantville* Effect: Memory, Nostalgia, and the Visual Framing of (White) Suburbia." *Western Journal of Communication* 70 (2006): 212–33.

Dickinson, Greg, Brian L. Ott, and Eric Aoki. "Memory and Myth at the Buffalo Bill Museum." *Western Journal of Communication* 69 (2005): 85–108.

———. "Spaces of Remembering and Forgetting: The Reverent Eye/I at the Plains Indian Museum." *Communication and Critical/Cultural Studies* 3 (2006): 27–47.

Dickinson, Greg, and Casey M. Maugh. "Placing Visual Rhetoric: Finding Material Comfort in Wild Oats Market." In *Defining Visual Rhetorics,* edited by Charles A. Hill and Marguerite Helmers. Mahwah, NJ: Lawrence Erlbaum, 2004. 259–76.

Ehrenhaus, Peter. "Silence and Symbolic Expression." *Communication Monographs* 55 (1988): 41–57.

Eves, Roslyn Collings. "A Recipe for Remembrance: Memory and Identity in African-American Women's Cookbooks." *Rhetoric Review* 24 (2005): 280–97.

Farrell, Thomas B. "The Tradition of Rhetoric and the Philosophy of Communication." *Communication* 7 (1983): 151–80.

Gallagher, Victoria J. "Memory and Reconciliation in the Birmingham Civil Rights Institute." *Rhetoric and Public Affairs* 2 (1999): 303–320.

———. "Memory as Social Action: Projection and Generic Form in Civil Rights Memorials." In *New Approaches to Rhetoric,* edited by Patricia A. Sullivan and Steven R. Goldzwig. Thousand Oaks, CA: Sage, 2004. 149–71.

———. "Remembering Together? Rhetorical Integration and the Case of the Martin Luther King, Jr. Memorial." *Southern Communication Journal* 60 (1995): 109–119.

Goodnight, G. Thomas, and Kathryn M. Olson. "Shared Power, Foreign Policy, and Haiti, 1994: Public Memories of War and Race." *Rhetoric and Public Affairs* 9 (2006): 601–634.

Grey, Stephanie Houston. "Writing Redemption: Trauma and the Authentication of the Moral Order in *Hibakusha* Literature." *Text and Performance Quarterly* 22 (2002): 1–23.

Gunn, Joshua. "Mourning Speech: Haunting and the Spectral Voices of Nine-Eleven." *Text and Performance Quarterly* 24 (2004): 91–114.

Hariman, Robert, and John Louis Lucaites. "Public Identity and Collective Memory in U.S. Iconic Photography: The Image of 'Accidental Napalm.'" *Critical Studies in Media Communication* 20 (2003): 35–66.

Hasian, Marouf, Jr. "Authenticity, Public Memories, and the Problematics of Post-Holocaust Remembrances: A Rhetorical Analysis of the Wilkomirski Affair." *Quarterly Journal of Speech* 91 (2005): 231–263.

———. "Nostalgic Longings and Imaginary Indias: Postcolonial Analysis, Collective Memories, and the Impeachment Trial of Warren Hastings." *Western Journal of Communication* 66 (2002): 229–55.

Hasian, Marouf, Jr., and A. Cheree Carlson. "Revisionism and Collective Memory: The Struggle for Meaning in the Amistad Affair." *Communication Monographs* 67 (2000): 42–62.

Hasian, Marouf, Jr., and Robert E. Frank. "Rhetoric, History, and Collective Memory: Decoding the Goldhagen Debates." *Western Journal of Communication* 63 (1999): 95–114.

Haskins, Ekaterina V. "'Put Your Stamp on History': The USPS Commemorative Program *Celebrate the Century* and Postmodern Collective Memory." *Quarterly Journal of Speech* 89 (2003): 1–18.

Jasinski, James. "Answering the Question: What Is Rhetorical Theory and What Does It Do?" *Review of Communication* 3 (2003): 326–29.

Jorgensen-Earp, Cheryl R., and Lori A. Lanzilotti. "Public Memory and Private Grief: The Construction of Shrines at the Sites of Public Tragedy." *Quarterly Journal of Speech* 84 (1998): 150–70.

Marback, Richard. "Detroit and the Closed Fist: Toward a Theory of Material Rhetoric." *Rhetoric Review* 17 (1998): 74–92.

McGee, Michael Calvin. "A Materialist's Conception of Rhetoric." In *Explorations in Rhetoric: Studies in Honor of Douglas Ehninger,* edited by Ray E. McKerrow. Glenview, IL: Scott, Foresman, 1982. 23–48.

Ott, Brian L., and Greg Dickinson. "Visual Rhetoric and/as Critical Pedagogy." *The Sage Handbook of Rhetorical Studies.* Edited by Andrea A. Lunsford, Kirt H. Wilson, and Rosa A. Eberly. Thousand Oaks, CA: Sage, 2009. 391–406.

Parry-Giles, Shawn J., and Trevor Parry-Giles. "Collective Memory, Political Nostalgia, and the Rhetorical Presidency: Bill Clinton's Commemoration of the March on Washington, August 28, 1998." *Quarterly Journal of Speech* 86 (2000): 417–37.

Pezzullo, Phaedra C. "Touring 'Cancer Alley,' Louisiana: Performances of Community and Memory for Environmental Justice." *Text and Performance Quarterly* 23 (2003): 226–52.

Prosise, Theodore O. "The Collective Memory of the Atomic Bombings Misrecognized as Objective History: The Case of the Public Opposition to the National Air and Space Museum's Atom Bomb Exhibit." *Western Journal of Communication* 62 (1998): 316–47.

———. "Prejudiced, Historical Witness, and Responsible Collective Memory and Liminality in the Beit Hashoah Museum of Tolerance." *Communication Quarterly* 51 (2003): 351–66.

Reyes, G. Mitchell. "The Swift Boat Veterans for Truth, the Politics of Re-

alism, and the Manipulation of Vietnam Remembrance in the 2004 Presidential Election." *Rhetoric and Public Affairs* 9 (2006): 571–600.

Rosenfield, Lawrence W. "Central Park and the Celebration of *Civic Virtue.*" *American Rhetoric: Context and Criticism.* Edited by Thomas W. Benson. Carbondale: Southern Illinois University Press, 1989. 221–66.

Stewart, Jessie, and Greg Dickinson. "Enunciating Locality in the Postmodern Suburb: FlatIron Crossing and the Colorado Lifestyle." *Western Journal of Communication* 72 (2008): 280–307.

Stormer, Nathan. "In Living Memory: Abortion as Cultural Amnesia." *Quarterly Journal of Speech* 88 (2002): 265–83.

———. "To Remember, to Act, to Forget: Tracing Collective Remembrance through 'A Jury of Her Peers.'" *Communication Studies* 54 (2003): 510–29.

Vivian, Bradford. "Jefferson's Other." *Quarterly Journal of Speech* 88 (2002): 284–302.

———. "Neoliberal Epideictic: Rhetorical Form and Commemorative Politics on September 11, 2002." *Quarterly Journal of Speech* 92 (2006): 1–26.

———. "On the Language of Forgetting." *Quarterly Journal of Speech* 95 (2009): 89–104.

Wright, Elizabethada. "Reading the Cemetery, *Lieu de mémoire par excellance.*" *Rhetoric Society Quarterly* 33 (2003): 27–44.

———. "Rhetorical Spaces in Memorial Places: The Cemetery as a Rhetorical Place/Space." *Rhetoric Society Quarterly* 35 (2005): 51–81.

Zelizer, Barbie. "Reading the Past against the Grain: The Shape of Memory Studies." *Critical Studies in Mass Communication* 12 (1999): 214–39.

Contributors

Eric Aoki is an Associate Professor in the Department of Communication Studies at Colorado State University. His research concerns the intersections of cultural (re)presentation, diversity communication, voice, and identity politics. His scholarship has appeared in the *Howard Journal of Communications, Rhetoric and Public Affairs, Women's Studies in Communication, Communication and Critical/Cultural Studies,* the *Journal of GLBT Family Studies,* and the *Western Journal of Communication.* His current works in progress include auto-ethnographic and media forays into the intersections of queer visibility, ethnicity, social class privilege, and queer fatherhood as connected to the power of cultured space.

Bernard J. Armada is Associate Professor of Communication Studies at the University of St. Thomas in St. Paul, Minnesota. His work has been published in the *Southern Communication Journal* and the *Review of Education, Culture, and Pedagogy.* His research interests are in the rhetoric of music as well as the intersection of race, public memory, and the built environment.

Teresa Bergman is an Associate Professor at the University of the Pacific and a former documentary filmmaker. She teaches courses in documentary film criticism and production as well as mass communication. Her articles explore the evolving representation of nationalism and citizenship in orientation films at U.S. national parks and memorials and have appeared in *Rhetoric and Public Affairs, Text and Performance Quarterly,* and *Western Journal of Communication.* She is currently working on a book on this topic.

Carole Blair, Professor of Communication Studies at the University of North Carolina, earned her B.A. and M.A. at the University of Iowa and her Ph.D. at Penn State. Her research focus is on the rhetorical and cultural

significance of U.S. commemorative places and artworks. Her research has been published in journals and anthologies across disciplines (communication studies, landscape architecture, English, philosophy, sociology). Her work has received the National Communication Association's Doctoral Dissertation Award and Golden Anniversary Monograph Award (twice), as well as the annual outstanding article award from the Organization for the Study of Communication, Language and Gender. She teaches related courses on visual and material rhetorics, rhetoric and public memory, and rhetorics of place, as well as contemporary rhetorical theory and criticism.

John Bodnar is Chancellor's Professor and Chair of History at Indiana University, Bloomington. His awards include the Guggenheim Fellowship (1983–84); Fellowship at the Center for Advanced Study in the Behavioral Sciences at Stanford University (2001–2002); and National Endowment for the Humanities Senior Fellowship (2006–2007). Books include *Remaking America: Public Memory, Commemoration, and Patriotism in the Twentieth Century* (Princeton, 1992); *Blue-Collar Hollywood: Liberalism, Democracy, and Working People in American Film* (Johns Hopkins, 2003).

Michael S. Bowman teaches Performance Studies at Louisiana State University, where he is an Associate Professor in the Department of Communication Studies. He would like to thank Fiona Colton of the Scottish Borders Council for kind permission to conduct fieldwork at the Mary Queen of Scots House and Visitor Centre and staff members Pat McNab and Margaret Woolson for their interest in and help with that research. He would also like to thank Brian Rusted and Wayne McCready of the University of Calgary and the Calgary Institute for the Humanities for a Visiting Scholar appointment that facilitated the writing of the essay.

Gregory Clark writes about the rhetorical functions of cultural experience in the United States. He is the author of *Rhetorical Landscapes in America: Variations on a Theme from Kenneth Burke* (2004) and coeditor of *Oratorical Culture in Nineteenth-Century America* (1993). He is the editor of *Rhetoric Society Quarterly* and is Professor of English at Brigham Young University.

Greg Dickinson (Ph.D., University of Southern California) is an Associate Professor and Director of Graduate Studies in the Department of Communication Studies at Colorado State University. His research explores the intersections of rhetoric, place, memory, everyday life, consumer culture, and suburbia. He has won the Gerald R. Miller Dissertation Award

and (along with coauthors Brian L. Ott and Eric Aoki) has won the NCA Visual Communication Division Excellence in Scholarship Award. His essays have appeared in *Communication and Critical/Cultural Studies, Quarterly Journal of Speech, Rhetoric Society Quarterly, Southern Communication Journal,* and *Western Journal of Communication.*

Victoria J. Gallagher is an Associate Professor in the Department of Communication at North Carolina State University, where she teaches courses in Rhetorical Theory and Criticism, Communication Ethics, and Organizational Communication. She has published articles in a variety of scholarly journals, including *Quarterly Journal of Speech, Rhetoric and Public Affairs, Southern Communication Journal,* and *Western Journal of Communication,* as well as chapters in peer-reviewed, edited collections. Her most recent publications include a coauthored article (with Kenneth Zagacki) titled "Visibility and Rhetoric: The Rhetorical Function of Visual Images in Civil Rights Activism and Commemoration" (*Quarterly Journal of Speech,* 2005) and a book chapter titled "Displaying Race: Cultural Projection and Public Memory," in Lawrence J. Prelli, ed., *Rhetorics of Display* (2006).

Margaret R. LaWare (Ph.D., Northwestern University) has been a faculty member at Iowa State University since 1997, where she is an Assistant Professor of English and teaches in the Speech Communication, English, and Women's Studies programs. Her research covers three areas: visual and material rhetoric in the form of public art, contemporary women's rhetoric and feminist rhetorical invention, and pedagogy in the Basic Course in Communication. A common theme that runs throughout much of her research in all three areas concerns the rhetorical construction of both public and private identities. Of particular interest in her work is bringing into focus and supporting marginalized groups' efforts to gain a space for recognition.

Brian L. Ott (Ph.D., Pennsylvania State University) is a visiting Professor of Media Studies in the Department of Communication at University of Colorado Denver. His research concerns the suasory character of visual media and rhetoric. He is particularly interested in how visual modes of communication train human consciousness and frame the way persons process information. In 2003, he won the Critical and Cultural Studies Division's award for outstanding article at NCA. His scholarship has appeared in *Critical Studies in Media Communication, Communication and Critical/Cultural Studies, Rhetoric and Public Affairs, Journal of Popular Culture, Western Journal*

of Communication, and *Women's Studies in Communication.* His books include *The Small Screen: How Television Equips Us to Live in the Information Age* and *Critical Media Studies: An Introduction* (with Robert Mack).

Cynthia Duquette Smith is Lecturer and Director of Public Speaking at Indiana University, Bloomington. Her research focuses on the rhetoric of the built environment with an emphasis on domestic architecture. She has published a book review in *Rhetoric and Public Affairs,* and an article on the rhetoric of Martha Stewart Omnimedia in *Women's Studies in Communication.*

Bryan C. Taylor is Chair of and a Professor in the Department of Communication at the University of Colorado-Boulder. His primary research program involves the cultural discourses of history, memory, and heritage surrounding the development of nuclear weapons by the United States. He has published related studies in *Critical Studies in Media Communication, Journal of Contemporary Ethnography, Journal of Organizational Change Management, Quarterly Journal of Speech, Rhetoric and Public Affairs, Studies in Cultures, Organizations, and Societies, Western Journal of Communication,* and elsewhere. He is coauthor with Thomas Lindlof of *Qualitative Communication Research Methods,* (2nd ed., Sage, 2002). Current projects include an edited volume concerning communication, controversy, and the post–Cold War U.S. nuclear weapons production complex.